THE
MOVIE
BOOK

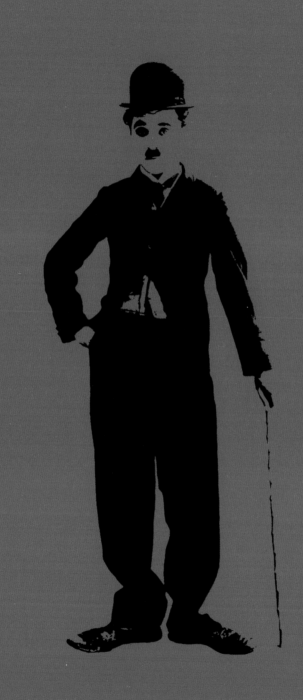

THE MOVIE BOOK

DK LONDON

SENIOR EDITORS
Sam Atkinson, Georgina Palffy

PROJECT ART EDITOR
Saffron Stocker

EDITORS
Stuart Neilson, Helen Ridge

US EDITORS
Margaret Parrish, Jane Perlmutter

DESIGNER
Phil Gamble

MANAGING EDITOR
Gareth Jones

SENIOR MANAGING ART EDITOR
Lee Griffiths

PUBLISHER
Liz Wheeler

DEPUTY ART DIRECTOR
Karen Self

PUBLISHING DIRECTOR
Jonathan Metcalf

ART DIRECTOR
Phil Ormerod

SENIOR JACKET DESIGNER
Mark Cavanagh

JACKET COORDINATOR
Claire Gell

JACKET DESIGN
DEVELOPMENT MANAGER
Sophia MTT

PRE-PRODUCTION PRODUCER
Dragana Puvacic

SENIOR PRODUCER
Mandy Inness

produced for DK by
TALL TREE LTD

EDITORS
Rob Colson, Camilla Hallinan,
David John, Kieran Macdonald

DESIGN
Ben Ruocco, Ed Simkins

DK DELHI

PROJECT EDITOR
Antara Moitra

SENIOR ART EDITOR
Chhaya Sajwan

ASSISTANT EDITOR
Tejaswita Payal

ART EDITORS
Tanvi Nathyal, Roohi Rais

ASSISTANT ART EDITORS
Meenal Goel, Priyansha Tuli

MANAGING EDITOR
Pakshalika Jayaprakesh

MANAGING ART EDITOR
Arunesh Talapatra

PRE-PRODUCTION MANAGER
Balwant Singh

DTP DESIGNER
Sachin Gupta

JACKET DESIGNER
Dhirendra Singh

SENIOR DTP DESIGNER
Harish Aggarwal

MANAGING JACKETS EDITOR
Saloni Singh

original styling by
STUDIO 8

First American Edition, 2016
Published in the United States by
DK Publishing 345 Hudson Street
New York, New York 10014

Copyright © 2016
Dorling Kindersley Limited, DK
a Division of Penguin Random House LLC
16 17 18 19 20 10 9 8 7 6 5 4 3 2 1
001—274827—Jan/2016

Published in Great Britain by Dorling
Kindersley Limited.

A catalog record for this book is available
from the Library of Congress.
ISBN 978–1–4654–3799–0

DK books are available at special
discounts when purchased in bulk for
sales promotions, premiums, fund-raising,
or educational use. For details, contact:
DK Publishing Special Markets, 345
Hudson Street, New York, New York,
10014 or SpecialSales@dk.com.

Printed and bound in China

A WORLD OF IDEAS:
SEE ALL THERE IS TO KNOW

www.dk.com

CONTRIBUTORS

DANNY LEIGH, CONSULTANT EDITOR

Danny Leigh is a journalist who regularly writes about movies for the *Financial Times* and *The Guardian*. Since 2010, he has cohosted BBC Television's long-running Film program, as well as writing and hosting documentaries for BBC TV and radio. He has also worked in film education and programming. Danny has written two novels, *The Greatest Gift* and *The Monsters of Gramercy Park*.

LOUIS BAXTER

Louis Baxter started watching and writing about movies as a boy, making his way through his parents' VHS collection and staying up until 3 a.m. to watch horror movies. He started his own movie blog and contributed to many others before studying film at Westminster University, London. He has since developed screenplays for a movie company and worked as a freelance writer and critic, specializing in horror movies.

JOHN FARNDON

John Farndon is a Royal Literary Fellow at Anglia Ruskin University in Cambridge and an author, playwright, composer, and poet. He taught the history of drama at the Actors Studio, studied playwriting at Central School of Speech and Drama, and is now Assessor for new plays for London's OffWestEnd Theatre Awards. He has also written many international best-sellers such as *Do You Think You're Clever?* and translated into English verse the plays of Lope de Vega and the poetry of Alexander Pushkin.

KIERAN GRANT

Kieran Grant is a writer and editor who lives in London. He has written about movies and television for *Radio Times*, the FILMCLUB website, and various licensed publications, and once traveled in the footsteps of Peter O'Toole's Lawrence of Arabia for *Esquire* magazine. He has been in love with British cinema since he first saw *Black Narcissus* on a big screen at university, and is proud to have made a tiny contribution by writing and codirecting *The Lights* (2015), a short film produced in association with the BFI and Film London.

DAMON WISE

A movie writer since 1987, Damon Wise is a Contributing Editor with *Empire* magazine and an advisor to the BFI London Film Festival's Thrill strand. As a journalist, his features, interviews, and reviews have been published in many notable UK magazines and newspapers. In addition to covering set visits and junkets, he is a regular attendee at key international film festivals. In 1998, he published his first book, *Come by Sunday*, a biography of British movie star Diana Dors.

CONTENTS

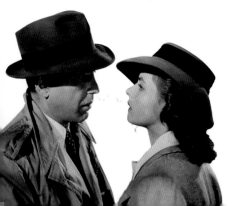

ANGELS AND MONSTERS
1975–1991

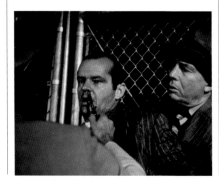

INTRODU

CTION

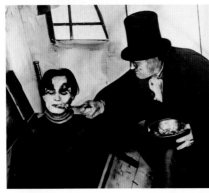
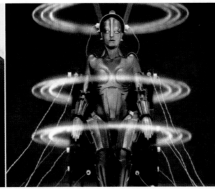
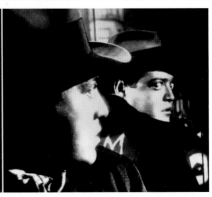

This book describes, discusses, and pays tribute to some of the movies that best capture the wonder of cinema. The movies gathered here are those that the authors feel, in the imprecise way of these things, to have had the most seismic impact on both cinema and the world.

The journey starts in 1902, when Parisian showman Georges Méliès unveiled the latest in the series of short silent movies with which he had been entertaining his countrymen. It was a romp through space called *A Trip to the Moon* (*Le voyage dans la lune*), and it was a huge and instant success—not just in France but across the world. (Sadly for Méliès, much of that success was due to the movie

No matter where the cinema goes, we cannot afford to lose sight of its beginnings.
Martin Scorsese

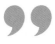

❝I don't know yet **what I'm going to tell them**. It'll be pretty **close to the truth**.**❞**
Philip Marlowe / *The Big Sleep*

being incessantly pirated by rivals.) Its popularity did more than any other movie of the time to secure the movie as the premier art form of the age. None before it had been as spectacular; none had such an intricate storyline.

Trains, panic, and hype
By the time Méliès was making his lunar adventure, cinema had already been established as a slightly disreputable pastime, to be enjoyed at theaters and fairgrounds. To find its true beginnings, it is necessary to step back further— to Paris again, but this time with two showmen in the spotlight. The pair, brothers Auguste and Louis Lumière, had their moment in 1896. That was when, after holding large-scale screenings of their movies the year before, they first showed the French public *L'arrivée d'un train en gare de La Ciotat*—also known as *The Arrival of a Train*. It was a mere 50 seconds of footage in which, as the title suggests, a steam train entered La Ciotat station, shot from the adjacent

platform. The sight sent all those watching fleeing in panic, convinced they were about to be mowed down by the speeding locomotive—or at least that's the story that circulated after the event. The exact truth has been lost to time, but either the Lumières had quickly mastered the new art form's ability to make the screen feel like life, or they had a stunning knack for promotional hype. Perhaps it doesn't matter either way—both those skills have a central place in the story of cinema.

But it may be necessary to step back further still. After all, before the Lumière brothers sent their audience bolting in terror, plenty of others had pioneered movies. There should be a tip of the hat to US inventor Thomas Edison, who had screened movies of boxing cats and men sneezing to individual customers a couple of years before the Lumières, and to English photographer Eadweard Muybridge, whose 1880s studies of humans and animals in motion were a vital preface to the moving picture.

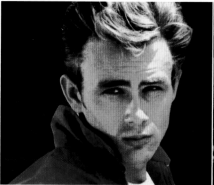
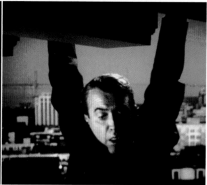

Telling stories

In fact, the story of movie arguably stretches back to prehistoric times, to human ancestors hunched around a fire as one among them used the light to cast shadows on the wall and illustrate tales of fearsome beasts or unlikely heroism. When the audience settle into their seats for an insanely expensive, effects-fueled blockbuster on a towering IMAX screen, they're back around that fire. Movie in the 21st century is still a telling of stories with words and images, bringing those images to believable life.

This book is an attempt to build a narrative of movie history out of the movies themselves, taking a tour of a hundred or so movies from Méliès on through the next century and beyond. Each entry discusses where a movie came from, maps its inspiration and how it was made, documents the men and women whose talent shaped it, and details the ripples of influence it sent out.

It is a story that crosses time. In the silent age, the first men and women explored the possibilities of moving pictures. From there, the story slips into the 1930s and 1940s, the gilded years when cinemas stood on every main street and movies were beloved slabs of mass appeal; the age of movie stars such as Humphrey Bogart, Katharine Hepburn, and James Stewart. In the 1950s, filmmakers from Europe, India, and Japan created a string of masterpieces that still receive acclaim to this day; this was the time of Henri-Georges Clouzot, Akira Kurosawa, Yasujirô Ozu, Nicholas Ray, and Satyajit Ray. A new generation took hold in the 1960s and 1970s, and broke the established molds. And then the story of cinema arrives in the present, where movies are made with technology that would have been the stuff of science fiction even 10 years ago, whole worlds spun into being at the push of a button.

Blissful immersion

The beauty of movies is that every individual has a different way of looking at them, and a different route into loving them. As a writer

Each picture has some sort of rhythm, which only the director can give it.
Fritz Lang

and movie journalist, this book's consultant has spent much of his adult life in cinemas seeking out movies that can give him that feeling of blissful immersion he was hooked on as a child: "I sit while the lights dim and I'm the seven-year-old who yelped with laughter at Harpo Marx on a rigged-up screen at a friend's birthday party; or who escaped a family Christmas at 10 to switch on the old TV set upstairs, and found that *Citizen Kane* was playing; or whose mind was comprehensively blown at 14 by the dark, unnerving movies of David Lynch. Those moments live on every time I see a film."

A couple of decades after *A Trip to the Moon*, with a luckless Méliès soon to find himself selling »

❝I live now in a world of ghosts, a prisoner in my dreams. ❞
Antonius Block / The Seventh Seal

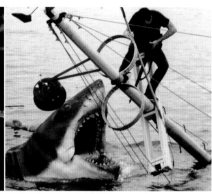

> We can't help identifying with the protagonist. It's coded in our movie-going DNA.
> **Roger Ebert**

trinkets at Montparnasse train station station, the youthful medium was given a nickname that still fits today: the "Seventh Art," after architecture, painting, music, sculpture, dance, and poetry. Its author was Ricciotto Canudo, an Italian scholar. To Canudo, the power of the movies was that they brought each of the great art forms of the past together into one—to watch movies was to experience all six of the older art forms at once.

Movies evolve

So many years later, the sheer sensory rush of the movies is still enough to overwhelm the audience, in the very best sense of the word. It's hard to imagine the creak and crackle of cinema's early years

drawing a viewer into the screen the way a movie does now—but as the Lumières' train movie shows, movies could make audiences take them as real from the start.

Charting how the movies have evolved as an art form is one of the great joys of being a movie lover. Sometimes the advances may be obvious: the momentous lurches from silence to sound, and from black and white to color. Elsewhere, the revolutions were subtler, as the crafts of filmmaking—cinematography, editing—took on lives of their own.

The wider historical context in which movies were made also needs to be considered—when you talk about movies, you're never *just* talking about movies. Once you dive into the history of movies, you can't help dealing with history in general. Look at the last century of movies and you see real life running through it like the rings of a tree. Purely as cinema, it is hard to overstate the impact of Godzilla, the movie monster who terrorized Tokyo Bay in 1954—and what was

Godzilla but Japan's nuclear trauma made scaly flesh? You don't need to be a movie lover to quote a line from *Some Like It Hot* ("Nobody's perfect!")—but how different a movie would it have been had its Austrian-born director, Billy Wilder, not been forced, like so many other European filmmakers, to flee to the US as the Nazis took power? The Russian Revolution, the Cold War, the hippie era, feminism, the computer age—every major moment in world history is up there on screen somewhere.

All this in a medium that began in the fairground, one step from the circus, and has spent much of its existence as an excuse for young couples to sit together in the dark. That what was happening on the screen ascended to such glorious entertainment was unlikely enough. That it became art is perhaps even more extraordinary.

A communal experience

In many ways, it is their contradictions that make the movies what they are. How else

❝If we're looking for a shark, we're not gonna find him on the land.❞
Hooper / *Jaws*

"**Art**, that's **special**. What can **you bring to it** that nobody else can?"

Mr. Turlington / *Boyhood*

to explain the effect they have on their audiences? When a viewer falls for a movie, it can feel like it has been made for them and them alone, like a hand extending from the screen. And yet, if you have ever watched a really great comedy in the middle of a packed cinema, or flinched to a horror alongside two hundred others doing exactly the same, you will know that movies are meant to be watched in a crowd, that cinema grew up as an experience to be shared with others.

Over the years, movies have been viewed in many different ways. At first, they were novelties, cheap dollops of sensation. Then they were impossibly glamorous moments of escapism whose stars glittered in pristine black and white. They evolved into profound accounts of the human condition, made by great auteurs. Today, they are often vastly expensive spectacles designed to make still more money for studios and corporations. They make you feel that you've slipped behind the eyes of the people on screen, the whole

thing not unlike a dream or an act of hypnosis, until you stumble back out into the light, maybe understanding something new about yourself, maybe just aching from laughing so hard.

A world of choice
Some of the movies in this book were adored by critics; others were pure crowd-pleasers. Quite a few were neither, flops that later generations then realized were masterpieces. Genre doesn't come into it. Thrillers rub shoulders with Westerns, romance with neorealism, and they all have to make room for the occasional musical.

Language and nationality are no concern either. Hollywood is well represented—although many see it as a dirty word, the true movie lover knows how many good things Tinseltown has produced over the years. But there has always been a big world beyond Beverly Hills, and no worthwhile book about movies could ignore that. *The White Ribbon* (2009) deserves its place every bit as much as *Jaws* (1975).

There will, of course, be both omissions and inclusions that will puzzle each reader. Part of the beauty of cinema is that no two opinions on movies are ever quite the same. If this were just a list of the favorites of the consultant and authors, it would deviate in places from the list that follows. You might think the job of selection would get easier if the criterion were "greatness," but really, that's just as subjective. Rather, this book chooses its movies as an atlas of influence, a collection of landmarks, and the hope is that, if a reader's own best-loved movie is missing, there will be others that make up for it. And also that there will be at least one movie that readers will choose to watch for the first time. ■

When you clean them up, when you make movies respectable, you kill them.
Pauline Kael

VISIONA
1902–1931

RIES

The French Lumière brothers shoot the **46-second short** *La Sortie des usines Lumière à Lyon.*

In **Charlie Chaplin's** second movie, *Kid Auto Races at Venice,* the character **the Tramp** appears for the first time.

The Cabinet of Dr. Caligari, a disturbing **German Expressionist** classic, reflects its authors' experiences in World War I.

F. W. Murnau's **unauthorized adaptation** of Bram Stoker's *Dracula,* titled *Nosferatu,* is released. It is nearly destroyed following a lawsuit.

1894 **1914** **1920** **1922**

1902 **1916** **1920** **1922**

Georges Méliès's *A Trip to the Moon* sets a new benchmark for high **production values** and **special effects**.

D. W. Griffith's 3.5-hour epic *Intolerance* is an early **Hollywood blockbuster** movie.

Buster Keaton stars in his first full-length comedy, *The Saphead.*

The Toll of the Sea is the first **Technicolor movie** to be put out in general release.

Movies are so much a part of today's culture that it is hard to imagine a time when they weren't there at all. It's hard, too, to appreciate the awe felt by the public of the 1890s at seeing moving pictures for the first time, as ghostly figures came to life before their eyes. From a 21st-century viewpoint, however, the real shock is how far those "movies" changed in the next three decades—quickly evolving into gorgeously vivid feature movies.

Magic on screen

For the early filmmakers, there were no masters to learn from. Some had a background in theater, others in photography. Either way, they were breaking new ground, and none more so than Georges Méliès. As soon as this sometime magician had begun entertaining the French public with movies, he looked for ways to make them more splendid and spectacular. In America, too, visionaries were at work. There, cinema thrived thanks to the likes of Edwin S. Porter, a former electrician who ended his 1903 feature *The Great Train Robbery* with a gunman turning toward the camera and appearing to fire at the audience.

Other filmmakers had grander plans. A few years later, Porter was approached by a fledgling playwright who hoped to sell him a script. Porter turned down the script, but hired the young man as an actor—and that same young man, the gifted and still controversial D. W. Griffith, later become a director himself, helping to father the modern blockbuster.

Movies as art

Although the pioneers clustered in France and America, it was in Germany that the movies first became art. In the aftermath of World War I, a country mired in political and economic chaos gave rise to a string of masterpieces whose influence still echoes today. The silent era was filled with some of the most glorious, pristine filmmaking that cinema would ever know: the works of Robert Wiene, F. W. Murnau, and Fritz Lang. Yet even then, it wasn't just directors who deserved the credit—take the giant Karl Freund, a huge man with an equally vast knowledge of cameras, who would become a master cinematographer, strapping the camera to his body and setting it on bicycles to revolutionize how a movie could look.

The Thief of Bagdad stars Douglas Fairbanks and a cast of thousands in an early and lavishly produced **swashbuckling adventure fantasy**.

1924

Alfred Hitchcock's first thriller, *The Lodger: A Story of the London Fog*, about the hunt for Jack the Ripper, is a commercial hit in the UK.

1927

The Jazz Singer is the first movie with **synchronized sound dialogue**. It mixes title cards with short sound sequences.

1927

Josef von Sternberg's *The Blue Angel* is released in German- and English-language versions, and makes **Marlene Dietrich** a worldwide star.

1930

1925

Sergei Eisenstein's **technical masterpiece** *Battleship Potemkin* is released to mark the 20th anniversary of the 1905 Russian Revolution.

1927

Fritz Lang's *Metropolis* is one of the first **full-length science-fiction** movies, set in a technologically advanced dystopian future.

1929

The **first Academy Awards** ceremony is held at the Hollywood Roosevelt Hotel in Los Angeles.

1931

Charlie Chaplin **defies the talkie revolution** with his hit silent classic *City Lights*.

Painters were also drawn to the screen, and in 1929, the famed Surrealist Salvador Dalí worked with a young movie fanatic named Luis Buñuel on the eternally strange *Un Chien Andalou*; Dalí then stepped away from movies, but Buñuel continued making iconoclastic movies into the 1970s. There were revolutionaries of the political kind, too. In the Soviet Union, cinema was embraced as *the* art form of the people. Movies became key to the global battle for hearts and minds.

Hollywood begins

Back in America, the cinematic hustlers became the first studio bosses of Hollywood. They built their businesses on stars such as Rudolph Valentino, Douglas Fairbanks, and Greta Garbo.

Charlie Chaplin and I would have a friendly contest: Who could do the feature film with the least subtitles?
Buster Keaton

The biggest stars were clowns, and of all the wonders of the silent age, it is the comedies that most reliably delight today. In Buster Keaton and Charlie Chaplin, Hollywood found two true geniuses who had honed their craft in American vaudeville and British music hall and now worked their magic on camera. Masters of mime, slapstick, and pathos, they could make audiences laugh just by looking at them. They were also meticulous filmmakers with a taste for innovation.

If one person defined the early movies, it was the phenomenally famous and endlessly ambitious Chaplin. By the end of this era, sound arrived—it was 1927 when Al Jolson declared in *The Jazz Singer*: "You ain't heard nothing yet!" But Chaplin's love for silent movies was such that he kept making them, and in 1931, with *City Lights*, he made one of the very greatest. By then, he had already helped the movies claim their rightful place, where they still are today—in the center of people's lives. ■

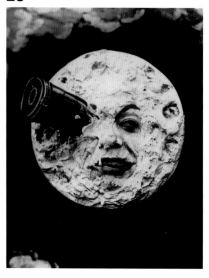

LABOR OMNIA VINCIT

A TRIP TO THE MOON / 1902

IN CONTEXT

GENRE
Science fiction, fantasy

DIRECTOR
Georges Méliès

WRITERS
Georges Méliès, from novels by Jules Verne and H. G. Wells (all uncredited)

STARS
Georges Méliès, Bleuette Bernon, François Lallement, Henri Delannoy

BEFORE
1896 Méliès's short movie *Le Manoir du Diable* (*The Devil's Castle*) is often credited as the first horror movie.

1899 *Cinderella* is the first of Méliès's movies to use multiple scenes to tell a story.

AFTER
1904 Méliès adapts another Jules Verne story with *Whirling the Worlds*, a fantasy about a group of scientists who fly a steam train into the sun.

A s its title suggests, the 12-minute-long movie *A Trip to the Moon* (*Le Voyage dans la Lune*) is a fantastical account of a lunar expedition. A group of scientists meets, a huge gun is constructed, and astronauts are blasted to the moon, where they fall into the hands of the moon-dwelling Selenites.

Chorus girls line up to fire the Monster Gun that will blast a spaceship to the moon. Méliès's overblown theatrical style keeps the action more absurd than heroic.

They are brought before the King of the Selenites, but manage to escape. They return to Earth, where a parade is held in their honor and an alien is put on display.

Magic tricks

Some pioneers of the cinema, such as the French Lumière Brothers, saw the new medium as a scientific breakthrough, a means of documenting reality. Frenchman Georges Méliès, the director of *A Trip to the Moon*, however, recognized it as a new way of performing magic tricks.

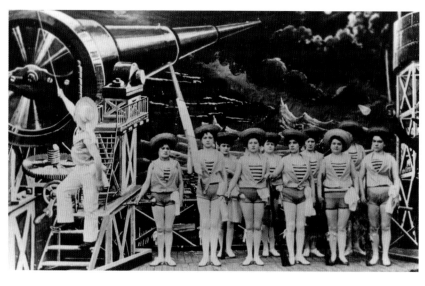

What else to watch: *The Man with the Rubber Head* (1901) ▪ *A Trip to Mars* (1910) ▪ *Metropolis* (1927, pp.32–33) ▪ *The Invisible Man* (1933) ▪ *First Men in the Moon* (1964) ▪ *Hugo* (2011)

Méliès's short movies were simply entertainments, created for the sensation seekers who roamed the boulevards of *fin-de-siècle* Paris. Filled with chorus girls, ghosts, and Mephistophelian devils, the movies started out as recordings of simple magic acts and evolved into fanciful stories realized through innovative and audacious camera trickery—cinema's fledgling special effects. By 1902, Méliès was ready to pull off his biggest illusion: to take his audiences to the moon and back.

Sci-fi and satire

A Trip to the Moon was the first movie to be inspired by the popular "scientific romances" of Jules Verne and H. G. Wells, and is widely acknowledged as the world's first science-fiction movie. But while it is true that Méliès conjured up the basic iconography of sci-fi cinema—the sleek rocket ship, the moon hurtling toward the camera, and the little green men—the director did not set out to invent a genre. His aim was to present a mischievous satire of Victorian values, a boisterous comedy lampooning the reckless industrial revolutionaries of Western Europe.

In Méliès's hands, men of science are destructive fools. Led by Professor Barbenfouillis (played by Méliès himself), they squabble and jump

When they reach the moon, the scientists discover a strange land. Their arrogant attitude toward the moon people has led the movie to be seen as an anti-imperialist satire.

Georges Méliès Director

Méliès's early short movies experimented with the theatrical techniques and special effects he had mastered as a stage magician. He used the camera to make people and objects disappear, reappear, or transform completely, and devised countless technical innovations. Méliès wrote, directed, and starred in more than 500 motion pictures, pioneering the genres of science fiction, horror, and suspense.

Key movies

1896 *The Devil's Castle*
1902 *A Trip to the Moon*
1904 *Whirling the Worlds*
1912 *The Conquest of the Pole*

up and down like unruly children, and when they land on the lunar surface, their rocket stabs the Man in the Moon in his eye. They cause chaos in the kingdom of the Selenites—whom they treat as mindless savages—and they only make it home by accident. A statue of Barbenfouillis appears in the final scene—a caricature of a pompous old man, resembling one of Méliès's political cartoons. Its inscription reads *"Labor omnia vincit"* (Work conquers all), which, in light of the chaos that has preceded it, takes on a decidedly ironic tone. ▪

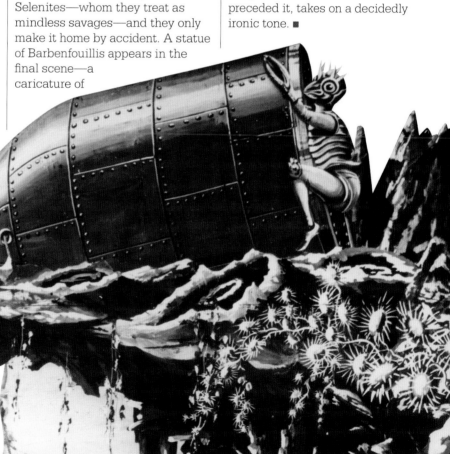

OUT OF THE CRADLE ENDLESSLY ROCKING
INTOLERANCE / 1916

IN CONTEXT

GENRE
Historical epic

DIRECTOR
D. W. Griffith

WRITERS
D. W. Griffith, Anita Loos

STARS
Vera Lewis, Ralph Lewis, Constance Talmadge, Lillian Gish, Mae Marsh, Robert Harron

BEFORE
1914 Italian director Giovanni Pastrone makes *Cabiria*, an early feature-length epic.

1915 Griffith's *The Birth of a Nation* is the first US feature movie, but sparks controversy with its racist content.

AFTER
1931 Griffith's final movie, *The Struggle* (his second sound feature), is a box-office failure. It is a semiautobiographical tale of a battle with alcoholism.

One of the most influential movies ever made, *Intolerance* is truly epic in its scope, with elaborate sets and countless extras. It was not the first movie to use techniques such as camera tracking and close-ups, but director D. W. Griffith used them with such mastery that many regard him as the father of modern moviemaking.

The movie was born in controversy. Griffith's previous movie in 1915, *The Clansman*, came to be called *The Birth of a Nation* and was the first full-length feature movie made in the US. Its innovative techniques foreshadowed those used in *Intolerance*. It was a hit, but was condemned by many for its overt racism, glorifying slavery and the Ku Klux Klan.

Its commercial success, however, bankrolled the cast of thousands required to make *Intolerance*, which lost as much at the box office as *The Clansman* had made. Some critics describe *Intolerance* as an apology for the earlier movie, but there is nothing apologetic in its ambition and scale.

Four-part drama
Four stories of intolerance, spanning three millennia, interweave through the movie, each with a different

D. W. Griffith Director

Born on a farm in Kentucky in 1875, David Llewelyn Wark Griffith was 10 when his father died, leaving the family in poverty. After several years of stage work, he got an acting job for a movie company in 1908, and was soon making his own movies, some of the first ever made in Hollywood. He set up his own company to make *The Birth of a Nation*, whose racism caused protests and riots. Griffith made about 500 movies in total, but his career entered into a downward spiral after *Intolerance*. He died in 1948.

Key movies

1909 *A Corner of Wheat*
1915 *The Birth of a Nation*
1916 *Intolerance*
1919 *Broken Blossoms*

What else to watch: *Cleopatra* (1917) ▪ *Broken Blossoms* (1919) ▪ *Sunrise* (1927, pp.30–31) ▪ *Metropolis* (1927, pp.32–33) ▪ *Modern Times* (1936) ▪ *Gone with the Wind* (1939, pp.62–63) ▪ *Ben-Hur* (1959)

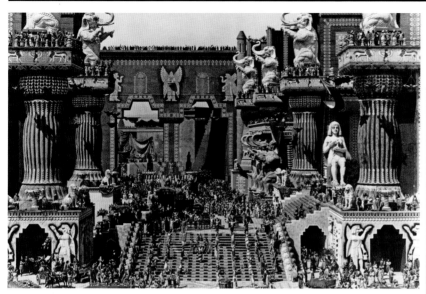

The central courtyard in Babylon was recreated with a life-size set. More than 3,000 extras were employed for Belshazzar's lavish feast.

film tint. They are linked by the ever-present image of a mother, played by Lillian Gish, rocking a cradle to symbolize the passing generations. Captioned "Out of the cradle endlessly rocking," it suggests that nothing changes.

The first of the four stories focuses on the conflict at the fall of ancient Babylon, fueled by the intolerant devotees of two warring religions. The second tells how, after the wedding at Cana, Christ is driven to his death by intolerance. The third tale depicts the St. Bartholomew's Day massacres in France in 1572, when Catholics massacred the Protestant Huguenots. The final story is of two young lovers who are caught up in a conflict between ruthless capitalists and moralistic striking workers. Griffith is clearly on the side of the lovers, who are hounded by the type of social reformers he clearly equates with those who protested against *The Clansman*.

The four stories are intercut with increasing rapidity as the movie approaches its climax. Racing chariots in one story cut into speeding trains and cars in another; this effect was achieved almost entirely in the edit, since Griffith shot the sections chronologically.

To some critics, the effect is almost symphonic, while others find it tiresome. But there is no doubt that this crosscutting and use of the edit was to prove hugely influential.

Other technical innovations we now take for granted include dissolves between scenes and the fade-out. Most significant of all, perhaps, was the close-up. The full-length shots of earlier movies called for an exaggerated, pantomime style of acting to convey the story. But as Griffith said, "The close-up enabled us to reach real acting, restraint, acting that is a duplicate of real life." ▪

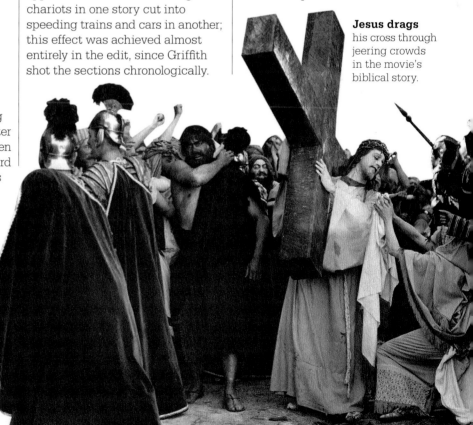

Jesus drags his cross through jeering crowds in the movie's biblical story.

I MUST BECOME CALIGARI!

THE CABINET OF DR. CALIGARI / 1920

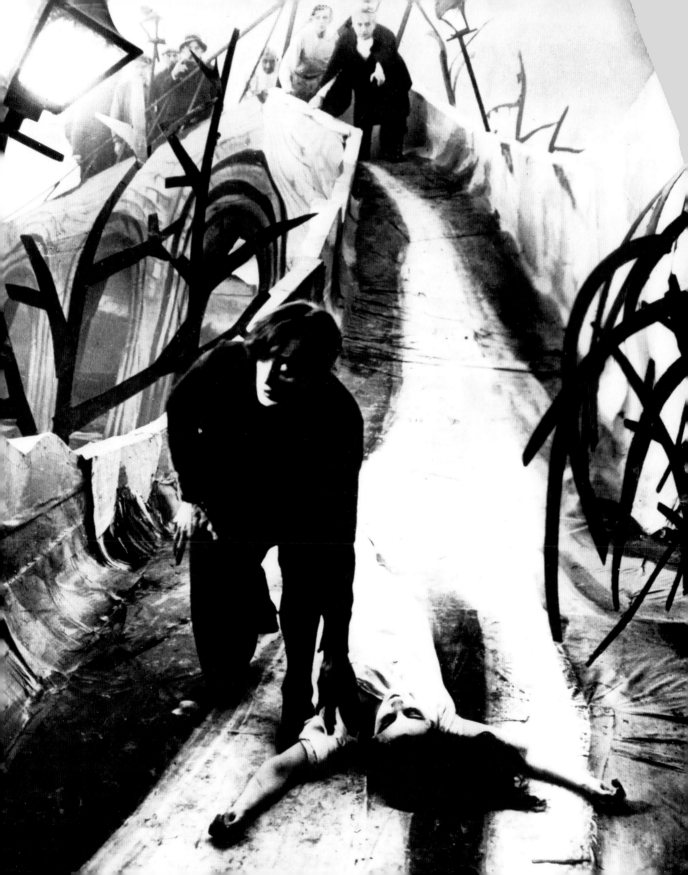

IN CONTEXT

GENRE
Horror

DIRECTOR
Robert Wiene

WRITERS
Hans Janowitz, Carl Mayer

STARS
Werner Krauss, Conrad Veidt, Friedrich Fehér, Hans Heinrich von Twardowski, Lil Dagover

BEFORE
1913 *The Weapons of Youth* is Wiene's first movie, now lost.

AFTER
1924 *The Hands of Orlac,* an Expressionist movie by Wiene, is later remade twice and inspires many horror movies.

1925 Wiene directs a silent movie of Richard Strauss's opera *Der Rosenkavalier.* Strauss conducts a live orchestra for the premiere, but a tour of the US is canceled with the arrival of sound movie.

I have never been able since to trust the authoritative power of an inhuman state gone mad.
Hans Janowitz

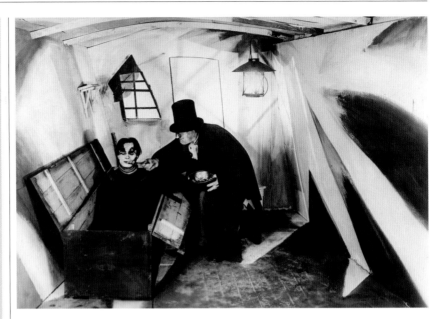

The Cabinet of Dr. Caligari has been described as the first feature-length horror movie, and it is easy to see its legacy in modern cinema, but not for the obvious reasons. Its ingenious set design—still avant-garde in its use of palpably unreal, theatrical environments—is the most striking of its features. Yet it is other, more subtle elements of Robert Wiene's groundbreaking psychological thriller that have become fixtures of movie storytelling.

The "unreliable narrator" had long been a staple of literature, since the time of the ancient Greek dramatist Aristophanes, but it had yet to be used in cinema. *Caligari* pioneers the use of this device in the character of Francis (Friedrich Fehér). The story Francis tells starts, innocently enough, with a love triangle, as two friends compete for the affections of the same woman— but of course, all is not as it seems.

The movie's screenwriters, Hans Janowitz and Carl Mayer, originally wrote the story as an indictment of Germany's government during World War I,

The somnambulist Cesare, who, the viewer is told, has been in a sleeping trance for 23 years, is roused by Caligari and fed sitting in his coffin.

with Caligari as a straightforward villain causing an innocent to sleepwalk into committing murder. As the movie neared production, however, the story morphed into something more complex, leading to possibly another first for cinema: the twist ending.

Opening the cabinet

Janowitz and Mayer were inspired by an 11th-century story about a confidence-trickster monk who exerted a strange influence over a man in his keep. In their screenplay, the monk became a doctor, whom Francis and his love rival Alan (Hans Heinrich von Twardowski) encounter at a village fairground.

Dr. Caligari (Werner Krauss) first appears as a fairground showman who opens his so-called cabinet— a coffin by any other name—to reveal the ghostly, heavy-lidded Cesare (Conrad Veidt) lying within.

Caligari, Cesare's "master," claims that his charge "knows all secrets" and invites the audience to ask a question. A visibly shaken Alan asks, "How long shall I live?"—to which Cesare replies, "Until dawn." And here we see another example of a horror-movie device lifted from countless tales: the fool who tempts fate. The unfortunate Alan is found dead the following morning.

Expressionist style

The look and style of the movie were heavily influenced by the legendary Max Reinhardt, director of the Deutsches Theatre in Berlin. His antirealist style, itself inspired by the Expressionist art movement of the early 20th century, embraced the artificiality of the theater set and manipulated darkness rather than light to create swathes of chiaroscuro, establishing an atmosphere of mystery and unease.

Wiene carefully employs lighting to suggest that this is simply an outlandish melodrama—a notion reinforced by the frequent use of sinister close-ups, mostly of the seemingly insane Caligari, to persuade his audience that they are watching a straightforward hero-and-villain story. Yet when it is revealed that no character's perspective may be taken at face value, suddenly the strange, distorted angles and backdrops of the production design begin to make sense. They are an integral part of the story and not simply an unsettling style; the sets by Walter Reimann, Walter Röhrig, and Hermann Warm seem to portray a whole world gone mad.

One reason that *The Cabinet of Dr. Caligari* has endured is that, anticipating Hitchcock's *Psycho*, it is the first movie to take audiences inside the mind of a madman. Its resonant horror stems from our fear of the mask of sanity that even the most disturbed individuals can wear in order to deceive those around them. ▪

Robert Wiene Director

Robert Wiene was born in 1873 in Breslau. In 1913, he wrote and directed a short movie, *The Weapons of Youth*, which was the first of 20 features and shorts he would make in the silent era. After a prolific movie career in Germany, Wiene fled the Nazi regime in the early 1930s and moved to France. He died of cancer during the shooting of his last movie, *Ultimatum* (1938), which was completed, uncredited, by fellow émigré Robert Siodmak.

Key movies

1913 *The Weapons of Youth*
1920 *The Cabinet of Dr. Caligari*
1923 *Raskolnikow*
1924 *The Hands of Orlac*

Cesare carries away Francis's sweetheart, Jane, through a landscape resembling the aftermath of World War I, which had ended just two years earlier.

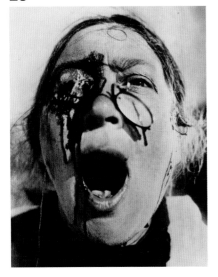

WHAT ARE WE WAITING FOR?
BATTLESHIP POTEMKIN / 1925

IN CONTEXT

GENRE
Historical drama

DIRECTOR
Sergei Eisenstein

WRITER
Nina Agadzhanova

STARS
**Aleksandr Antonov,
Vladimir Barsky,
Grigori Aleksandrov**

BEFORE
1925 Eisenstein's first full-length feature, *Strike*, tells the story of a 1903 walkout in a Russian factory and the repression of the workers.

AFTER
1928 Eisenstein's *October (Ten Days That Shook the World)* uses a documentary style to tell the story of the 1917 October Revolution.

1938 In a more restrictive political climate, Eisenstein retreats to distant history with *Alexander Nevsky*.

Sergei Eisenstein's *Battleship Potemkin* was commissioned by the Soviet authorities to commemorate the 20th anniversary of the 1905 Revolution, when Russian sailors mutinied against their naval commanders and protested in the port of Odessa (now in Ukraine). The result was a movie that revolutionized cinema. Ninety years later, it is rare that an action movie does not owe it something.

The opening scenes are historically accurate. The cooks did take issue with the maggot-ridden

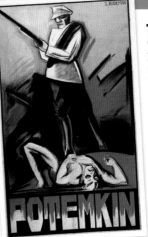

This was one of the first movie posters by Dutch designer Dolly Rudeman. It depicts a Cossack soldier with one of his victims at his feet. Its bold futurist style is typical of 1920s posters in Europe.

View it in the same way that a group of artists might view and study a Rubens or a Raphael.
David O. Selznik

meat, only to be told that it was fit for consumption. The crew's spokesman, Quartermaster Grigory Vakulinchuk (Aleksandr Antonov), did call for a boycott and was shot. The crew did turn on their superior officers before hoisting a red flag and sailing to Odessa, where there had been ongoing civilian unrest. And Vakulinchuk's body was put on display, with a note: "This is the body of Vakulinchuk, killed by the commander for telling the truth."

When the sailors reach Odessa, however, Eisenstein's movie veers into propaganda. While it is true that Tsar Nicholas II took action against the striking citizens of Odessa, this did not happen at the

What else to watch: *Strike* (1925) ▪ *October* (1928) ▪ *Man With a Movie Camera* (1929) ▪ *The Untouchables* (1987) ▪ *JFK* (1991)

A carriage careers down the steps past and over the bodies of the dead and dying. The baby's mother has been shot: as she fell, she nudged ir forward, starting its headlong descent.

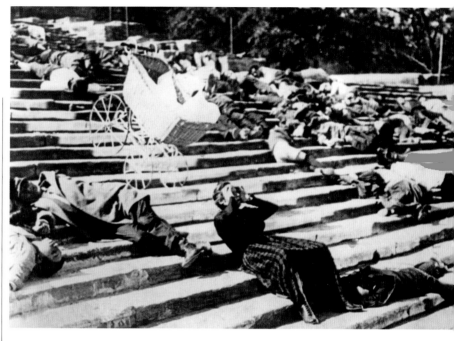

Odessa Steps. Now known as the Potemkin Stairs, they were then just the Boulevard Steps, or Giant Staircase. The director made full use of the 200 steps to show the tsarist troops advancing. The crowds' celebration with the sailors is cut short by an title card that says simply "And suddenly." The scenes of carnage that follow have lost none of their power. Nobody is safe from the advancing troops, filmed from a low angle and often tightly cropped: for the director, only their rifles needed to be visible. The outraged sailors fire back with shells, before heading off to sea where they are joined in revolt by other sailors.

Montage and collision

As a history lesson, *Battleship Potemkin* took liberties, but factual accuracy was never Eisenstein's concern. It was more important for him to pursue a new cinematic language, which he did by drawing on the experiments in montage pioneered by Soviet movie theorist Lev Kuleshov between 1910 and 1920. For Kuleshov, meaning lay not in individual shots but in the way that the human mind contextualizes them: for example, by using the same image of a man's face and intercutting it with a bowl of soup, a coffin, and a woman, Kuleshov could conjure up images of hunger, grief, and desire. Eisenstein's belief in montage—although he preferred to use images in "collision" with each other—can be shown by statistics alone: at under 80 minutes, *Battleship Potemkin* consists of 1,346 shots, when the average movie of the period usually contained around 600.

Manipulating emotions

Eisenstein's approach to storytelling still seems radical today. Its juxtaposition of the epic and the intimate virtually rules out the possibility of engaging with the characters on a personal level, and in that way it is indeed perfectly communist. Even Vakulinchuk, the hero and martyr of the piece, is seen only as a symbol of humanity to be contrasted with the faceless tsarist troops. The most famous scene—a baby in a carriage tumbling down the steps—is the ideal symbol of the movie's manipulative grip on our helpless emotions. ▪

Sergei Eisenstein Director

Born in 1898 in Latvia, Sergei Eisenstein started work as a director for theater company Proletkult in Moscow in 1920. His interest in visual theory led to the "Revolution Trilogy" of *Strike*, *Battleship Potemkin*, and *October*. He was invited to Hollywood in 1930, but his projects there stalled. Back in the Soviet Union, he found that the political tide had turned against his "formalist" ideas, to more traditional storytelling. He died in 1948, leaving behind just eight finished movies.

Key movies

1925 *Battleship Potemkin*
1928 *October*
1938 *Alexander Nevsky*

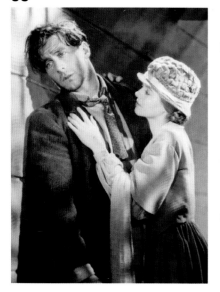

THIS SONG OF THE MAN AND HIS WIFE IS OF NO PLACE AND EVERY PLACE
SUNRISE / 1927

IN CONTEXT

GENRE
Silent drama

DIRECTOR
F. W. Murnau

WRITERS
**Carl Mayer (screenplay);
Hermann Sudermann
(short story)**

STARS
**George O'Brien, Janet
Gaynor, Margaret
Livingston, Bodil Rosing**

BEFORE
1922 Murnau's *Nosferatu* helps
to define the horror genre in a
nightmarish version of *Dracula*.

AFTER
1927 *Metropolis*, Fritz Lang's
science-fiction classic, also
features the spectacle of the
modern city.

1930 Murnau's *City Girl* tells
the story of a flapper falling in
love with a farm boy and being
rejected by his family.

In 1927, one movie changed the course of cinema history: *The Jazz Singer*, starring Al Jolson, was the first ever feature-length "talkie." But another song was playing in picture palaces that year, and it was a silent movie. In *Sunrise: A Song of Two Humans*, German director F. W. Murnau attempted to distill a universal human experience into 90 wordless minutes of beautiful monochrome imagery, accompanied only by music and sound effects.

At a lakeside village, two clandestine lovers meet under the moonlight. The man (George O'Brien) is an honest country fellow who has been seduced by the vampish woman from the city (Margaret Livingston). She urges him to sell his farm and come with her to pursue a life of excitement in the city. The man is married, however, to his sweet young wife (Janet Gaynor). When he asks the woman: "And my wife?" a sly look comes into his lover's eyes. "Couldn't she get drowned?" is the chilling title card.

The rural setting, creeping fog, and shifting, spidery shadows of this scene recall Murnau's other great masterpiece, the archetypal vampire movie *Nosferatu*. *Sunrise* looks set to deliver an equally

F. W. Murnau Director

Born in Germany in 1888, Friedrich Wilhelm Murnau fought for his country in the horror of World War I before making a horror of his own: *Nosferatu*, the first movie to be based on *Dracula*. *The Last Laugh* proved that Murnau could move his audiences as skillfully as he could terrify them. A highly literate man, Murnau brought Goethe's *Faust* to the big screen before moving to Hollywood in 1926. His first US movie was *Sunrise: A Song of Two Humans*. He died in a car crash in 1931.

Key movies

1922 *Nosferatu*
1924 *The Last Laugh*
1927 *Sunrise*

What else to watch: *The Cabinet of Dr. Caligari* (1920, pp.24–27) ▪ *Faust* (1926) ▪ *The Lodger* (1927) ▪ *Wings* (1927) ▪ *Street Angel* (1928) ▪ *Man with a Movie Camera* (1929) ▪ *City Lights* (1931, pp.38–41) ▪ *A Star Is Born* (1937)

sensationalist story of sex, death, violence, and betrayal. But will the man commit murder? With her black bob, sleek satin dress, and smoldering cigarette, the woman from the city embodies the amorality of the metropolis, while the man is a symbol of rustic innocence. The viewer assumes that *Sunrise* will be a chronicle of corruption; at one point the woman appears devil-like on the man's shoulder, urging him to sin. The man invites his wife to take a boat ride, but when the moment comes to drown her, he can't go through with it.

The man hesitates, the wife escapes, and when he catches up with her, the pair find themselves on a tram bound for the city. Unable to discuss what has happened at the lake for fear of being overheard, they stay on the tram.

City awakening

This is where *Sunrise* surprises us. The metropolis has a magical effect on the man and his wife as they spend the day wandering through its vertiginous throng, thrown together in a touching, accidental second courtship.

Yet there is still much drama ahead, and more unforgettable sights: crowds through which the camera swoops, street carnivals,

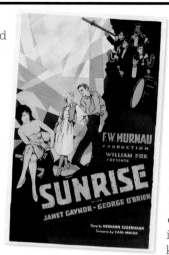

Unable to go through with the murder, the man follows his wife to a tram, and they both end up heading for the city.

Sunrise was one of the first movies with sound effects, but its innovations were largely overlooked.

and strange hallucinogenic patterns in the bright lights. Danger, too, will reappear, the past not so easily escaped. And all of it is made with the kind of ambition— Murnau's "city" was made up of vast, complex, hugely expensive sets—that has led many to see *Sunrise* as a pinnacle of the silent movies, a beautiful last waltz.

Last sunrise

Sunrise plays like a montage of the silent era's greatest hits, a flickering carousel of melodrama, suspense, horror, spectacle, slapstick, and tragedy. The US release was given

Murnau's films are gorgeous, and *Sunrise* is no exception. Its luscious black-and-white photography and sweeping camera moves haven't aged.
Pamela Hutchinson
The Guardian

a Movietone soundtrack, which added piglet squeals, traffic horns, and other clunky effects, but the movie doesn't need these to bring its world to life. "Wherever the sun rises and sets," says the closing title card, "in the city's turmoil or under the open sky on the farm, life is much the same; sometimes bitter, sometimes sweet." ▪

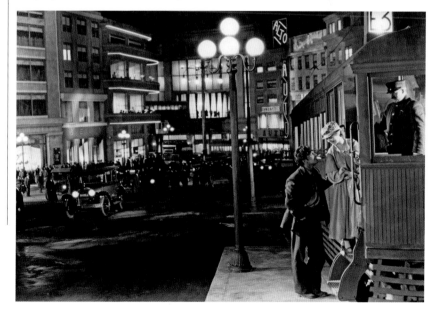

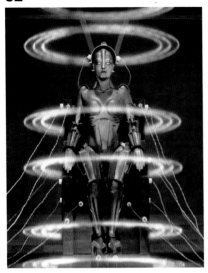

THOSE WHO TOILED KNEW NOTHING OF THE DREAMS OF THOSE WHO PLANNED
METROPOLIS / 1927

IN CONTEXT

GENRE
Science fiction

DIRECTOR
Fritz Lang

WRITERS
**Fritz Lang,
Thea von Harbou**

STARS
Alfred Abel, Gustav Fröhlich, Rudolf Klein-Rogge, Brigitte Helm

BEFORE
1922 With *Dr. Mabuse the Gambler,* Lang and von Harbou introduce the arch-criminal to the big screen for first time.

1924 *The Nibelungs* is Lang and von Harbou's epic two-part silent fantasy.

AFTER
1929 *Woman in the Moon* is Lang's next science-fiction masterpiece after *Metropolis.*

1931 *M* stands for "Murderer" in Lang and von Harbou's desolate thriller.

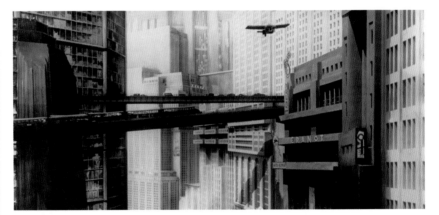

Many movies have journeyed into the future, and most of them owe a debt to Fritz Lang's *Metropolis.* Made in Germany in 1927, this tale of city life projects itself a hundred years ahead of its time.

Mirror image
Metropolis is set in 2026, but it is really a warped reflection of the era in which it was made. In its striking black-and-white imagery, influenced by German Expressionism, lie the nightmares of a world in flux. The mechanized horrors of World War I were fresh in the memory, and the Nazis would soon begin their rise to power, proposing totalitarian solutions to Germany's problems.

Lang's vision of the cityscape of the future was heavily influenced by the skyscrapers that were being built at the time in New York.

Lang often said that the idea for *Metropolis* came to him on a visit to New York in 1924, and it shows. The American city, with its soaring skyscrapers and views of ant-sized citizens, clearly inspired the first science-fiction cityscape ever shown on screen. Lang worked with visual-effects pioneer Eugen Schüfftan to create an exaggerated version of Manhattan, combining models of monorails and shining pinnacles with vast clockwork sets, in which the humans operating the machines are little more than cogs.

What else to watch: *The Cabinet of Dr. Caligari* (1920, pp.24–27) ▪ *The Bride of Frankenstein* (1935, p.52) ▪ *Modern Times* (1936) ▪ *Blade Runner* (1982, pp.250–55) ▪ *Brazil* (1985, p.340) ▪ *The Matrix* (1999) ▪ *Minority Report* (2002)

Alfred Abel Actor

Born in Leipzig in 1879, Alfred Abel tried his hand at forestry, gardening, art, and business before taking up acting. Moving to Berlin, he worked with stage director Max Reinhardt, who gave him his first movie role in 1913. He went on to star in more than 100 silent movies, most famously *Metropolis*. Always elegant, and eschewing florid gestures, Abel remained in demand in the age of sound, but a brief foray into directing was not a success. He died in 1937, two years after the Nazi regime barred his daughter from acting.

Key movies

1922 *Dr. Mabuse the Gambler*
1927 *Metropolis*

In *Metropolis*, the architecture of the city reflects the rigid structure of its society, whose ruling class, led by Fredersen (Alfred Abel), lives in luxurious towers, while the workers, represented by Maria (Brigitte Helm), are consigned to the sunless slums at ground level and below. The two groups—literally the high-ups and the low-downs—know little of each other, and in the smooth running of the machine city their paths never cross. Only when Fredersen's privileged son glimpses the worker Maria and falls in love with her does the machine begin to break down, as the two groups—the "mind" and the "hands"—are brought together by the heart.

Technology and terror

Lang's movie revels in cutting-edge special effects, but it doesn't trust technology with the future of humanity. The 21st-century city is depicted as a malevolent monster, a living, breathing machine incapable of compassion. Maria is duplicated as a *Maschinenmensch* ("machine-human"), whose unholy birth would later be imitated by Hollywood in *Frankenstein* (1931). Mechanization is ultimately a means to deceive, dehumanize, and enslave.

Metropolis is often described as the first screen dystopia, and in its prediction of a segregated German society, it is bleakly prescient. But Lang's movie remains optimistic at its core—it believes the human heart can triumph even when our dreams turn into oppressive nightmares, and for all its concerns, it sees a frightening beauty in the world of tomorrow. ▪

In an Art Deco vision of hell, the Industrial Machine powering the city is seen as a sacrificial temple of Moloch that consumes its workers.

Should I say now that I like *Metropolis* because something I have seen in my imagination comes true, when I detested it after it was finished?
Fritz Lang

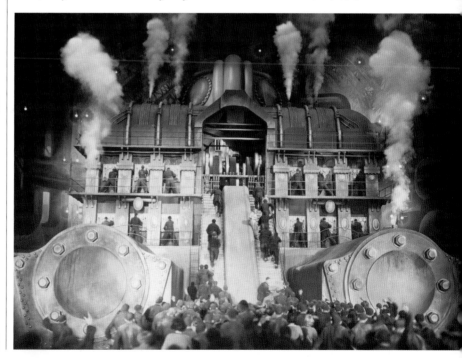

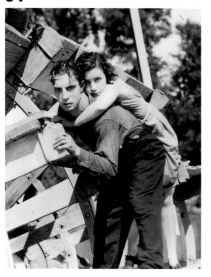

IF YOU SAY WHAT YOU'RE THINKING, I'LL STRANGLE YOU

STEAMBOAT BILL, JR. / 1928

IN CONTEXT

GENRE
Comedy

DIRECTOR
Charles Reisner

WRITER
Carl Harbaugh

STARS
Buster Keaton, Tom McGuire, Ernest Torrence, Marion Byron

BEFORE
1924 Keaton fractures his neck while shooting the pratfalls for *Sherlock, Jr.*

1926 Keaton's *The General*, now considered a classic, flops at the box office.

AFTER
1928 *Steamboat Bill, Jr.* is the inspiration for Walt Disney's *Steamboat Willie*, the first Mickey Mouse animation.

1929 Keaton makes his final silent movie, *Spite Marriage*, about a celebrity wife who divorces her humble husband.

Buster Keaton was a master of deadpan slapstick. He was born into a vaudeville family and grew up familiar with the demands of physical comedy, which he transferred from stage to screen. Although he didn't always take a credit as director, he was invariably the mastermind behind the laughs. Today, what impresses most about his movies is their comic precision, and the sophisticated way in which he misleads his audiences. *Steamboat Bill, Jr.* is typical of the way in which Keaton plays with expectations.

Straight to the jokes

The movie sets course in almost record time—the grizzled captain of a dilapidated paddle steamer faces competition from a stylish new riverboat on the same day that his long-lost son (Keaton) reappears—and goes straight to the jokes. Keaton uses a slew of visual puns and sight gags even before his character has arrived. When he finally does appear, Keaton starts a symphony of silliness, playing against

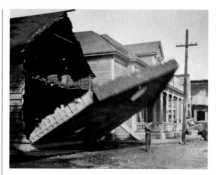

Keaton performed his own stunts, many of which, like this building falling on him in *Steamboat Bill, Jr.*, relied on precise timing and positioning to avoid serious injury.

type as a fey bohemian, complete with Oxford bags, a tiny ukulele, and a beret, before the movie moves up a notch with a storm. After he has been swept by high winds through a town on a hospital bed, Keaton stands immobile as an entire storefront crashes over his head, perfectly framing him in its top window. The scene—highly dangerous to perform—captures Keaton's philosophy in a nutshell: "Stuntmen don't get laughs." ∎

What else to watch: *Our Hospitality* (1923) ▪ *Sherlock, Jr.* (1924) ▪ *The Navigator* (1924) ▪ *The General* (1926) ▪ *The Cameraman* (1928)

HAS GOD PROMISED YOU THINGS?

THE PASSION OF JOAN OF ARC / 1928

IN CONTEXT

GENRE
Historical drama

DIRECTOR
Carl Theodor Dreyer

WRITERS
Joseph Delteil, Carl Theodor Dreyer

STAR
Maria Falconetti

BEFORE
1917 Falconetti stars in *La Comtesse de Somerive,* the first of her two feature movies.

AFTER
1932 Dreyer makes his first sound movie with the horror movie *Vampyr.*

1943 Dreyer's movie *Day of Wrath* returns to the theme of witchcraft with a tale of 17th-century persecution.

1957 Otto Preminger adapts George Bernard Shaw's play *Saint Joan* for cinema, starring Jean Seberg in her debut role.

T he story of Jeanne d'Arc (Joan of Arc), or the Maid of Orleans, has been filmed several times, mostly as an action-adventure in which she leads an army against English invaders in 15th-century France. But Danish director Carl Theodor Dreyer went back to the transcripts of Joan's trial to create an intimate and emotionally grueling account of her persecution and execution at the hands of the church.

By all accounts, the shoot was as grim and punishing as anything depicted on screen, particularly for Maria Falconetti as Joan, who was put through an exhausting ordeal. The director keeps his camera tight on her face, contrasting her tortured expressions with the pinched features of the clerics— all shot in extreme close-up, with no makeup, and harsh lighting.

As matters get progressively worse for Joan, the movie keeps the audience inside her tormented world for as long as it can. Even as she is burned at the stake, Dreyer focuses relentlessly on Joan rather than on the attempt to save her. As the director himself once put it, "Nothing in the world can be compared to the human face." ∎

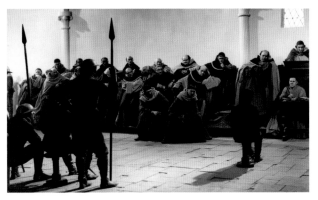

The trial scene was shot in a hugely expensive replica of the ecclesiastical court at Rouen Castle, where the historical Joan was tried.

What else to watch: *Sunrise* (1927, pp.30–31) ▪ *Vampyr* (1932) ▪ *Day of Wrath* (1943) ▪ *Ordet* (1955) ▪ *Gertrud* (1964)

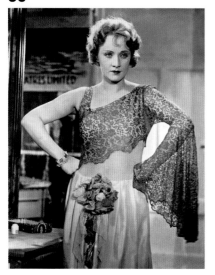

FALLING IN LOVE AGAIN, NEVER WANTED TO

THE BLUE ANGEL / 1930

IN CONTEXT

GENRE
Comedy drama

DIRECTOR
Josef von Sternberg

WRITERS
Carl Zuckmayer, Karl Vollmöller, Robert Liebmann (screenplay); Heinrich Mann (novel)

STARS
Marlene Dietrich, Emil Jannings

BEFORE
1929 Von Sternberg's first talkie is the US crime drama *Thunderbolt*.

AFTER
1930 Von Sternberg and Dietrich team up for a second time with the Hollywood romance *Morocco*.

1932 Dietrich and von Sternberg reunite for *Shanghai Express*, a huge box-office hit, and the fourth movie of seven the two would make together.

Marlene Dietrich's Lola-Lola, the showgirl of *The Blue Angel* (*Der Blaue Engel*), is one of cinema's most indelible sirens. The movie was banned by the Nazis in 1933, but Hitler, a fan of Dietrich, reputedly kept a private copy.

Moral message
Lola-Lola's decadence and sexually charged ennui are captured in songs that made Dietrich famous: *Falling in Love Again* became her personal anthem. Ironically, Josef von Sternberg's movie is also a moral sermon, warning of the dangers of chasing the pleasures of the flesh. Set in Weimar Germany, it tells the tale of Professor Immanuel Rath (Emil Jannings), who gives up his respectable job as a schoolteacher to pursue Lola-Lola, a performer at cabaret club The Blue Angel.

Professor Rath journeys through the seamy demimonde of show business, and when Lola-Lola rejects him, he ends up a laughing stock: spineless, emasculated, and powerless, a grotesque shadow of his censorious former self. ∎

Professor Rath (Emil Jannings, right) becomes a humiliated clown in Lola-Lola's troupe. He is ridiculed by the audience when the troupe visits his home town.

What else to watch: *Shanghai Express* (1932) ▪ *Blonde Venus* (1932) ▪ *Desire* (1936) ▪ *Destry Rides Again* (1939) ▪ *Cabaret* (1972)

IF I WERE YOU, I'D MAKE A BIT OF A SCENE

PEOPLE ON SUNDAY / 1930

IN CONTEXT

GENRE
Silent drama

DIRECTORS
**Robert Siodmark,
Curt Siodmark**

WRITERS
**Curt Siodmark, Robert
Siodmark, Edgar G. Ulmer,
Billy Wilder**

STARS
**Erwin Splettstößer, Annie
Schreyer, Wolfgang von
Waltershausen, Christl
Ehlers, Brigitte Borchert**

BEFORE
1927 Walther Ruttmann's
silent documentary *Berlin:
Symphony of a Great City*
chronicles one day in Berlin
to an orchestral score.

AFTER
1948 Vittorio De Sica's
The Bicycle Thief, a key
Italian neorealist movie,
tells an everyday story
shot entirely on location.

German cinema in the 1920s and 30s was noted for its style and technical expertise. But *People on Sunday (Menschen am Sonntag)* is pioneering in a very different way, creating a fluid, freewheeling movie aimed at realism.

Filmmakers Robert Siodmak and Edgar G. Ulmer, then both novices, would later carve out a career in Hollywood making tense thrillers, but *People on Sunday* is the polar opposite. It is also very different from the later works of its screenwriter Billy Wilder, who developed its documentary style from reportage by Siodmak's brother Curt, soon to write many of Universal Studios' horror pictures.

A movie experiment
The movie's subtitle was "a film without actors." It follows 24 hours in the lives of five Berliners, played by nonactors in roles based on their real lives. Wine merchant Wolfgang flirts with movie extra Christl. They arrange to meet in the lake resort of Nikolassee. Later that day Wolfgang

visits Erwin, a cabdriver, and his wife Annie, a model. He invites them to the lake, but, after an argument, Erwin leaves Annie behind to join Wolfgang, Christl, and Brigitte, a salesclerk.

In retrospect, the artlessness of what happens next in the film is truly affecting, given that the movie's makers would all be forced into exile before the decade was out. There is no cynicism, only the pathos of its characters' optimistic faith in the often-repeated word "tomorrow." ∎

We'd sit at a nearby table
while they'd decide what
to do that day. It was
completely improvised.
Brigitte Borchert

What else to watch: *The Bicycle Thief* (1948, pp.94–97) ∎ *À bout de souffle*
(1960, pp.166–67) ∎ *Saturday Night and Sunday Morning* (1960, pp.168–69)

TOMORROW
THE BIRDS WILL
SING

CITY LIGHTS / 1931

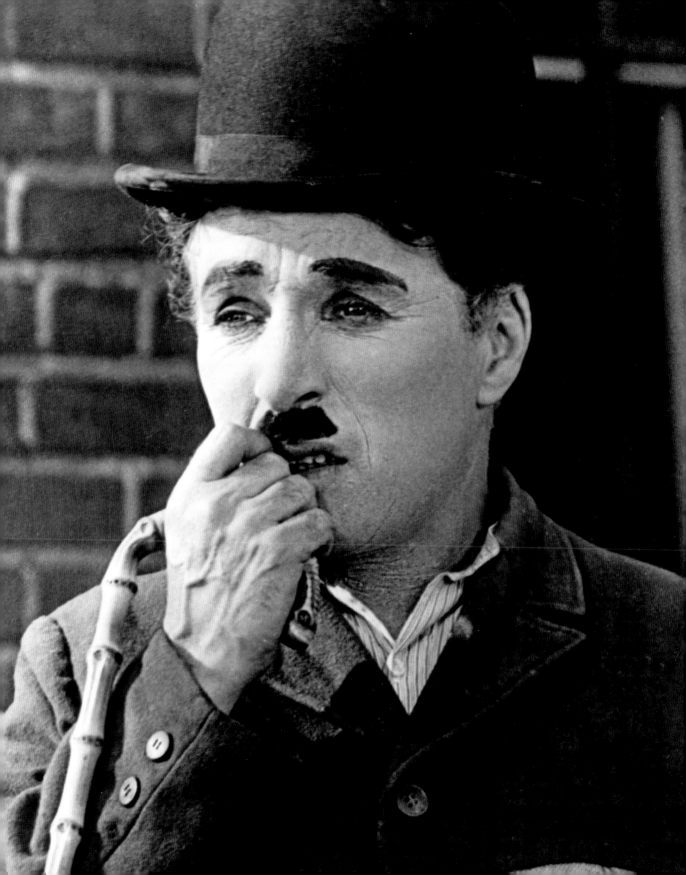

IN CONTEXT

GENRE
Silent comedy

DIRECTOR
Charlie Chaplin

WRITER
Charlie Chaplin

STARS
Charlie Chaplin, Virginia Merrill, Harry Myers

BEFORE
1921 Chaplin makes his first feature movie, *The Kid*, with 13-year-old Lita Grey, whom he marries three years later.

1925 Chaplin's *The Gold Rush*, his first blockbuster featuring the Tramp, is a huge success.

1927 The silent era comes to an end with *The Jazz Singer*, the first feature-length movie with full sound dialogue.

AFTER
1936 Chaplin makes *Modern Times*, his last silent feature, a protest against the Great Depression workers' conditions.

Charlie Chaplin's movie *City Lights*—which he wrote, directed, and starred in—was one of the last great movies of the silent era, acknowledged by many as one of the best comedies of all time. Although it was released in 1931, four years after the first real talkie, *The Jazz Singer*, Chaplin defiantly made *City Lights* a silent movie with only a few distorted sound effects and a sound track of his own music.

Tramp and the Flower Girl

The story begins in a large city, where Chaplin's Tramp is fleeing from a policeman who threatens to arrest him for vagrancy. Escaping by climbing through a car, he meets a poor blind flower girl (played by Virginia Merrill). He buys a flower from her with his last coin, and the girl, hearing the sound of a luxury car door, believes he is a wealthy man.

Not judged as a vagrant by this blind girl, the Tramp falls in love with her and wants to be the rich and handsome benefactor she imagines him to be. He determines to rescue her from her life of poverty and when he hears of an operation that will restore her sight, he

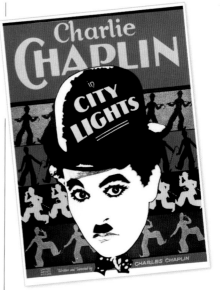

The poster for the movie's original release in 1931 makes full use of the audience's recognition of Chaplin's Tramp persona.

searches desperately for ways to raise the money to fund it, from sweeping the streets to getting beaten in a prizefight—vehicles for Chaplin's trademark slapstick, bawdiness, and melodrama.

The Tramp also saves a millionaire who is threatening to commit suicide after his wife has left him. In return, the millionaire offers the Tramp $1,000 to help the girl. Unfortunately, the millionaire only sees the Tramp as a friend when he is blind drunk. When the millionaire sobers up, he accuses the Tramp of stealing the money. Going on the run, the Tramp gives the girl the money to pay for the sight operation, but is captured and thrown in jail.

A touching encounter

Finally, he is released from jail and finds himself outside the flower shop. In the window, the girl is arranging flowers. She has had the operation and can see. Full of

Charlie Chaplin Director

Actor-director Charlie Chaplin was the biggest star of silent movies. Born in London in 1889, he survived a childhood beset by poverty. His alcoholic father abandoned his singer mother, who was later committed to an asylum. These early experiences inspired the character of the outcast Tramp. As a teenager, Chaplin joined a circus troupe and an impresario took him to the US. By age 26, he was a star with his own movie company. He made a string of hit silent movies before his first talkie, the anti-Hitler satire *The Great Dictator*. He died in 1977.

Key movies

1921 *The Kid*
1925 *The Gold Rush*
1931 *City Lights*
1936 *Modern Times*
1940 *The Great Dictator*

What else to watch: *The Gold Rush* (1925) ▪ *The General* (1926) ▪ *Metropolis* (1927, pp.32–33) ▪ *Modern Times* (1936) ▪ *A Patch of Blue* (1965) ▪ *Chaplin* (1992) ▪ *The Artist* (2011)

kindness for the Tramp, who is now dressed in shabby clothes, the girl picks up the flower that has been knocked from his grasp by street kids, and as their hands touch, she suddenly recognizes him—so very different from the debonair prince she may have imagined. The Tramp looks anxiously into the eyes of the once-blind flower girl and asks, "You can see now?" "Yes," she replies, "I can see now."

This poignant exchange is one of the most famous dialogues in movie history—all the more telling because it comes from the silent era—and in many ways it is emblematic of the entire movie. It is not just the Tramp that the girl is seeing for the first time, but the truth, and the audience must see it too. In the noisy, brightly flashing world of the modern city, the little people, the downtrodden, and the lonely are forgotten and brushed aside. It is only through the purity of silence, simplicity, and blindness that people can regain their senses and learn to see clearly again.

Hope of tomorrow

The movie has a conservative and sentimental—some might even say mawkish—message, but there's no doubt that it touched a chord on its release, just two years after the Wall Street Crash. Times were troubled for countless millions, the poor in the US were beginning to feel the pinch of the Great Depression, and suicides

struck both the rich and the poor as the crisis deepened. While the movie offered no recipes for recovery, what it did, cleverly, was to provide a glimmer of hope. After rescuing the millionaire from suicide in the river, the Tramp urges him to be hopeful. "Tomorrow the birds will sing," he says. No matter how bleak things look today, people must cling to the idea that there may be joy tomorrow—that seems to be the core of the movie's message.

Happy ending?

When the flower girl finally sees the Tramp for who he really is, Chaplin the director does not immediately have them fall into each other's arms in recognition. We do not know if the flower girl will embrace or reject him because he is so different from the man of her imagination. There is no neat happy ending.

While the Tramp's winsome look elicits pathos, it also restores the movie to a comic level, distancing the audience from the pain of his possible rejection. But as the flower girl looks back at him and viewers see the thoughts turning over behind her eyes and the faintly

fluttering flares of hope, that's enough. It's not clear what that hope is—that she will find her true happiness with such a bedraggled man, or that they will both walk away, wiser but content. All that matters is that there is hope, the hope inspired by the thought that the birds will sing tomorrow, come what may. ▪

The boxing scene, in which the Tramp spends most of his time hiding behind the referee or running from his opponent to avoid combat, shows off Chaplin's clowning skills.

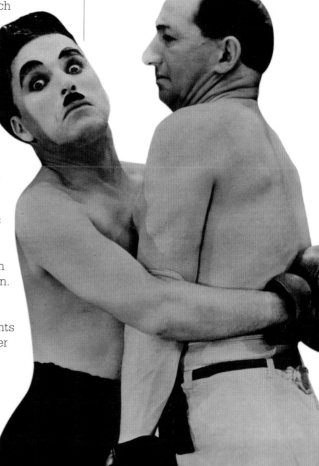

"I'm cured. You're my friend for life."

The millionaire / *City Lights*

A GOLDEN
BLACK AN
1931–1949

AGE IN
D WHITE

In contrast to the more theatrical "talkies," Fritz Lang's first sound movie, *M*, uses a complex **sound track** to **build suspense**.

In Germany, studios fall under the control of **Nazi propaganda chief** Joseph Goebbels. Major German directors and stars flee to Hollywood.

Starting with *The 39 Steps*, **Alfred Hitchcock** makes a series of British thrillers that reflect an anxiety about the rise of hostile powers in Europe.

MGM's Technicolor epic *Gone with the Wind* is an international hit and one of the most **profitable movies ever made**.

1931 **1933** **1935** **1939**

1931 **1934** **1937** **1939**

Bela Lugosi as **Dracula** and Boris Karloff as **Frankenstein** become horror-movie legends. Depression-era theaters introduce **"double features"**—two full-length movies for the price of one.

Introduced in 1930 by the Motion Picture Producers and Distributors of America as a guideline for **moral decency** in movies, the **Hays Code** is now strictly enforced.

Snow White and the Seven Dwarfs, Walt Disney's first full-length **animated movie**, becomes an instant classic.

In France, Jean Renoir's *The Rules of the Game* is a **critical disaster**, but will later be recognized as a brilliant class satire.

Ⅰn an ordinary Berlin street in 1931, a child is playing. From the shadows nearby, a haunting melody is whistled by a murderer.

The talkies had already made their entrance four years earlier, but this, perhaps, is the moment in cinema when the sound era truly begins. The movie was *M*, a dark thriller by German director Fritz Lang. In that single scene, Lang went far beyond simply adding sound to movies. He was playing with sound, *using* it. He was making it a character's signature.

Early sound

The first years of sound were a disruptive time for the industry. Many stars lost their careers when they failed the voice test, and there were times when the

We are not trying to entertain the critics. I'll take my chances with the public.
Walt Disney

new technology made the movies so cumbersome to produce that some might have been better left silent. Yet the technical troubles were overcome, new stars emerged, and the magic returned. Even today, there are many for whom

movies will never again equal those made in the 1930s and 1940s, the height of the classical Hollywood period. It was an era when, for all the trauma of world events—not least the Great Depression and World War II—movies had swagger, confidence, and mass appeal. They were glamorous and escapist. And they made their audiences laugh. While Charlie Chaplin never fully took to sound (Buster Keaton even less so), others were perfect for it. The Marx Brothers' verbal virtuosity had their audiences in stitches, while the very essence of screwball comedy was the wisecracking one-liner.

Monster spectacles

While *M* is a good place to open this new era, classical Hollywood's symbol could be *King Kong* (1933).

Citizen Kane, Orson Welles's first movie, is based on the press tycoon **William Randolph Hearst**, who bans all mention of the movie in his newspapers.

Ernst Lubitsch, a refugee from Germany, directs *To Be or Not to Be*, a movie that **lampoons the Nazis**, and is said by critics to be in poor taste.

Children of Paradise, a **lavish historical drama** directed by Marcel Carné, is filmed in German-occupied France.

Suspected communists, 10 Hollywood filmmakers are called before the Committee Investigating **Un-American Activities**, blacklisted by the studios, and later jailed.

1941 **1942** **1944** **1947**

1941 **1943** **1946** **1948**

Humphrey Bogart stars in *The Maltese Falcon*, the **archetypal film noir**, and (the following year) in *Casablanca*.

In Italy, *Ossessione*, an **early neorealist** movie by Luchino Visconti, runs afoul of Fascist government censors.

The Best Years of Our Lives, by William Wyler, reflects the difficulties of US servicemen **readjusting to civilian life** after World War II.

The Bicycle Thief by Vittorio De Sica is a neorealist **alternative to Hollywood**, with a powerful, simple story acted by ordinary people.

This monumental movie spectacular was proof of the studios' willingness to make movies ever larger in their quest for excitement. Kong joined a monster hall of fame. Universal Studios had already made the iconic horror movies *Frankenstein* and *Dracula* (both 1931), *The Mummy* (1932), and *The Invisible Man* (1933), all popular entertainments that also exhibited some brilliant filmmaking.

King Kong was big, but it didn't have a monopoly on scale. By 1939, audiences were being wowed by *The Wizard of Oz* (its yellow-brick road seen in saturated Technicolor) and roused by *Gone With the Wind*, an epic romance set against the historical backdrop of the American Civil War.

In Europe, however, another war was about to start. By the end of the 1930s the Nazis' brutal rule had had a major impact on the industry. Scores of directors and actors, among them some of Europe's most talented, had defected to Hollywood.

A postwar edge

World War II gave the movies that came after it a new, abrasive edge. Even Britain's typically sweet-centered Ealing comedies acquired a darker tone when Alec Guinness played multiple roles in the murder story *Kind Hearts and Coronets* (1949). Darker still was writer Graham Greene's peerless web of intrigue and betrayal in postwar Vienna, *The Third Man* (1949).

In the US, crime drama evolved into a new genre—film noir. Its swirl of stylized shadow play borrowed heavily from the German Expressionists of the 1920s, its femmes fatales and world-weary gumshoes becoming some of cinema's defining figures.

From Italy came a different kind of downbeat. In the Rome of 1948, director Vittorio De Sica used a cast of real people to tell a tale of everyday struggle called *The Bicycle Thief*. It was the type of movie that lit a fuse in all who saw it. But perhaps the most influential movie of the era had already been made. An ambitious portrait of a press baron, 1941's *Citizen Kane* goes in and out of favor with critics, but its impact was immense. Its cowriter, producer, director, and star, Orson Welles, was 25 when he made it. As it would be again in the next decade, movies had been reshaped by young people too much in love with its possibilities to be hampered by the past. ∎

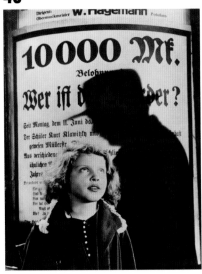

DON'T WANT TO, BUT MUST!

M / 1931

IN CONTEXT

GENRE
Crime drama

DIRECTOR
Fritz Lang

WRITERS
**Fritz Lang,
Thea von Harbou**

STARS
**Peter Lorre, Otto Wernicke,
Gustaf Gründgens**

BEFORE
1927 *Metropolis*, Lang's
seminal science-fiction epic,
is groundbreaking for the
scale of its futuristic vision.

AFTER
1935 Karl Freund, who was
the cinematographer on
Metropolis, directs *Mad Love*,
a Hollywood horror starring the
by now famous Peter Lorre.

1963 In the last movie he
makes, Lang appears in front
of the camera, playing himself
in Jean-Luc Godard's *Le
mépris* (*Contempt*).

C lassic old movies as
influential as Fritz Lang's
M—without which there
would have been no *Psycho*, *Silence
of the Lambs*, or *Se7en*—can be
slightly disappointing when
viewers finally come to see them.
By then the movies will have been so
emulated and borrowed from that
they can end up looking somewhat
hackneyed. Not so with *M*—Lang's
crime masterpiece still bristles
with chilling invention.

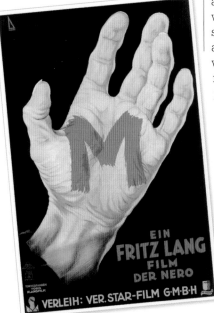

The real-life crimes of Peter Kürten,
known in the press as the Vampire
of Düsseldorf, were fresh in the
minds of German audiences when
M was released in May 1931. Lang
later denied that Kürten was the
inspiration for his script. Although
he was clearly tapping into a theme
that was sitting high in the public
consciousness, his portrayal of a
murderer was far from predictable.

The first surprise was in the
casting. Little-known Hungarian
actor Peter Lorre, a small man
with bulging, oddly innocent eyes,
seemed an unlikely choice to play
a child killer. The next surprise
was in the movie's oblique
narrative. While concerned with
justice, *M* is not a simple tale of
crime and punishment, and defies
expectations from the outset.

Shots of absence

The movie's opening murder is
set up with a heartbreaking
poignancy: as Beckert, who
is seen only in silhouette,
approaches a young girl at a

The movie's iconic poster
displays the "M" (for murderer) that
will be imprinted on the killer's
back so that he can be trailed.

What else to watch: *Dr. Mabuse the Gambler* (1922, p.330) ▪ *Metropolis* (1927, pp.32–33) ▪ *Fury* (1936) ▪ *Ministry of Fear* (1944) ▪ *The Beast with Five Fingers* (1946) ▪ *The Big Heat* (1953, pp.332–33) ▪ *While the City Sleeps* (1956)

> The tangled mind is exposed... hatred of itself and despair jumping at you from the jelly.
> **Graham Greene**

fairground, the scene cuts to her anxious mother at home, then out of the window, then into the yard. Her calls become desperate over shots of absence: vacant rooms, an empty dinner plate. When the actual murder is committed, Lang shows nothing but the girl's ball rolling into the grass and a stray balloon floating away.

Beckert, the killer, seen only from behind, writes to the papers, protesting that the police are not publicizing his crimes. Instead of trailing Beckert, however, Lang cuts to the wider repercussions of the girl's murder. A reward is posted, and as the police pursue

The killer Hans Beckert (Peter Lorre) stares wide-eyed at his back, as he sees in the mirror that he has been marked with the letter "M."

their investigations, the citizens plan their own justice. Vigilantism, a common theme in Lang's later career, becomes a major element of the story.

A human monster

Part of the power of *M* is the way in which Lang effortlessly wrong-foots the viewer. So meek is the monster at the heart of the story, when his face is finally revealed, that the audience is thrown off guard, put into his shoes and made to feel his fear. Lang then expertly cranks up the tension, with the killer unwittingly marked with a chalk letter "M," for *Mörder* (murderer), and Beckert's distress increasing as the chase gathers momentum.

M was Lang's first "talkie," and he makes incredible use of sound, and silence. The director subtly creates tension in the killer's very first entrance: as he is about to strike, Beckert whistles a familiar tune—to unsettling effect. Lang uses sound to different but equally

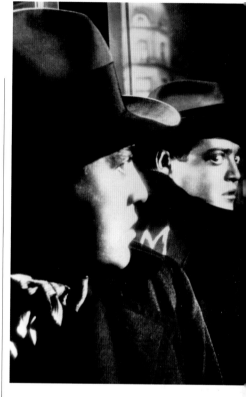

disturbing ends when Beckert is on the run, when the noise of fire-engine sirens and traffic create a disorienting cacophony.

Final judgment

M keeps nudging the audience off balance to the end. The movie's tension comes not only from the relentless ticktock of the narrative, but also from the question that Lang asks the audience: what kind of justice it wants to see for the killer. It's a sophisticated approach even now, let alone for an audience that would still have been acclimatizing to Lang's innovations with sound and subject matter. Lang himself—in a long career filled with truly great movies—always insisted that *M* was the finest of them all. ■

Fritz Lang Director

Born in Vienna in 1890, Fritz Lang made his directorial debut at the German UFA studios with *Halbblut* (*The Weakling*) in 1919, about a man ruined by his love for a woman—a recurrent theme in his movies. After a series of hits, including science-fiction classic *Metropolis*, Lang made his masterpiece with *M*.

Impressed by his talent, the Nazis asked Lang to head the UFA studio in 1933. Instead, he fled to the US, where he forged a highly successful career. He died in 1976.

Key movies

1922 *Dr. Mabuse the Gambler*
1927 *Metropolis*
1931 *M*
1953 *The Big Heat*

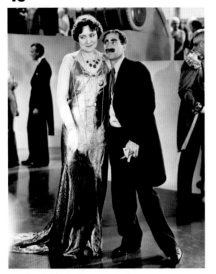

WILL YOU MARRY ME? DID HE LEAVE YOU ANY MONEY? ANSWER THE SECOND QUESTION FIRST

DUCK SOUP / 1933

IN CONTEXT

GENRE
Musical comedy

DIRECTOR
Leo McCarey

WRITERS
Bert Kalmar, Harry Ruby, Arthur Sheekman, Nat Perrin

STARS
Groucho Marx, Chico Marx, Harpo Marx, Zeppo Marx, Margaret Dumont

BEFORE
1921 The Marx Brothers' first movie, a short, *Humor Risk*, is made. It is now believed lost.

1929 The first full-length movie to star them, *The Cocoanuts*, is a musical comedy.

AFTER
1935 *A Night at the Opera*, the first Marx Brothers' movie not to feature Zeppo, is a hit.

1937 The Marx Brothers' seventh movie, *A Day at the Races*, is their biggest hit.

L ike so many movies now regarded as classics, the Marx Brothers' *Duck Soup* received a mixed reception from critics when it opened in 1933. Now it's seen for what it is: a sharp, anarchic, and above all hilarious political satire (even if the brothers themselves denied doing anything but trying to be funny). The movie is a riot of the brothers' trademark puns and visual gags, including the famous mirror scene, in which, after breaking a mirror, Harpo mimics Groucho's every move to avoid detection.

Absurd plot

Groucho plays Rufus T. Firefly, invited for reasons that never become clear to become dictator of Fredonia by the wealthy Mrs. Teasdale, played by the brothers' regular straight woman, Margaret Dumont. Firefly only wants Mrs. Teasdale for her money. But he has a rival, Trentino, ambassador to

From the left, Groucho, Chico, Harpo, and Zeppo Marx were real-life brothers, who honed their comic personas in vaudeville theater.

neighboring Sylvania. With Chico and Harpo working as Trentino's spies, war breaks out between the two countries, leading to some of the most bizarre battle scenes in cinema history. Amid the madcap encounters, Groucho veers between flirts, insults, and some of his finest ever quips: "If you can't get a taxi, you can leave in a huff." If that's too soon you can leave in a minute and a huff." ■

What else to watch: *Animal Crackers* (1930) ▪ *Monkey Business* (1931) ▪ *A Night at the Opera* (1935) ▪ *A Day at the Races* (1937)

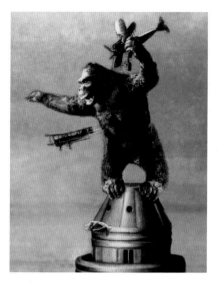

DON'T BE ALARMED, LADIES AND GENTLEMEN, THOSE CHAINS ARE MADE OF CHROME STEEL

KING KONG / 1933

IN CONTEXT

GENRE
Monster movie

DIRECTORS
**Merian C. Cooper,
Ernest B. Schoedsack**

WRITERS
**James Ashmore Creelman,
Ruth Rose, Edgar Wallace**

STARS
**Fay Wray, Robert
Armstrong, Bruce Cabot**

BEFORE
1925 An adaptation of Arthur
Conan Doyle's novel, *The Lost
World* features humans
battling with dinosaurs.

AFTER
1949 Cooper and Schoedsack
team up for another adventure
featuring a giant ape with
Mighty Joe Young.

1963 Inspired by *King Kong*,
animator Ray Harryhausen
works on stop-motion classic
Jason and the Argonauts.

King Kong was probably the
first true special-effects
blockbuster. It is the simple
story of a huge ape discovered on
an uncharted island, which he
shares with other giant creatures,
including dinosaurs. The ape Kong
is captured and brought to New
York for people to stare at, only for
him to break free from his chains
and go on a rampage.

The stop-motion effects look
creaky today. Yet such is the power
of the storytelling that it can move
the viewer in a way that is beyond
many slicker modern movies. The
movie is full of iconic scenes,
including a memorable climax in
which Kong bats away a biplane as
he clings to the top of the Empire
State Building.

The movie's secret was to portray
the ape sympathetically. Kong is
protective of his female captive, and
only attacks when provoked. Kong's
tormentor, Carl Denham (Robert
Armstrong), who exhibits Kong as
the "Eighth Wonder of the World," is
the movie's villain. And when Kong
finally tumbles from the skyscraper,
it is a moment of tragedy—the
audience is on his side. ∎

Ann (Fay Wray)
is terrified of Kong
at first, but later
tries to save him.
In New York, he
escapes to look
for her, leading his
captor Denham to
say, "It was beauty
killed the beast."

What else to watch: *The Lost World* (1925) ▪ *Mighty Joe Young* (1949) ▪
Clash of the Titans (1981) ▪ *Jurassic Park* (1993) ▪ *King Kong* (2005)

WAR IS DECLARED! DOWN WITH MONITORS AND PUNISHMENT!

ZERO DE CONDUITE / 1933

IN CONTEXT

GENRE
Surrealist comedy

DIRECTOR
Jean Vigo

WRITER
Jean Vigo

STARS
Jean Dasté, Louis Lefebvre, Coco Golstein

BEFORE
1924 René Clair's Surrealist short, *Entr'acte*, plays with the frame rate to produce a spooky slow-motion effect.

1929 Director Luis Buñuel teams up with artist Salvador Dalí to make the Surrealist movie *Un Chien Andalou*.

AFTER
1934 Vigo's only full-length movie, *L'Atalante*, tells the poetic story of a newly married couple living on a barge.

1968 Lindsay Anderson's *If...* depicts a rebellion in a British public school.

J ean Vigo's 41-minute *Zero de Conduite (Zero for Conduct)* caused both outrage and delight when it premiered in Paris in April 1933. But although its anarchic spirit was deplored by the Establishment (it was banned by the French Ministry of the Interior until 1946), with hindsight the movie isn't really all that political, at least not in the way that the authorities first perceived it.

One of the most poetic films ever made, and one of the most influential.
Pauline Kael

On its release, *Zero de Conduite* provoked strong reactions against its irreverence for conventional sensibilities. It was banned in France until 1946.

Zero de Conduite is perhaps best seen in the context of French Surrealist cinema, following in the tradition of René Clair and Luis Buñuel, who threw narrative sense out the window, juxtaposed random images, and often morphed into strange scenarios with bizarre dialogue. These were serious works of art, aiming to explore the subconscious, yet also simply irreverent.

A child's-eye view
The movie was funded by a private patron, who paid Vigo to create a story based on his childhood experiences of boarding school. This was not to be a nostalgic trip down memory lane for the director, but an attempt to recreate the state of being a child. Some of the movie's rough

The boys' revolution against the school's stuffed-shirt authorities takes the form of an anarchic pillow fight—for Vigo, the essence of the spirit of childhood.

sequence, he takes them all with him as he follows a young woman who has caught his eye.

The boys themselves are all serial offenders who seem to spend every Sunday in detention (hence the "zero marks for conduct" implied by the movie's title). Throughout the movie, they plot their revenge, but when it comes, the revolution starts not with a grand dramatic gesture but with a long pillow fight. Taking to the school's rooftop, they hurl objects down at the school board, a row of mannequins lined up for the annual "commemoration day" celebration. The joy of Vigo's movie is that the boys don't really try to beat the system—they want to rise above it, as gallant rebels driven by the irrepressible spirit of childhood.

Vigo did not live to see his movie achieve recognition, but his legacy went on to inform the works of directors including François Truffaut and Lindsay Anderson. ▪

edges can be attributed to Vigo's inexperience as a director, but there are many deliberately eccentric flourishes—such as a cartoon sketch that suddenly comes to life.

Diving straight in

The beginning of the movie dispenses with any sense of buildup—a simple title card reads, "After the holidays, back to school." A boy, Causset (Louis Lefebvre), on a train with only a sleeping adult for company, welcomes his old friend Bruel (Coco Golstein) as they prepare to return to the boredom of boarding school. The journey is filled with a sense of freedom, curtailed when they arrive at the station, to be confronted by an aloof prefect, played by an adult.

In the battle to control the boys, the prefect is revealed as a spy who steals their things. The housemaster

(Delphin), a tiny, ridiculous-looking man with a bushy beard, is also pitted against them. On the boys' side is the young teacher Huguet (Jean Dasté), who indulges his charges with impersonations of Charlie Chaplin and plays soccer with them. In one especially odd

Jean Vigo Director

Jean Vigo was born in 1905, the son of an anarchist. His father spent most of his life on the run and was murdered in prison when Jean was 12, but he cast a long shadow over the director's short but influential career. After a series of shorts, Vigo made his lone feature, *L'Atalante,* in 1934. Although initially cut to ribbons by distributors, the movie's poetry found favor in the 1940s, going

on to inspire the founders of the French New Wave. An ill man throughout his life, Vigo died of tuberculosis at just 29. As his work gained fame in France, the Prix Jean Vigo was set up in 1951 for first-time directors.

Key movies

1930 *À propos de Nice*
1933 *Zero de Conduite*
1934 *L'Atalante*

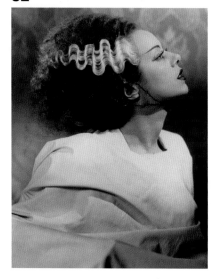

TO A NEW WORLD OF GODS AND MONSTERS!
THE BRIDE OF FRANKENSTEIN / 1935

IN CONTEXT

GENRE
Horror

DIRECTOR
James Whale

WRITERS
William Hurlbut, John L. Balderston (screenplay); Mary Wollstonecraft Shelley (novel)

STARS
Boris Karloff, Colin Clive, Valerie Hobson, Elsa Lanchester

BEFORE
1931 James Whale adapts Mary Shelley's *Frankenstein*. Karloff stars as the monster.

1933 Whale films H. G. Wells's story *The Invisible Man*, about a scientist who finds a way to become invisible.

AFTER
1936 Whale moves away from the horror genre, directing a musical adaptation of the play *Show Boat*.

Through the 1930s, Universal Studios made a string of hits adapting classic horror literature into mainstream movies. What separates James Whale's *Frankenstein* movies from the other horror movies in the universal canon is its empathy for its monster. This is never more apparent than in *The Bride of Frankenstein*, in which the monster implores Dr. Frankenstein to build him a mate.

Morality tale

Much of the movie's narrative presents Frankenstein's monster as lost in a world to which he does not belong. He longs for friendship, but is rejected at every turn. At one point, a blind man introduces him to the pleasures of domestic life, only for armed villagers to drag him away. He learns to speak, saying, "I want friend like me," but even Dr. Frankenstein's efforts to provide him with a bride backfire, when the bride also rejects him. In the end, *The Bride of Frankenstein* feels as much a morality tale as a horror movie, suggesting that monstrousness might be no more than skin deep. ∎

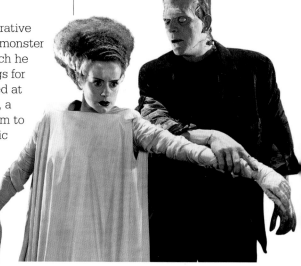

An excited monster
(Boris Karloff) steadies his bride (Elsa Lanchester) as she comes to life in Dr Frankenstein's laboratory.

What else to watch: *Metropolis* (1927, pp.32–33) ▪ *Frankenstein* (1931) ▪ *Dracula* (1931) ▪ *The Mummy* (1932) ▪ *Gods and Monsters* (1998)

MAGIC MIRROR ON THE WALL, WHO IS THE FAIREST ONE OF ALL?

SNOW WHITE AND THE SEVEN DWARFS / 1937

© 1937 Disney

IN CONTEXT

GENRE
Animation, musical

DIRECTOR
David Hand

WRITERS
Ted Sears, Richard Creedon, Otto Englander, Dick Rickard, Earl Hurd, Merrill De Maris, Dorothy Ann Blank, Webb Smith (screenplay); Jacob Grimm, Wilhelm Grimm (fairy tale)

STARS
Adriana Caselotti, Lucille La Verne, Moroni Olsen

BEFORE
1928 Disney releases the Mickey Mouse short *Steamboat Willie*, its first sound cartoon.

AFTER
1950 Disney revisits Grimms' fairy tales with *Cinderella*.

2013 Disney's *Frozen*, loosely inspired by Hans Christian Andersen's *The Snow Queen*, is an enormous hit.

Released in 1937, *Snow White and the Seven Dwarfs* was the first full-length movie made by the Walt Disney Company. Disney sought to combine the slapstick tone of its successful short movies with an injection of the macabre by turning to one of the Grimm Brothers' most famous fairy tales, the story of an evil queen hunting an innocent girl who is declared "the fairest of all" by a magic mirror. This set the template for Disney movies for the next 80 years, from *Cinderella* to *Frozen*.

Adding jeopardy

One of the challenges for filmmakers making children's movies is to keep the material appropriate for the audience, while at the same time investing it with enough jeopardy to create tension. *Snow White* deliberately terrifies its young viewers, from the sequence where Snow White panics in the woods as the trees come alive, to the scenes in which the malevolent Queen gleefully plots the girl's death. By the time the prince awakens the heroine with a kiss, evil has been vanquished, and fear conquered. Disney realized that, without the authenticity of conflict, the happy resolution at the end would never be heartfelt. ∎

Snow White hides from the wicked Queen in the dwarfs' home. She cooks and cleans for them, and also makes them wash their hands.

© 1937 Disney

What else to watch: *Fantasia* (1940) ▪ *Pinocchio* (1940) ▪ *Dumbo* (1941) ▪ *Cinderella* (1950) ▪ *Beauty and the Beast* (1991) ▪ *Frozen* (2013)

I'VE A FEELING WE'RE NOT IN KANSAS ANYMORE

THE WIZARD OF OZ / 1939

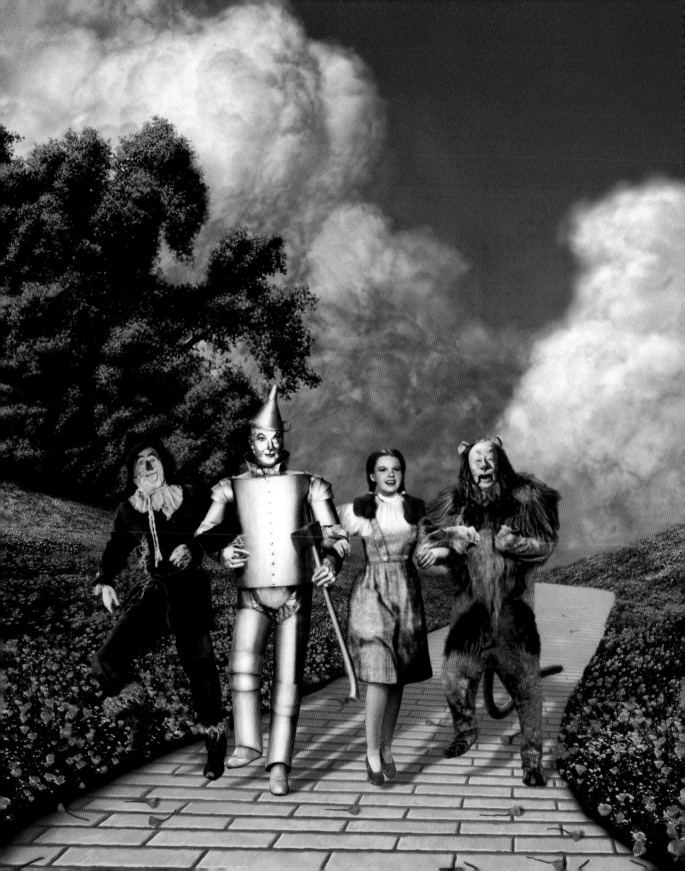

IN CONTEXT

GENRE
Musical, adventure

DIRECTOR
Victor Fleming

WRITERS
Noel Langley, Florence Ryerson, Edgar Allan Woolf (screenplay); L. Frank Baum (novel)

STARS
Judy Garland, Frank Morgan, Ray Bolger, Bert Lahr, Jack Haley, Margaret Hamilton

BEFORE
1938 Judy Garland stars alongside Mickey Rooney in *Love Finds Andy Hardy*.

AFTER
1939 A few months after *The Wizard of Oz*, Fleming's *Gone with the Wind* is released.

1954 Garland stars opposite James Mason in hit musical *A Star Is Born*, her first movie in four troubled years.

Plenty of big movies from the classical Hollywood period have faded into obscurity. Other movies remain respected by the critics, but modern audiences struggle to connect with them. Then there are movies like Victor Fleming's *The Wizard of Oz*, which not only stands the test of time, but continues to entertain. The movie is discovered and embraced by each new generation as passionately as the previous one, and the story has crossed over into a global cultural consciousness. Even if they have never seen the movie, people can sing along to "Somewhere over the Rainbow," and will understand the reference when someone taps their shoes and says "There's no place like home." *The Wizard of Oz* is now more than 70 years old, but it remains a key picture in the making of modern cinema.

A magnificent spectacle

The movie's story sees Dorothy (played by the 17-year-old Judy Garland), a young girl growing up on a Kansas farm, caught in the eye of an impressively rendered twister and magically transported to the Land of Oz. Here, along with a ragtag trio of misfits—

I would watch the movie every day when I was two. I had a hard time understanding that I couldn't go *into* the film, because it felt so real to me.
Zooey Deschanel
in the documentary film
These Amazing Shadows, 2011

a Scarecrow, a Tin Man, and a Cowardly Lion—she must travel along the Yellow Brick Road, while avoiding the attentions of the Wicked Witch of the West. Her destination is the Emerald City, where the mysterious Wizard of Oz himself resides. The story is probably familiar, but what really sets apart *The Wizard of Oz* is not so much the "what" as the "how". It is a movie in service of spectacle, a movie that sets out to test the limits of the newly born medium of cinema in every frame.

Minute by minute

00:11
Dorothy runs away from home in Kansas to save her dog Toto from an officious neighbor, Miss Gulch. Professor Marvel, a fortune-teller, persuades her to return.

00:19
The house crashes in Oz, killing the Wicked Witch of the East. The Munchkins celebrate. The Wicked Witch of the West swears revenge.

00:58
The friends arrive at the Emerald City, where the Wizard agrees to grant their wishes if they bring him the Wicked Witch's broom.

01:21
Toto leads the friends to the Castle where they are trapped by the Witch. She sets fire to the Scarecrow. Dorothy throws water, and in doing so melts the Witch.

| 00:00 | 00:15 | 00:30 | 00:45 | 01:00 | 01:15 | 01:42 |

00:17
A mighty twister develops, lifting Dorothy's farmhouse into a spin. Miss Gulch on her bicycle is transformed into a witch on a broomstick.

00:34
Dorothy befriends the Scarecrow on the Yellow Brick Road, followed soon after by the Tin Man and the Cowardly Lion.

01:14
In her crystal ball, the Witch watches the friends enter the Haunted Forest. She sends flying monkeys to capture Dorothy.

01:28
Toto exposes the Wizard as a sham. The Good Witch tells Dorothy she can return home by tapping her ruby slippers together.

What else to watch: *Pinocchio* (1940) ▪ *A Star Is Born* (1954) ▪ *Return to Oz* (1985) ▪ *Wild at Heart* (1990) ▪ *Spirited Away* (2001, pp.296–97)

When Dorothy arrives in Oz, viewers see her open her eyes in faded, sepia-toned black and white, the frame crackling with the technical imperfections of the time. But as she opens the door and steps outside, they glimpse Oz and are overwhelmed with Technicolor. In 1939, when it was released, this would have been the very first time many audience members had seen a color movie. As the scene plays out, the director Victor Fleming is fully aware of this fact and he takes his

time to pan around Munchkinland, lingering on the extravagantly constructed set as its wave of hallucinatory colors hits the viewer from all angles. Then come the special effects, a musical number featuring hundreds of actors, and a showdown with the antagonist, the Wicked Witch of the West (the scenery and costume designers were encouraged to use as much color as possible to take full advantage of the Technicolor format). The whole time, viewers are adjusting to seeing color for the first time. This is a movie with the approach that "if less is more, then how much more must more

be," dazzling with its no-expenses-spared production. In that sense, it is very much a forerunner of the modern blockbuster, with musical numbers in place of action set pieces.

Character-led story

Although the story is crafted to be the perfect vehicle to show off the wonderful new toys Hollywood had at its disposal, it is nonetheless deeply rooted in character and emotion. While we discover a new world, we do so through the prism of a distinct framing device. Whereas most adventure movies feature a group of »

When Dorothy first meets the Tin Man (Jack Haley), he is in desperate need of an oiling.

Critics have interpreted motifs and characters from the *Wizard of Oz* as symbolic of US political and economic issues.

The rusted Tin Man may be a metaphor for the state of workers in the stalled steel industry.

Dorothy's slippers (silver in the book) may symbolize a silver standard, while the Yellow Brick Road is the gold standard.

The Cowardly Lion was a popular caricature of pacifist politician William Jennings Bryan.

The Scarecrow may be a metaphor for the dire condition of Midwest farmers in the Depression era.

The Emerald City, an illusion of its citizens, may be allegorical of the greenback, the first US paper money.

sees the orphan Dorothy undergo a formative transition from a child protected in her home to navigating a new and dangerous world, relying on her trio of friends—symbolically, the emotions, intellect, and courage.

Dream world

Throughout the movie, the action stays intimate even as it becomes epic, and each character is already strangely familiar. The Wicked Witch of the West is a dead ringer for Dorothy's evil neighbor, Miss Gulch, who wants to have Dorothy's dog Toto put down. The Scarecrow, Tin Man, and Cowardly Lion all strongly resemble the farmhands from back home, while the Wizard of Oz appears to be Professor Marvel, a phoney fortune-teller. The most prominent characters in Oz mirror characters back home in Kansas, making it clear that this is Dorothy's dream world.

The movie revels in spectacle, in witches and woods, in lions, tigers, and bears. Yet at its core, it is a tale of friendship and personal growth, and balancing the two may be the secret to its longevity. A memorable story, told with imagination and in vivid splendor, it is a movie that transcends its time. ∎

characters united by a common goal, here each of our heroes is searching for something they lack. Not fame or fortune, but a personal quality, something they believe will make them whole. Dorothy lacks a home, the Tin Man a heart, the Scarecrow a brain, and the Cowardly Lion his courage.

Each character in the magical world of Oz is introduced to the audience in a location where they are vulnerable, where they think the Wizard's help is the only thing

that can save them. All four of the travelers are on their own "hero's journey," and it is just as important to the viewer that the Tin Man should get a heart as it is to see the Wicked Witch defeated.

Although the movie marked a groundbreaking step in terms of technical achievement, its success also lies in keeping close to the principles of simple storytelling and in its universal appeal as a "quest" movie that follows the rite-of-passage trajectory. The audience

Victor Fleming Director

Born in California in 1889, Victor Fleming was a stuntman before rising through the ranks of the camera department to become a director. His first movie, *When the Clouds Roll By*, was released in 1919. His greatest year was 1939, when he directed *The Wizard of Oz* and *Gone with the Wind*. He was hired as a last-minute substitute on both, replacing Richard Thorpe on the former and George Cukor on the latter. The two movies won several Oscars.

Fleming never again reached those heights, but he went on to make the critically acclaimed *Dr. Jekyll and Mr. Hyde* and *A Guy Named Joe* (1943). He died in 1949, a year after the release of his last movie, *Joan of Arc*.

Key movies

1925 *Lord Jim*
1939 *Gone with the Wind*
1939 *The Wizard of Oz*
1941 *Dr. Jekyll and Mr. Hyde*

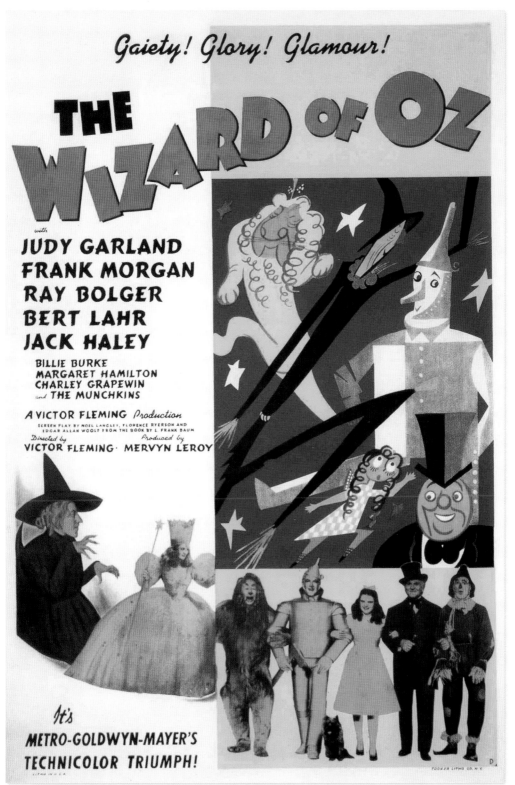

The movie was a success on its initial release, but the cost of the production meant that it did not register a profit for its producers MGM until 1949.

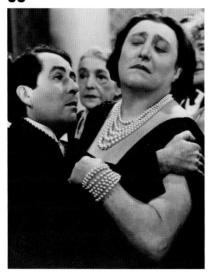

EVERYBODY HAS THEIR REASONS
THE RULES OF THE GAME / 1939

IN CONTEXT

GENRE
Comedy of manners

DIRECTOR
Jean Renoir

WRITERS
Jean Renoir, Carl Koch

STARS
Nora Gregor, Marcel Dalio, Paulette Dubost, Roland Toutain, Jean Renoir

BEFORE
1937 Renoir's movie about prisoners of war in World War I, *Grand Illusion* is the first foreign-language movie to receive a Best Picture nomination at the Oscars.

1938 Renoir's adaptation of Émile Zola's novel *The Human Beast* is a huge success.

AFTER
1941 After the critical and box-office failure of *The Rules of the Game*, Renoir makes his way to Hollywood. His first US movie is *Swamp Water*.

The Rules of the Game (*La Règle du jeu*) is a biting satire about the French upper classes on the brink of World War II, who are endlessly frivolous despite, or perhaps because of, the impending conflict.

At the time of its release in 1939, *The Rules of the Game* was an expensive flop, shunned by the public and critics alike—in part because of its contrast to director Jean Renoir's previous movie, *Grand Illusion* (1937), a reflection on humanity's triumph over class. At its premiere on July 7, 1939, the audience booed. In October that year, the authorities banned the movie, as "depressing, morbid, immoral... an undesirable influence over the young."

Rediscovering the movie
During the war, the original negatives of the movie were thought to have been destroyed in a bombing raid. In the

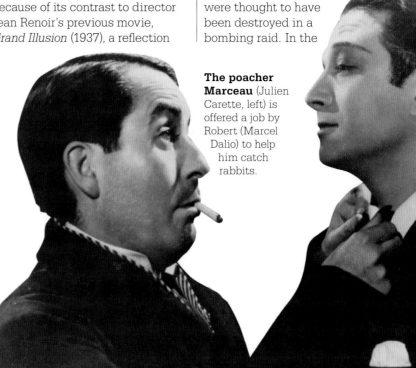

The poacher Marceau (Julien Carette, left) is offered a job by Robert (Marcel Dalio) to help him catch rabbits.

What else to watch: *Boudu Saved from Drowning* (1932) ▪ *Grand Illusion* (1937) ▪ *Citizen Kane* (1941, pp.66–71) ▪ *French Cancan* (1954) ▪ *Smiles of a Summer Night* (1955) ▪ *Gosford Park* (2001)

late 1950s, two movie enthusiasts found them in boxes at the bombed-out film lab. With Renoir's help, they painstakingly pieced the negatives together. The restored version was premiered at the 1959 Venice Film Festival to acclaim.

Country retreat

Renoir's movie focuses on a weekend at the country estate of society lady Christine (Nora Gregor) and her husband Robert (Marcel Dalio). Relationships gradually unravel, and the weekend will end in a tragedy. André (Roland Toutain), a last-minute invitee, has just flown solo across the Atlantic to impress Christine. When she fails to turn up to greet him, André refuses to play by the rules and act the hero in interviews, something for which he will be made to pay. His friend Octave (played by Renoir) obtained the invitation for André, but he too has ulterior motives. Octave hopes to set André up with Robert's erstwhile mistress Geneviève, distracting André from Christine and Geneviève from Robert.

There is intrigue both upstairs and down. Later, a gun will be fired and tragedy will strike after a bloody case of mistaken identity. But Renoir makes sure to let viewers know that even this changes nothing in the cloistered lives of his characters. They just keep playing on as before. The movie depicts the callousness of the ruling class—no more tellingly than during a rabbit hunt, in which the men blast away at any animal that

passes in front of their guns. However, it was not Renoir's purpose in this movie to demonize the upper classes. He presents them as children, trapped in a game they feel compelled to play. "The awful thing about life is this:" says Octave, "Everybody has their reasons."

In order to heighten the sense of being trapped—within the country house and in the claustrophobic social games of the upper class—Renoir developed a new way of filming with superfast lenses to allow extreme depth of field. This novel "deep-field" technique meant that he could keep the foreground action in focus while people were seen flitting to and fro in the background, carrying on with their own personal stories. ▪

Love is a game that is played according to complex, dangerous rules in the enclosed, upper-class world of the movie.

&&That's also **part of the times—** today **everyone lies**.''

André / The Rules of the Game

Jean Renoir Director

The son of the impressionist painter Pierre-Auguste Renoir, Jean Renoir was born in 1894 in Montmartre, Paris, and grew up among artists. He started out as a ceramicist, then tried his hand at screenwriting in the 1920s. His early movies were flops, but he scored major successes in the late 1930s. After the poor reception of *The Rules of the Game*, Renoir moved to the US, where he enjoyed only limited success for movies such as *Swamp Water* (1941). He died in Beverly Hills, California, in 1979.

Key movies

1931 *La Chienne*
1937 *Grand Illusion*
1938 *The Human Beast*
1939 *The Rules of the Game*

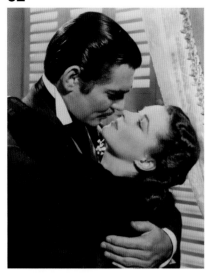

TOMORROW IS ANOTHER DAY

GONE WITH THE WIND / 1939

IN CONTEXT

GENRE
Historical romance

DIRECTOR
Victor Fleming

WRITERS
**Sidney Howard
(screenplay); Margaret
Mitchell (novel)**

STARS
**Vivien Leigh, Clark
Gable, Leslie Howard,
Olivia de Havilland**

BEFORE
1915 D. W. Griffith's *The Birth
of a Nation* (or *The Clansman*),
an epic chronicle of the Civil
War, is condemned as racist.

1933 George Cukor directs
Little Women, a Civil War era
family drama adapted from the
novels by Louisa May Alcott.

AFTER
1948 Vivien Leigh takes the
title role in Alexander Korda's
adaptation of *Anna Karenina*
by Leo Tolstoy.

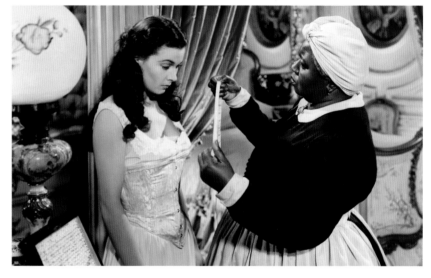

Dressing Scarlett (Vivien Leigh) for
the ball, Mammy (Hattie McDaniel)
upbraids her newly widowed mistress
for trying to ensnare a married man.

Now viewed nostalgically
as a relic of a long-gone
Hollywood, *Gone with the
Wind* was itself a rose-tinted portrait
of a bygone age. Its preamble pays
tribute to a lost America, in a paean
to the Old South: "Here in this pretty
world, Gallantry took its last bow.
Here was the last ever to be seen
of Knights and their Ladies Fair, of
Master and of Slave. Look for it only
in books, for it is no more than a
dream remembered, a Civilization
gone with the wind..." In 1939,
America was still smarting from
the grinding poverty of the Great

Depression, and audiences were
swept off their feet by the movie's
sheer scale, romance, and blazing
color palette.

Epic adaptation
What is now regarded as a great
historical epic was a work of fiction
by Margaret Mitchell, whose best-
selling Civil War love story was first
published in 1936. Before the year

What else to watch: *The General* (1926) ▪ *Little Women* (1933) ▪ *A Streetcar Named Desire* (1951, pp.116–17) ▪ *Cold Mountain* (2003) ▪ *12 Years a Slave* (2013)

> A landmark in movie history, and only the very blasé can say of it that frankly they don't give a damn.
> **Philip French**
> *The Observer*, 2010

was out, producer David O. Selznick had committed to making the movie version. It was a gargantuan task. The draft screenplay ran to six hours and took four writers to edit. It is said that 1,400 unknowns and dozens of stars were seen for the role of its heroine, Scarlett O'Hara. Having waited a year for actor Clark Gable to be free, Selznick then fired director George Cukor just three weeks into filming and replaced him with Victor Fleming.

Love, loss, and longing

The movie is, at heart, a love triangle writ large: Scarlett (Vivien Leigh) is in love with Ashley Wilkes (Leslie Howard), who is engaged to marry his cousin. On the rebound she catches the eye of Rhett Butler (Clark Gable). The violence of war aptly reflects the tortured love affair between Rhett and Scarlett, captured in stunning Technicolor by cinematographer Ernest Haller.

The movie's depiction of, and open nostalgia for, the slave-based society of the Old South betrays many questionable assumptions, but some of the

novel's more openly racist passages are simply sidestepped. Hattie McDaniel, who played Scarlett's house slave Mammy, won one of the movie's 10 Oscars—the first African-American to be so honored.

Ultimately this is Scarlett's story. While the movie ends with her alone, undone by her own selfishness, it is also a metaphor for America as a land of hope and regeneration. Although she is rebuffed by Rhett, who shuns her desperate pleas for reconciliation with a curt, "Frankly, my dear, I don't give a damn," the last line of the movie belongs to Scarlett. "I'll go home," she says, thinking of her home at Tara, her family, and her roots, "and I'll think of some way to get him back. After all... tomorrow is another day." ▪

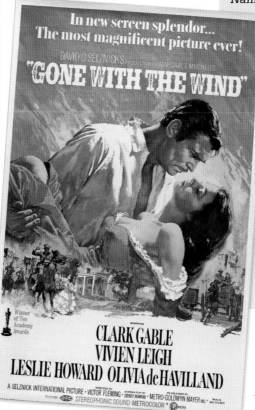

Vivien Leigh Actress

Born in Darjeeling, India, in 1913, Vivien Leigh shot to international fame with *Gone with the Wind*, becoming the first British actress to win a Best Actress Oscar. She was equally accomplished on stage and on screen, and won her second Oscar for playing Blanche DuBois in *A Streetcar Named Desire*, a role she had first played in the theater. Described by director George Cukor as "a consummate actress, hampered by beauty," Leigh had a troubled private life; her fragile mental and physical health resulted in a limited output. She succumbed to tuberculosis in 1967, and died at 53.

Key movies

1939 *Gone with the Wind*
1951 *A Streetcar Named Desire*

The movie's premiere in 1939 in Atlanta, Georgia, drew one million people to the city. This poster dates to 1967, when the movie was rereleased in a wide-screen print.

YOU'RE WONDERFUL, IN A LOATHSOME SORT OF WAY

HIS GIRL FRIDAY / 1940

IN CONTEXT

GENRE
Screwball comedy

DIRECTOR
Howard Hawks

WRITERS
Charles Lederer (screenplay); Ben Hecht, Charles MacArthur (play)

STARS
Cary Grant, Rosalind Russell

BEFORE
1931 The first movie version of the stage play *The Front Page* is directed by Lewis Milestone, and stars Adolphe Menjou and Pat O'Brien.

AFTER
1941 Grant and Russell reprise their roles for a radio version of the movie, broadcast by The Screen Guild Theater.

1974 Billy Wilder directs a remake of *The Front Page*, starring Jack Lemmon and Walter Matthau.

Howard Hawks's sharply scripted screwball comedy about the daily newspaper world is one of the smartest movies of the black-and-white era. Famous for its overlapping, machine-gun-fast dialogue, it portrays journalists who will stoop to anything in their hunt for a good story. The movie's press hotshot leads lie, cheat, and connive, yet they win the viewer over with their charm, energy, and brilliant comic timing.

Play adaptation

His Girl Friday was based on a 1928 play about the corrupt world of the press, *The Front Page*, of which a movie version had already been made. In *The Front Page*, the battle of wits is between two newspapermen, but Hawks made a key change. After reading scenes from the play with his girlfriend, Hawks is said to have exclaimed, "Hey, it's even better with a woman and a man than with two men." And so, in Charles Lederer's screenplay, the two newspapermen become a recently divorced couple: hard-boiled editor Walter Burns

Walter (Cary Grant) schemes to prevent his ex-wife Hildy (Rosalind Russell) from marrying another by reminding her how much she loves her job.

What else to watch: *Bringing Up Baby* (1938) ▪ *The Philadelphia Story* (1940) ▪ *Roman Holiday* (1953) ▪ *The Seven-Year Itch* (1955) ▪ *The Apartment* (1960)

and Hildy Johnson, his ex-wife, who is an ace journalist. This switch added a romance angle to the satire, playing with ideas of what men and women want in life.

A woman's dilemma

In the opening scene, Rosalind Russell's Hildy, struggling to get a word in edgewise in a quick-fire verbal sparring match with her ex-husband and ex-boss Walter (Cary Grant), announces that she is about to marry insurance man Bruce Baldwin (Ralph Bellamy).

Bruce is dull, but Hildy says that she wants to escape from the beastly, corrupt world of journalism to become "a human being" who lives a "normal" life as a wife and mother. It's a choice between home and career, but Walter is sure that

Howard Hawks Director

Howard Hawks directed more than 40 classic Hollywood movies, but it was only late in his life that he came to be recognized as one of the directing greats. Born in Goshen, Indiana, in 1896, Hawks moved with his family to California in 1910 and was drawn into the movie business, working briefly as a prop man on a handful of movies such as *The Little American* (1917).

After serving in World War I as an airman, he returned to Hollywood, where he wrote and directed his first movie in 1926,

the silent *Road to Glory*. When he moved into talkies, his 1932 gangster thriller *Scarface* was a huge success, and there followed a string of movies, among them "screwball" comedies with Cary Grant such as *Bringing Up Baby* and *His Girl Friday*. Later movies included movie noir classics such as *The Big Sleep*, and the Western *Rio Bravo* (1959).

Key movies

1932 *Scarface*
1938 *Bringing up Baby*
1940 *His Girl Friday*
1944 *To Have and Have Not*
1946 *The Big Sleep*

the thrill of the press world is too alluring for her to quit as star reporter. The movie revolves around his efforts to remind her of this, as he involves her in an unfolding news story about the upcoming execution of convicted murderer Earl Williams (John Qualen).

Walter behaves outrageously in his efforts to win Hildy back. He barely misses a beat when Molly, the girl who has befriended Williams, leaps to her death from a window. Yet Grant endows Walter with such panache and sheer cleverness that the viewer roots for him as he reels Hildy in. No wonder Hildy says to him, "Walter, you're wonderful, in a loathsome sort of way." And yet

❝Who do you think I am, **a crook?**❞
Walter / His Girl Friday

Hildy matches him every step of the way, which is why, of course, they are made for each other. ∎

The movie uses much of the script from the original play, but Hawks also encouraged the actors to ad-lib.

IT ISN'T ENOUGH TO TELL US WHAT A MAN DID. YOU'VE GOT TO TELL US WHO HE WAS

CITIZEN KANE / 1941

IN CONTEXT

GENRE
Mystery drama

DIRECTOR
Orson Welles

WRITERS
**Orson Welles,
Herman J. Mankiewicz**

STARS
**Orson Welles, Joseph
Cotten, Dorothy
Comingore**

BEFORE
1938 Welles directs a radio
adaptation of H. G. Wells's
War of the Worlds, about an
invasion from Mars. Its news-
bulletin style is said to have
caused some listeners to
believe that it was real.

AFTER
1958 Welles's noir thriller *Touch
of Evil* tells a story of corruption
in a Mexican border town.

1962 Welles makes a visually
stunning adaptation of Franz
Kafka's novel *The Trial.*

I don't think any word can explain a man's life," says Charles Foster Kane, the towering press-baron protagonist of *Citizen Kane.* And yet the genius of this movie—cowritten, starring, and directed by Orson Welles at the age of just 25—is that it does just that: takes a single word that captures the origin and essence of the mercurial Kane, and teases the audience with it for nearly two hours, before offering an enigmatic clue to its meaning.

Shot in secrecy to preempt legal attempts to block production, and ambiguously billed as a love story, Welles braced himself for trouble upon its release. Kane's character was not only based on a living person, but one who was extremely powerful.

Citizen Kane is a murder mystery without a murder, even though it famously opens with Kane, in old age, as a dying man. Starting his movie at the end is just the first of Welles's many innovative

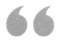

Your faithful bystander reports that he has just seen a picture which he thinks must be the best picture he ever saw.
John O'Hara
Newsweek, **1941**

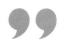

temporal devices. The narrative then switches to a newsreel clip that recalls the life and deeds of the great Kane. It shows the building of his stately home, Xanadu, a sprawling mansion that he fills with art ("Enough for ten museums—the loot of the world"). It shows Kane's influence spreading across the US and then across the world, as he stands on a balcony next to Adolf

❝Old age. It's the **only disease**…that you don't look forward to **being cured of**.❞
Bernstein / Citizen Kane

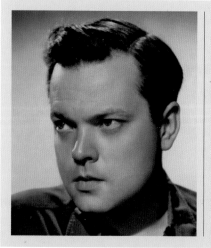

Orson Welles Director

Welles's life mirrors that of Charles Foster Kane, in that he was taken in by a family friend, having lost both parents at 15. In 1934, he began working on radio plays and in 1937 founded the Mercury Theater—two things that would bring him great notoriety in 1938 when the company performed *War of the Worlds* as a live news broadcast. Welles was approached by RKO Studios in Hollywood, where he was given unheard of privileges for a new director, including the final cut for *Citizen Kane.* His next movie *The Magnificent Ambersons,* was butchered by RKO, the first of many creative quarrels that would plague his career. He died at 70 in 1985.

Key movies

1941 *Citizen Kane*
1942 *The Magnificent Ambersons*
1958 *Touch of Evil*
1962 *The Trial*

What else to watch: *The Magnificent Ambersons* (1942) ▪ *The Lady from Shanghai* (1947) ▪
The Third Man (1949, pp.100–03) ▪ *Touch of Evil* (1958, p.333) ▪ *The Trial* (1962) ▪ *Me and Orson Welles* (2008)

Minute by minute

00:12
Following a newsreel of Kane's life, reporter Jerry Thompson is charged with discovering the meaning of Kane's final word, "Rosebud."

00:33
Bernstein tells Thompson of the early days at the *Inquirer*, in which Kane wrote his "Declaration of Principles."

01:26
Thompson speaks to Susan. She describes her marriage to Kane, and how he forced her to continue singing.

01:36
Susan takes an overdose, saying that she does not want to sing any more. Kane slaps her, and she walks out on him.

00:00	00:15	00:30	00:45	01:00	01:15	01:30	01:59

00:18
Thompson reads Thatcher's memoirs, which tell the story of the young Charles Kane, whom Thatcher had adopted, and how Kane first took over the *Inquirer* newspaper.

00:49
Leland recounts Kane's unhappy first marriage, and how he began the affair with Susan that would end his political career.

01:32
After Susan's first night, Kane writes Leland's review for him, truthfully describing her performance as terrible. He then fires Leland and they never speak again.

01:49
The butler tells Thompson that Kane trashed the room after Susan left, and said "Rosebud" on seeing a snow globe.

Hitler (cutting to a shot of Kane declaring, pompously, "You can take my word for it, there will be no war"). Next come the women in his life, and how an illicit affair cut short his political career. The audience is shown his rise, fall, and withdrawal from public life.

The riddle of Rosebud

When the newsreel ends, its producer isn't satisfied: he wants to know who Charles Foster Kane was, not what he did, and sends reporter Jerry Thompson (William Alland) to discover the meaning of the word Kane uttered with his last breath: "Rosebud." At this point, *Citizen Kane* essentially becomes two movies. The framework is Kane's life as recounted by his friends and enemies, as Thompson squares up to this extraordinary riddle wrapped in a larger-than-life enigma. But Welles also slyly offers the audience other scenes from Kane's life in flashback, a »

In happier days, Kane and Leland stand surrounded by copies of the *Inquirer*. Kane intends to use the paper to campaign for ordinary folk, a pledge that Leland will later throw back at him.

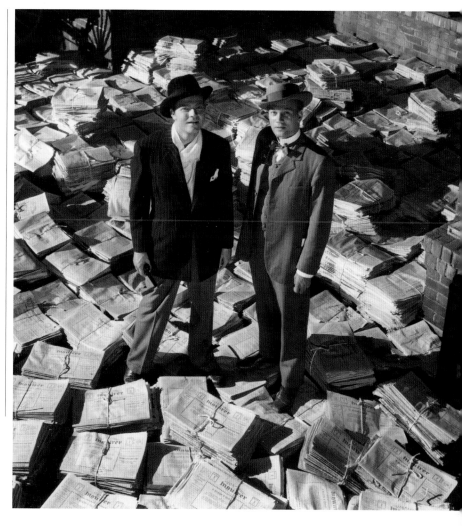

technique that will finally allow him to reveal the truth that will elude Thompson and all the others.

A good deal of the movie's artistic success can be attributed to Welles's experience of working in theater. *Citizen Kane* is a movie that not only uses temporal devices in the narrative, but spatial ones, too, so that it can sometimes almost seem like a 3D movie. In a crucial early scene, Thompson discovers how Kane was born to a poor family who discovered gold on their land and, as part of a business deal, handed the boy over to a wealthy guardian. As the bargain is made in the foreground, we see the young

Kane through the window, playing in the snow, oblivious. It is a simple perspective trick imported from theater, and it is used to capture the tragedy that befalls Kane. It is the moment in which the life he should have led ends.

Innovative shots

Welles and cameraman Gregg Toland employed such spatial devices throughout the movie, a feat achieved with deep-focus lenses and camera angles so low that Kane may appear, variously, as a titan and as a gangster. This in itself was a novelty, since prior to *Citizen Kane* filmmakers rarely used such upward shots, for the simple reason that few studios had ceilings due to the lighting and sound equipment. ("A big lie in order to get all those terrible lights up there," said

Welles.) Yet Welles took his camera so far down that, for a scene in which Kane talks with his friend Leland after losing his first election, a hole had to be dug in the concrete studio floor.

Toland's input is a vital part of *Citizen Kane*'s legacy, since, although it would seal Welles's status as one of America's first auteur directors, this was very much a collaborative effort. Also vital was the risk Welles took with his cast and production team—for whom *Citizen Kane* launched their careers in movies. Many of the actors were unknown to audiences—they came from Welles's Mercury Theatre group. His editor, Robert Wise, would soon begin a successful directing career of his own; and the score marked a debut for Bernard Herrmann, later to form an

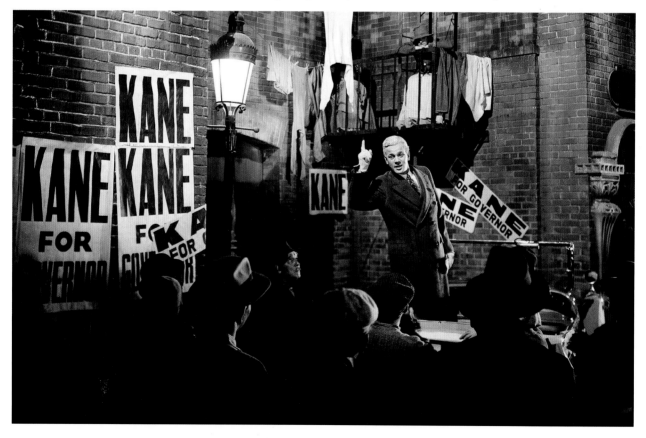

Leland (Joseph Cotten) speaks at Kane's political rally. Ultimately the campaign, and their friendship, will be derailed by Kane's obsessive affair.

Parallel lives

The character of Charles Foster Kane was a brutal portrait of newspaper magnate William Randolph Hearst. Determined to shut the movie down, Hearst had negatives burned and waged a campaign to discredit Welles.

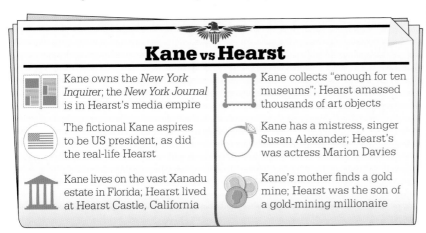

Kane vs Hearst

Kane owns the *New York Inquirer*; the *New York Journal* is in Hearst's media empire

The fictional Kane aspires to be US president, as did the real-life Hearst

Kane lives on the vast Xanadu estate in Florida; Hearst lived at Hearst Castle, California

Kane collects "enough for ten museums"; Hearst amassed thousands of art objects

Kane has a mistress, singer Susan Alexander; Hearst's was actress Marion Davies

Kane's mother finds a gold mine; Hearst was the son of a gold-mining millionaire

all too clear. It is a common fallacy that the movie flopped on release (it was the sixth-highest grossing movie of the year and nominated for nine Oscars), but a blanket ban by Hearst's vast media empire ensured that its success was short-lived. Although it satirizes several cherished ideals, including the American dream (Kane sees no irony in being an autocratic capitalist who claims to fight for the common man), *Citizen Kane* does have sympathy for its subject. With Kane dead and Thompson unable to finish his quest, Welles's camera takes viewers through the clutter of Xanadu, where Kane's vast and gaudy art collection is being packed away.

Finally, the shot settles on the sled, named Rosebud, that Kane was playing with in the snow outside his parents' shack. No one knows but us, and Kane, that this sled represents the key moment of his life: the moment he lost his innocence and happiness. ∎

extensive creative partnership with Alfred Hitchcock. But more than anything, the movie's brilliance is due to its script, which Welles cowrote with screenwriter Herman J. Mankiewicz. Although Mankiewicz's exact contribution has been disputed, often by Welles, the movie does bear extensive traces of Mankiewicz's satirical style: at one particularly loaded

moment, having his affair discovered by his wife, Kane simply says, dryly, "I had no idea you had this flair for melodrama, Emily."

Parallels with Hearst

Despite the arguments over who wrote what, it is agreed that it was Mankiewicz who first came up with the idea for the movie. Having attained some success as a writer in the silent era, Mankiewicz became a sought-after script doctor, and it was in this capacity that he came to know the press tycoon William Randolph Hearst and his mistress, the movie actress Marion Davies. Although everyone denied it—including Hearst, who behaved with a very Kane-like determination to destroy the movie and its makers' reputations—the parallels between Hearst and Kane were

Welles's eye for publicity was evident in the posters for the original release, which talked up the movie without giving anything away.

> The film's style was made with the ease and boldness and resource of one who controls and is not controlled by his medium.
> **Dilys Powell**
> *The Sunday Times*, 1941

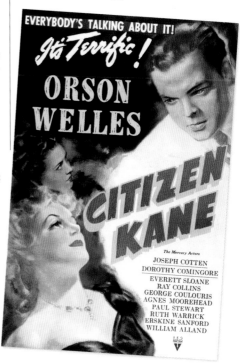

EVERYBODY'S TALKING ABOUT IT!
It's Terrific!
ORSON WELLES
CITIZEN KANE

The Mercury Actors
JOSEPH COTTEN
DOROTHY COMINGORE
EVERETT SLOANE
RAY COLLINS
GEORGE COULOURIS
AGNES MOOREHEAD
PAUL STEWART
RUTH WARRICK
ERSKINE SANFORD
WILLIAM ALLAND

OF ALL THE GIN JOINTS IN ALL THE TOWNS IN ALL THE WORLD, SHE WALKS INTO MINE
CASABLANCA / 1942

Made at the height of World War II, *Casablanca* is a romance set in neutral Morocco, just as the fighting is getting uncomfortably close.

Few of those working on the production thought they were making a great movie. Ingrid Bergman, who had not been the producers' first choice, was anxious to move on to *For Whom the Bell Tolls* (1943); and by all accounts, there was no love lost between Humphrey Bogart

Warner Bros. promoted the movie as a typical romance of its time, little thinking that it would become one of the most popular movies ever made.

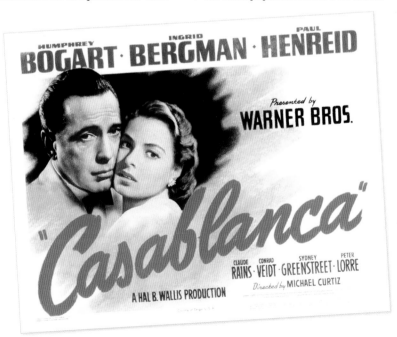

What else to watch: *Only Angels Have Wings* (1938) ▪ *The Maltese Falcon* (1941, p.331) ▪ *To Have and Have Not* (1944) ▪ *Brief Encounter* (1945, p.332) ▪ *Notorious* (1946) ▪ *Key Largo* (1948) ▪ *Charade* (1963) ▪ *Play It Again, Sam* (1972)

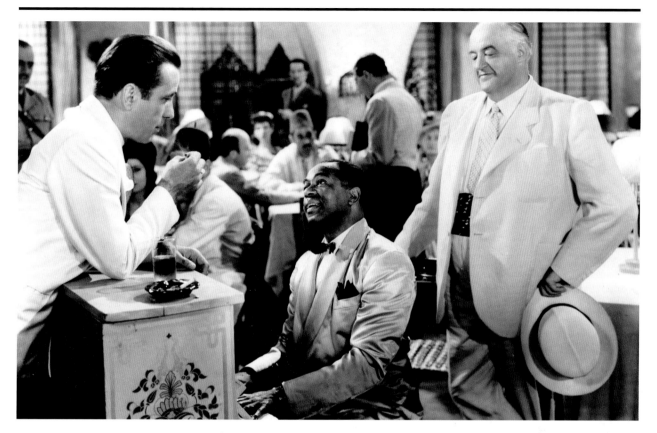

Sam, the pianist at Rick's Café (center), was played by Dooley Wilson. He was a band leader and a drummer, but not a piano player, and had to mime.

and Paul Henreid, who played his rival for Bergman's heart. And yet the movie was an instant success.

At the end of the movie, Bogart's character Rick says, "It doesn't take much to see that the problems of three little people don't amount to a hill of beans in this crazy world." *Casablanca* manages to make its audience feel that the problems of these people are the most important thing they can

imagine. As we discover part way through the movie, Rick, the cynical, hard-drinking owner of Rick's *Café Américain*, an upmarket nightclub, has been stung in Paris by the sudden desertion of his lover, Ilsa (Bergman), as the Germans were invading. Hurt, he has retreated to Casablanca, a town full of spies, Nazi collaborators, Resistance fighters, and desperate refugees.

The shadow of war

"I stick my neck out for nobody," says Rick. In reply to Major Strasser's question, "What is your nationality?" Rick's reply is, "I'm a drunkard."

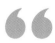

It is a movie to play again, and again.
Sheila Johnston
The Daily Telegraph, 2014

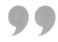

But in a telling parallel with the real war, such a neutral stance proves impossible. In his bar, different factions end an evening competing with their national »

❝Play it, Sam. **Play** *As Time Goes By.*❞
Ilsa Lund / Casablanca

anthems, and Rick must choose sides. He allows the band to play the *Marseillaise* to drown out the Germans. At the very time *Casablanca* was being filmed, a previously neutral US joined the fight against Germany and Japan, and, as it premiered in New York in

Rick tells Ilsa at the airport that she must get on the plane with her Resistance-fighter husband, Victor Laszlo.

" You're **getting on that plane** with **Victor** where you **belong**. "

Rick / Casablanca

November 1942, the Allies were advancing on the Axis powers to capture Casablanca for real.

When Ilsa arrives at his club, Rick is decidedly cool toward her, commenting wryly: "Of all the gin joints in all the towns in all the world, she walks into mine."

But Ilsa still loves Rick. Her Resistance-fighter husband, Victor Laszlo (Henreid), turned up alive when she believed him to be dead, and that is why she

abandoned Rick. When Rick discovers that Ilsa and Laszlo need his help, he is forced to make a choice. Does he keep the papers they need, and so keep Ilsa, or does he let her go? In the end, Rick does the noble thing, and puts Ilsa on a plane to freedom with Laszlo. In a heartrending parting, as they stand by the plane, he explains why she would regret it if she stayed with him: "Maybe not today, maybe not tomorrow, but soon and for the rest of your life." It's a

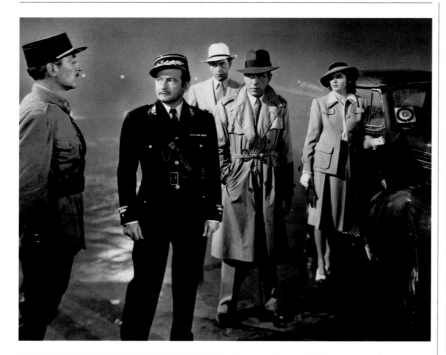

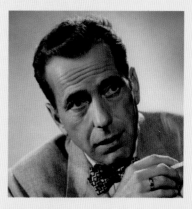

>
>
> It is about a man and a woman who are in love, and who sacrifice love for a higher purpose.
> **Roger Ebert**
> *Chicago Sun-Times*, 1996
>
>

deeply poignant moment. While the audience longs for the romance to endure, it recognizes that nobility must win the day.

Enduring appeal

When Rick tells Ilsa, "You're getting on that plane with Victor where you belong," the audience vicariously shares his heroism and her self-denial—basking in the reflected glory of renouncing romantic love

Actors Henreid, Bogart, and Bergman did not know, until the final day of shooting, who would get on the plane. This uncertainty contributed to the emotional ambivalence of Bergman's performance.

for the greater good. Clearly a powerful message at the time of the movie's release, it has not lost any of its power over the years. Indeed, audiences today may be tempted to look back on a better, albeit fictional, world, in which personal gratification appeared less likely to prevail over the common cause, while the on-screen chemistry of the movie's stars enhances the viewer's pleasure at identifying with them.

However, the movie's appeal does not lie in the passion and selflessness of its leads alone. It has a strong cast of minor characters, including a black-marketeer played by Peter Lorre and a police chief by Claude Rains. They play morally ambiguous roles in a corrupt world, yet are ultimately redeemed along with the hard-drinking and cynical Rick. ∎

Humphrey Bogart
Actor

Humphrey Bogart was renowned for playing world-weary outsiders with a noble streak. Born on Christmas Day 1899 to a wealthy New York family, he had a privileged, if lonely, childhood. He served in the US Navy during World War I, after which he struggled for a decade to establish his acting career before finally making a name for himself playing gangsters and villains in Hollywood B-movies. His big breakthrough came when he played the damaged hero in *The Maltese Falcon*. A string of great movie roles followed, including *To Have and Have Not*, *The Big Sleep*, and *Key Largo* (1944), with his wife Lauren Bacall. *The African Queen* won Bogart his only Academy Award, for Best Actor, in 1951. He appeared in more than 75 movies over a 30-year career and died, at 57, in 1957.

Key movies

1941 *The Maltese Falcon*
1944 *To Have and Have Not*
1946 *The Big Sleep*
1951 *The African Queen*

HOW DARE YOU CALL ME A HAM?

TO BE OR NOT TO BE / 1942

IN CONTEXT

GENRE
War comedy

DIRECTOR
Ernst Lubitsch

WRITERS
**Melchior Lengyel,
Edwin Justus Mayer**

STARS
**Jack Benny, Carole
Lombard, Robert Stack**

BEFORE
1940 *The Shop Around the
Corner,* Lubitsch's hit romantic
comedy, is also set in Europe
on the eve of World War II.

AFTER
1943 After the disappointing
initial reception of *To Be or
Not to Be,* Lubitsch returns to
more conventional comedies
with *Heaven Can Wait.*

1983 *To Be or Not to Be* is
remade, with husband-and-
wife comedy actors Mel
Brooks and Anne Bancroft
in the lead roles.

It's astonishing now to realize that Ernst Lubitsch's hilarious satire of the Nazis began production in 1941, when the US had not yet entered World War II and was still maintaining neutrality. German-born Lubitsch set out to challenge that neutrality. Knowing the political risk he was taking, he took himself out of the studio system for the first time in his career and signed a deal with United Artists. This paid him less than his usual fee but gave him artistic control.

The story was unusual for Lubitsch in that it was not taken from an existing source, but was developed by him with two trusted collaborators, Hungarian screenwriter Melchior Lengyel, and US playwright Edwin Justus Mayer.

Actors' vanity

The starting point was Lubitsch's memories of the vanity of actors during his years on the Berlin stage, and his observation that

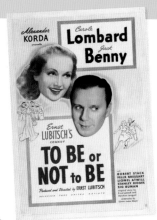

The movie's release in March 1942 was marred by tragedy. Carole Lombard had died in a plane crash weeks earlier, while work was in postproduction.

actors remain actors, no matter what situation they're in. But the story quickly became much darker than that.

Although it was made in Hollywood, the movie is set in Warsaw, Poland, in 1939, just as Germany is about to invade. The highly strung members of a theater company—led by Joseph Tura (Jack Benny) and the leading lady who is also his wife, Maria (Carole Lombard)—are rehearsing an anti-Nazi spoof by day and performing Shakespeare's *Hamlet* by night. When Maria becomes romantically involved with a dashing young admirer, pilot Lieutenant Stanislav Sobinski (Robert

What else to watch: *Trouble in Paradise* (1932) ▪ *Ninotchka* (1939) ▪ *The Shop Around the Corner* (1940) ▪ *Heaven Can Wait* (1943) ▪ *That Lady in Ermine* (1948)

Stack), she is drawn into a plan to track down a German spy who is about to endanger the Polish Resistance network. In a rapidly escalating farce, the actors (many of them Jewish) use their skills at disguise to fool the invading Nazis.

Comedy

This sounds as much like the premise of a dark, intricate spy thriller as the light, romantic comedies for which Lubitsch was known, which is exactly what the director intended: a satire/comedy with dark intent. Lubitsch claimed that he wanted to steer clear of two traditional comedic formulas: "Drama with comedy relief and comedy with dramatic relief. I had

Ernst Lubitsch Director

Born in Berlin in 1892, Ernst Lubitsch joined the Deutsches Theater in 1911. Two years later he made his screen debut in *The Ideal Wife*, but by 1920 his focus shifted to directing. He left for the US in 1922 to direct Mary Pickford in the hit movie *Rosita*, and made a smooth transition into sound. With *Trouble in* *Paradise* (1935) he found ways to smuggle risqué ideas past the censor: a trick known as "the Lubitsch touch." This paid off in comedies such as *Ninotchka* (1939). He died in 1947 at 55.

Key movies

1940 *The Shop Around the Corner*
1942 *To Be or Not to Be*

made up my mind to make a picture with no attempt to relieve anybody from anything at any time." The movie succeeds in being both an anti-Fascist tract and,

bizarrely, a showbiz satire (the self-obsessed Tura consoles himself with the thought that an audience member who walks out during his *Hamlet* soliloquy may have been suffering from a heart attack). The war provides the sobering counterpoint to the comedy: people die. There is a double edge to the code message that Sobinski passes to Maria, unwittingly via a double agent. "To be, or not to be," it says, and as the Turas bravely lead their theater troupe in a deadly game of double bluff, it is clear that Lubitsch is using Hamlet's famous line to question a complacent United States. To fight or not to fight, and let the Nazis get away with it? For Lubitsch, this was no question at all. ∎

> **❝I don't know, it's not convincing. To me, he's just a man with a little moustache.❞**
>
> **Stage manager** / To Be or Not to Be

Jewish actor Bronski (Tom Dugan) and the other members of Tura's cast fool the Germans by disguising themselves as Hitler and his entourage.

IT'S HOT IN HERE BY THE STOVE
OSSESSIONE / 1943

IN CONTEXT

GENRE
Film noir, romance

DIRECTOR
Luchino Visconti

WRITERS
Luchino Visconti, Mario Alicata, Guiseppe De Santis, Gianni Puccini (screenplay); James M. Cain (novel)

STARS
Clara Calamai, Massimo Girotti, Juan de Landa

BEFORE
1935 Visconti's movie career begins as an assistant director on Jean Renoir's drama *Toni*.

AFTER
1946 Tay Garnett's *The Postman Always Rings Twice* is the first US adaptation of the novel. It stars Lana Turner and John Garfield.

1981 The second US version stars Jack Nicholson and Jessica Lange.

On its release in Italy, Luchino Visconti's debut as director had to contend with the disapproval of the Fascist regime. It was beset by copyright problems, too, yet his unauthorized adaptation of James M. Cain's 1934 crime novel *The Postman Always Rings Twice* has endured as well as the later Hollywood versions.

A study of jealousy

Although Visconti would become known for the lush, baroque, and melodramatic style of later movies such as *Senso* (1954), *Ossessione* reflects his training as an assistant to French director Jean Renoir, who first gave him Cain's book. It has been heralded as the first of the Italian neorealist movies, shot in the torrid flatlands of the Po delta in order to capture the texture of everyday life.

While *Ossessione* is nominally a crime yarn, Visconti plays those elements down, creating a story about desperation and jealousy. Both main characters are stuck: one in a marriage, another on the road.

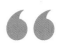

> A movie that stinks of latrines.
> **Gaetano Polverelli**
> **Mussolini's Culture Minister**

Neither of the protagonists is a straightforward hero or heroine. The drifter Gino (Massimo Girotti) is filthy and broke, and the beautiful, put-upon Giovanna (Clara Calamai), married to slovenly restaurant owner Giuseppe (Juan de Landa), is never allowed the trappings of the femme fatale. In Visconti's eyes, Giovanna is no temptress, and Gino no villain; it is the oppression of capitalism that leads the working class astray. It was this view that offended the Fascists, leading the censor to butcher the master copy. Happily, Visconti kept a secret print. ∎

What else to watch: *The Postman Always Rings Twice* (1946) ▪ *The Bicycle Thief* (1948, pp.94–97) ▪ *The Leopard* (1963) ▪ *Death in Venice* (1971)

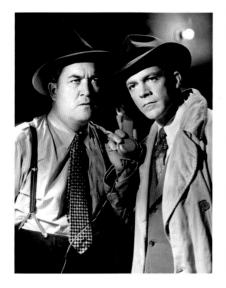

HOW SINGULARLY INNOCENT I LOOK THIS MORNING

LAURA / 1944

IN CONTEXT

GENRE
Film noir, romance

DIRECTOR
Otto Preminger

WRITERS
Jay Dratler, Samuel Hoffenstein, Elizabeth Reinhardt (screenplay); Vera Caspary (novel)

STARS
Gene Tierney, Dana Andrews, Clifton Webb

BEFORE
1940 Tierney makes her screen debut in Fritz Lang's *The Return of Frank James*.

AFTER
1955 Preminger's *The Man With the Golden Arm* deals with drug addiction, one of several controversial topics that he will tackle.

1959 In *Anatomy of a Murder*, Preminger depicts rape more frankly than it had ever been shown in Hollywood movies.

Although it is synonymous with film noir, *Laura* works best when viewed as a twisted romance. Otto Preminger's movie plays out as a love triangle within a murder mystery, as New York detective Mark McPherson (Dana Andrews) falls for the title character (Gene Tierney), a beautiful advertising executive apparently gunned down on her doorstep at the start.

McPherson's investigation checks all the requisite boxes for a gumshoe movie—Laura's wayward playboy beau, her two-faced aunt, and her overprotective best friend—but Preminger adds a strange, dreamlike quality to the movie. The femme-fatale formula is slightly subverted: Tierney plays Laura as an unwitting siren, unaware of the spell she is casting. The movie's witty script still sparkles today, and it features a sumptuous original score by David Raksin, whose main theme became a jazz standard. ■

Writer Waldo Lydecker (Clifton Webb, center) and playboy Shelby Carpenter (Vincent Price) are two of the suspicious men in Laura's life.

What else to watch: *Leave Her To Heaven* (1945) ▪ *The Killers* (1946) ▪ *Build My Gallows High* (1947, p.332) ▪ *Anatomy of a Murder* (1959)

A KICK IN THE REAR, IF WELL DELIVERED, IS A SURE LAUGH

CHILDREN OF PARADISE / 1945

IN CONTEXT

GENRE
Romantic drama

DIRECTOR
Marcel Carné

WRITER
Jacques Prévert

STARS
Arletty, Jean-Louis Barrault, Pierre Brasseur, Marcel Herrand, Louis Salou

BEFORE
1939 US historical romance *Gone with the Wind* is released.

1942 Set in 1485, *The Night Visitors* is the first movie made during World War II by Carné and Prévert with Arletty.

AFTER
1946 Carné and Prévert reunite to make *Gates of the Night*, but it is a flop and they never work together again.

Among the many great landmarks of French cinema, *Children of Paradise* (*Les enfants du paradis*), made at the height of the German occupation in 1943 and 1944, is now seen as among the very greatest. With a compelling script by the poet Jacques Prévert, director Marcel Carné turned a story set in 1830s Paris about four different men's love for the enigmatic courtesan Garance into a profound and romantic drama.

The movie itself is glorious. But what makes the achievement of Carné and Prévert all the more extraordinary is the degree of difficulty they overcame even making it in occupied France. Practically, materials for sets and costumes were almost nonexistent: fruit and loaves of bread intended to be used on camera were eaten by half-starved crew members. Under the eye of the Nazis and the Vichy French regime, every move was monitored. And yet Carné's invention—and independence—triumphed.

Shooting in Vichy France
The ambition and scale of the movie required a large cast and production team. The cast included Nazi collaborators, whom the producers had been coerced into hiring. But what the Vichy overseers didn't know was that Carné had found a place for Resistance fighters among the 1,800 extras, using the movie as daytime cover for their clandestine

A film poem on the nature and varieties of love—sacred and profane, selfless and possessive.
Pauline Kael
5001 Nights at the Movies, 1982

What else to watch: *Le jour se lève* (1939) ■ *Gone with the Wind* (1939, p.62–63) ■ *Le Colonel Chabert* (1943) ■
Phantom of the Opera (1943) ■ *An American in Paris* (1951) ■ *The Last Metro* (1980)

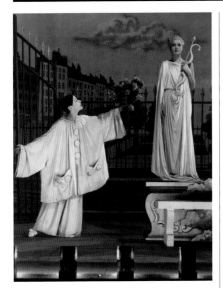

The mime sequences were developed by Jean-Louis Barrault (who plays Baptiste, left), and his teacher, Étienne Decroux (who plays Baptiste's father).

heroism. The production team also included Jews in hiding, whose identities were kept secret—in particular designer Alexandre Trauner and composer Joseph Kosma. Trauner lived with Carné during filming under an assumed name, while Kosma's work was credited to Maurice Thiriet, who arranged the music for orchestra.

Boulevard du Crime

There were endless logistical headaches assembling the movie's gigantic set, which Carné built in Nice, in southern France. It was 1,300 ft (400 m) long, and while building materials were scarce, he somehow recreated a street that resembled the famous Boulevard du Temple in Paris during the early 19th century. The street was nicknamed the Boulevard du Crime for the crime melodramas popular

"I'd spill **torrents of blood** to give you a **river of diamonds**."

Pierre François Lacenaire / Children of Paradise

in its lowbrow theaters. At one point during the shoot, when an Allied invasion of southern France was expected, the production was forced to abandon Nice and move to Paris, only to find on their return that the set had been ruined by storms. It had to be completely rebuilt.

Despite these problems, Carné and his team succeeded in creating a lavish and technically brilliant movie, and in coaxing unforgettable performances from the cast. The star, Arletty, oozes

sexual allure in her portrayal of Garance, entrancing the four men who are competing for her love.

Historical suitors

Three of these suitors are based on real historical figures: Jean-Louis Barrault plays the mime artist Baptiste Deburau, who transformed the role of Pierrot into a poignant, childlike character; Pierre Brasseur plays the actor Frédérick Lemaître; and Marcel Herrand the suave criminal Pierre François Lacenaire. The fourth character, the cynical aristocrat Édouard de Montray, »

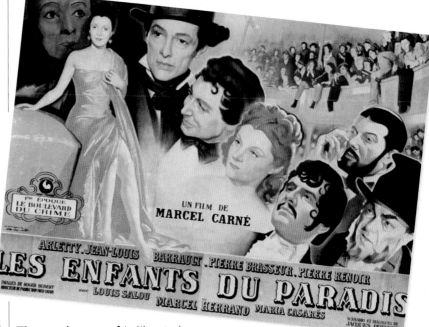

The movie opened in liberated Paris in 1945, and proved such a success that it played for more than a year. It was credited with helping to restore French national pride.

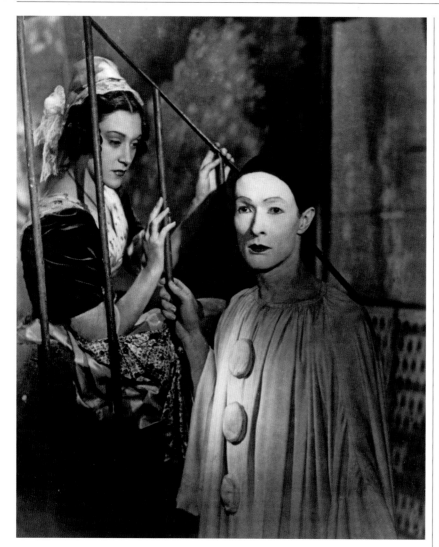

like a stage, jostled through and
caroused on by a vast and rowdy
army of colorful figures, courtiers,
and lowlifes alike. The movie opens
with a theater curtain that parts as
the camera glides down a Boulevard
du Crime crowded with extras, and
enters a carnival display where
another curtain labeled "The Naked
Truth" opens to reveal Garance
bathing in a barrel of water, visible
only from the shoulders up, and
staring at her reflection in a mirror.

Elusive love

Garance becomes involved with
each of her suitors in turn: first
with Baptiste, the mime, who
saves her from a false charge of
theft; then with Frédérick, who
steps in confidently after Baptiste
realizes that Garance can't return
his love; thirdly, with the criminal
Lacenaire; and finally, de Montray,
who offers Garance protection
when she is drawn unwittingly
into Lacenaire's crimes.

Garance is briefly intrigued by
all four men, bestowing her affection
on each of them in her own way,
yet she remains utterly elusive, and
cannot love them in the way that
they dote upon her. In the first half
of the story, as each receives some
measure of attention from her, the

played by Louis Salou, was inspired
by Charles Auguste, Duc de Morny,
half brother of Napoleon III.

The world's a stage

From the outset, the movie blurs
the line between the stage and
real life. Everything is about the
theatrical show of life. Even the title
of the movie refers to the highest

Rejected by Garance, Baptiste
marries Nathalie, played by Maria
Casares, an exiled Spanish Republican
associated with the Resistance.

balcony in the theater, known as
"paradise" (in Britain they call it
"the gods"), where the cheapest
seats in the house are situated. The
Boulevard du Crime itself seems

❝Jealousy belongs to all if a woman
belongs to **no one**.❞

Frédérick Lamaître / *Children of Paradise*

> Cinema and poetry are the same thing, Prévert said. Not always, alas. But it's surely true here.
> **Derek Malcolm**
> *The Guardian*, 1999

men are content, but, as the movie progresses, her hold over each of them changes their lives.

Ultimate disappointment

In the movie's second half, the suitors' dissatisfaction breeds resentment. Frédérick achieves his dream of playing Othello since at last he understands the pain of jealousy. For Lacenaire, the story

ends in tragedy as he dies on the scaffold for killing de Montray. For Garance, too, there is no happy resolution: the man she finally sets her heart upon – Baptiste – is ultimately out of her reach.

Much of this drama unfolds before the eyes of the "children of paradise," the working-class audience in the cheap seats. They are the most boisterous characters in the story—like the cinema audience, furthest from the stage yet also the most demanding. The paradise crowd cries out for entertainment. They are eager to see suffering and pain. As Baptiste's father says, "A kick in the rear, if well delivered, is a sure laugh." They want novelty, too. But "novelty," he says, "is as old as the hills." ∎

Baptiste's father plays for laughs from the "children of paradise," even as Baptiste reinvents the role of Pierrot as a childlike, disappointed lover, whose pain tugs at the audience's heartstrings.

Marcel Carné Director

Born in Paris in 1906, Marcel Carné began his movie career as a critic, while working in his spare time as a cameraman on silent movies. By 1931, he was directing his own short movies. In 1936, Carné teamed up with surrealist poet Jacques Prévert for the first time on the movie *Jenny*. Over the next decade, the pair made a series of "poetic realist" movies, casting a fatalistic eye over the lives of characters on the margins of society, which established Carné as a star in French cinema.

In the 1950s, Carné's reputation was eclipsed as the younger generation of the French New Wave demanded a less artificial style. However, he remained in high regard among his fellow directors, and François Truffaut once said that he "would give up all my movies to have directed *Children of Paradise*." Carné continued to make movies into the 1970s. He died in 1996.

Key movies

1938 *Hôtel du Nord*
1942 *Night Visitors*
1945 *Children of Paradise*
1946 *Gates of the Night*

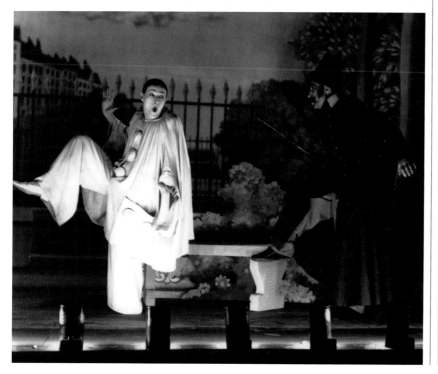

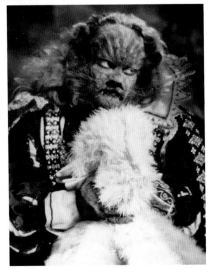

CHILDREN BELIEVE WHAT WE TELL THEM
LA BELLE ET LA BÊTE / 1946

IN CONTEXT

GENRE
French fantasy

DIRECTOR
Jean Cocteau

WRITER
Jean Cocteau

STARS
Jean Marais, Josette Day

BEFORE
1902 Georges Méliès's *A Trip to the Moon* is an early special-effects fantasy movie.

1930 *The Blood of a Poet*, Cocteau's first movie, explores the power of visual metaphors.

1933 *King Kong* portrays a sympathetic relationship between a beast and a girl.

AFTER
1950 *Orphée* is the second of Cocteau's movies about the Greek legend of Orpheus.

1991 Disney's *Beauty and the Beast* is one of the company's most successful movies.

For some critics, Jean Cocteau's *La Belle et la Bête* (*Beauty and the Beast*) is one of the most poetic movies ever made. It is the story of a young girl (Josette Day) trapped in the palace of a beastly creature (Jean Marais). Though repelled by the beast at first, the girl can see the goodness within him and falls in love with him. Cocteau tells the tale with such serious honesty that it is elevated from bedtime story into something morally profound.

For almost 40 years before he made *La Belle et la Bête*, Cocteau was a poet, and poetry had been the theme of his first, 55-minute experimental movie in 1930, *The Blood of a Poet*, about the mythical poet Orpheus. Cocteau was eager to deny that there was any symbolism in *La Belle et la Bête*, which was his first full-length feature movie, although he also believed that poetry was an unconcious process.

Contemporary US critic Bosley Crowther was struck by the movie's "gorgeous visual metaphors." At the same time, it is striking how plainly the story is told.

Supernatural simplicity
Tellingly, the movie opens not with the story, but with Cocteau writing on a school blackboard. He is making it clear that this is a story with a moral lesson, not a fantasy to be indulged in. "Children believe what we tell them," he writes.

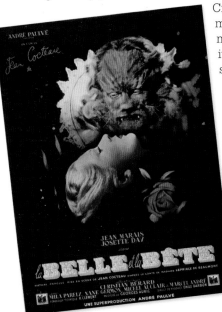

On the movie's release, critics praised its exquisite and imaginative costumes, designed by Christian Bérard.

What else to watch: *A Trip to the Moon* (1902, pp.20–21) ▪ *King Kong* (1933, p.49) ▪ *Vasilissa the Beautiful* (1939) ▪ *The Red Shoes* (1948, p.332) ▪ *The Night of the Hunter* (1955, pp.118–21)

> The secret to it all is that Cocteau set out to make a movie that would stir adults; along the way he discovered the child's imagination, too.
> **David Thomson**
> *Have You Seen...?*, 2008

The Beast's palace is more like a stage set than a fantasy world. The magic in the palace is surreal, rather than fantastic. Real hands and arms emerge from walls and tables to hold candles and pour drinks, and caryatids have real human faces that roll their eyes and blow smoke. It is reminiscent of the art of Salvador Dalí, rather than the fairy tales of the Brothers Grimm—unsettling, but also more

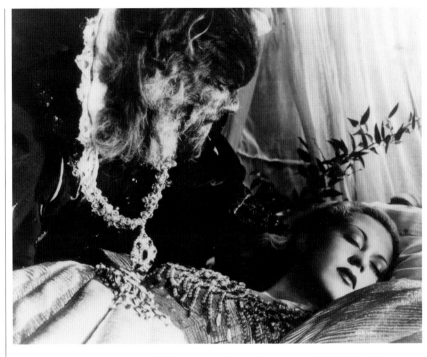

Fainting at the sight of the Beast, Beauty is carried to her bed chamber. He tells her that he will ask her to marry him every day that they are together.

adult and more moving. With settings inspired by the engravings of Gustave Doré and paintings of Jan Vermeer, and exteriors shot at Château de la Roche Courbon and Raray in France, cinematographer Henri Alekan created a world of Gothic enchantment. Cocteau himself credited Alekan for achieving "a supernatural quality within the limits of realism." ▪

Jean Cocteau Director

Writer, artist, and director Jean Cocteau was born in 1889, near Paris. He published his first book of poetry when he was 19, which gave him an entrée to the literary and artistic avant-garde in Paris.

In 1917, Cocteau wrote *Parade*, the story for a ballet composed by Erik Satie for the Ballets Russes. His most famous novel was *Les Enfants Terribles* (1929). Cocteau directed his first short movie in 1930, about the mythical ancient Greek poet Orpheus, but it was not until 1946, at the age of 57, that he made his first full-length movie, *La Belle et la Bête*. Four years later, he made a second movie about Orpheus, *Orphée*. He combined movies, poetry, and theater until his death, in 1963.

Key movies

1930 *The Blood of a Poet*
1946 *La Belle et la Bête*
1950 *Orphée*
1962 *The Testament of Orpheus*

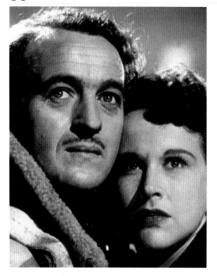

THIS IS THE UNIVERSE. BIG, ISN'T IT?

A MATTER OF LIFE AND DEATH / 1946

IN CONTEXT

GENRE
Wartime fantasy

DIRECTORS
**Michel Powell,
Emeric Pressburger**

WRITERS
**Michel Powell,
Emeric Pressburger**

STARS
**David Niven, Kim Hunter,
Roger Livesey, Raymond
Massey, Marius Goring,
Katherine Byron**

BEFORE
1943 Powell and Pressburger's
*The Life and Death of Colonel
Blimp* is based on a British
comic-strip character.

AFTER
1947 *Black Narcissus* is a
psychological drama set in
a convent in the Himalayas.

1960 Powell's dark thriller
Peeping Tom is savaged
by the critics. His career
never recovers.

A *Matter of Life and Death* is the story of a young British bomber pilot, Peter Carter (David Niven), whose aircraft is damaged over the English Channel, leading him into an epic fight to live.

In the memorable opening sequence, the camera tracks across stars and distant galaxies. "This is the universe," a narrator informs us amid the twinkling. "Big, isn't it?" Eventually, we home in on a view of Europe from space, then zoom into the interior of the bomber. The camera pans to reveal Peter sending a final radio message before he must jump without a parachute. He jumps… and to his and our surprise, wakes on a deserted beach.

Peter fights for his life after surviving the crash. The movie plays with the possibility that heaven is a product of Peter's delirious mind.

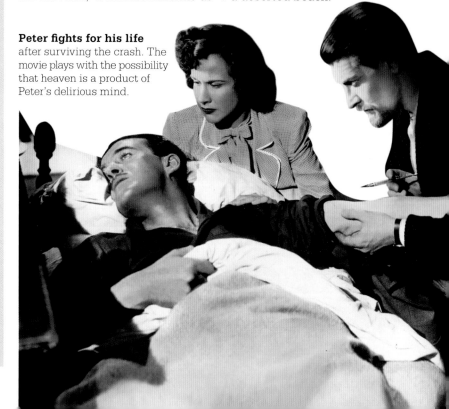

What else to watch: *Between Two Worlds* (1944) ▪ *It's a Wonderful Life* (1946, pp.88–93) ▪ *Black Narcissus* (1947) ▪ *Heaven Can Wait* (1978)

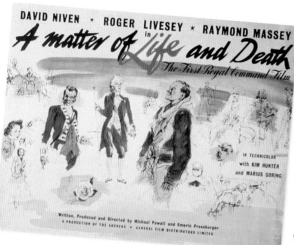

It was released in the US as *Stairway to Heaven*, a reference to the escalator linking Earth to the afterlife.

amphitheaters and shiny spaces. It is, in fact, all quite soulless. But on Earth, life goes on in Technicolor.

Wartime message

Originally developed during World War II, the British Ministry of Information encouraged Powell and Pressburger to use the movie to promote Anglo-American relations, frayed by the presence of US servicemen in the UK. As such, the heavenly legal battle is less about the merits of Peter's case than easing transatlantic tensions. When the American prosecutor questions whether an Englishman and a Boston girl could really ever be happy together, the answer may not surprise you—but it's still a wonderfully human note in a deceptively strange movie, brimming with imagination. ▪

The angelic guide Conductor 71 (Marius Goring), sent to bring him to Heaven, has missed him, and he has survived by mistake. After meeting and falling in love with the American radio operator June (Kim Hunter) he was speaking to just before jumping, Peter appeals to the celestial authorities against the attempt to elevate him to "the Other World." The rest of the movie shows Peter negotiating his appeal before a heavenly court.

Special effects

The transitions between Heaven and Earth inspire a host of dizzyingly inventive special effects. A ping-pong match is frozen mid-action. A spilled table of books rights itself. Can any of this be real, or is Peter imagining it all? In a reversal of expectations, heaven is portrayed not as a colorful paradise, but in subtle silvery monochrome— streamlined and modernist, with bright

Michael Powell and Emeric Pressburger
Directors

Michael Powell (above, right) was born in Kent, UK, in 1905. Emeric Pressburger (left) was born in Hungary in 1902. Pressburger worked in Germany as a screenwriter before fleeing the Nazis in 1935 and moving to Britain, where he began a productive collaboration with Powell. Their production company, The Archers, made 24 movies, sealing their reputations with classics such as *The Life and Death of Colonel Blimp*, *Black Narcissus*, and *The Red Shoes*. Their last movie was the wartime story *Ill Met by Moonlight* (1957). In 1960, Powell made the psychological thriller *Peeping Tom*. Now considered a masterpiece, it was vilified on its release and all but ended Powell's career. He made one more movie, *Age of Consent* (1969), and died in 1990. Pressburger had died two years earlier.

Key movies

1943 *The Life and Death of Colonel Blimp*
1947 *Black Narcissus*
1948 *The Red Shoes*

Life, empowered by love, triumphs over everything, Powell seems to conclude.
J. G. Ballard
The Guardian, 2005

GEORGE, REMEMBER NO MAN IS A FAILURE WHO HAS FRIENDS

IT'S A WONDERFUL LIFE / 1946

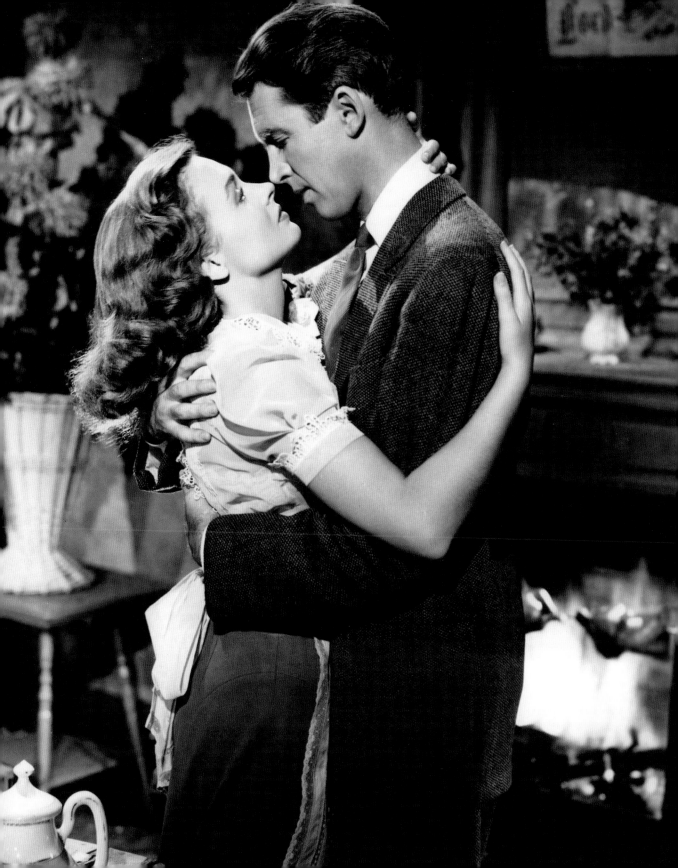

IN CONTEXT

GENRE
Fantasy drama

DIRECTOR
Frank Capra

WRITERS
Frances Goodrich, Albert Hackett, Frank Capra

STARS
James Stewart, Donna Reed, Lionel Barrymore

BEFORE
1934 Frank Capra has his first major hit with the screwball comedy *It Happened One Night.*

1939 In Capra's *Mr. Smith Goes to Washington*, James Stewart plays a naive but honest man who takes a place in the US Senate.

AFTER
1950 In Henry Koster's *Harvey*, Stewart has a big hit playing a likeable man who speaks to an invisible human-sized rabbit.

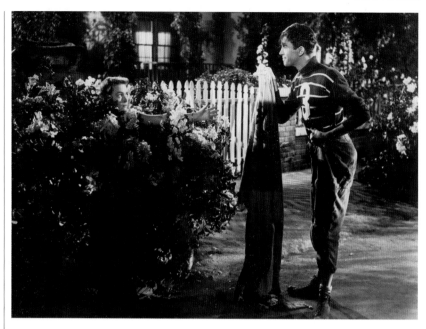

Ironically, the release of Frank Capra's most enduring motion picture was one of his greatest disappointments. Despite being amply praised by his peers, who appreciated the movie's craft, and winning five Oscar nominations plus a Golden Globe for its director, the movie flopped at the box office. Through the years, however, popular perceptions of the movie changed, and over the course of his life Capra saw it become one of the

George Bailey (James Stewart) woos Mary (Donna Reed), just before tragedy strikes: George's father dies. He has to take over the family business, and never leaves Bedford Falls.

best-loved movies of all time. Today, *It's a Wonderful Life* has become a festive favorite that seems to embody the Christmas spirit.

In the 1930s, Capra had been the voice of Hollywood. He refined the screwball comedy genre with

Minute by minute

00:04
George saves his brother Harry from drowning in an icy lake. In the process, George suffers an ear infection that leaves him partially deaf, and will later keep him out of the war.

00:51
George marries his sweetheart, Mary. They are about to go on honeymoon, when there is a run on the bank. George stays, and saves the bank with his own money.

01:20
At the end of the war, with Harry due to return home, Uncle Billy accidentally gives Potter $8,000 on the day the bank examiner is visiting. Potter keeps the money to ruin George.

01:44
Clarence shows George what the world would have been like if George had never existed. This leads George to beg to be allowed to live again.

```
00:00    00:20        00:40        01:00        01:20        01:40        02:00    02:10
```

00:25
After his father dies, George gives up his travel plans to manage the family's Bailey Building and Loan, the only way he can stop Mr. Potter, a slum landlord, taking over the business.

01:10
Potter offers George a $20,000-a-year job. George turns it down and returns home to hear from Mary that she is pregnant.

01:36
In a bar, George implores God to help; then he drives to the bridge, where he intends to end his life. Clarence, his angel, saves him by jumping into the water first so that George can rescue him.

02:02
George runs home, where he discovers that the townspeople have made a collection to save him. Harry returns as they all sing Auld Lang Syne.

What else to watch: *It Happened One Night* (1934) ▪ *You Can't Take It With You* (1938) ▪ *Mr. Smith Goes to Washington* (1939) ▪ *The Philadelphia Story* (1940) ▪ *Harvey* (1950) ▪ *Vertigo* (1958, pp.140–45)

the peerless *It Happened One Night* (1934), starring Clark Gable and Claudette Colbert, but he became best known for feel-good movies in which the common man triumphs over cynical corporations or corrupt politicians—themes that resonated strongly with audiences during the Great Depression.

A new mood

Had it been made 10 years earlier, *It's a Wonderful Life* might have been another hit for Capra, but in 1946 he was out of step with the prevailing mood in the US. World War II had robbed the nation's young of any sense of innocence, and audiences no longer had an appetite for pure escapism. Film noir was on the rise, in which morally ambiguous detectives were little better than the criminals they chased.

Yet to the modern eye, *It's a Wonderful Life* seems surprisingly dark, an attempted suicide being the central premise for a story in which a man discovers the true worth of his own life.

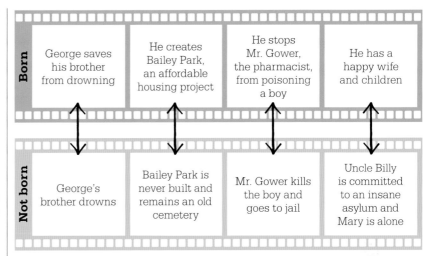

Born
- George saves his brother from drowning
- He creates Bailey Park, an affordable housing project
- He stops Mr. Gower, the pharmacist, from poisoning a boy
- He has a happy wife and children

Not born
- George's brother drowns
- Bailey Park is never built and remains an old cemetery
- Mr. Gower kills the boy and goes to jail
- Uncle Billy is committed to an insane asylum and Mary is alone

After George makes the wish that he had never been born, an angel, Clarence, shows him what would happen if he had never existed

Capra's masterstroke is to begin with a series of whispered prayers for help, heard by heavenly beings who decide to intervene in the life of one George Bailey (James Stewart). They send an angel, but the only one available is Clarence Odbody (Henry Travers) who, at the tender age of 200, has yet to earn his wings. As Clarence studies George's life in flashback, from boyhood to adulthood, Capra paints a portrait of a loyal townsman who has sacrificed his dreams of travel and career in order to follow in his father's footsteps, helping the local community and working at a small bank in Bedford Falls, New York. »

James Stewart Actor

James Stewart was born in 1908 in Indiana, PA. After a brief stint on Broadway, he followed his old roommate Henry Fonda to Hollywood. His movie career took off in 1938 when Frank Capra cast him in the comedy *You Can't Take It With You*. The following year, the pair made *Mr. Smith Goes to Washington*, which earned Stewart an Oscar nomination. He took time off to join the war effort, but his popularity did not fade, and his first postwar movie, *It's A Wonderful Life*, brought a third Oscar nomination. The movie epitomized Stewart's quiet, folksy charm, which was again brought to the fore in the 1950 hit *Harvey*. He also made a number of Westerns, and collaborated with Alfred Hitchcock. He died in 1997.

Key movies

1938 *You Can't Take It With You*
1939 *Mr. Smith Goes to Washington*
1946 *It's a Wonderful Life*
1958 *Vertigo*

I made mistakes in drama. I thought drama was when actors cried. But drama is when the audience cries.
Frank Capra

In the process, George protects the community from the greedy bank director and slum landlord, Henry F. Potter (Lionel Barrymore).

Shocking decline

George's rapid transition from saint to suicidal drunk is shocking and credible, perhaps rooted in Capra's own struggle with depression in his early twenties, when, as an Italian immigrant, he found work difficult to come by. Years of self-sacrifice and disappointment lie behind George's breakdown, and as a portrait of despair his downward spiral is utterly compelling.

George and Uncle Billy (Thomas Mitchell, second from right) celebrate at the close of business on the day of the bank run. With $2 left, they are still in business.

While contemporary audiences may have been put off by the story's divine intervention, Capra's movie wasn't so much about magic realism as tragic realism: the angel doesn't appear at the bridge until the movie's final quarter. Another director might have focused more on the drama that makes George want to end his life, but Capra keeps it from us, not so that it becomes a mystery but because, when we do find out, it adds to the pathos of a man trying to do right.

On the brink

Potter is the villain of the piece. When George realizes that his uncle Billy has mislaid $8,000 of the townspeople's money, he goes to Potter—his lifelong enemy—to negotiate a loan. George has nothing but a life insurance policy to offer as collateral, and Potter sneers at him: "You're worth more dead than alive." Within this loaded insult lies one of the movie's main tenets: just as one life can make all the difference, so can its absence.

In despair, George drives to the toll bridge to jump to his death. The movie's most famous moment doesn't occupy much of its running time but it sticks in the memory for its darkness. Wishing aloud that he'd "never been born," George is taken by Clarence to a parallel reality, one in which George never existed, and where

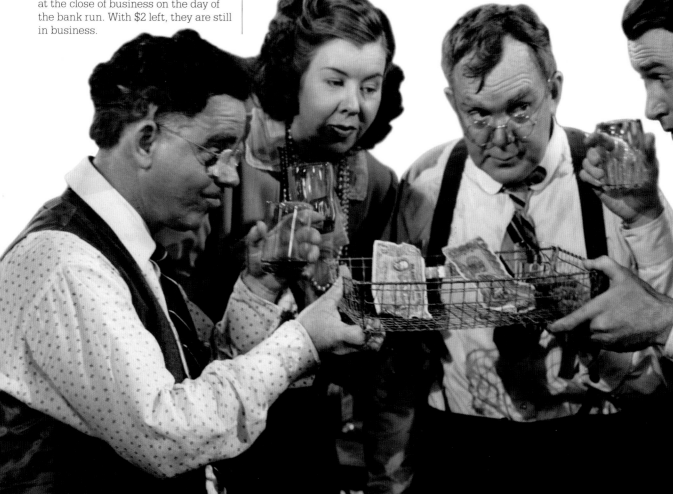

The movie opened in 1946 and was a box-office flop. Postwar America was in the mood for morally ambiguous noir, not feel-good small-town sentimentality.

Bedford Falls (now Pottersville) looks very different. "Each man's life touches so many other lives," says Clarence, and this ultimately is the movie's message.

Perceived as an optimistic movie, perhaps it can also be seen as one that shows the world as a glass half empty rather than half full. For Capra, George is one man who makes all the difference in people's lives; he is not the Everyman that we all are or could be. In that sense, the movie may be a warning that we are not all in it together: some people, happily for those around them, are simply less selfish than others.

Accidental classic

The movie's later popularity involves another twist. Due to a legal error, it fell out of copyright in 1974, enabling it to be shown on TV with no repeat fees. The oversight has since been corrected by the studio, something George might have had a few things to say about. ∎

It is a story of being trapped, of compromising, of watching others move ahead and away, of becoming so filled with rage that you verbally abuse your children, their teacher and your oppressively perfect wife.
Wendell Jamieson
The New York Times, 2008

Frank Capra Director

At the height of his career, Frank Capra was the biggest director in Hollywood, leading the escapist assault on the Depression years with a slew of Oscar-winning comedies. Having moved to Los Angeles from Sicily at the age of five in 1903, he studied chemical engineering but struggled to find work. After bluffing his way into a movie studio in San Francisco, he landed work in Hollywood, directing silent one-reelers with comedy mogul Hal Roach. Effortlessly moving into the sound age thanks to his engineering skills, Capra came into his own in the 1930s. After making propaganda movies in World War II, he saw his star begin to wane; his best-known movie, *It's A Wonderful Life*, was not a commercial hit. Increasingly disillusioned with Hollywood, he started making educational movies on science in the 1950s. He died in 1991.

Key movies

1934 *It Happened One Night*
1938 *You Can't Take It With You*
1939 *Mr. Smith Goes to Washington*
1946 *It's a Wonderful Life*

I MIND MY OWN BUSINESS, I BOTHER NOBODY, AND WHAT DO I GET? TROUBLE
THE BICYCLE THIEF / 1948

Vittorio De Sica's *The Bicycle Thief* (*Ladri di biciclette*) was made using untrained actors and shot on location on the dusty streets of Rome. It has almost no plot, beyond that of the fruitless search by an ordinary man and his son for a stolen bicycle. The movie's style contrasts sharply with the glossy Hollywood movies of the day, with their sophisticated scripts, lavish sets, and slick acting. Yet the movie packs such an emotional

While Hollywood may sometimes deal with these facts by analogy, the Italians deal with the facts, period.
Arthur Miller
The New York Times, 1950

punch and grips so powerfully from first to last that it is regarded as one of the most important movies of the post-World War II era. It influenced generations of young filmmakers, who see capturing real life, rather than producing a neatly turned plot, as the object of their work.

Cycle of hope
Adapted for the screen by Cesare Zavattini from a novel by Luigi Bartolini, the movie focuses on hard-up father Antonio (Lamberto Maggiorani), who finds a job after a long period without work. To do the job, he needs a bicycle, and must redeem his old bicycle from the pawn shop, Antonio's wife (Lianella Carell) must pawn the family's only sheets. Despite this, husband and wife are overjoyed at the prospect of him earning at last. But while Antonio is up a ladder on his first day at work, sticking posters up around Rome, the bicycle is stolen by a young thief.

Taking his young son Bruno (Enzo Staiola) with him, Antonio embarks on a desperate hunt to recover his bicycle. With the aid

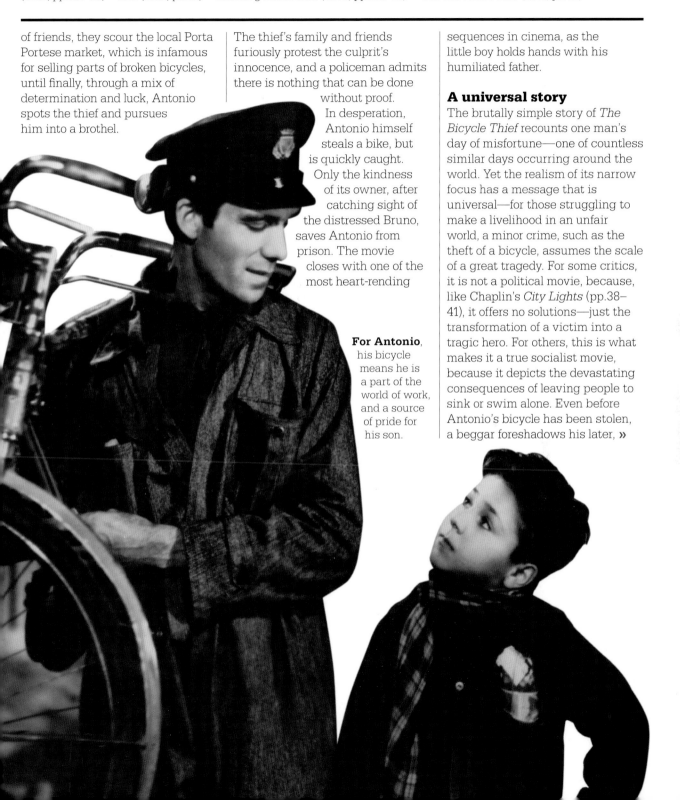

of friends, they scour the local Porta Portese market, which is infamous for selling parts of broken bicycles, until finally, through a mix of determination and luck, Antonio spots the thief and pursues him into a brothel.

The thief's family and friends furiously protest the culprit's innocence, and a policeman admits there is nothing that can be done without proof.

In desperation, Antonio himself steals a bike, but is quickly caught. Only the kindness of its owner, after catching sight of the distressed Bruno, saves Antonio from prison. The movie closes with one of the most heart-rending

For Antonio, his bicycle means he is a part of the world of work, and a source of pride for his son.

sequences in cinema, as the little boy holds hands with his humiliated father.

A universal story

The brutally simple story of *The Bicycle Thief* recounts one man's day of misfortune—one of countless similar days occurring around the world. Yet the realism of its narrow focus has a message that is universal—for those struggling to make a livelihood in an unfair world, a minor crime, such as the theft of a bicycle, assumes the scale of a great tragedy. For some critics, it is not a political movie, because, like Chaplin's *City Lights* (pp.38–41), it offers no solutions—just the transformation of a victim into a tragic hero. For others, this is what makes it a true socialist movie, because it depicts the devastating consequences of leaving people to sink or swim alone. Even before Antonio's bicycle has been stolen, a beggar foreshadows his later, »

troubled, situation: "I mind my own business, I bother nobody," he says, "and what do I get? Trouble."

Toward realism

The Bicycle Thief is often considered the high point of Italian neorealism. In cinema, the neorealist movement was a reaction against the so-called white telephone Italian movies of the 1930s, which depicted the frivolous lives of the rich, characterized by

Bruno watches his father anxiously as he sits, despondent, on the roadside, all hopes of a new life shattered.

> ❝**You live** and **you suffer**. To hell with it. **You want a pizza?**❞
>
> **Antonio Ricci** / *The Bicycle Thief*

the white telephones seen in their gilded homes—movies such as *I Will Love You Always* (*T'amerò sempre*, 1933), that, while not overt tools of propaganda, portrayed an image of prosperity that implicitly endorsed Italy's Fascist regime.

It was not only in Italy that filmmakers tried to break from the milieu of high society. Chaplin

attempted it in *Modern Times* (1936) in Hollywood. But Italian neorealists went further. They did not simply focus on the poor; they also wanted to make movies in a new way that would show the reality of people's lives as they were lived.

Neorealism took the director's camera away from the set and out onto location. The goal was to

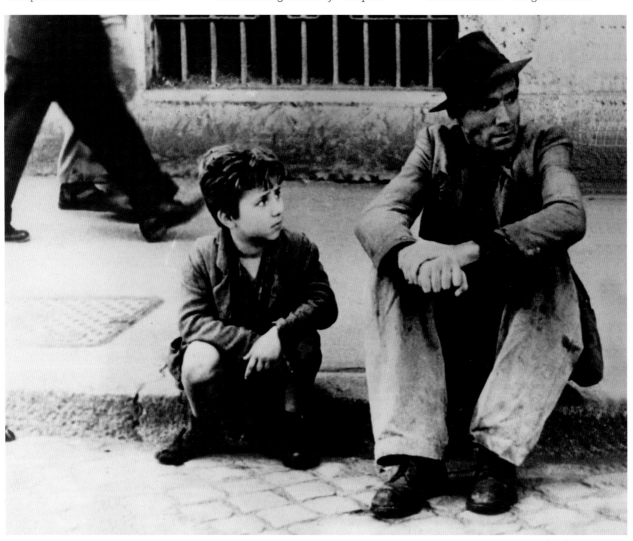

capture real life, and part of the brilliance of *The Bicycle Thief*' cinematography in particular is the sense it gives of a world that is continuing beyond the frame—by briefly following incidents away from the main characters, or including real life going on in the background of a frame. To strip away the artificiality of studio movies, neorealist directors often cast untrained actors, as Vittorio De Sica did in *The Bicycle Thief*. Enzo Staiola, the boy who plays Bruno with such tough and emotional directness, was spotted by the director in the crowd watching him film while on location.

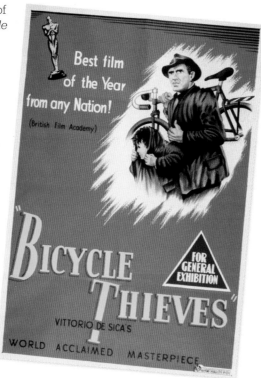

Lasting influence

Italian neorealism had already been championed by directors such as Luchino Visconti, with his 1943 masterpiece *Ossessione* (p.78). Yet what gives De Sica's movie in particular its lasting power is the magnificence of its filmmaking. The sweep, design, and movement

This is poverty's authentic sting: banal and horrible loss of dignity.
Peter Bradshaw
The Guardian, 2008

On its release in Italy, the movie met with some hostility for its negative portrayal of the country. However, it received great reviews around the rest of the world.

of its black-and-white photography as it follows Antonio and Bruno on their quest give an epic quality that engrosses the viewer in their lives. Directors such as Ken Loach and Satyajit Ray have cited De Sica's movie as the most important influence on their careers. Such was its impact on its release that it was hard for innovative filmmakers not to think in terms of real streets, snatches of life, and ordinary people as the stuff of cinema. In the years that followed, movements such as the *Nouvelle Vague* (New Wave) in France and the "kitchen sink" dramas of the UK marked a shift in filmmaking toward this more naturalistic and candid approach. ∎

Vittorio De Sica
Director

Born in 1901 to a poor family, Vittorio De Sica grew up in Naples, Italy, working as an office boy to support his family. He got his first movie part at just 17. His good looks and natural screen presence soon turned him into a matinee idol. When he met writer Cesare Zavattini, De Sica became a serious director and a leading exponent of Italian neorealist movie. With Zavattini, he made *Shoeshine* (1946) and *The Bicycle Thief*, both heartbreaking studies of postwar poverty in Italy that won special Oscars in years before the foreign movie category was established. After the box-office disaster of relentlessly bleak *Umberto D.* (1952), De Sica returned to lighter movies, such as a trilogy of romantic comedies *Yesterday, Today, and Tomorrow* (1963), and to acting. He died in 1974.

Key movies

1948 *The Bicycle Thief*
1952 *Umberto D.*
1963 *Yesterday, Today, and Tomorrow*

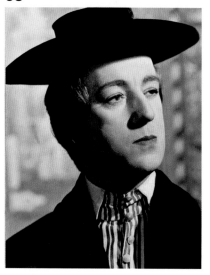

IT IS SO DIFFICULT TO MAKE A NEAT JOB OF KILLING PEOPLE WITH WHOM ONE IS NOT ON FRIENDLY TERMS
KIND HEARTS AND CORONETS / 1949

IN CONTEXT

GENRE
Ealing comedy

DIRECTOR
Robert Hamer

WRITERS
**Robert Hamer
with John Dighton**

STARS
**Alec Guinness, Dennis
Price, Joan Greenwood,
Valerie Hobson**

BEFORE
1942 *Went the Day Well?* is
one of the first successful
movies made at Ealing Studios.

1947 *It Always Rains on a
Sunday* is the first of Robert
Hamer's three Ealing movies.

AFTER
1951 *The Lavender Hill Mob*
features Alec Guinness as a
mousy clerk who becomes
a criminal mastermind.

1957 *Barnacle Bill* is the last
of the Ealing comedies. Alec
Guinness plays multiple roles.

Kind Hearts and Coronets
is one of a series of British
comedies that came out
of the Ealing Studios in London
between 1947 and 1957. Starring
Alec Guinness as all eight members
of the D'Ascoyne family, each of
whom falls victim to a gentleman
murderer, the movie has the urbane
charm and light wit characteristic
of the Ealing style. The plot centers
on the rise of Louis Mazzini (Dennis
Price), who is determined to avenge
his mother for the shabby treatment
she received at the hands of the
D'Ascoyne family. One by one, he
plots to remove all family members
that stand between him and the
D'Ascoyne fortune and dukedom.
His murder spree begins with the
arrogant young Ascoyne D'Ascoyne,
and ends with Lord Ascoyne.

Comic killings
Guinness is the star of the movie, and
each of his absurd characters is so
sharply drawn that they are instantly
delineated, to great comic effect. But
Guinness is matched by the movie's
"straight man," Price. As Mazzini, he
is the epitome of manners, exhibiting
such courtesy and aplomb that the
audience feels a sense of glee as he
dispatches each D'Ascoyne in turn.

Alec Guinness Actor

Sir Alec Guinness was one of
the great British actors of the
last century, noted for his subtle
gentlemanly manner. Born in
1914 in London, he started life
as an advertising copywriter,
before taking up stage acting.
He became acclaimed for his
Shakespearean roles, and by
1950 was a celebrated actor of
the London stage. He began his
screen career with a series of
Ealing comedies before working
with director David Lean on
more serious movies, winning
an Oscar for his performance in
The Bridge on the River Kwai.
Playing Obi-Wan Kenobi in
the *Star Wars* movies made
him hugely famous in the
1980s. He died in 2000 at 86.

Key movies

1949 *Kind Hearts and Coronets*
1955 *The Ladykillers*
1957 *Bridge on the River Kwai*
1965 *Doctor Zhivago*

What else to watch: *It Always Rains on a Sunday* (1947) ▪ *Passport to Pimlico* (1949) ▪ *Whisky Galore!* (1949) ▪
The Man in a White Suit (1951) ▪ *The Titfield Thunderbolt* (1953) ▪ *The Ladykillers* (1955)

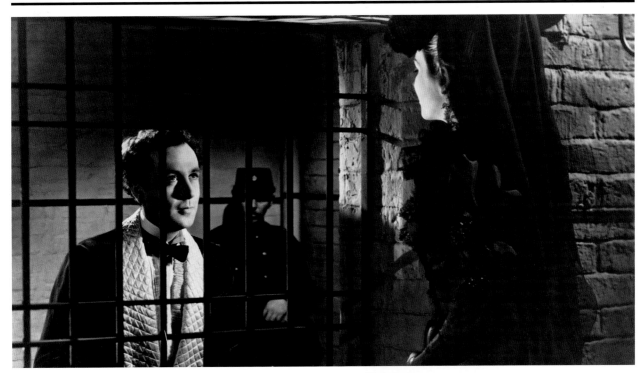

The charmingly selfish Sibella presents her marriage deal to Mazzini in his cell. Sibella is competing with Edith, the widow of one of Mazzini's victims, to marry him.

Here is director Robert Hamer's genius in having Guinness play all eight victims. Because the audience knows that when one Guinness character is bumped off, another will take his place, it never feels repelled by the murders, but rather remains in thrall to Price's charm and wills him on as he eliminates the obstacles to inheriting the title. A subplot shows Mazzini in a complex romantic relationship with his materialistic childhood sweetheart Sibella (Joan Greenwood), who made the mistake of turning down the lowly Mazzini to marry the rich but very dull Lionel, only to see Mazzini rise to become a duke and fabulously rich, while Lionel descends into bankruptcy and suicide. Mazzini, having got away with the D'Ascoyne murders, is convicted of murdering Lionel,

The movie's title is taken from a poem by Alfred, Lord Tennyson: "Kind hearts are more than coronets, and simple faith than Norman blood."

the one death of which he's innocent. His only hope of escaping the hangman comes when Sibella hints that she might "find" Lionel's suicide note if Mazzini promises to marry her. But even then, the movie has one more twist up its sleeve—a typically sardonic finale. Ealing movies were not always as sweetly innocent as their reputation suggests, and Hamer's movie was the perfect mix of the comic and the caustic. ▪

> ❝I shot an arrow in the air; **she fell to earth** in Berkeley Square.❞
>
> **Louis Mazzini** / Kind Hearts and Coronets

THE WORLD DOESN'T MAKE ANY HEROES OUTSIDE OF YOUR STORIES
THE THIRD MAN / 1949

Carol Reed's 1949 film noir *The Third Man* captured Europe's fractured spirit after World War II. Unusually for the time, Reed shot it in partly on location, in bomb-damaged Vienna. Dramatic pools of light and shade, and tilted camera angles, turn the city into a nightmarish setting for the tale of racketeer Harry Lime, played by Orson Welles. Echoing through it all is the haunting zither music of Anton Karas, whom Reed found while shooting in Vienna.

The movie was hugely popular in Britain, but fared poorly in Austria. To Austrian audiences, it was a painful reminder of a troubled past.

The screenplay was developed by novelist Graham Greene from his own novella. It came from a simple thought that occurred to Greene: "I saw a man walking down the street whose funeral I had only recently attended." This idea inspired the story of a man who fakes his own death.

The third man

American pulp-fiction author Holly Martins (Joseph Cotten) arrives in a Vienna wrecked and divided by war at the invitation of his old friend Harry Lime, only to find that Lime has been killed by a speeding car just days earlier. At the funeral, Martins meets the two men who were with Lime when he died. He also meets Lime's girlfriend Anna (Alida Valli), with whom he becomes smitten. Together they question the porter at Lime's apartment building, who tells them there was an unknown third man present at the fatal moment.

On Vienna's giant Ferris wheel, known as the Riesenrad, police chief Calloway (Trevor Howard) advises Martins to leave Vienna,

revealing that Lime was a black marketeer who sold adulterated penicillin. Martins visits Anna, who tells him that she might be deported to the Soviet sector of the city. As he leaves, he spots a figure in the shadows. It's Lime.

Martins meets Lime the next day at the Riesenrad, where Lime has invited Martins to join him. Martins, realizing how much his old friend has changed, agrees to help Calloway trap Lime, on the condition that Anna receive safe passage out of Vienna. When Anna refuses to accept the police chief's deal, Calloway takes Martins to a children's hospital to show him the devastation caused by Lime's adulterated penicillin—and »

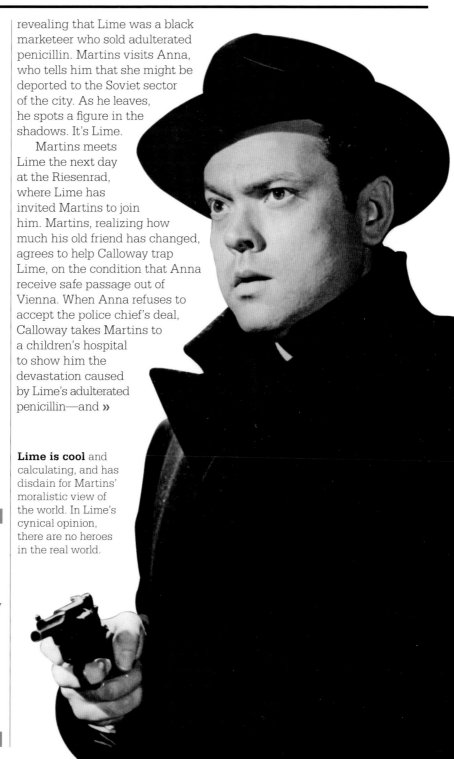

Lime is cool and calculating, and has disdain for Martins' moralistic view of the world. In Lime's cynical opinion, there are no heroes in the real world.

Has there ever been a film where the music more perfectly suited the action than in Carol Reed's *The Third Man*?
Roger Ebert
Chicago Sun-Times, **1996**

persuades Martins on moral grounds to help him trap Lime even if Anna is not saved.

Anna warns Lime of the trap, and he tries to escape through the sewers. The climax, a masterful symphony of action beneath the Viennese streets, is one of the most thrilling moments in cinema.

Casting Welles

That the movie turned out as it did is due largely to the determination of the director Carol Reed. Producer David O. Selznick had wanted suave British actor Noel Coward to play Harry Lime, but Reed insisted on Orson Welles. The influence of

Welles can be seen not just in his acting but in the dramatic film noir shooting style, which clearly owes a lot to Welles's own movies *Citizen Kane* (1941) and *The Lady from Shanghai* (1947).

For the final chase through the sewers of Vienna, scenes were shot partly on location and partly on studio sets. Reed brilliantly edited together the long, empty caverns of the sewers, with their glistening bricks and sudden shafts of light, and the echoing footsteps and close-ups of Lime's sweaty face glistening like the bricks, eyes darting this way and that as he searches for a way out.

As ever-growing teams of police chase Lime through the sewers, only the running water and the cops' echoing calls in German can be heard. The sense of panic rises as Lime flees like a rat.

Both Selznick and Greene had wanted an upbeat ending, but Reed insisted on keeping it bleak. Greene later admitted Reed had been right.

Clever use of shadows heightens the sense of menace in the dark streets of war-ravaged Vienna. The noir style is strongly reminiscent of Orson Welles's own movies, but Welles later insisted that he had taken no direct role in the movie's direction or editing.

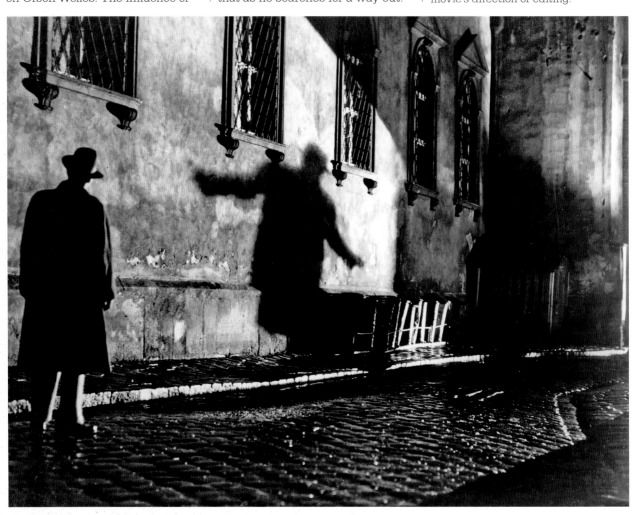

Moral vacuum

As part of the postwar Allied occupation of Austria, Vienna had been divided into four zones—US, British, French, and Soviet—with a jointly controlled central district. *The Third Man* exploits the political tensions that existed between the occupying forces, and the dramatic potential of characters' movements between the sectors. Those without papers, such as Anna, are desperate to avoid the Soviet sector, where their fate is uncertain.

As far as Lime is concerned, this situation has created the perfect moral vacuum, in which inventive, dynamic, ruthless men such as him can, and should, thrive. Europe is world-weary and cynical in the aftermath of the war, and for Lime, his fellow American, Martins, is a naive child stepping into it.

Improvised lines

Greene's script for *The Third Man* is as taut as you would expect from such a peerless writer, but some of the movie's most memorable lines were improvised by Welles. One reason for the movie's durability is that it successfully connects the talents of three hugely gifted men: Reed, Greene, and Welles.

Lime looks down from the wheel on the people like dots below, and asks Martins if he would feel pity if one of them "stopped moving forever". He challenges Martins: "If I offered you twenty thousand pounds for every dot that stopped,

Over it all spreads the melancholy, inert beauty of a ruined city, passive on the surface, twitching with uneasy life underneath.
Vogue, 1949

would you really, tell me to keep my money, or would you calculate how many dots you could afford to spare?"

Back on the ground, Lime says, in lines added in by Welles for timing: "You know what the fellow said—in Italy, for 30 years under the Borgias, they had warfare, terror, murder and bloodshed, but they produced Michelangelo, Leonardo da Vinci, and the Renaissance. In Switzerland, they had brotherly love, they had 500 years of democracy and peace, and what did that produce? The cuckoo clock." According to Welles, the words came from an old Hungarian play. Ironically, the Swiss did not invent the cuckoo clock at all, and they had been decidedly warlike at the time of the Borgias. Nonetheless, the words seem to sum up perfectly Lime's amoral outlook on the world. ∎

Carol Reed Director

Born in London in 1906, Carol Reed was the son of the famous Shakespearean actor-producer Herbert Beerbohm Tree and his mistress May Reed, whose name he took. He started acting at an early age, and joined the theater company of the thriller writer Edgar Wallace, becoming his personal assistant. This led to his first work as an assistant director.

Reed's early movies as a director, such as *Midshipman Easy* (1935), met with only moderate success, but the novelist Graham Greene saw great potential in them. Reed made his first significant movie, *Odd Man Out*, about an Irish terrorist on the run, in 1947. The producer, Alexander Korda, introduced Reed to Greene and they made two great movies together, *The Fallen Idol* and *The Third Man*, which was critically acclaimed and a huge box-office success. Reed died in London in 1976.

Key movies

1947 *Odd Man Out*
1948 *The Fallen Idol*
1949 *The Third Man*
1968 *Oliver!*

> ❝In **Switzerland**, they had **brotherly love**, they had **500 years of democracy** and **peace**, and what did that **produce**? The **cuckoo clock**.❞

Harry Lime / *The Third Man*

FEAR AN WONDER

1950–1959

Hollywood introduces **widescreen** cinema and gimmicks such as **3D** to counter the growing medium of television.

Billy Wilder directs *Sunset Boulevard*, a controversial satire on the Hollywood system; **Bette Davis** lands her sharpest role in *All About Eve*.

A Streetcar Named Desire, directed by Elia Kazan, catapults a young **Marlon Brando** to movie superstardom.

Fred Zinnemann's *From Here to Eternity*, based on James Jones's epic novel of military life, sweeps eight Academy Awards.

1950　　　　**1950**　　　　**1951**　　　　**1953**

1950　　　　**1951**　　　　**1952**　　　　**1953**

Akira Kurosawa's *Rashomon* tells a crime story from four **different viewpoints**, a template that would be imitated in many movies.

The Day the Earth Stood Still is the first of many **science-fiction** movies that reflect widespread fears about the **Cold War**.

US judges rule that movies are a form of **free speech**: Roberto Rossellini's *L'Amore* cannot be banned for "sacrilege."

With the success of the thriller *The Wages of Fear*, director **Henri-Georges Clouzot** is dubbed the "French Hitchcock."

This chapter covers the shortest time period of any in the book—the 10 years between 1950 and 1959. Yet in that one decade we find a swathe of extraordinary movies. Many, as before, are American movies produced in Hollywood (which, by this period, had enough of a history to inspire the Tinseltown satire *Sunset Boulevard*), but great cinema was also rising to prominence in other parts of the world.

In the years that followed World War I, it had been Germany that blazed the trail of cinematic innovation. Now, after World War II, it was the turn of Japan.

Rise of Japan

In 1950, Akira Kurosawa released *Rashomon*, a fractured, brilliant story of a murder in ancient Japan.

The movie's impact was sudden and immense: not only did it make Kurosawa's name as a director, but it sparked a growing curiosity in the West toward international cinema. Also from Japan came the finely drawn, deceptively simple dramas of Yasujirô Ozu. And of course, there was *Godzilla*, whose towering monstrousness was inspired by Japan's direct experience of nuclear war, still raw in the national memory.

Cold War dread

Many movies of the 1950s provided the most delirious form of popular entertainment (even today, it's impossible for anyone to watch *Singin' in the Rain* without a grin on their face), and yet some of the key movies of this period also reflected anxieties over the Cold War and are

imbued with an existential dread. In *The Wages of Fear* (1953), a movie about a group of desperate men driving truckloads of nitroglycerine through rough country, French director Henri-Georges Clouzot made what was probably the most tense movie since *Battleship Potemkin* (1925). It was also a bitingly satirical story of imperialism, capitalism, and human greed.

In several countries, directors were creating movies that offered at once entertainment, intellectual stimulation, and stunning displays of technique. Douglas Sirk, for example, made lush melodramas about suburban American life, such as *All That Heaven Allows* (1955). Long dismissed as kitsch, they are now recognized as sensitive, multilayered masterpieces. In France, meanwhile, a group of

Federico Fellini's
La Strada is released
(and later wins the first
Oscar for best foreign
film); **François
Truffaut** describes
his auteur theory.

1954

Satyajit Ray's
low-budget *Pather
Panchali*, a coming-
of-age story, is the first
Indian movie to win
international acclaim.

1955

Hollywood **drops
racial epithets** from
movies, and allows
some references to
drugs, abortion, and
prostitution.

1956

Alfred Hitchcock's
psychological thriller
Vertigo is released.
Hitchcock **is hailed**
by French critics **as
a true auteur**.

1958

1954

Toho studios in
Japan releases the first
of the *Godzilla* **monster
movies**. Kurosawa
redefines the Western
with *Seven Samurai*.

1956

The **science-fiction
classics** *Forbidden
Planet* and *Invasion
of the Body Snatchers*
are released.

1957

Ingmar Bergman
releases *The Seventh Seal*
and *Wild Strawberries*,
dealing with his
trademark themes
of life and death.

1959

Truffaut's debut movie,
The 400 Blows, marks
a high point in the
French New Wave,
dealing realistically
with modern society.

young film critics from the
magazine *Cahiers du Cinéma*
expounded a whole new way
of looking at movies. To them,
movies deserved respect and
intellectual scrutiny. Their studious
gaze examined not only "serious"
directors such as Ingmar Bergman,
but also the populist brilliance
of Alfred Hitchcock. The best
directors, they argued, filled their
work with personal obsessions and
visual signatures—what we saw on
screen was "authored" by a director
just as a novel is by its writer. This
was the auteur theory, and for
decades it would shape perceptions
of movies and their makers.

High ambition

Fittingly, this was the decade in
which Hitchcock made what is now
the most highly regarded of all his

> If it's a good movie, the
> sound could go off and
> the audience would still
> have a perfectly clear idea
> of what was going on.
> **Alfred Hitchcock**

movies. Some years before, he had
been eager to adapt a novel by
French crime writers Pierre Boileau
and Thomas Narcejac. On that
occasion he was beaten to it by

Henri-Georges Clouzot, with
whom he enjoyed a friendly rivalry,
and who turned the book into the
supremely creepy *Les Diaboliques*
(1955). Hitchcock made sure he
secured the movie rights to what
Boileau and Narcejac wrote next—
and the result was the intense
psychological thriller *Vertigo* (1958),
a tale of memory, lust, and loss that
now frequently tops the lists of the
greatest movies ever made.

In 1959, a movie was made by
one of those young French critics
responsible for the auteur theory.
His name was François Truffaut,
and the movie, a portrait of a rough
Parisian kid, was *The 400 Blows*.
Influenced by Orson Welles but
possessed of an energy all of its
own, it marked the end of an
extraordinary cinematic decade,
and the start of a new era. ∎

WE ALL WANT TO FORGET SOMETHING, SO WE TELL STORIES

RASHOMON / 1950

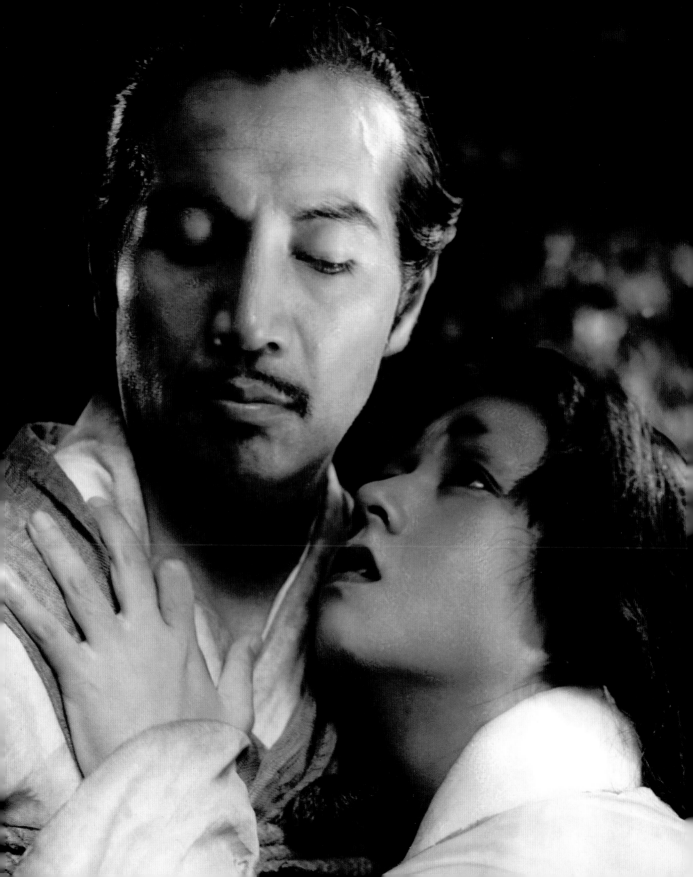

IN CONTEXT

GENRE
Mystery drama

DIRECTOR
Akira Kurosawa

WRITERS
**Akira Kurosawa
(screenplay); Ryunosuke
Akutagawa (short stories)**

STARS
**Toshirô Mifune, Machiko
Kyô, Masayuki Mori,
Takashi Shimura**

BEFORE
1943 Akira Kurosawa makes
his directorial debut with
Sanshiro Sugata, a historical
drama about the struggle
for supremacy between the
adherents of judo and jujitsu.

AFTER
1954 Kurosawa's *Seven
Samurai*, a 16th-century epic
in which a village enlists
seven warriors to protect
it from bandits, is widely
regarded as his masterpiece.

Akira Kurosawa's *Rashomon* is a thriller that revolves around two possible crimes that take place in a secluded glade: the rape of a woman (Machiko Kyô) and the violent death of the woman's samurai husband (Masayuki Mori). The truth, however, is hard to get at; it is tangled up in a knot of yarns spun by four eyewitnesses. Whom does the audience trust to tell them the truth? The alleged rape victim? The bandit accused of committing the offense? The ghost of the dead man? The woodcutter who found the body? Whose story is *the* story?

Beneath the gate

The opening shot of the movie is of the Rashomon city gate, a huge ruin in medieval Kyoto, seen from afar through a curtain of rain. Sheltering beneath the gate are a woodcutter (Takashi Shimura) and a priest (Minoru Chiaki), and they are soon joined by a commoner (Kichijirô Ueda). The newcomer strikes up a conversation, and

Human beings are unable to be honest with themselves about themselves. They cannot talk about themselves without embellishing. This script portrays such human beings.
Akira Kurosawa

is told about the crime and the subsequent arrest of the bandit Tajômaru (Toshirô Mifune).

As the woodcutter and the priest relate the tale, flashbacks show the bandit and the woman explaining what they saw at an inquest—or what they think they saw. Then a medium (Noriko

❝Dead men tell no lies.❞

The priest / Rashomon

Akira Kurosawa Director

Kurosawa was the first Japanese director to find popularity in the West. His movies *Rashomon*, *Seven Samurai*, and *Yojimbo* were remade as Westerns (*The Outrage* in 1964, *The Magnificent Seven* in 1960, and *A Fistful of Dollars* in 1964, respectively). Kurosawa ultimately found greater critical appreciation in Europe and the US than he did in his native country.

The son of an army officer, Kurosawa studied art before embarking on his career in cinema, which saw him develop a sensibility that was partially Westernized. He experimented with courtroom drama, crime thriller, film noir, and medical melodrama. He continued making movies until his death in 1998.

Key movies

1950 *Rashomon*
1954 *Seven Samurai*
1961 *Yojimbo*
1985 *Ran*

Honma) shows up and channels the spirit of the dead samurai, who gives his version of events. Finally, the woodcutter relates what he saw. Each of the stories is radically different, and in its own way entirely self-serving. The bandit asserts that he killed the samurai in a heroic battle; the woman claims not to recall the moment, but suggests that she stabbed her husband on seeing his expression after the rape; the samurai claims to have killed himself; and the woodcutter says that

he observed a fight between the bandit and the samurai, but that it was a messy scrap between two physical cowards.

On the surface, *Rashomon* is a whodunnit: it sets up a mystery, introduces the suspects, presents

The movie established Kurosawa as an internationally renowned filmmaker. It also made a star of Toshirô Mifune (the bandit), with whom Kurosawa would make 16 movies between 1948 and 1964.

Tajomaru describes the fight between himself and the samurai as a heroic struggle between two master swordsmen. The woodcutter saw it as a brawl between two terrified men.

the evidence, and asks the audience to draw its own conclusions. But there's a problem. Kurosawa is more interested in the elusive nature of truth than he is in capturing it— he refuses to provide the audience with a definitive account of what happened in the glade.

Shot in an unfussy, austere style, *Rashomon* relies on subtle symbolic imagery to communicate its ideas about memory and truth. The curtain of rain, tinted black by Kurosawa so that it would show up »

Four conflicting versions of events

The bandit's version
- He tricked the samurai and tied him to a tree
- He seduced the samurai's wife, after initial resistance
- The wife convinced him to fight a duel with the samurai; he defeated him honorably

The samurai's version
- The bandit raped his wife; she chose to go with the bandit
- The bandit gave him a choice: let his wife go, or kill her as punishment for her infidelity
- His wife fled, followed by the bandit; he killed himself

The wife's version
- The bandit raped her
- She begged her husband to kill her to save her honor
- She fainted, holding the dagger, and awoke to find her husband dead

The woodcutter's version
- The bandit begged the samurai's wife to marry him; instead she freed the samurai
- The wife encouraged the bandit and the samurai to duel
- They dueled pathetically, and the bandit won by luck

Forests have always had a primal association with the human imagination—as dark places located far from civilization. In the traditional folklores of many cultures, forests are the sites of magical, inexplicable encounters. The earliest known Japanese prose narrative, *The Tale of the Bamboo Cutter*, also known as *Princess Kaguya*, is a 10th-century fable in which a lonely and childless woodsman stumbles across a phantasmal infant in the depths of a forest.

Kurosawa's movie reaches back to such folklore with its rural setting, its archetypal characters, and its notion that what we see is shaped unconsciously by our deepest fears and desires. The movie even features an abandoned child at the end, whom the woodsman takes home with him as the rain stops.

Embellishing stories
Kurosawa has said that humans cannot help embellishing stories about themselves, and this is what

on camera, divides the present from the past, which is sun-dappled in flashbacks. The forbidding gate symbolizes the viewer's gateway to the world of the movie, a realm in which nothing is what it seems and no one can be trusted.

The glade is also symbolic. We first see it through the woodcutter's eyes as he traipses deep into the forest at the beginning of the first flashback. In this beautiful, wordless sequence, Kurosawa leads the viewer away from reality and into the febrile undergrowth of the subconscious; the forest clearing is an enchanted space in which the drama of the samurai's death will unfold again and again, each time in a different way.

> **❝Just think**. Which one of **these stories** do you **believe?❞**
>
> **The commoner** / *Rashomon*

Minute by minute

00:07
The woodcutter says that he was the first person to find the body of the samurai, and also the person who found Tajomaru.

00:17
At the inquest, Tajomaru tells his version of events, in which the wife begs him not to leave, and he cuts her husband loose so that they may fight for her honor.

00:51
The dead samurai tells his version through a medium. He says that his wife and Tajomaru ran off, and that he stabbed himself.

01:11
The woodcutter describes a desperate fight between the samurai and the bandit, in which both shake with fear.

00:00	00:15	00:30	00:45	01:00	01:15	01:28

00:12
The priest recounts how he saw the samurai before he died, leading a woman on a horse through the woods.

00:39
The wife tells her story. She says that she fainted, only to come round to find the dagger in her husband's chest. She then tried to drown herself.

01:03
At the gate, the woodcutter says that he saw everything. He says the husband did not want to fight, and wanted his wife to kill herself.

01:20
A baby is found crying at the gate. The woodcutter offers to take the baby home with him as the rain abates.

happens in *Rashomon*'s glade: four people witness a simple chain of events, but they interpret it through the filter of their own imaginations. Each of them transforms what they have seen into a story. These stories are not lies, however, but tricks of the mind—indeed, with *Rashomon*, Kurosawa suggests that there is no such thing as objective truth.

Since the movie's release in 1950, the primary storytelling device of *Rashomon* has been borrowed and imitated countless times, from the American remake in 1964, *The Outrage*, a Western starring Paul Newman, to the sleight-of-hand potboiler plots of *The Usual Suspects* (1995) and *Gone Girl* (2014). However, rarely do the imitators dare to withhold a satisfying solution, as Kurosawa does at the end of his masterpiece. We never find out who killed the samurai, nor what really happened between the woman and the bandit, but we do see the characters change as they sift through their own recollections.

The Rashomon effect

The "*Rashomon* effect" has entered language as shorthand for any situation, in art or life, in which the truth remains elusive because no one can agree on what happened. What is certain is that *Rashomon* was one of the most influential movies of the 20th century. It set box-office records for a subtitled movie and acted as a gateway through which Western moviegoers could look for the first time at the beguiling, unfamiliar world of Japanese cinema. And each of those moviegoers would have seen something different. ∎

In the wife's story, she offers her husband a knife to kill her after she sees a look of disgust on his face following the rape.

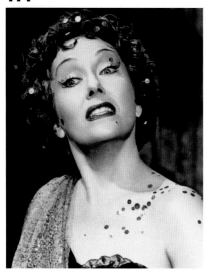

I AM BIG. IT'S THE PICTURES THAT GOT SMALL

SUNSET BOULEVARD / 1950

IN CONTEXT

GENRE
Drama

DIRECTOR
Billy Wilder

WRITERS
**Charles Brackett,
Billy Wilder**

STARS
**Gloria Swanson, William
Holden, Erich von
Stroheim, Nancy Olson**

BEFORE
1928 Gloria Swanson's silent
movie career peaks with
Sadie Thompson, a drama
set in the South Pacific.

1944 *Double Indemnity* is Billy
Wilder's classic film noir about
the double dealings at an LA
insurance company.

AFTER
1959 Wilder shows his
versatility with *Some Like It
Hot,* a comedy in which Tony
Curtis and Jack Lemmon dress
in drag to escape the mob.

A t one point in Billy Wilder's
Sunset Boulevard, faded
silent-movie star Norma
Desmond (Gloria Swanson) flashes
a look at the audience. "We didn't
need dialogue. We had faces!"
she says, as her eyes shine with
madness, sorrow, and fear. Norma's
cracked state of mind, and her fall
from sanity and fame, can all be
seen in that single close-up.

Sunset Boulevard is a blackly comic
elegy to Hollywood's silent age, and
the movie is filled with faces from
those glory days, including Buster
Keaton, looking time ravaged at a
card table, and legendary director
Cecil B. DeMille, both playing
themselves in wry, self-deprecating
cameos. Norma's servant Max is
played by Erich von Stroheim,
another famous director of the

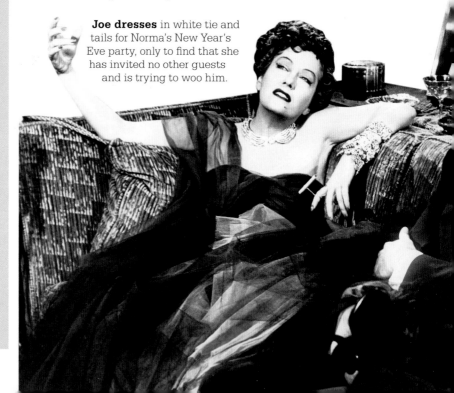

Joe dresses in white tie and
tails for Norma's New Year's
Eve party, only to find that she
has invited no other guests
and is trying to woo him.

What else to watch: *A Star is Born* (1937) ▪ *All About Eve* (1950, p.332) ▪ *Some Like It Hot* (1959, pp.148–49) ▪ *Whatever Happened to Baby Jane?* (1962)

Billy Wilder
Director

Wilder's movie marked an extraordinary screen comeback for Gloria Swanson. She effectively retired from movies afterward.

silent era. Swanson herself had been a huge star of the silent screen, so in taking on the role of the deranged Miss Desmond, she creates a grotesque parody of her celebrity self.

The movie tells the story of Joe Gillis (William Holden), a down-on-his-luck screenwriter who falls in

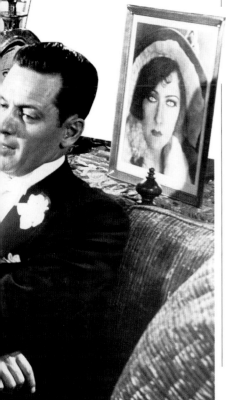

with the reclusive Norma when she asks him to write her comeback movie. The aging diva is convinced that her millions of fans are waiting, "out there in the dark," for her return to the silver screen. Joe reluctantly moves into the star's creepy mansion on Sunset Boulevard, and Norma falls in love with the young writer, who is drawn into her delusions. Joe eventually tries to escape Norma and salvage what little dignity he has left, but we know things end badly for him because his story is told in flashback; at the start of the movie he is a corpse floating in a swimming pool. "The poor dope. He always wanted a pool," is Joe's narration—a gallows-humor gag told from beyond the grave.

Silent tribute
Wilder's movies are celebrated for their cynical dialogue and one-liners—"You'll make a rope of words and strangle this business!" is one of Norma's most memorable lines—but there is also a suggestion of melancholia in *Sunset Boulevard*. Beneath his cynicism, Wilder's reverence for a vanished era is obvious. Ultimately, while there is a glittering monstrousness to the deluded Norma, she is also a tragic figure. Wilder suggests that she may have a point about the movies: that they lost some of their magic when their stars began to talk. ▪

"Nobody's perfect" is the final line of Billy Wilder's *Some Like It Hot*. All Wilder's movies are based on this simple truth—with characters whose flaws are fascinating, from Fred MacMurray's Walter Neff in *Double Indemnity* to Robert Stephens's detective in *The Private Life of Sherlock Holmes* (1970). As a filmmaker, Wilder himself was as close to perfect as it's possible to get.

Born in Austria in 1909, Samuel "Billy" Wilder fled the Nazis to make his directorial debut in Paris. In the 1930s he came to Hollywood, where he wrote movies with Charles Brackett. *Double Indemnity,* his collaboration with novelist Raymond Chandler, is often credited as the first film noir. His later movies were mostly comic, but retained the cynical bite—and eye for human weakness—of his earlier tragedies. He died in 2002.

Key movies

1944 *Double Indemnity*
1945 *The Lost Weekend*
1950 *Sunset Boulevard*
1955 *The Seven Year Itch*
1959 *Some Like It Hot*

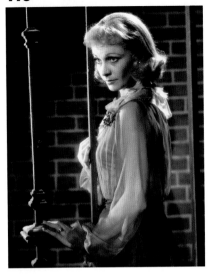

I HAVE ALWAYS RELIED ON THE KINDNESS OF STRANGERS

A STREETCAR NAMED DESIRE / 1951

IN CONTEXT

GENRE
Drama

DIRECTOR
Elia Kazan

WRITERS
Tennessee Williams, Oscar Saul (screenplay); Tennessee Williams (play)

STARS
Marlon Brando, Vivien Leigh, Kim Hunter, Karl Malden

BEFORE
1950 Tennessee Williams adapts his own play, *The Glass Menagerie*, for the screen. It is a thematic companion piece to *A Streetcar Named Desire*.

AFTER
1954 Elia Kazan is reunited with Marlon Brando to make *On the Waterfront*.

1958 Elizabeth Taylor and Paul Newman star in *Cat on a Hot Tin Roof*, another blistering adaptation of a Williams play.

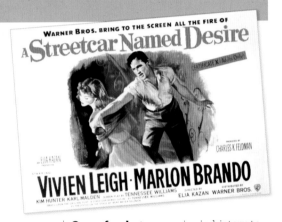

There isn't much kindness on display in *A Streetcar Named Desire*, which tells the story of Blanche Dubois (Vivien Leigh), a woman whose past catches up with her one stifling summer's evening in New Orleans. "Deliberate cruelty," she says, "is the one unforgivable thing."

When she comes to stay with her younger sister Stella (Kim Hunter), Blanche thinks she is running away from her former life as a scandal-hounded teacher. In reality, she is running toward a cataclysm of destruction and cruelty in the hulking shape of Stella's husband, Stanley Kowalski (Marlon Brando). Blanche has a horror of the naked truth, which she has a habit of disguising with illusions and wily fantasies: "I don't tell the truth. I tell what ought to be the truth!" The moment Blanche arrives at Stella's apartment, Stanley scents her fear, and a game of cat and mouse ensues. He is a predator who resents his sister-in-law's snooty put-downs, and the game ends with a violent sexual

One of only two movies in history to win three Academy Awards for acting, *A Streetcar Named Desire* made a household name out of its star, the now legendary Marlon Brando.

attack. This taut adaptation of Tennessee Williams's play sparked outrage when its director, Elia Kazan, first screened it for Warner Bros., and he was forced to cut five minutes from his movie before the studio's executives would release it.

Controversial themes

These small but crucial edits papered over the more sordid aspects of the story—Blanche's "nymphomania," her late husband's secret homosexuality, Stella's lust for Stanley, and the climactic rape—inadvertently mirroring the self-

What else to watch: *A Place in the Sun* (1951) ▪ *The Wild One* (1953) ▪ *Rebel Without a Cause* (1955, p.131) ▪ *The Rose Tattoo* (1955) ▪ *Baby Doll* (1956)

delusional madness of its central character. However, the movie was also criticized for its staginess, and it is true that Kazan refuses to open up the drama beyond the four peeling walls of Stella and Stanley's poky, run-down love nest. But it is the movie's claustrophobic atmosphere that becomes the source of its electricity—the actors prowl and pace the set like caged animals, straying into each other's territories and overstepping their marks.

This is especially true of Brando. A student of the "Method" approach to creating a character, he dedicated himself to unearthing the inner life of the brutish Stanley, and the results are truly volcanic. The performance made Brando into a star, but even he could not outshine Vivien Leigh's flickering, iridescent portrait of a woman haunted by her own desires. "Whoever you are," she says at the end of the movie, her Southern-belle accent fluttering delicately around the sad truth at the heart of her self, "I have always relied on the kindness of strangers." ▪

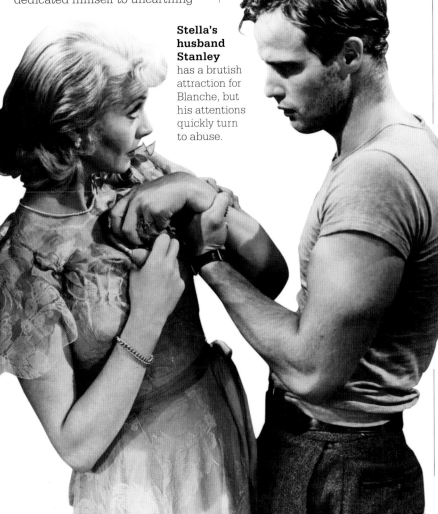

Stella's husband Stanley has a brutish attraction for Blanche, but his attentions quickly turn to abuse.

Elia Kazan
Director

Turkish-born US director Elia Kazan was one of the most famous practitioners of the "Method" technique developed by Lee Strasberg, which encouraged actors to draw on their personal experiences and to "become" the characters they played. In the 1930s, he joined New York's experimental Group Theatre and triumphed on Broadway, cofounding the Actors Studio in 1947. By the mid-1950s he was a major player in Hollywood.

In 1952, Kazan testified before the House Un-American Activities Committee. Having been a member of the American Communist Party, he informed on eight former colleagues who had been communists. He resumed his career but his focus changed from controversial movies to historical allegories, such as an adaptation of John Steinbeck's *East of Eden*.

Key movies

1951 *A Streetcar Named Desire*
1954 *On the Waterfront*
1955 *East of Eden*
1961 *Splendor in the Grass*

IT'S A HARD WORLD FOR LITTLE THINGS

THE NIGHT OF THE HUNTER / 1955

IN CONTEXT

GENRE
Thriller, horror

DIRECTOR
Charles Laughton

WRITERS
**James Agee (screenplay);
Davis Grubb (novel)**

STARS
**Robert Mitchum, Shelley
Winters, Lillian Gish**

BEFORE
1933 Charles Laughton wins
an Oscar for the lead role in
The Private Life of Henry VIII.

1947 Robert Mitchum makes
his name in film noir with
Build My Gallows High.

AFTER
1962 In *Cape Fear*, Mitchum
again plays an ex-con who
terrorizes a family, pitted
against lawyer Gregory Peck.

Upon its release, *The Night of the Hunter* was such a critical and commercial failure that actor-turned-director Charles Laughton never directed another movie. The movie was marketed as, and appeared to be, a film noir, an idea reinforced by the casting of genre mainstay Robert Mitchum in the lead role. Yet it has more in common with 1920s German Expressionist horror movies than it does with hard-boiled noir,

Charles finally had very little
respect for [screenwriter] Agee.
And he hated the script, but
he was inspired by his hatred.
Elsa Lanchester
Charles Laughton's wife

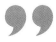

with its use of exaggerated framing shots and shadow to create an escalating mood of dread. Contemporary audiences were, perhaps, confused when their expectations were confounded, but over time the movie has established itself as a key work of American cinema, a modern-day fairy tale unafraid of reveling in its darkness, both literally and figuratively.

Wolf in sheep's clothing
This is the story of a psychopath in preacher's clothing, Harry Powell (Mitchum), a con man who seduces and murders women. The action is set in the Great Depression, which has driven desperate family man Ben Harper to attempt a bank robbery. Harper is caught and sentenced to death for murdering two people during the robbery.

Powell shares a cell with Harper while Harper awaits execution. He learns that the condemned man has hidden $10,000 with his family. On his release, Powell sets out to ingratiate himself with Harper's widow, Willa (Shelley Winters), and

What else to watch: *M* (1931, pp.46–47) ▪ *Build My Gallows High* (1947, p.332) ▪ *Angel Face* (1952) ▪ *Les Diaboliques* (1955) ▪ *Touch of Evil* (1958, p.333) ▪ *Cape Fear* (1962)

her two children. Willa is to be the next hapless victim of his creepy yet all too smooth preacher act.

Light and shadow

One of the most notable aspects of *The Night of the Hunter* is how powerfully it communicates significance in ways other than dialogue. For instance, encroaching threat is conveyed by the overtly styled framing of the children's hiding place in a barn, juxtaposed with Powell on the distant horizon, or by the way shadows overwhelm a bedroom, leaving what little light remains to create the effect of an altar as Powell murders Willa. The

Light and shade are used to frame key images. As Powell stands over Willa, knife in hand, her bedroom is converted by the shadows into a perverted church.

image of a corrupted altar in a church mirrors Powell's own status as a false prophet, an amoral man who uses the word of God to serve his own nefarious purposes.

The use of high-contrast black-and-white photography also helps to highlight the contrast between good and evil in the movie. »

> ❝She'll **not be back**. I reckon I'm safe in promising you that.❞
>
> **Harry Powell** / The Night of the Hunter

Menace and meaning are further conveyed through the use of song. Harry Powell appropriates a hymn "Leaning on the everlasting arms," which he sings to himself as he hunts the children, Pearl and John.

Powell uses his tattoos to tell a moralizing tale of love and hate, but Rachel Cooper can see right through him.

Its lyrics are about the peace and joy believers find in the arms of the Lord. In the small town that he infiltrates, Powell poses as a man of God whom the bereaved Willa can lean on as she copes with the loss of her husband, and whom the local community trusts with the care of the children after she

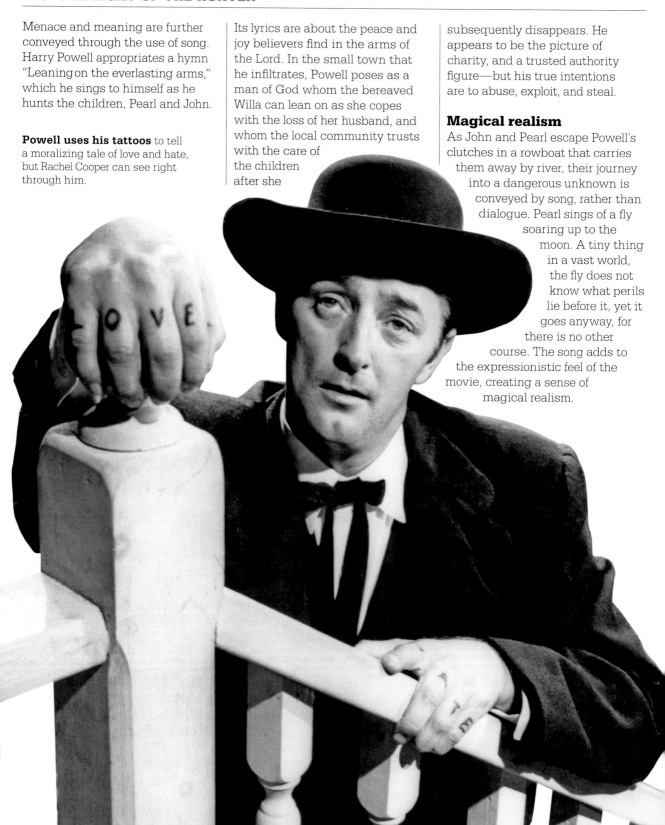

subsequently disappears. He appears to be the picture of charity, and a trusted authority figure—but his true intentions are to abuse, exploit, and steal.

Magical realism

As John and Pearl escape Powell's clutches in a rowboat that carries them away by river, their journey into a dangerous unknown is conveyed by song, rather than dialogue. Pearl sings of a fly soaring up to the moon. A tiny thing in a vast world, the fly does not know what perils lie before it, yet it goes anyway, for there is no other course. The song adds to the expressionistic feel of the movie, creating a sense of magical realism.

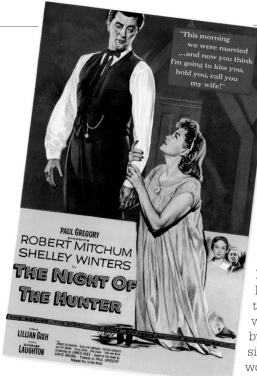

PAUL GREGORY presents
ROBERT MITCHUM
SHELLEY WINTERS in
THE NIGHT OF THE HUNTER

LILLIAN GISH

The widow Willa is won over by the phoney charm of the false preacher, who brings horror into her home.

down to the cellar by candlelight. These scenes terrify audiences because they tap into an innate fear: the violation of the home, the place where people should feel safe.

Fairy-tale ending

Eventually, the children are taken in by the kindly and wise Rachel Cooper (played by Hollywood veteran of the silent era Lillian Gish), an old woman who has adopted a number of children that have fallen victim to the Depression. Like a fairy godmother, Rachel protects Pearl and John—but Powell is not yet finished, and the children are not yet safe.

The Night of the Hunter is hard to categorize, which may explain why, on its release, it was met with incomprehension. It is experimental, with close stylistic ties to German Expressionism. Scene after scene hovers on the cusp between dream and nightmare, real and surreal. Above all, it is a terrifying but hopeful fairy tale—candid in its depiction of the evil Powell, but also insistent on the possibility that evil can be fought. It is a story of love and hate, the words tattooed on Powell's knuckles. These two elemental forces collide in one of the most magical movies ever made. ∎

Horror in the home

In the 1970s, movies such as *Halloween* and *The Exorcist* were praised for domesticating horror, bringing it out of the abandoned asylums and castles and into the home. Yet, 20 years earlier, *The Night of the Hunter* had already done this. Terror is built up during the movie as Powell ingratiates his way into John and Pearl's family, seducing their mother with his religious fervor. One by one, he violates the domestic norms that are supposed to make the children feel safe in his care. Rather than nurturing and feeding them as expected, he starves them in his attempt to make them confess where the money is hidden. The sense of menace becomes almost unbearable as he leads them

Charles Laughton
Director

Charles Laughton was born in 1899 in Scarborough, in the north of England. He trained at RADA, the London dramatic arts academy, which enabled him to get his first acting work on the London stage.

He made his Hollywood movie debut with the 1932 movie *The Old Dark House*, starring opposite Boris Karloff. His most iconic role came a year later, starring as the title character in *The Private Life of Henry VIII*, a performance that won him the Academy Award for best actor in 1933. Laughton went on to star in such movies as *Mutiny on the Bounty* (1935), *Jamaica Inn* (1939), and *Spartacus* (1960).

Laughton's only foray into directing was with *The Night of the Hunter*. Although it has gained critical mass over the years, the movie's initial box-office failure discouraged him, and he did not direct again. He died in California in 1962.

Key movie

1955 *The Night of the Hunter*

❝Salvation is a last-minute business, boy.❞

Harry Powell / The Night of the Hunter

WHAT'S THE FIRST THING AN ACTOR LEARNS? "THE SHOW MUST GO ON!"

SINGIN' IN THE RAIN / 1952

IN CONTEXT

GENRE
Musical, satire

DIRECTORS
Gene Kelly, Stanley Donen

WRITERS
**Betty Comden,
Adolph Green**

STARS
**Gene Kelly, Donald
O'Connor, Debbie Reynolds**

BEFORE
1927 *The Jazz Singer* is the
world's first feature-length
"talkie." It is mentioned in the
plot of *Singin' in the Rain*.

1945 For *Anchors Aweigh*,
Kelly was given free rein to
create his own dance routines.

AFTER
2011 *The Artist* revisits the
end of silent movies and the
birth of cinematic sound.

From *A Star Is Born* in 1937
to *The Artist* in 2011, the
movie industry has exhibited
a narcissistic obsession with itself.
Drawing on its own experiences of
studios stifling creativity, the
corrupting influence of fame and
money, and the compromises they
make for the sake of their careers,
many filmmakers have made satires
about the movies. *Singin' in the Rain*
approaches the movie industry
with more affection than others.
It sees Hollywood, despite its
decadence and eccentricities, as
a place where talent can thrive,
and it remains one of the finest
examples of why that optimism
is justified: a movie so brimming
with creativity and invention
that more than 60 years later, it
retains the capacity to inspire
and entertain.

End of an era

Singin' in the Rain is set in the
late 1920s, toward the end of
the silent-movie era, and it
deals with the need for a
studio and its silent star, Don
Lockwood (Gene Kelly), to

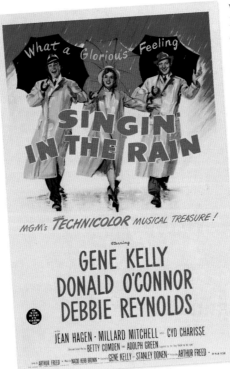

Singin' in the Rain is
considered one of the all-time
great musicals for its gentle
satirizing of Hollywood mores.

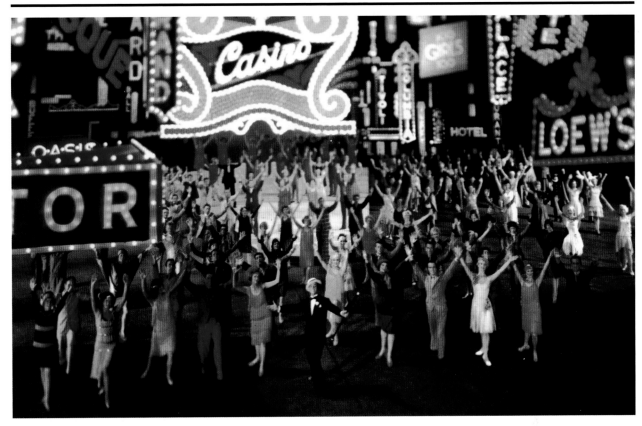

change with the times. Unless he can learn to work with synchronized sound, Don is destined, in his words, to become "a museum piece."

His position very much mirrors the status of the musical as a genre at the time that *Singin' in the Rain* was released: in 1952, it was a format whose heyday seemed to be passing. There is one memorable sequence when *The Dueling Cavalier*, a silent movie Don is making with his shallow co-star, Lina Lamont (Jean Hagen), is being reshot for sound. The cast and crew are out of their depth with the new technology; for example, even the talented Don asks for dialogue to be replaced with him repeating "I love you," unaware of how wooden that will sound in a "talkie." The scene addresses his fears of replacement, as his skills and methodology become redundant, and the

In one of Don's (Gene Kelly's) flashback career moments, we see him becoming a big Broadway star and performing *Gotta Dance*.

mistakes he makes on account of that anxiety, but it is also about the eclipsing of the musical by other genres of movie.

The arc of creativity

One of the key themes of *Singin' in the Rain* is the undignified and humiliating work that creative people are willing to do in order to get ahead in the industry. This is highlighted in three stories within the movie. In the first, Don reminisces to a journalist on the red carpet at a premiere. As he waxes lyrical about his dignified rise to stardom, the »

> ❝If we bring **a little joy** into your humdrum lives, **it makes us feel** as though **our hard work** ain't been in vain for nothin'.❞

Lina Lamont / *Singin' in the Rain*

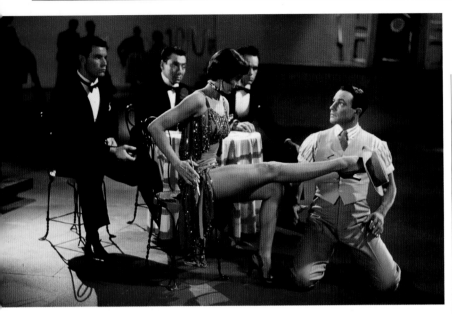

Cyd Charisse is Kelly's sensational dance partner in the "Broadway Melody" musical sequence.

movie star from the moment we meet him, yet he is not truly successful until the last scene, when he is in his element, having become a musical star instead of a silent actor, and is with the girl he loves, Kathy Selden (Debbie Reynolds), instead of the self-serving Lina. The movie takes an optimistic view, suggesting that the path to finding your creative self is long and difficult, but if you have the talent and conviction, as Don does, you'll eventually get to where you belong.

Singin' in the Rain stands out in the pantheon of musicals for a number of reasons. It takes a self-deprecating look at its own craft, and it features several iconic musical numbers (from the titular Singin' in the Rain to the comedic Make 'em Laugh), but above all it has endured because it speaks to a timeless fascination: the celebration and power of talent. While many movies portray the eventual corruption of talent and creative ambition, Singin' in the Rain salutes genuine talent as an irrepressible force that will always prevail. ∎

viewer is shown a montage that contradicts his words. He is seen working his way up from rock bottom as a musical performer, as he and his partner Cosmo Brown (Donald O'Connor) perform in dive bars, get booed off the stage, and stand in the unemployment line. The second story takes place within the extended fantasy sequence "Broadway Melody," in which Don arrives on Broadway as an eager

performer and is then corrupted by fame and adulation, before eventually rediscovering why he wanted to sing and dance in the first place. The final story is that of the movie itself, in which Don evolves from a silent star to his true vocation as a musical performer.

The movie uses these stories to examine just what it is that constitutes artistic success. It is not the same as simply making it, and getting rich—it is about the artist doing what he or she loves without compromise. Don is a

One of this movie's pleasures is that it's really about something. Of course it's about romance, as most musicals are, but it's also about the film industry in a period of dangerous transition.
Roger Ebert

Gene Kelly Actor

Gene Kelly was born in 1912 in Pittsburgh, PA, and became a dance teacher before making it to Broadway. His big break came in 1940 when he got the lead role in Rodgers and Hart's show, Pal Joey. Anchors Aweigh gave Kelly his first and last Oscar nomination for best actor, although An American in Paris, which Kelly starred in, won several Oscars, including Best Picture. Singin' in the Rain was a modest success upon release, but its popularity soon grew. Kelly died in 1996.

Key movies

1945 Anchors Aweigh
1946 Ziegfeld Follies
1951 An American in Paris
1952 Singin' in the Rain
1960 Inherit the Wind

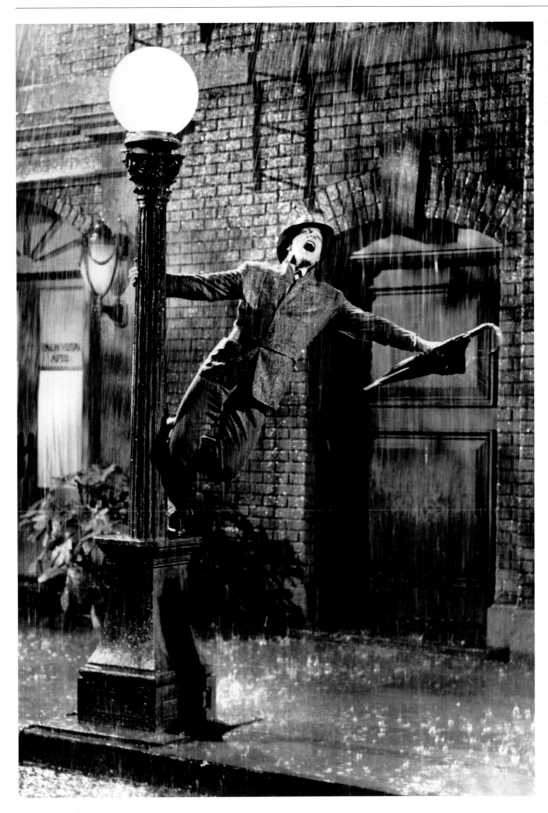

Don is finally in his element as a song-and-dance man, not a silent movie star, as he performs the movie's titular musical number.

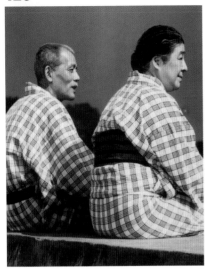

LET'S GO HOME

TOKYO STORY / 1953

IN CONTEXT

GENRE
Drama

DIRECTOR
Yasujirô Ozu

WRITERS
Kôgo Noda, Yasujirô Ozu

STARS
Chishû Ryû, Chieko Higashiyama, Sô Yamamura, Kuniko Miyaki

BEFORE
1949 The first great movie in Ozu's final period, *Late Spring*, is an example of *shomin-geki*, a story of ordinary people's lives in post-war Japan.

1951 Ozu continues his preoccupation with the state of the Japanese family with *Early Summer*.

AFTER
1959 In Ozu's *Floating Weeds*, a group of *kabuki* theater actors arrive in a seaside town, where the lead actor meets his son for the first time.

T okyo Story was made in the wake of the decades of militarism in Japan that culminated in catastrophic defeat in World War II. Ripples from the war can be detected in it, but unlike many Japanese movies of the postwar period, Yasujirô Ozu's movie remains even-keeled throughout. Its characters go about their lives without fuss, and it ends with a quiet tragedy that mirrors Japan's somber introspection at the time.

THE ACADEMY CINEMA CLUB
167 Oxford Street W1 · GER 8815
MEMBERS ONLY

One of the great classics of the Japanese cinema
YASUJIRO OZU'S
TOKYO STORY
"TOKYO MONOGATARI"

The movie depicts Japan at a moment of profound change, but its story of familial disintegration resonated with audiences worldwide.

As the title suggests, *Tokyo Story* is a simple tale. The movie is more a carefully curated collection of moments than a drama, and concerns relations within a family. Shukichi (Chishû Ryû) and Tomi (Chieko Higashiyama) have four

Yasujirô Ozu Director

Often described as the most Japanese of filmmakers, Yasujirô Ozu is also the most accessible of the great directors to emerge from that country in the postwar period. His unfussy style won him the reputation of a minimalist—but his movies are busy with the rich detail of human life and drama. Between 1927 and 1962, Ozu directed more than 50 features. All of them focused in some way on the changing rhythms of family life in the modern age. His "Noriko Trilogy," of which *Tokyo Story* was the last, all starred Setsuko Hara as Noriko.

Key movies

1949 *Late Spring*
1951 *Early Summer*
1953 *Tokyo Story*

What else to watch: *Brothers and Sisters of the Toda Family* (1941) ▪ *There Was a Father* (1942) ▪ *The Flavor of Green Tea Over Rice* (1952) ▪ *Tokyo Twilight* (1957) ▪ *Equinox Flower* (1958) ▪ *Good Morning* (1959) ▪ *The End of Summer* (1961)

The children return home for Tomi's funeral. Over the funeral dinner, the conversation turns into a discussion of the inheritance with almost indecent speed.

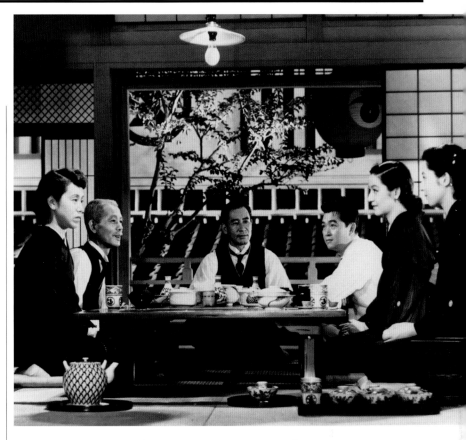

children: Kyoko (Kyoko Kagawa), an unmarried daughter who lives with them at home; Keizo (Shiro Osaka), their youngest son, who works in Osaka; Koichi (Sô Yamamura), a doctor living in Tokyo with a wife and two sons of his own; and Shige (Haruko Sugimura), also a Tokyoite, who runs a beauty salon. A fifth child, a son, died in World War II.

A journey

Shukichi and Tomi decide to pay a visit to their children in Tokyo and meet their grandchildren for the first time, and embark on a train trip to the hurly-burly of the city. They are unfailingly positive and polite, but viewers sense the pair's disappointment in the way their offspring have turned out. None of the children make time for their parents in their busy schedules. Indeed, it seems that Noriko (Setsuko Hara), the widow of their dead son, is the only person who cares about them. At one point, the parents are packed off by Koichi to a coastal spa, so that the room in which they are staying can be used for a business meeting.

Static observer

This funny-sad odyssey is observed in Ozu's trademark style: through a static camera positioned low down, at the eye level of a person seated on a *tatami* mat. Characters come and go, moving in and out of the frame, but Ozu sees everything, as though a silent and invisible observer planted in every scene. The camera's positioning is all about tradition, just as the story it records is about the mutation of family life and an ancient culture in the age of modernity.

"Let's go home," says Shukichi to his wife after a few days. "Yes," replies Tomi. In their words is an acceptance between them, an acknowledgment that their shared role as parents has become redundant. This sparse exchange is typical of the couple's interaction in that few words are spoken but much is said. It is also Ozu's way of telling stories on film: a small and fleeting moment that contains huge significance.

The couple is sitting on a sea wall in their spa gowns. As Tomi gets up, she has a dizzy spell. "It's because I didn't sleep well," she explains to her concerned husband. Shukichi's face tells us what he is thinking: she is going home to die, which she does a few days later. Now it is the turn of their children to make a journey for the family. ▪

> **❝This place is meant for the younger generation.❞**
>
> **Shukichi /** *Tokyo Story*

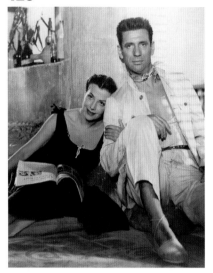

WHEN I WAS A KID, I USED TO SEE MEN GO OFF ON THESE KIND OF JOBS— AND NOT COME BACK

THE WAGES OF FEAR / 1953

IN CONTEXT

GENRE
Drama

DIRECTOR
Henri-Georges Clouzot

WRITERS
**Henri-Georges Clouzot,
Jérôme Géronimi
(screenplay); Georges
Arnaud (novel)**

STARS
**Yves Montand, Charles
Vanel, Peter van Eyck,
Folco Lulli**

BEFORE
1943 Clouzot's caustic drama
Le Corbeau tells the story
of a poison-pen writer who
signs his missives "The Raven."

1947 Clouzot's third movie,
Quai des Orfèvres, is a crime
drama set in postwar Paris.

AFTER
1955 In Clouzot's taut and
twist-filled *Les Diaboliques*,
two women take revenge on
a sadistic headmaster.

Henri-Georges Clouzot's *The Wages of Fear* is a juggernaut of suspense driven by greed and desperation. A contemporary and friendly rival of Alfred Hitchcock, Clouzot succeeds in gripping the viewer with a nerve-wracking story. Four men, Mario (Yves Montand), Jo (Charles Vanel), Luigi (Folco Lulli), and Bimba (Peter van Eyck), are desperate to escape life in a grim South American

Mario (Yves Montand) accidentally runs over Jo (Charles Vanel) in a pool of oil.

village. When they are hired by a ruthless US oil company, they think it's their ticket out. But they are told to drive trucks of nitroglycerine across a wilderness of potholes, crumbling ledges, and rickety bridges to put out an oil fire hundreds of miles away. Not everyone is expected to make it back alive.

The movie exhibits a low opinion of men's motives, and an even lower one of the aggressive capitalism that exploits them, but first and foremost it's a movie about terror: a white-knuckle adrenaline ride. From the treacherous road that threatens the trucks, to the fire-and-brimstone finale, each set piece is more gut-wrenchingly tense than the one before. ∎

What else to watch: *Le Corbeau* (1943) ▪ *Eyes Without a Face* (1960) ▪ *Henri-Georges Clouzot's Inferno* (1964) ▪ *Duel* (1971)

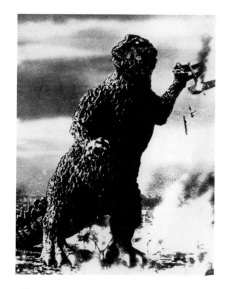

BUT IF WE DON'T USE YOUR DEVICE AGAINST GODZILLA, WHAT ARE WE GOING TO DO?
GODZILLA / 1954

IN CONTEXT

GENRE
Science fiction

DIRECTOR
Ishirô Honda

WRITERS
Takeo Murata, Ishirô Honda (screenplay); Shigeru Kayama (story)

STARS
Akira Takarada, Momoko Kôchi, Akihiko Hirata, Takashi Shimura

BEFORE
1949 Ishirô Honda works as assistant director on *Stray Dog*, a film noir directed by his friend Akira Kurosawa.

1953 In Honda's *Eagle of the Pacific*, special effects are created by Eiji Tsuburaya, who would go on to create Godzilla.

AFTER
1961 Atomic tests summon another monster in Honda's movie *Mothra*, about a giant moth terrorizing Tokyo.

odzilla (*Gojira* in Japanese) is a low-budget monster movie in which a giant lizard rises from the Pacific Ocean and attacks Tokyo. For all the clumsiness of its special effects, the monster of Ishiro Honda's movie resonated powerfully with its audiences in 1954.

The creature remains mostly in shadow as an indistinct threat, while the grainy, black-and-white imagery is chillingly reminiscent of newsreel footage from August 1945, when atom bombs were dropped on Japan in the final days of World War II. Japanese viewers were therefore no strangers to the concept of horrific

Honda saw Godzilla as means of absorbing the trauma of the atom bomb attacks into Japanese culture.

new threats and mass devastation. Honda is bold in his use of images ripped straight from his country's recent memory: huge, white-hot explosions that turn night into day; Tokyoites cowering in concrete bunkers as cityscapes crumble to rubble. The only hope of defeating Godzilla is a device called the "oxygen destroyer," another grim invention of human progress. Honda, a nature lover, saw his lizard-king as Earth's revenge for science's environmental recklessness.

Mega franchise
Godzilla spawned a franchise of monster proportions, with sequels stretching from 1955's *Godzilla Raids Again* to the US blockbuster of 2014, although the creature itself has become an icon of kitsch. ■

What else to watch: *King Kong* (1933, p.49) ▪ *The Beast from 20,000 Fathoms* (1953) ▪ *Godzilla vs. Hedorah* (1971) ▪ *Monsters* (2010) ▪ *Pacific Rim* (2013)

JUST WAIT UNTIL YOU SEE YOUR MOTHER. SHE'S NEVER LOOKED SO RADIANT

ALL THAT HEAVEN ALLOWS / 1955

IN CONTEXT

GENRE
Romantic drama

DIRECTOR
Douglas Sirk

WRITERS
Peg Fenwick (screenplay); Edna L. Lee, Harry Lee (story)

STARS
Jane Wyman, Rock Hudson, Agnes Moorehead, Conrad Nagel

BEFORE
1954 Sirk pairs Hudson with Wyman in *Magnificent Obsession*, a melodrama about a reckless playboy.

AFTER
1956 In *Written on the Wind*, Sirk directs another romance with Hudson as a working-class underdog.

1959 Sirk's *Imitation of Life* tackles gender and race with the tale of an actress hiring a widow to care for her daughter.

Douglas Sirk was a director skilled at balancing the conventional with the subversive. His lush Hollywood melodramas were the chick flicks of the 1950s: a parade of magazine-cover movie stars dressed and lit to perfection, falling in and out of love against a backdrop of cherry-blossom suburbia. But these big-screen soaps contained dark depths that were disguised by Sirk's craft, and none more so than *All That Heaven Allows*.

Suburban prison

On the surface, the movie is a love story, in which a widowed housewife, Cary (Jane Wyman), falls for her handsome gardener, Ron (Rock Hudson). Ron doesn't care about the difference in age or social class. Unfortunately others do, and when Cary's college-age kids object, Cary breaks off the affair. Beneath this tragedy is an indictment of small-town America's moral codes, which contrived to keep women in their place.

"The community saw to it," says Cary's daughter early in the movie, as she explains an ancient Egyptian custom in which widows were buried alive in the tombs of their husbands. "Of course, it doesn't happen anymore." But Sirk shows his audience that it does. The glossy colors he uses to portray Cary's suburban cage mock its ideal image. Every frame communicates her unhappiness, to the point where even her daughter admits that it may have been wrong to force the breakup with Ron. Will Cary find the courage to defy the conventions that dictate her life? Sirk knew he'd get his audience firmly on Cary's side. ∎

> **❝You were ready for a love affair, but not for love.❞**
> **Cary /** All That Heaven Allows

What else to watch: *Written on the Wind* (1956) ▪ *Imitation of Life* (1959) ▪ *Seconds* (1966) ▪ *Ali: Fear Eats the Soul* (1974, pp.222–23)

I DON'T THINK THAT I WANT TO LEARN THAT WAY

REBEL WITHOUT A CAUSE / 1955

IN CONTEXT

GENRE
Drama

DIRECTOR
Nicholas Ray

WRITERS
Stewart Stern, Irving Shulman (screenplay); Nicholas Ray (story)

STARS
James Dean, Natalie Wood, Sal Mineo, Jim Backus

BEFORE
1948 Ray's *They Live by Night,* about three outlaws on the run, explores his fascination with the outsider.

1955 Elia Kazan's *East of Eden,* the first of James Dean's three movies, is an adaptation of John Steinbeck's epic novel.

AFTER
1956 Dean is killed in a car crash before the family saga *Giant* is released, lending George Stevens's movie added tragic resonance.

The title of Nicholas Ray's iconic teen movie is misleading, because the movie's central character is a rebel whose cause could not be more clear: 17-year-old Jim Stark (James Dean) wants his parents to stop lying.

When Jim starts a new school in a new town, his troubled past catches up with him and his home life deteriorates. Jim looks at the respectability of his mother and his weak, ineffectual father and sees nothing but hypocrisy and failure. "You'll learn when you're older," his father tells him. But Jim rejects his parents' life lessons; he gets into knife fights at school and races cars in a game of "chicken" to prove he hasn't inherited their cowardice.

Rebel Without a Cause spawned numerous imitations—teen movies noisy with sex, drugs, and rock and roll. But the loudest noise in Ray's movie is the howl of anguish. He does not exploit his young characters, he sympathizes, coaxing a powerful performance from Dean, who came to symbolize teen angst for a whole generation. ∎

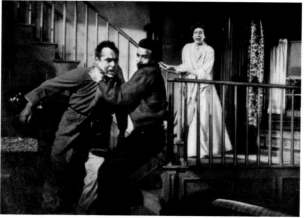

Jim (James Dean) attacks his father, Frank (Jim Backus), for his cowardice. Jim is unhinged and violent, but he's not a sociopath—he's a victim, and his cause is the truth.

What else to watch: *The Wild One* (1953) ▪ *Bigger than Life* (1956) ▪ *Easy Rider* (1969, pp.196–97) ▪ *American Graffiti* (1973) ▪ *The Warriors* (1979)

WHEN I'M BETTER, WE'LL GO AND LOOK AT THE TRAINS AGAIN

PATHER PANCHALI / 1955

IN CONTEXT

GENRE
Drama

DIRECTOR
Satyajit Ray

WRITERS
Satyajit Ray (screenplay); Bibhutibhushan Bandyopadhyay (novel)

STARS
Kanu Banerjee, Karuna Banerjee, Subir Banerjee, Chunibala Devi

BEFORE
1948 Vittorio De Sica's *The Bicycle Thief* inspires Ray to make the story of Apu.

AFTER
1956 Ray's follow-up to *Pather Panchali*, *Aparajito*, continues the story of Apu, who journeys to a new life in Calcutta.

1959 The final movie in the "Apu Trilogy," *Apur Sansar* follows the adult Apu on a trip to a provincial town that will change his life forever.

Pather Panchali tells the story of Apu (Subir Banerjee), a young boy learning about the world around him. He lives with his mother, father, sister, and aunt in an impoverished Bengali village in India. The family edges ever closer to financial ruin, but Apu's eyes are full of wonder. Although his life is blighted by despair, he doesn't yet know it, and director Satyajit Ray allows the audience to share in his protagonist's innocence.

Apu isn't the only one who is learning. Ray himself had never written or directed a movie before; his cast had never acted before, with the exception of Chunibala Devi; the photographer Subrata Mitra, whose cinematography captures the languid beauty of an Indian summer, had never worked with moving images; even Ravi Shankar, who provides the movie's shimmering sitar score, and who would later be world famous, was a novice.

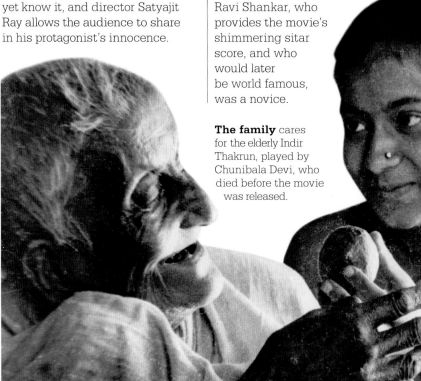

The family cares for the elderly Indir Thakrun, played by Chunibala Devi, who died before the movie was released.

What else to watch: *The Bicycle Thief* (1948, pp.94–95) ▪ *Jalsaghar* (1958) ▪ *The Cloud-Capped Star* (1960) ▪ *Charulata* (1964) ▪ *Ashani Sanket* (1973)

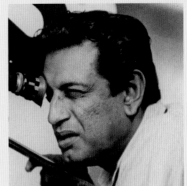

Satyajit Ray Director

On the first day of shooting, Ray had no script, but Apu's story—based loosely on the novel by Bibhutibhushan Bandyopadhyay—was all in the director's head. He had already visualized it in a series of illustrations for the novel, which perhaps explains why so much of *Pather Panchali*'s beguiling power can be found in its imagery: white-hot light cutting swathes through the forest; the gathering clouds of the monsoon; water bugs twitching on a pond; a steam train glimpsed on the horizon.

Slow speed

Apu and his sister Durga (Uma Das Gupta) delight in running alongside the train, whose whistle vibrates along the wires of vast electricity pylons and can be heard long before the train itself appears. This is the fastest moving thing in Ray's tranquil movie. "When I'm better," says Durga later on, as she lies dying of a fever,

Sarbojaya Ray (Karuna Banerjee) tends to her sick daughter Durga (Uma Das Gupta). She is helpless to stop a deadly fever.

"we'll go and look at the trains again." It's possible that Durga believes she will recover, and that Apu believes it too, but the audience knows there is really no hope. The camera paces queasily to and fro in the storm-wracked sickroom, following Apu's mother, Sarbojaya, as she watches her daughter slip away. It's a long, heartbreaking moment, and one that Apu will carry with him to the end of the movie and beyond, into two more movies about his life. ▪

> Beautiful, sometimes funny, and full of love.
> **Pauline Kael**

"Never before had one man had such a decisive impact on the films of his culture," wrote American film critic Roger Ebert, summing up Satyajit Ray's contribution to cinema in his review of the filmmaker's "Apu Trilogy." Before Ray, Indian movies were generally musicals, romances, and swashbucklers; after Apu, something of what it meant to be alive in India had been captured on film, and a new cultural tradition was born.

Ray founded Calcutta's first film society in 1947. He was working at an advertising agency when he directed his first feature, *Pather Panchali*, which won awards in France, London, and Venice. This and the two other Apu movies all strove for realism, but Ray later experimented with genre cinema, including fantasy and science fiction. His instinct for character, however, remained strong. He died at 70 in 1992.

Key movies

1955 *Pather Panchali*
1956 *Aparajito*
1959 *Apur Sansar*
1964 *Charulata*
1970 *Aranyer Din Ratri*

GET ME TO THAT BUS STOP AND FORGET YOU EVER SAW ME

KISS ME DEADLY / 1955

IN CONTEXT

GENRE
Science fiction, crime

DIRECTOR
Robert Aldrich

WRITERS
A. I. Bezzerides (screenplay); Mickey Spillane (novel)

STARS
Ralph Meeker, Albert Dekker, Cloris Leachman, Gaby Rodgers

BEFORE
1955 Aldrich adapts Clifford Odets's play *The Big Knife*, about Hollywood corruption.

AFTER
1962 *What Ever Happened to Baby Jane?* is Aldrich's twisted drama with Bette Davis and Joan Crawford.

1967 In Aldrich's wartime thriller *The Dirty Dozen*, Lee Marvin, John Cassavetes, Ernest Borgnine, and Charles Bronson form a suicide squad.

C hristina Bailey (Cloris Leachman) is a mysterious blonde with a terrible secret. She begs private eye Mike Hammer (Ralph Meeker) to forget he ever saw her. For the viewer, however, nothing about *Kiss Me Deadly* is easy to forget, from Christina running barefoot down a highway at night, her eyes wide with fear, to the movie's shocking climax.

Science fiction meets noir

Robert Aldrich's crime thriller is based on one of a series of popular novels about the exploits of thuggish Los Angeles private eye Mike Hammer. Aldrich uses the story to explore the weirder pathways of the film-noir detective genre, adding a sinister science-fiction edge. The movie opens with Christina's escape from a mental institution and veers into a quest for "the great whatsit," a strange box that is hot to the touch and

must never, ever be opened. The paranoid nihilism of 1950s science fiction overlaps with film noir: instead of a priceless jewel or a lost statuette, these pulp-fiction crooks are fighting over a doomsday weapon. Yet despite its bleakness of spirit, *Kiss Me Deadly* is highly entertaining. The dialogue is diamond sharp in every scene. "The little thread leads you to a string, and the string leads you to a rope," wisecracks Velda (Maxine Cooper), "and from the rope you hang by the neck." ∎

BLOOD-RED KISSES!

WHITE-HOT THRILLS!

Mickey Spillane's **LATEST H-BOMB!**

KISS ME DEADLY

RALPH MEEKER

The movie used the form of a pulp-fiction crime drama to explore the atmosphere of fear and paranoia that had developed in the US by the 1950s.

What else to watch: *The Maltese Falcon* (1941, p.331) ▪ *Murder, My Sweet* (1944) ▪ *The Big Sleep* (1946) ▪ *Touch of Evil* (1958, p.333) ▪ *Repo Man* (1984)

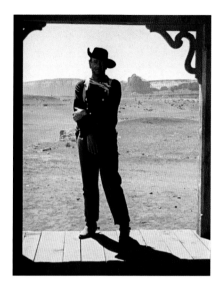

THAT'LL BE THE DAY

THE SEARCHERS / 1956

IN CONTEXT

GENRE
Western

DIRECTOR
John Ford

WRITERS
Frank S. Nugent (screenplay); Alan Le May (novel)

STARS
John Wayne, Jeffrey Hunter, Vera Miles

BEFORE
1940 *The Grapes of Wrath* is Ford's screen version of the famous Depression-era story.

1952 Ford directs John Wayne in *The Quiet Man*, a lavish comic drama shot in Ireland.

AFTER
1959 In *Rio Bravo*, Wayne stars as a sheriff standing up to a powerful rancher.

1969 *True Grit* is the story of a young girl who hires an aging US marshal (Wayne) to track down her father's killer.

From the moment John Ford gave John Wayne his big break in the 1939 movie *Stagecoach*, one of the most iconic partnerships in cinema was born. Wayne's rugged masculinity combined with Ford's riveting action sequences to create movies that elevated the Western from B-movie status to a classic popular Hollywood genre in its own right.

The Searchers is regarded by critics as the best movie of the Ford–Wayne partnership. Its story follows Ethan Edwards (Wayne) as he tracks down his niece (Vera Miles), who was kidnapped by Indians in an attack that killed her family.

New vision of the Old West

Many Westerns benefited from (and contributed to) the romantic revisionism of the time, which presented the Old West as a dangerous place, but also one of noble heroes with clear-cut American values. In *The Searchers*, any heroism is tempered by the harsh realities of place and time. The movie foreshadows the darker Westerns of the 1960s. Ford takes pains to portray the difficulty of surviving in the West, with its icy winters and scarcity of food. Meanwhile, Ethan Edwards is portrayed as ruthless, bigoted, and crazy, a man who would rather kill his niece (who is not happy to be rescued) than see her grow up as an Indian. At one point, he shoots at the eyes of an Indian corpse so that its spirit cannot see in the afterlife. This is not a simplistic tale of cowboys and Indians. ∎

In *The Searchers* I think Ford was trying, imperfectly, even nervously, to depict racism that justified genocide.
Roger Ebert

What else to watch: *Stagecoach* (1939) ▪ *Rio Bravo* (1959) ▪ *The Good, The Bad and The Ugly* (1966) ▪ *Unforgiven* (1992)

I HAVE LONG WALKED BY YOUR SIDE
THE SEVENTH SEAL / 1957

IN CONTEXT

GENRE
Drama

DIRECTOR
Ingmar Bergman

WRITER
Ingmar Bergman (from his play *Wood Painting*)

STARS
Max von Sydow, Gunnar Björnstrand, Bengt Ekerot, Nils Poppe, Bibi Andersson

BEFORE
1955 Bergman's first hit, *Smiles of a Summer Night,* is a partner-swapping comedy.

AFTER
1957 Bergman's next movie, *Wild Strawberries*, is a tale of an old man preparing for death.

1966 In *Persona*, Bergman directs a bleak fable about death, illness, and insanity.

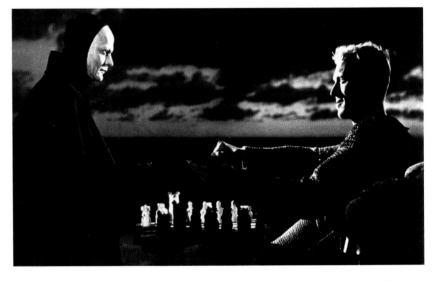

The Seventh Seal (*Det sjunde inseglet*) takes the form of a medieval morality play. A knight returns from the Crusades to find his native land devastated by plague. He goes to confession in a church surrounded by corpses. "I want God to put out his hand, show his face, speak to me," he says to the hooded figure on the other side of the grille. "I cry out to him in the dark but there is no one there."

The knight Antonius Block offers Death a game of chess for his life. Death agrees to the game, to which they will return several times during the movie, but which Block cannot win.

The figure reveals itself as Death, who has been following the knight on his journey from the Holy Land.

Having fought for God in the desert, the knight, Antonius Block (Max von Sydow), is experiencing

What else to watch: *Death Takes a Holiday* (1934) ▪ *The Virgin Spring* (1960) ▪ *Through a Glass Darkly* (1961) ▪
The Silence (1963) ▪ *Winter Light* (1963) ▪ *Hour of the Wolf* (1968) ▪ *Cries and Whispers* (1972) ▪ *Love and Death* (1975)

❝What will happen to us who want to believe, and cannot?❞

Antonius Block / The Seventh Seal

a crisis of faith. Whereas the Almighty refuses to show Himself, Death (Bengt Ekerot) turns out to be a certainty with a fondness for morbidly funny one-liners. "Appropriate, don't you think?" says the Grim Reaper when he chooses black in a game of chess—a game that the knight must win if he wants to live. It is Antonius who suggests the contest, a battle between black and white, darkness and light, death and life.

Playing for his life

The image of the knight and Death playing chess on the beach has become one of the most iconic—and imitated—in the history of cinema. It is a starkly monochrome vignette, the absence of color symbolic of the absence of God. The world of Ingmar Bergman's movie is drained of life and vitality: the water that laps the shore is slate gray, the sky above it smudged with dark clouds; the faces of God's abandoned subjects are flinty, bloodless, and unsmiling, while Death's is chalk white. Antonius already resembles the carved stone effigy on a Crusader's tomb.

There are two flickers of hope in this miserable landscape: Jof (Nils Poppe) and his wife Mia (Bibi Andersson). They are traveling players, and they have a baby son, Mikael, who is their hope for the future. Jof and Mia are creators—of both art and life—and as such they are the enemies of Death, who only knows how to destroy. When the knight encounters them on the road to his castle, Death not far behind, he finds comfort in the couple's laughter and lust for life. In fact, he is reminded of Joseph and Mary from the Bible—could these performers be emissaries of God?

Where is God?

The grim, austere imagery and obsession with biblical allegory in *The Seventh Seal* (the title was taken from the apocalyptic Book of Revelation) has its roots in Bergman's childhood: as the son of a Lutheran pastor, he was surrounded by religious art from a young age. The director was haunted by memories of the crude yet graphic representations of Bible stories that could be found in the woodcuttings of rural churches and households. As a filmmaker, he dedicated his career to asking the same, unanswerable question over and over again: where is God? »

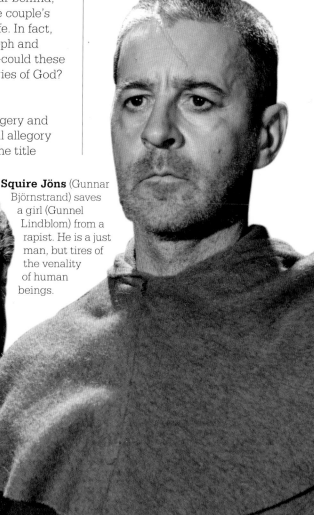

Squire Jöns (Gunnar Björnstrand) saves a girl (Gunnel Lindblom) from a rapist. He is a just man, but tires of the venality of human beings.

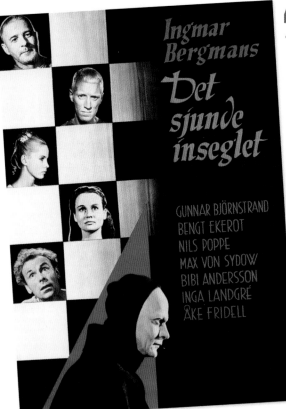

> **"Feel**, to the very end, the **triumph** of being **alive! "**

Squire Jöns / The Seventh Seal

The movie's original Swedish poster shows death waiting impassively at the bottom, with the human characters on the black squares of a chessboard.

The knight searches, but he finds nothing. At one point he happens upon a girl (Maud Hansson) imprisoned in a cage, who is about to be burned at the stake. She is accused of sleeping with the Devil and bringing the plague upon the people. Antonius is hopeful: if the Devil exists, then so must God. "Look in my eyes," the girl says, as she tells him that the priest would not come near her. "I see nothing but terror," the knight replies, sadly. The girl is burned, and the knight's squire, Jöns (Gunnar Björnstrand), can see no meaning in her murder. "Look into her eyes," he echoes. "She sees nothing but emptiness." The squire is scornful of people's fears and the ignorance that leads them to burn the witch.

Self-flagellation

If all of this sounds somewhat earnest, that's because it is. *The Seventh Seal* is concerned with the soul and damnation; with man's masochistic relationship with his Creator; and with the howling wilderness that awaits each of us at the end of the road. Bergman communicates his vast ideas in the simplest and most striking of images. In one extraordinary sequence, a group of self-flagellating monks lurches past the camera, some staggering under the heavy weight of crosses, others whipping themselves. The plague, which they believe to be a punishment from God, has driven them insane. Bergman cuts to the faces of Jof and Mia as they watch

this spectacle from their wooden stage, which suddenly resembles the platform of a gallows. They have been singing a comical song about death, which they stop as the penitents appear. Death spreads all around them, like the fog of incense spread by the monks, infecting and transforming everything in the frame. Many onlookers fall to their knees in prayer. It is a powerful, wordless metaphor for the human condition, blackly comic in its surreal grotesquery.

Regardless of whether I believe or not, whether I am a Christian or not, I would play my part in the collective building of the cathedral.
Ingmar Bergman

There are light touches of dark humor all over *The Seventh Seal*, and its final image is a cruel joke. "The master leads with scythe and hourglass," says Jof, pointing to the horizon, where the Grim Reaper leads his latest victims—including the knight—in a *danse macabre* against the gray sky. "They move away from the dawn in a solemn dance, toward the dark country, while the rain washes over their faces and cleanses their cheeks of salt."

Jof is mesmerized by the parade of the dead dancing beneath the darkening skies, but for some reason Mia cannot see the phantoms. She tuts affectionately at her husband. "You and your dreams and visions," she smiles, and the two of them shake their heads, turn their backs on Death, and return to the business of living. ∎

Death leads the dead in a dance that only Jof can see. The scene was improvised at the end of a day's filming on the coast at Hovs Hallar, using crew members and a couple of passing tourists.

Ingmar Bergman
Director

Born in Uppsala, Sweden, in 1918, Ingmar Bergman was the son of a Lutheran chaplain and was raised in a strict household. Invariably bleak, his movies deal with the major conflicts at the heart of human existence: madness versus sanity, death versus life, nothingness versus God. The human spirit rarely triumphs in these battles. *The Seventh Seal* was followed by *Wild Strawberries* and, later, a trilogy that explored the effects of human isolation: *Through a Glass Darkly*, *Winter Light*, and *The Silence*. His celebrated *Persona* was the first in a series inspired by Farö, a remote island in the Baltic Sea. Bergman died in 2007.

Key movies

1957 *The Seventh Seal*
1957 *Wild Strawberries*
1961 *Through a Glass Darkly*
1966 *Persona*

IF I DO WHAT YOU TELL ME, WILL YOU LOVE ME?

VERTIGO / 1958

IN CONTEXT

GENRE
Thriller

DIRECTOR
Alfred Hitchcock

WRITERS
Alec Coppel, Samuel Taylor (screenplay); Pierre Boileau, Thomas Narcejac (novel)

STARS
James Stewart, Kim Novak, Barbara Bel Geddes

BEFORE
1946 In *It's a Wonderful Life*, James Stewart plays to type as a sympathetic everyman.

1948 In *Rope*, Stewart teams up with Hitchcock for the first of his Technicolor movies.

AFTER
1959 Eva Marie Saint is the next "Hitchcock Blonde," playing opposite Cary Grant in *North by Northwest*.

1960 Hitchcock shocks audiences with *Psycho*.

Director Alfred Hitchcock's career was a 50-year-long duel with the audience. The more they thought they knew about his work, the more he would use that knowledge against them. He would employ structural devices, narrative twists, and other tricks to give the audience something they had never seen before. While some directors sought to understand the meaning of art or the essence of human relationships, Hitchcock was the great trickster. Audiences could never be sure what was coming next.

Vertigo plays the same games as the rest of Hitchcock's catalogue, but it has come to stand out as something more complex. It is the story of a retired cop, John "Scottie" Ferguson (James Stewart), who is roped in to an investigation into the mysterious behavior of Madeleine (Kim Novak), the wife of old college friend Gavin Elster (Tom Helmore). He becomes obsessed with her, adding an emotional intensity to the movie's usual magic show.

The Hitchcock Blonde

As a director, Hitchcock used a certain type of female character in his movies so frequently that she

My good luck in life was to be a really frightened person. I'm fortunate to be a coward, to have a low threshold of fear, because a hero couldn't make a good suspense film.
Alfred Hitchcock

eventually earned her own moniker: "The Hitchcock Blonde." Although this left him open to accusations of misogyny, it is also true that his movies had more leading roles for women than many in Hollywood. Hitchcock's blonde was cultured, fashionable, and intelligent, but also icy and initially resistant to the male hero's charms. Over the course of the movie, the character's barriers would be broken down and she would end up in awe of the hero, her individualism slightly lost in the process. Hitchcock himself indicated that blondes were ideal

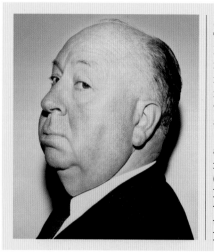

Alfred Hitchcock Director

Hitchcock was born in London in 1899. He started in the movie industry as a set designer. His first chance to direct came with the incomplete movie *Number 13*, and then in 1925 *The Pleasure Garden*. After gaining fame as a director in Britain with such movies as The *Lady Vanishes* (1938), Hitchcock moved to Hollywood in 1940, when he was hired by David O. Selznick to direct an adaptation of Daphne Du Maurier's *Rebecca*. He went

on to have a 30-year career in Hollywood, directing classics such as *Rear Window* (1954), *North by Northwest* (1959), *Psycho*, and *The Birds*. He died in 1980, at the age of 81.

Key movies

1929 *Blackmail*
1951 *Strangers on a Train*
1958 *Vertigo*
1960 *Psycho*
1963 *The Birds*

What else to watch: *Laura* (1944, p.79) ▪ *Spellbound* (1945) ▪ *Rear Window* (1954) ▪ *North by Northwest* (1959) ▪ *La jetée* (1962, p.172) ▪ *Marnie* (1964) ▪ *Bad Education* (2004)

Hitchcock's blondes

Hitchcock favored icy, "sophisticated blondes" in his movies. "We're after the drawing-room type, the real ladies, who become whores once they're in the bedroom," he said.

Tippi Hedren
The Birds

Grace Kelly
Rear Window

Ingrid Bergman
Spellbound

Kim Novak
Vertigo

Janet Leigh
Psycho

Eva Marie Saint
North by Northwest

Marlene Dietrich
Stage Fright

for creating cinematic suspense, saying in a 1977 TV interview, "Blondes make the best victims. They're like virgin snow that shows up the bloody footprints."

Vertigo's lead, Scottie, remakes salesgirl Judy Barton (also played by Kim Novak) in Madeleine's image. He removes everything that makes Judy an individual in order to have her conform to this visual archetype, a lifeless host for sexual objectification. Scottie's requirements are hugely specific. He agonizes over the exact shades of gray for Judy's suit, and is disappointed when she returns home with a hairstyle slightly different from the one he chose (changing her from brunette to blonde). Hitchcock may have put together bloodier sequences,

Scottie (James Stewart) is a police officer seen in a rooftop chase at the start of the movie. He slips, and a colleague falls while trying to help him. This is the start of his vertigo.

specifically geared around creating tension, but the subtext of emotional abuse in this sequence, along with the notion that it is a self-examination by Hitchcock regarding the way he treats women on film, makes it as unsettling as anything he ever filmed.

The fallen star

Another common theme in Hitchcock's movies is the exploration of the concept of the movie star and how it affects the telling of a story, more specifically how stardom could be manipulated to surprise the audience. The most famous example of this is *Psycho*, in which star Janet Leigh is murdered after just 30 minutes, manipulating audience assumptions of the way stories with stars in leading roles usually progress in order to shock them. But while the twist in *Psycho* is loud and unavoidable, in *Vertigo* it is subtle and slow to unfold, and its effect depends on the particular star chosen to play Scottie. »

"He did nothing. The law has little to say on **things left undone. "**
Coroner / *Vertigo*

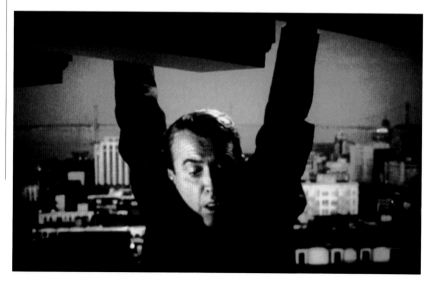

The casting of James Stewart affects the direction and impact of the movie profoundly; it adds an extra textual layer of dissonance to the final act. Stewart's image as an actor since the days of his early career, including previous roles for Hitchcock in *Rear Window* (1954) and *The Man Who Knew Too Much (1956)*, had always been that of the incorruptible everyman, decent and likeable to a fault. John "Scottie" Ferguson begins as a good man, a typical Stewart character, but ends it as a man lost in sexual despair, his mind ruined by tragedy. By putting James Stewart through this transformation, Hitchcock is not just undoing a man, he's undoing a screen icon. What we think we know of Stewart's character makes Ferguson's psychosis that much more painful to watch, and his unraveling affects us that much more deeply. The visual representation of this

process is never more clear than in a dream sequence that sees Stewart's disembodied head spiraling down into an abyss. His usual clean-cut image is distorted as a wind unsettles his hair and his expression. He looks lost.

Twisted thriller

Vertigo is an expertly crafted thriller, but one with twisted perspectives. The villain's murderous

plan succeeds, the love story is poisoned by lies, and the protagonist is broken emotionally and physically. It is arguably the darkest movie the director ever made. It is a Hitchcock movie with no Hollywood obligations, as the director seeks a richer form of terror—not simply to shock, repulse, or unsettle the audience, but to disturb them, to take everything they think they know about his style of filmmaking and to corrupt it to reveal something new. In *Vertigo*, Hitchcock bares a little bit more of his soul so that he can twist the knife a little bit deeper. ∎

Scottie and Madeleine (Kim Novak) first embrace after she has asked him whether she is crazy. Judy, as Madeleine, has fallen for Scottie, and it is this that will ultimately lead to her downfall.

Minute by minute

00:12
Scottie meets with old college friend Gavin Elster, who asks him to follow his wife, Madeleine. Scottie first sees her as she is having dinner with Elster.

00:34
At a bookstore, Elster tells Scottie and down-to-earth friend Midge the story of suicidal Carlotta, Madeleine's great-grandmother. Elster says that Madeleine is possessed by her.

01:16
Madeleine climbs the bell tower. Scottie tries to follow but cannot. He sees a woman fall to her death.

01:47
Scottie buys Judy clothes and has her dye her hair in order to make her look just like Madeleine.

00:00	00:30	01:00	01:30	02:08

00:28
Scottie follows Madeleine to a hotel, where she is registered under the name Carlotta Valdez.

00:40
Madeleine jumps into the bay. Scottie is watching and pulls her out. He takes her back to his apartment. She appears not to remember what happened.

01:34
Scottie sees Judy Barton and asks her to dinner. When he leaves, she starts to write a note, and the plot with Elster is revealed. She decides to stay.

01:58
Scottie recognizes the necklace. He takes Judy back to the tower. They climb to the top as he reveals that he knows. She panics and falls.

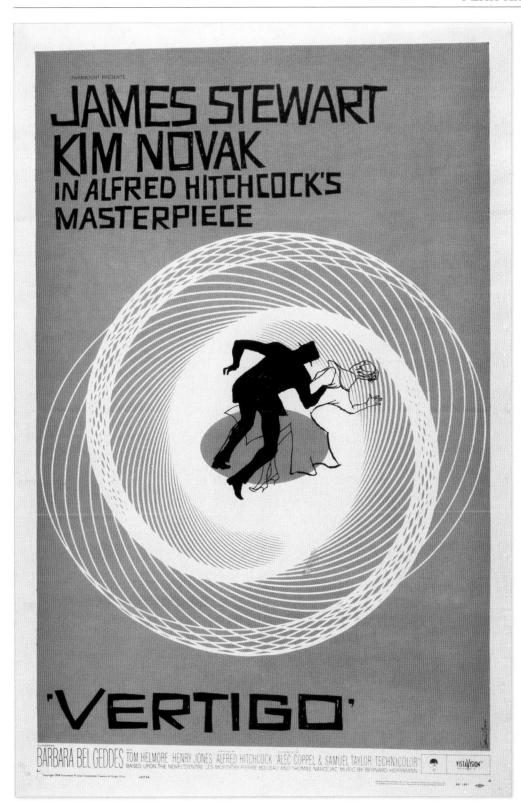

This poster shows the spiral motif that features in Scottie's nighmare, and which recurs with the staircase and in Madeleine's hairstyle.

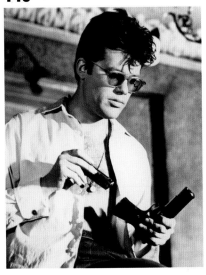

WHAT DID YOU DO DURING THE UPRISING?

ASHES AND DIAMONDS / 1958

IN CONTEXT

GENRE
War drama

DIRECTOR
Andrzej Wajda

WRITERS
Andrzej Wajda, Jerzy Andrzejewski (screenplay); Jerzy Andrzejewski (novel)

STARS
Zbigniew Cybulski, Waclaw Zastrzezynski, Adam Pawlikowski, Bogumil Kobiela

BEFORE
1955 Wajda's directorial debut, *A Generation*, is the story of Stach, a wayward teen living in Nazi-occupied Warsaw, Poland, during World War II.

AFTER
1969 After the death of actor Zbigniew Cybulski in a train wreck, Wajda channeled his grief into his next, highly personal work, *Everything for Sale*, a movie within a movie.

The title of Andrzej Wajda's war movie comes from a line of romantic poetry by 19th-century Polish poet Cyprian Norwid: "Will there remain among the ashes a star-like diamond, the dawn of eternal victory?" It is this uncertainty that characterizes all of Wajda's movies, most of which recreate the horror and heartbreak of Poland's recent history—from its occupation by the Nazis during World War II to the Stalinist regime that lasted until 1989—in order to make sense of it. They sift through the wreckage of ordinary people's lives, looking for glimmers of hope.

Maciek (Zbigniew Cybulski) is plunged into self doubt when he meets Krystyna (Ewa Krzyzewska). His crisis is played out over a single night—May 8, 1945, the last day of war, when Poland, too, is deeply divided.

Wajda emerged as a world-class filmmaker during the renaissance of Polish cinema in the 1950s. He made three movies dealing with the war. *A Generation* (1955) followed a group of men and women fighting in Nazi-occupied Poland. This was followed by *Kanal* (1957), which chronicles the tragic events of the 1944 Warsaw Uprising, in which

What else to watch: *How to Be Loved* (1963) ▪ *The Army of Shadows* (1969) ▪ *The Birch Wood* (1970) ▪ *The Promised Land* (1975) ▪ *Man of Marble* (1977) ▪ *Rough Treatment* (1978) ▪ *Man of Iron* (1981) ▪ *A Love in Germany* (1983) ▪ *Katyn* (2007)

Andrzej Wajda Director

Born in Poland in 1926, Andrzej Wajda became one of his country's most celebrated filmmakers. He lived through the German occupation of Europe, which shaped most of his work. A key figure of the "Polish Film School," he brought a fresh air of neorealism to his depictions of the men and women who endured the war, and his movies play an enormously important part in understanding what happened to Poland—and the world—in the last century.

Key movies

1957 *Kanal*
1958 *Ashes and Diamonds*
1975 *The Promised Land*
1977 *Man of Marble*

Polish Resistance fighters were crushed by the German army. Third was *Ashes and Diamonds*, an angry, melancholy movie set during the chaos of the German occupation's aftermath, once the dust of the liberation had begun to settle.

Questioning the cause

Ashes and Diamonds focuses on Maciek (Zbigniew Cybulski), a young soldier in Poland's right-wing Nationalist Army who fought in the uprising against the Nazis with the goal of establishing Polish sovereignty. As the Soviet Union takes control, Maciek is ordered to assassinate a new Communist official, but he has second thoughts about waging a doomed war against the incoming left-wing administration. He bungles the murder, killing two bystanders.

Torn between his conscience and loyalty to the cause for which he fought in the war, Maciek embarks on a second half-hearted attempt at

In the ruins of a bombed-out church, Maciek reflects on his equally battered ideals. It is here that Krystyna finds an inscription of the poem from which the movie takes its name.

the killing. This time he is waylaid when he falls in love with Krystyna (Ewa Krzyzewska), who works at the hotel in which his target is a guest. She confuses him further, forcing him to question the beliefs that have driven him for as long as he can remember. Looking up at the sky, Maciek sees fireworks exploding in the darkness. The fireworks—glittering diamonds rising from the ashes of Warsaw—announce Germany's surrender and the end of war. Yet Wajda's trademark note of uncertainty hangs in the air: it's the end of an era for Poland, but what will the future bring?

Dubious dawn

"What did you do during the uprising?" is a question that echoed around daily lives in Poland for decades after the war. In his portrait of one man's fractured identity, Wajda constantly draws our attention to broken glass and splintered buildings. This sense of fracture runs through the country, and cannot be ignored. ▪

❝You know not if flames bring freedom or death.❞

Krystyna / *Ashes and Diamonds*

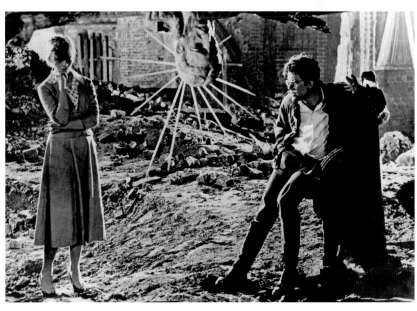

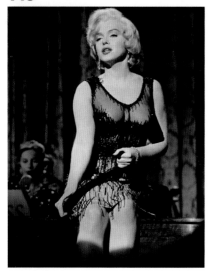

WELL, NOBODY'S PERFECT

SOME LIKE IT HOT / 1959

IN CONTEXT

GENRE
Comedy

DIRECTOR
Billy Wilder

WRITERS
**I. A. L. Diamond,
Billy Wilder**

STARS
**Marilyn Monroe, Jack
Lemmon, Tony Curtis**

BEFORE
1953 *Gentlemen Prefer
Blondes*, Howard Hawks's
musical comedy, is an early
hit for Marilyn Monroe.

1955 In Billy Wilder's romantic
comedy, *The Seven Year Itch*,
Monroe poses on a subway
grate, an updraft lifts her dress.

AFTER
1960 *The Apartment* reunites
Jack Lemmon with Billy Wilder
for a darker, more cynical take
on romantic comedy.

1961 John Huston's *The
Misfits* is Monroe's last movie.

The final words
of *Some Like It
Hot*, "Nobody's
perfect," could have
been writer/director
Billy Wilder's motto. His
movies are case studies
of the fatally flawed and
the cheerfully cynical, the
suckers, hustlers, and
fraudsters who are
motivated by money and
sex and not much else.

Set at the tail end of the Roaring
Twenties, *Some Like It Hot* is no
exception. Its main characters are
as selfish, deceitful, and grasping

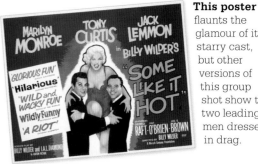

This poster flaunts the glamour of its starry cast, but other versions of this group shot show the two leading men dressed in drag.

as they come—they'll do anything
to get what they want. But Wilder's
movie is also a breezy feel-good
comedy that sparkles with charm,
pathos, and the spirit of romance.

Money and lust

Tony Curtis and Jack Lemmon play
Joe and Jerry, two Chicago jazz
musicians who disguise themselves
as women to flee the mob after
they witness a gangster shootout
during the famous Saint Valentine's
Day Massacre of 1929. They join an
all-girl orchestra en route to Florida
and meet vocalist Sugar Kane
(Marilyn Monroe), who dreams of
bagging a millionaire husband.
Joe falls head over heels in lust and
disguises himself again, this time
as a playboy, in a bid to bed the
singer. He's after sex, she's after
money, but they also fall in love.

Hilariously innocent,
though always on the
brink of really disastrous
double-entendre.
Pauline Kael
5001 Nights at the Movies, 1982

What else to watch: *Ninotchka* (1939) ▪ *How to Marry a Millionaire* (1953) ▪ *Sabrina* (1954) ▪ *The Prince and the Showgirl* (1957) ▪ *The Apartment* (1960) ▪ *Irma la Duce* (1963) ▪ *The Fortune Cookie* (1966) ▪ *Tootsie* (1982)

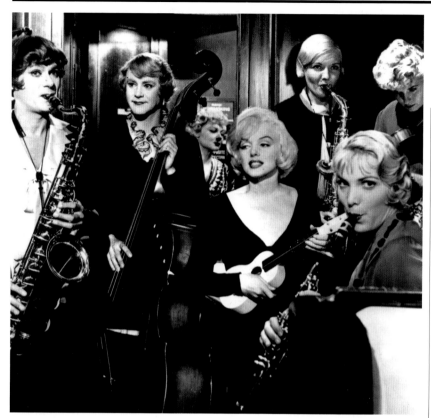

As "Josephine" and "Daphne", Joe and Jerry hope to blend in with Sweet Sue and her Society Syncopators on a night train to Florida, but there's no mistaking who plays the ukulele.

describes her body. Yet Monroe's performance delivers something truly magical. In one scene, during a lull in the action, Monroe sings *I Wanna Be Loved By You* straight into the camera: she's seductive, sweet, and wistful all at once, and she succeeds in transforming Sugar's cynicism into a childlike vulnerability. When she kisses Joe on the yacht, he is transformed, too—from seducer to seduced.

Flaws and frailty

Some Like It Hot reputedly suffered from behind-the-scenes tensions. Monroe was initially unhappy with being filmed in period-style black and white, and Curtis famously said that kissing Monroe was "like kissing Hitler." Whether the actor meant it or not, this illusion-shattering jibe echoes Wilder's great preoccupation with human flaws and frailties. Nobody's perfect, it seems—not even the legendary Marilyn Monroe. ■

While Joe cavorts with Sugar on a yacht—in Curtis's memorable spoof of Cary Grant—the dress-wearing, tango-dancing, but decidedly heterosexual Jerry gets engaged to an aging but genuine millionaire, Osgood (Joe E. Brown). "You're a guy! Why would a guy want to marry a guy?" asks Joe when he finds out. "Security!" replies Jerry, without missing a beat, his eyes moony at the thought of all that cash.

In the end, Jerry drops the act and tells Osgood the truth. "I'm a man!" he admits with a growl. But Osgood isn't bothered. "Nobody's perfect!" he beams, and Jerry shoots the camera a "Well, whaddyaknow?" look as the movie fades out.

In *Some Like It Hot*, everybody is desperate to get their hands on something, and in Marilyn Monroe the movie has the most lusted-after star in Hollywood history—"Like Jell-O on springs!" is how Jerry

Jack Lemmon Actor

"Magic time" was how Jack Lemmon (1925–2001) described acting. He would mutter this phrase to himself before stepping onto a stage or in front of a camera. Lemmon worked in television and light entertainment before finding his feet in movies, where his everyman qualities made him a star. He was often one half of a double act; key collaborators included zany comedian Ernie Kovacs, actor Walter Matthau, and filmmaker Billy Wilder.

Key movies

1959 *Some Like It Hot*
1960 *The Apartment*
1968 *The Odd Couple*
1992 *Glengarry Glen Ross*

YOUR PARENTS SAY YOU'RE ALWAYS LYING

THE 400 BLOWS / 1959

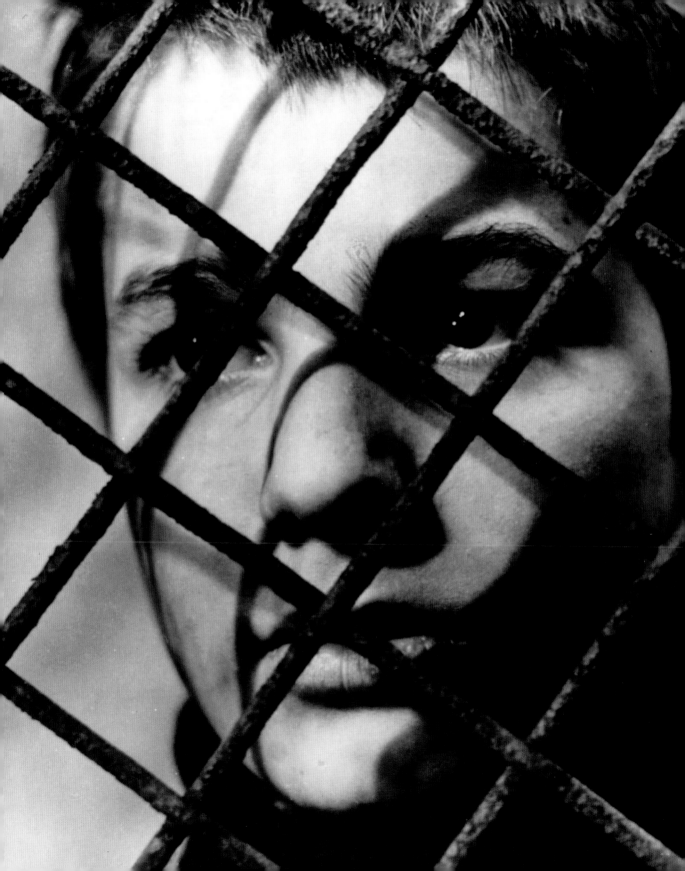

IN CONTEXT

GENRE
Drama

DIRECTOR
François Truffaut

WRITERS
**François Truffaut,
Marcel Moussy**

STARS
**Jean-Pierre Léaud, Claire
Maurier, Albert Rémy,
Guy Decomble**

BEFORE
1955 Truffaut's first short, *The
Visit*, is the tale of a bungled
proposal of love. It is screened
only for a handful of friends.

AFTER
1960 Jean-Luc Godard follows
his colleague Truffaut into
cinema with *À bout de souffle*.

1962 Truffaut's *Jules et Jim* is
a story of a love triangle set at
the time of World War I.

1968 Jean-Pierre Léaud
reprises the role of Antoine
in *Stolen Kisses*.

Much has been written by critics about *The 400 Blows*. Indeed, the movie's director, François Truffaut, was one of France's best-known film critics before he decided to show the world how he thought movies should be made. He and the other filmmakers who led the French New Wave in the late 1950s and early 1960s believed that a director was an author (*auteur*) and the camera a pen (a "camera-pen," or *caméra-stylo*).

Semiautobiography

The 400 Blows is in part a painfully personal memoir describing Truffaut's Parisian childhood, with certain names and events changed, not to disguise the victims, but to express something new and true. The young Truffaut becomes Antoine Doinel (Jean-Pierre Léaud), a fledgling troublemaker who is constantly accused of distorting the facts. "Your parents say you are always lying," says the psychiatrist sent to figure him out. "Sometimes I'd tell them the truth and they still wouldn't believe me," replies the boy, "so I prefer to lie."

Antoine reads the works of Honoré de Balzac, and when he adapts the author's work for a school

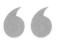

> I demand that a film express either the joy of making cinema or the agony of making cinema. I am not at all interested in anything in between.
> **François Truffaut**

essay, using the thoughts and feelings to express his own emotions, he is punished by a teacher. It's an act of homage condemned as plagiarism, and Antoine's response is an act of delinquency: he steals a typewriter from his stepfather's workplace.

Recreating adolescence

There is often romance in youthful rebellion, but *The 400 Blows* is not a nostalgic work. It does not look back on adolescence from an adult's point of view, but rather recreates it in the present tense,

François Truffaut Director

It's a brave film critic who picks up a camera and directs a movie of their own. François Truffaut did just that with *The 400 Blows*, and his courage paid off—the movie was hailed as a masterpiece, and Truffaut went on to direct more than 20 movies before his death in 1984.

As a journalist writing for the influential film magazine *Cahiers du Cinéma*, Truffaut pioneered the auteur theory, a controversial school of thought that identified the director as a movie's author. Truffaut was critical of most contemporary French movies, earning the nickname "The Gravedigger of French Cinema." But after *The 400 Blows*, his reputation was transformed.

Key movies

1959 *The 400 Blows*
1962 *Jules et Jim*
1966 *Fahrenheit 451*
1973 *Day for Night*

What else to watch: *À bout de souffle* (1960, pp.166–67) ■ *Shoot the Piano Player* (1960) ■ *Jules et Jim* (1962, p.334) ■ *The Wild Child* (1970) ■ *Two English Girls* (1971) ■ *Day for Night* (1973) ■ *The Story of Adele H.* (1975) ■ *Small Change* (1976)

Minute by minute

00:05
Antoine is held back after class when he is caught with a picture of a girl. At the end of the day, he swears he'll take his revenge on the teacher.

00:35
Antoine's parents turn up at school after he has lied to the teacher about his mother having died. His stepfather slaps him. He decides to run away.

01:07
After stealing a typewriter from Antoine's stepfather's workplace, Antoine and René try unsuccessfully to pawn it.

01:24
After a discussion with the judge, Antoine's mother agrees to send him to a detention center for three months.

| 00:00 | 00:15 | 00:30 | 00:45 | 01:00 | 01:15 | 01:38 |

00:25
While playing hooky with his best friend René, Antoine sees his mother kissing a man in the street.

00:54
In French class, Antoine is accused of plagiarizing Balzac. He is sent to see the principal, but runs off to hide out at René's house.

01:15
Antoine is locked up in a police holding cell after his stepfather turns him in to the police. He is fingerprinted and photographed.

01:35
While the boys are playing soccer, Antoine escapes from the detention center.

as it is felt, in all its agony, uncertainty, joy, and heartlessness. The movie's enigmatic English title comes from the French phrase *faire les quatre cents coups*, which mean "to raise hell," which Antoine certainly does. He doesn't steal the typewriter so he can use it— he plans to sell it and finance his escape from Paris. Truffaut is unafraid to color his protagonist as a mercenary as well as a lover of literature.

When Antoine has second thoughts about the theft, he attempts to return the typewriter, but is caught. His stepfather (Albert Rémy) decides to hand him over to the police, and the boy spends a night in a jail cell with prostitutes and thieves. The police take a mug shot, and the movie freezes for the instant in which the photograph—and Antoine— are captured. "Around here to escape is bad enough," says an inmate at the institution to which Antoine is eventually sent, "but getting caught is worse."

Truffaut mirrors this freeze-frame with the movie's final shot, which captures Antoine in the

act of escaping. He heads for the sea, which he has never seen, and runs down country roads until he arrives at the beach. The camera, like the boy, is constantly moving, keeping track of his flight. Antoine sprints into the surf, dips his toe in

the ocean, then turns back to the land and looks straight into the camera. Truffaut freezes the image and zooms in on Antoine's face.

It is a bold and ambiguous period at the end of the first chapter in Antoine's life (Truffaut would »

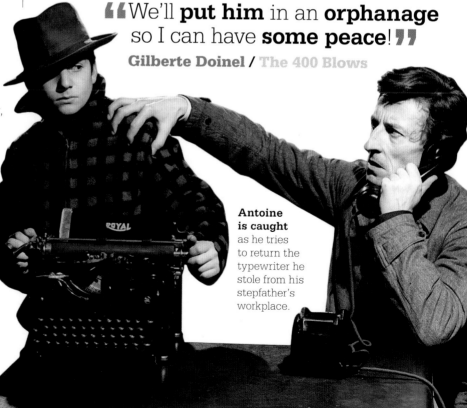

❝We'll put him in an orphanage so I can have some peace!❞
Gilberte Doinel / *The 400 Blows*

Antoine is caught as he tries to return the typewriter he stole from his stepfather's workplace.

The poster for the movie's cinematic release shows Antoine staring back at the land as he reaches the shore and can escape no further.

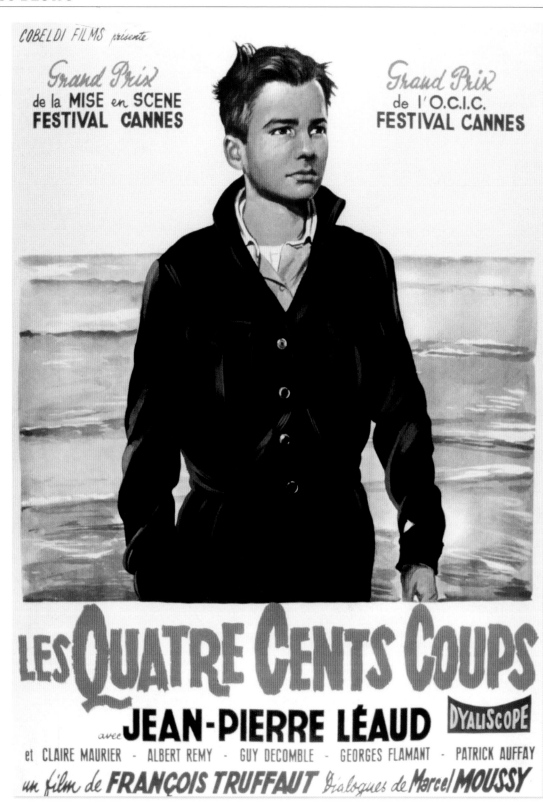

continue to chronicle the character's adventures in a series of movies). When he reaches the water's edge, he can run no further. The final, frozen moment as he turns back seems to say that, far from having escaped, he will remain forever captured. The impression it makes is one of hope mixed with defeat.

Escape to the movies

Antoine finds another means of escape: the movies. He slips into a movie theater whenever he can, to lose himself in the dark of the theater's seats and the images on the screen, much as the young Truffaut himself did.

It is here that the character's life crosses irresistibly into the life of his creator. There is the constant sense that the director is trying to explore or exorcise his own past, redefining it with shots and scenes borrowed wholesale from other movies, such as *Zero de Conduite* (1933, pp.50–51) and *Little Fugitive* (1953), in the same way that Antoine borrows from Balzac to make sense of himself. It's not just a passion for the movies that Antoine and Truffaut have in common. Antoine doesn't know who his biological father is, and he lives with a distant stepfather, just as the director did in his youth. Antoine runs away from home, as Truffaut did when he was eleven. Antoine tries to convince his teacher that his mother has died (one of his outrageous lies). The young Truffaut claimed that his father had been arrested by the Germans.

All movies comprise outrageous lies, and conjure worlds of illusion and pretense populated by people acting as someone they are not. But Truffaut's debut movie proves that, when arranged for a certain purpose and related with heart, lies can reveal and illuminate the truth in a way that the bare facts cannot. It was this truth, as well as the promise of escape, that excited those French filmmakers who dipped their toes into the New Wave. ∎

After Antoine sets fire to his shrine to Balzac, his favorite author, his stepfather threatens to send him to a military academy.

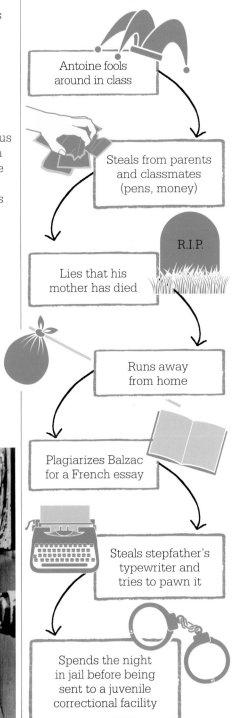

***The 400 Blows* charts** Antoine's descent into delinquency, from classroom jokes to imprisonment, as the adult world rejects him.

Antoine fools around in class

Steals from parents and classmates (pens, money)

Lies that his mother has died

R.I.P.

Runs away from home

Plagiarizes Balzac for a French essay

Steals stepfather's typewriter and tries to pawn it

Spends the night in jail before being sent to a juvenile correctional facility

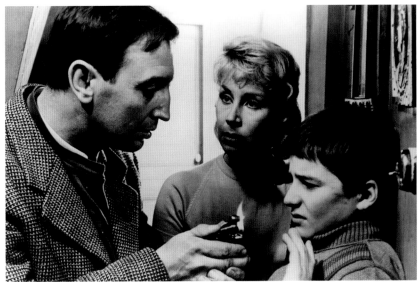

REBEL REBEL
1960–1974

French New Wave breathes new life into movies with *À bout de souffle*, as does British New Wave with *Saturday Night and Sunday Morning*.

The Berlin Wall goes up and the USSR takes the lead in the **Cold War space race** by sending the first man into space, 60 years after *A Trip to the Moon*.

While America's growing **civil rights** movement fights racism, so too does lawyer Atticus Finch in the movie adaptation of *To Kill a Mockingbird*.

Musicals continue to charm: *The Sound of Music* breaks international box-office records.

1960 1961 1962 1965

1960 1962 1964 1966

Italian epic *La Dolce Vita* **spurns conventional narrative** in following one man's search for love and happiness among the café society of Rome.

In the year of the Cuban Missile Crisis, **spy mania** runs amok as 007, British secret agent James Bond, makes his debut in *Dr. No*.

Dr. Strangelove satirizes **Cold War paranoia**, while the Vietnam War escalates and the US introduces the draft.

Shot in **newsreel style**, *The Battle of Algiers* exposes the brutal realities of guerrilla warfare, in an era of decolonization.

Released in the last moments of the 1950s, François Truffaut's *The 400 Blows* was the bridge into the decade to come, and the seismic shake ups that would arrive with it. From the very beginning of the 1960s, cinema was, like its audience, set on breaking rules.

New Wave
The impetus came from Europe, in particular from France, where Truffaut's colleagues from the movie magazine *Cahiers du Cinéma* were creating a whole new language for movies. The era of the *Nouvelle Vague* (New Wave) would be embodied by director Jean-Luc Godard, a gifted ball of mischief who would release his own first feature in 1960: *À bout de souffle* (*Breathless*). Stylish and extremely

> The film of tomorrow will be directed by artists for whom shooting a film constitutes a wonderful and thrilling adventure.
> **François Truffaut**

witty, it immediately made everything that had come before look hopelessly old-fashioned.

All this was at a time when many observers thought cinema was dying, doomed by the spread of TV in Western homes during the 1950s. Cinema's response was thrilling. Many of the greatest movies of the era were born out of a mood of bubbling outrage. In the US, the young genius Stanley Kubrick took a jab at the ongoing insanity of the Cold War with *Dr. Strangelove*, in which Peter Sellers paid homage to Alec Guinness's multitasking in *Kind Hearts and Coronets* by playing three different characters. Later, as demands for change coursed around the world, the Italian director Gillo Pontecorvo would influence a generation of filmmakers with the incendiary *The Battle of Algiers*.

Counterculture
Elsewhere, the politics were less overt but the air just as thick with restlessness and the rejection of

Sex gets surreal in Luis Buñuel's *Belle de Jour*, while Hollywood **teases social taboos** in *The Graduate*, and smashes them wide open in *Bonnie and Clyde*.

New Hollywood hits the road with Peter Fonda and Dennis Hopper in *Easy Rider*, and Jon Voight and Dustin Hoffman in *Midnight Cowboy*.

Cinematic violence is taken to new extremes by *A Clockwork Orange*, *The French Connection*, and *Dirty Harry*.

Kung fu goes global, and Hong Kong actor Bruce Lee acquires cult status in *Enter the Dragon*.

1967 **1969** **1971** **1973**

1968 **1970** **1972** **1974**

Space-age **science fiction thrills** audiences in *2001: Space Odyssey* and in the erotically charged *Barbarella*.

MASH and *Catch-22* target the **insanity of war**, while *Le Boucher* explores the impulses that lead to murder.

Francis Ford Coppola **redefines the gangster genre** with the first of *The Godfather* movies.

Chinatown's **neo noir** goes head to head with *The Godfather: Part II*, while Gene Hackman eavesdrops on *The Conversation*.

old orders. In Britain, another New Wave made hard-edged portraits of working-class life, such as *Saturday Night and Sunday Morning*. And a new, boldly unsqueamish attitude to screen violence took hold as the decade went on. Taking its cues from Godard and its story from the lives of two wild young outlaws in the Great Depression, Arthur Penn's *Bonnie and Clyde* set a benchmark of stylized bloodshed.

While the movies got on with what they had always done best— entertaining mass audiences— some filmmakers also tapped into the avant-garde and upended ideas of what a movie was. From the post-nuclear time-travel feature *La jetée* (*The Pier*, 1962), made up almost wholly of still photographs, to the teasing *Last Year At Marienbad*, (1961) or the split screen of Andy Warhol's *Chelsea Girls* (1966), cinema was in the middle of a creative free-for-all. It was hardly surprising to find the ever-subversive Luis Buñuel at large in such an atmosphere, filming *The Discreet Charm of the Bourgeoisie* (1972) half a century after *Un Chien Andalou*.

New Hollywood

In response to the prospect of losing young audiences to television, the Hollywood that had once kept such a tight grip on its filmmakers now handed over a measure of control to a new breed of singular talents.

The results were American movies shot through with cynicism and irresolution. Some are best seen as historical documents, but others are enduring masterpieces. Francis Ford Coppola's *The Conversation* is a mystery of surveillance with a dazzlingly intricate use of sound, while his saga of family and crime, *The Godfather*, is an all-time classic that still holds audiences in its grip. as does *The Godfather: Part II*, the prequel that follows Vito Corleone from the Old World to the New.

For an era that began with Truffaut and Godard gleefully riffing on Hollywood tropes, it was fitting to close with a relentless crisscross of influence between Europe and the US: visions of Boris Karloff amid the Spanish Civil War in *The Spirit of the Beehive*; the relocation of German-born Douglas Sirk's lush melodramas from Hollywood to 1970s Munich in Rainer Werner Fassbinder's *Ali: Fear Eats The Soul*; and *Chinatown*, a noir exposé of the black heart of southern California, directed by the Polish émigré Roman Polanski. ∎

YOU ARE THE FIRST WOMAN ON THE FIRST DAY OF CREATION

LA DOLCE VITA / 1960

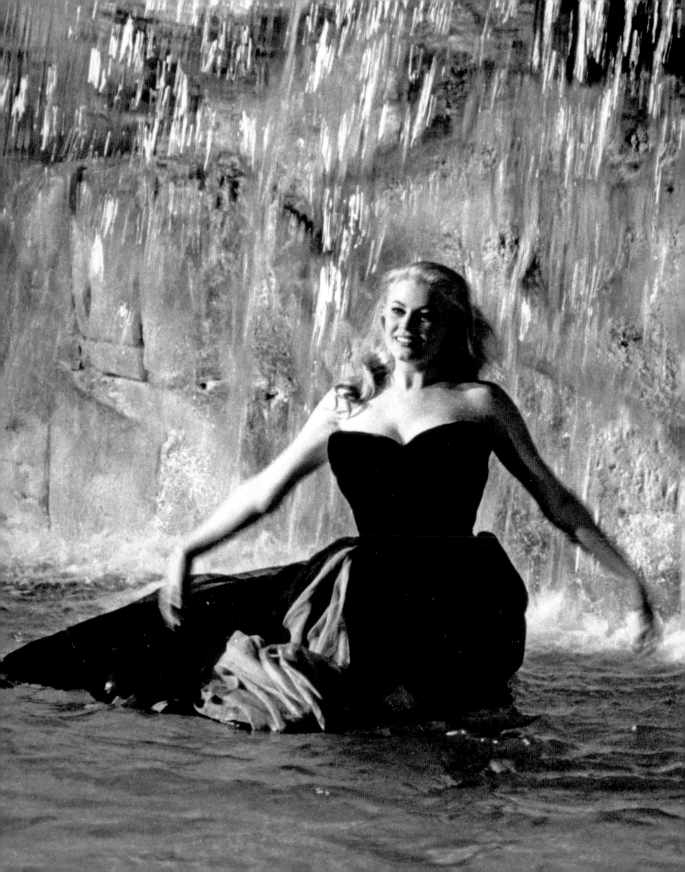

IN CONTEXT

GENRE
Satire

DIRECTOR
Federico Fellini

WRITERS
Federico Fellini, Ennio Flaiano, Tullio Pinelli, Brunello Rondi, Pier Paolo Pasolini

STARS
Marcello Mastroianni, Anita Ekberg, Anouk Aimée, Yvonne Furneaux

BEFORE
1945 Fellini cowrites *Rome, Open City*, Roberto Rossellini's gritty Nazi-occupation drama.

1958 Marcello Mastroianni gets his big break in the stylish crime-comedy *Big Deal on Madonna Street*.

AFTER
1963 Fellini's autobiographical comedy-drama *8½* follows a director (played by Mastroianni) suffering from writer's block.

In April 1953, the partially clad body of a young woman was discovered on a beach near Rome. Had Wilma Montesi accidentally drowned or committed suicide, or had she been murdered? The police investigated, and so did Italy's rapacious media. Gossip and conspiracy theories snowballed into a national scandal as the corrupt, hedonistic underworld of postwar Rome was illuminated by the flash bulbs of the city's paparazzi. Politicians, movie stars, gangsters, artists, prostitutes, fading aristocrats—they were living *la dolce vita*, "the sweet life," a whirl of drugs, orgies, and general depravity that had spun tragically out of control.

La Dolce Vita became the title of Federico Fellini's satire of this turbulent period in the history of his beloved Rome. The movie contains a veiled reference to the Montesi affair in its closing scene, when a group of characters emerge from a beach-house orgy to find a dead manta ray washed up on the shore, a metaphoric reference to Wilma Montesi. They gather around the corpse in the dawn light, the sea monster's eye staring back accusingly at them.

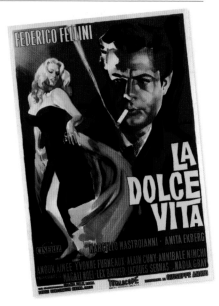

The movie poster casts Marcello Mastroianni as a paparazzo in the shady underworld, searching for light in the form of his perfect Eve.

It's a chilling image that is both grotesque and sad—the final entry in Fellini's catalogue of lost souls.

Seven sins
La Dolce Vita was released seven years after the death of Wilma Montesi. It takes place on the seven hills of Rome, its narrative divided into seven nights and

Federico Fellini Director

Born in Rimini, Italy, in 1920, Federico Fellini moved to Rome when he was 19 years old. He went to study law, and stayed to make movies that would immortalize the city. His early adventures as a reporter and gossip columnist exposed him to the world of show business, and in 1944 he became the apprentice of famed director Roberto Rossellini. In the 1950s, Fellini made movies of his own, and established himself as one of Italy's most controversial artists.

Fellini's work combines baroque imagery with everyday city life, often depicting scenes of excess. He was fascinated with dreams and memory, and many of his later movies tipped into the realm of psychological fantasy.

Key movies

1952 *The White Sheik*
1954 *La Strada*
1960 *La Dolce Vita*
1963 *8½*

What else to watch: *The Bicycle Thief* (1948, pp.94–97) ▪ *L'Avventura* (1960) ▪ *Juliet of the Spirits* (1965) ▪ *Amarcord* (1973) ▪ *Cinema Paradiso* (1988) ▪ *Celebrity* (1998) ▪ *Lost in Translation* (2003)

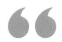

All art is autobiographical. The pearl is the oyster's autobiography.
Federico Fellini
The Atlantic, 1965

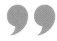

cafés, and after-dark debauchery, searching for happiness in the shape of an idealized love. There are several contenders, including his suicidal fiancée, Emma (Yvonne Furneaux), and the mysterious Maddalena (Anouk Aimée). But it's not until Ekberg's Sylvia arrives in the city, amid a riot of adulation and publicity, that Marcello glimpses perfection. In the movie's most celebrated scene, Sylvia wanders into the waters of the Trevi Fountain after a long, carnivalesque night on the town. She calls to Marcello to follow her in, and the viewer sees Sylvia through Marcello's eyes: the ideal »

seven dawns. If you look hard enough, you'll also find that it contains the seven deadly sins and allusions to the biblical story of the seven days it took God to make the world. Religion is core to Fellini's work. When the movie's hero, a nocturnal journalist named Marcello Rubini (Marcello Mastroianni), falls for the beautiful movie star Sylvia (Anita Ekberg), he tells her, "You are the first woman on the first day of Creation. You are mother, sister, lover, friend, angel, devil, earth, home."

It's up to the viewer to decide on the significance of *La Dolce Vita*'s religious overtones and apparent obsession with the number seven. What is more certain is that the movie is concerned with the nature of men's relationship with women. Marcello spends his nights on Via Veneto, 1950s Rome's street of nightclubs, sidewalk

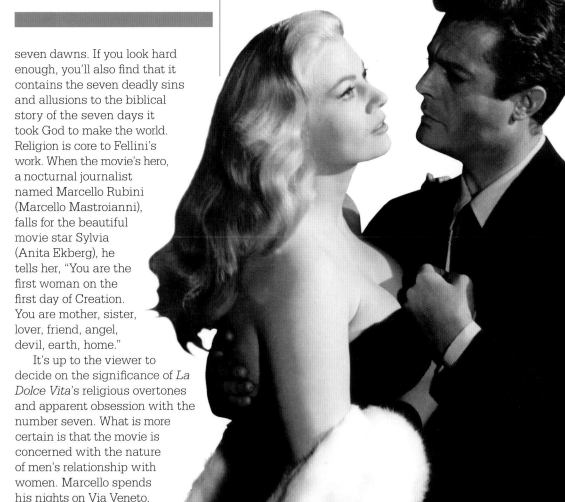

Marcello (Marcello Mastroianni) is smitten with Sylvia, but they can only spend one night together.

woman, unearthly in her radiance, a vision of light in the dark city. But then dawn arrives and the magical spell of nighttime is broken, just as Sylvia anoints Marcello's head with water from the fountain. The next day Sylvia leaves Rome, and Marcello must begin his search again.

The chaos of Marcello's night-wanderings is reflected in the movie's meandering, episodic story structure. His adventures take him all over the city, from a field in which two children claim to have seen a vision of the Virgin Mary—the archetypal elusive, idealized woman—to the domestic bliss of Steiner's house. Steiner (Alain Cuny) is Marcello's best friend, and the epitome of all that Marcello envies: Steiner is stable, happily married with two perfect children, and enjoys a balance of materialistic comfort and intellectual fulfilment. When Marcello visits Steiner's home, he ascends from the dark underworld of the streets, clubs, and basement bars, into a kind of heaven.

Illusion of happiness

But, just as Sylvia and the Virgin Mary turn out to be illusions, Steiner's domestic happiness is also a lie, as Marcello discovers when Steiner tells him, "Don't be

La Dolce Vita takes place over seven days, nights, and dawns. While day appears to offer Marcello hope, night leads him into depravity, and dawn brings rude epiphanies.

- Marcello follows Christ statue flying over Rome
- Climbs St. Peter's dome with Sylvia
- Reports on children's vision of the Madonna
- Encounters Steiner playing Bach in church
- Sees angelic waitress Paola by the sea
- Spots Paola beckoning to him from riverbank, but can't hear her

- Meets Maddalena at club; sleeps with her
- Dances with Sylvia at Baths of Caracalla
- Witnesses stampede at site of fake miracle
- Attends Steiner's literary salon
- Sets up father with girl
- Sleeps with Jane at aristocratic house party
- Argues with Emma
- Instigates beach orgy

- Finds fiancée Emma overdosed at apartment
- "Anointed" by Sylvia in Trevi Fountain
- Observes mourning for trampled child
- Hears Steiner has killed himself and his children
- Learns of father's stroke
- Spies matron at Mass
- Reconciles with Emma
- Discovers sea monster washed up on beach

> **" A man who agrees to live like this is finished man, he's nothing but a worm! "**
>
> **Marcello** / La Dolce Vita

like me. Salvation doesn't lie within four walls." That there is no comfort in either a sheltered, intellectual, domestic life nor the hedonistic "sweet life" is the existential conundrum Marcello wrestles with in the face of Steiner's subsequent suicide. After an unspecified time

lapse, we see Marcello at the beach house in Fiumicino, owned by his friend Riccardo, where the all-night party descends into mayhem. As morning approaches, he finds himself staggering across the beach, where the staring eye of the dead manta ray is waiting for him.

Minute by minute

00:17
Marcello and Maddalena make love at the residence of a prostitute. He returns home to find that his fiancée has overdosed.

00:50
Sylvia wades into the Trevi Fountain and Marcello follows. They return to her hotel, where her fiancé, Robert, slaps her and punches Marcello.

01:33
Marcello introduces his father to Fanny, a dancer. She takes Marcello's father back to her apartment, but he suffers a minor heart attack.

02:23
Marcello rushes to his friend Steiner's apartment, where he is told that an awful tragedy has occurred.

| 00:00 | 00:30 | 01:00 | 01:30 | 02:00 | 02:30 | 02:54 |

00:33
On the balcony of the dome of St. Peter's, Marcello gets a moment alone with Sylvia. He takes her dancing.

01:29
Working on his novel at a seaside restaurant, Marcello meets Paola and tells her that she looks like an angel.

02:02
Marcello bumps into Maddalena at a party. Drunk, she asks him to marry her, but is soon distracted by another man.

02:48
On the beach, a dead ray is pulled out of the water. Marcello sees Paola in the distance, but he cannot hear her.

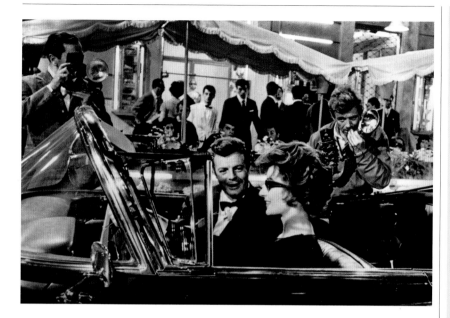

Marcello Mastroianni
Actor

The final scene of *La Dolce Vita* contains a second allusion. The fisherman who hauls the ray out of the sea says the bloated, rotting leviathan has been dead "for three days." In the Bible, this is the same period of time that Jesus spends in the tomb. *La Dolce Vita* is a carnival of Roman Catholic imagery and symbols, much of it controversial in its use. The opening sequence, in which a golden statue of Christ flies over an ancient Roman aqueduct,

Marcello is repeatedly drawn to Maddalena (Anouk Aimée), but his love for her cannot lead anywhere. She asks him to marry her, only to fall into the arms of another man moments later.

dangling benignly from a helicopter with Marcello following it in a second helicopter, caused outrage when the movie was first screened.

Although two Christ figures (the statue and the manta ray) bookend the narrative, they fail to offer hope or salvation to any of its characters. In fact, Fellini constantly connects religious myth with disillusionment. Marcello is looking for his Eve, the first woman on the first day of Creation, an angelic figure untainted by the corruptions of *la dolce vita* or any earthly experience. "I don't believe in your aggressive, sticky, maternal love!" he tells Emma during their endlessly recurring fight. "This isn't love," he screams at her, "it's brutalization!" And so whenever he dives back into the chaos of the Roman night, he knows that Eve doesn't really exist; all he is doing is trying to forget what he knows. ∎

Following a brief period of theater work, Marcello Mastroianni became famous with a role in *Big Deal on Madonna Street*. He was Fellini's only choice for the role of Marcello Rubini in *La Dolce Vita*. The studio had wanted Paul Newman, but Fellini fought to keep his friend, and the pair went on to make six more movies together. Mastroianni often played a version of the director in these movies.

A suave and darkly handsome figure, Mastroianni became closely associated with the glamour of Rome and its beautiful leading ladies, especially Sophia Loren (who shared the screen with him in 11 movies). He earned two Academy Award nominations during his career, one for the comedy *Divorce Italian Style* in 1961 and the other for *A Special Day* in 1977.

Key movies

1958 *Big Deal on Madonna Street*
1960 *La Dolce Vita*
1961 *Divorce Italian Style*
1963 *8½*

In sum, it is an awesome picture, licentious in content but moral and vastly sophisticated in its attitude and what it says.
Bosley Crowther
New York Times, 1960

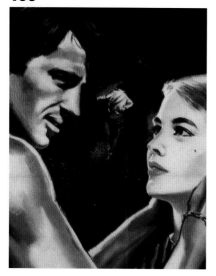

DON'T USE THE BRAKES. CARS ARE MADE TO GO, NOT TO STOP
À BOUT DE SOUFFLE / 1960

IN CONTEXT

GENRE
French New Wave

DIRECTOR
Jean-Luc Godard

WRITERS
Jean-Luc Godard, François Truffaut, Claude Chabrol

STARS
Jean-Paul Belmondo, Jean Seberg

BEFORE
1941 Humphrey Bogart's performance in *The Maltese Falcon* provides the inspiration for the character of Michel in *À bout de souffle*.

AFTER
1964 Owing much of its style to *À bout de souffle*, Richard Lester's Beatles movie, *A Hard Day's Night,* has a huge influence on British movies.

1967 Arthur Penn's *Bonnie and Clyde* introduces the French New Wave style to mainstream US cinema.

Jean-Luc Godard's *À bout de souffle* (*Breathless*) marked a turning point in cinema. Not everyone liked its hectic cutting, loose plot, and disdain for conventional morality. But even Godard's critics were struck by his innovation, and directors such as Scorsese and Tarantino have acknowledged their debt to him.

In the movie, petty thug Michel (Jean-Paul Belmondo) shoots a policeman. He hides in the apartment of American student Patricia (Jean Seberg), who is unaware of what he's done. Eventually, Patricia turns Michel in to the police, who shoot him in the street.

Godard has spent his life confronting issues central to the future of cinema.
Derek Malcolm
The Guardian, 2000

Before he began directing, Godard was a critic for the radical movie magazine *Cahiers du Cinema*, and he pays homage to earlier movies again and again in *À bout de souffle*. For example, Michel idolizes Humphrey Bogart and has a giant poster of him on his wall.

But for all his references, Godard and the other young filmmakers of what came to be known as the French *Nouvelle Vague* (New Wave), such as François Truffaut and Claude Chabrol, were determined to overthrow what they saw as *cinéma de papa* (dad's cinema)—studio-bound productions with little to say about modern life. Rather, they saw themselves not simply as directors but as *auteurs*, who would create a new, personal style of cinema, filming on location and tackling tough social issues.

A gun and a girl
Godard was adamant that a movie did not need a well-constructed plot. "All you need for a movie," he famously said, "is a gun and a girl." The story of *À bout de souffle* is loosely based on the real-life story of Michel Portail, who shot dead a motorcycle cop in 1952 and who, like the character of Michel in the

❝I don't know if I'm unhappy because I'm not free, or if I'm not free because I'm unhappy.❞

Patricia / À bout de souffle

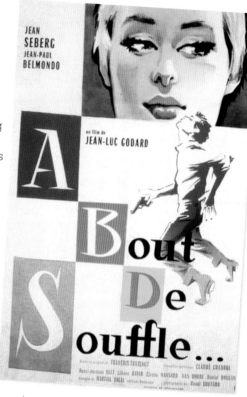

movie, also had an American girlfriend, but Godard wrote the script as he filmed.

He was deliberately chaotic in his shooting method, filming on busy Paris streets, snatching shots on the run, and improvising dialogue. To work in this way, he needed to shoot with a handheld camera and in low light conditions, and this is partly what gives the movie its high contrast monochrome look. It also led to a distinctive new cinematic technique: the jump cut.

Jump cuts

Previously, one of the requirements for a well-made movie had always been complete continuity between clips shot from different angles or on different days. However, Godard made no attempt to make a smooth transition between shots, splicing them together in a fast-moving montage. In one scene that follows Patricia driving in a sports car, the background jumps instantly from one place to another as different shots are spliced together. The jump cut has now become a staple of filmmaking, but at the time critic Bosley Crowther complained that it was a "pictorial cacophony."

It was not just the movie's jump cuts that created controversy, but also its coolness. Its young hero's self-obsessed detachment and disdain for authority became hallmarks of movie for the new generation. As the 1960s began, filmmakers and audiences embraced rebellion over the self-sacrificing heroism portrayed in previous decades. ▪

À bout de souffle was the first movie of the French New Wave. Its bold visual style and break from the classic studio style were implied in the movie's poster.

Jean-Luc Godard Director

Jean-Luc Godard was born in Paris in 1930. In his early 20s, he joined Paris's ciné-club scene and took up film criticism. Encouraged by François Truffaut, another young critic turned filmmaker, Godard began to make his own movies. His first major movie, *À bout de souffle*, took the world by storm with its new style. But Godard's work soon became even more radical, both in look—with movies such as *Contempt*, *Band of Outsiders* (1964), and *Alphaville* (1965)—and politically, in movies such as *A Married Woman* and *Pierrot le Fou* (1965). In the late 1960s, Godard walked away from commercial cinema completely, but continued to make movies that pushed the boundaries of the medium.

Key movies

1960 *À bout de souffle*
1963 *Contempt*
1964 *A Married Woman*

THAT'S WHAT ALL THESE LOONY LAWS ARE FOR, TO BE BROKEN BY BLOKES LIKE US

SATURDAY NIGHT AND SUNDAY MORNING / 1960

IN CONTEXT

GENRE
British New Wave

DIRECTOR
Karel Reisz

WRITER
Alan Sillitoe

STARS
Albert Finney, Shirley Anne Field, Rachel Roberts

BEFORE
1947 Robert Hamer's *It Always Rains on Sunday*, a gritty tale set in London's East End, is a precursor of the British realist dramas.

1959 *Look Back in Anger*, directed by Tony Richardson and based on a play by John Osborne, is the first British "kitchen sink" drama movie.

AFTER
1965 Starting with his TV docudrama *Up the Junction*, Ken Loach makes a series of movies mixing working-class drama with documentary.

Karel Reisz's *Saturday Night and Sunday Morning* brought working-class Britain to the screens in a way that had never been seen before. Based on a semiautobiographical novel by Alan Sillitoe, who also wrote the screenplay, the movie focuses on the story of young Arthur, who wants more out of life than a factory job. This was one of the first British movies to focus on the working class not as victims, but as individuals with their own aspirations and frustrations. Reisz was a leader of the British New Wave of filmmakers that paralleled the French New Wave. Both

Doreen and Arthur meet in secret. While they rebel against their parents, whom they consider "dead from the neck up," they are not immune to reality when Arthur gets another girl pregnant.

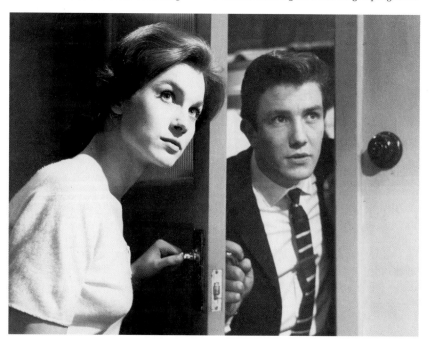

What else to watch: *Look Back in Anger* (1959) ▪ *À bout de souffle* (1960; pp.166–67) ▪ *The Loneliness of the Long Distance Runner* (1962) ▪ *Billy Liar* (1963) ▪ *This Sporting Life* (1963) ▪ *Alfie* (1966) ▪ *Kes* (1969, p.336) ▪ *Naked* (1993, p.340–41)

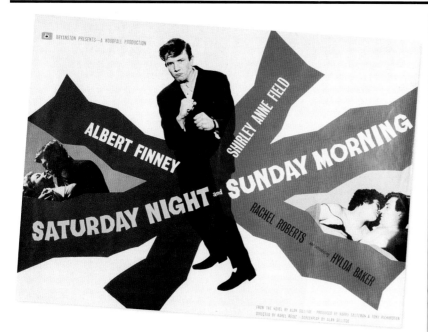

The poster style was influenced by that of the French movie *À bout de souffle,* made in the same year.

movements aimed for a more authentic approach to filmmaking by venturing out of the studio and into real locations.

British New Wave filmmakers, however, were less concerned with innovative cinematography than their French peers. The realism they sought was in their subject matter: the personal lives of the working class. The first of these "kitchen sink" dramas on film was *Look Back in Anger* (1959), adapted from John Osborne's play. It spawned the so-called Angry Young Man movie genre of the 1960s, featuring working-class heroes.

Yet while *Look Back in Anger* is relatively theatrical, *Saturday Night and Sunday Morning* is matter-of-fact, almost documentary, in its depiction of the troubled lives of its characters. It pulls no punches

in its inclusion of adultery, abortion, drunkenness, and violence as everyday realities. Fifty years on, such dramas are the staple of British television soaps, but in 1960 they were new. Arthur, brilliantly

portrayed by Albert Finney, is determined not to be diminished by the limitations of life as a lathe operator at a bicycle factory in Nottingham. He rebels against the drudgery of his class.

Bucking expectations

Despite his declaration "That's what all these loony laws are for, to be broken by blokes like us," Arthur is neither a political rebel nor a criminal. He simply bucks expectations by having an affair with Brenda (Rachel Roberts), the wife of an older colleague, while two-timing her with young Doreen (Shirley Anne Field). Even this small personal rebellion is brought low by reality when Brenda becomes pregnant and is forced into an abortion, and Arthur is beaten up by Brenda's husband and his soldier friends. Yet Arthur's spirit is not crushed, and although harrowing, the film is ultimately uplifting. ▪

❝What I'm out for is a good time—all the rest is propaganda!❞

Arthur Seaton / *Saturday Night and Sunday Morning*

Karel Reisz Director

Born in Ostrava, Czechoslovakia, in 1926, Karel Reisz was sent to Britain when he was 12, just before Nazi Germany invaded his country in 1939. His parents died in Auschwitz. He served in World War II and studied chemistry at Cambridge, then became a film critic. Reisz led the Free Cinema movement, which strived for a less class-bound, more politically aware British cinema, and began to direct his own movies in 1960.

Key movies

1960 *Saturday Night and Sunday Morning*
1964 *Night Must Fall*
1981 *The French Lieutenant's Woman*

I HAVE NEVER STAYED SO LONG ANYWHERE
LAST YEAR AT MARIENBAD / 1961

IN CONTEXT

GENRE
Experimental

DIRECTOR
Alan Resnais

WRITER
Alain Robbe-Grillet

STARS
Delphine Seyrig, Giorgio Albertazzi, Sacha Pitoëff

BEFORE
1955 *Night and Fog* is Resnais' contemplation of the memory of the Nazi concentration camps.

1959 *Hiroshima mon amour*, Resnais' first big success, deals with memory and forgetfulness in the wake of the Hiroshima bomb.

AFTER
1977 *Providence*, Resnais' movie about the memories of an aging writer, is hailed in France as a masterpiece but panned by critics in the US.

Beautifully shot in black and white and in widescreen, Alan Resnais' *Last Year at Marienbad* has a glacier-paced coolness. Lacking any conventional narrative, it deliberately challenges preconceptions about how movies should work. This approach has influenced a generation of directors, including Stanley Kubrick, David Lynch, and Peter Greenaway.

The movie is set in a palatial hotel in rural central Europe. Here, a handsome stranger known only as X (Giorgio Albertazzi) insists to a beautiful fellow guest, known as A (Delphine Seyrig), that they met and fell in love the previous year in the resort of Marienbad, where she agreed to leave her husband M (Sacha Pitoëff) the following year. A denies his claims, but X persists, in between playing rounds of the mathematical game Nim with M, which M always wins.

For Resnais, the movie was an exploration of time and memory. The script, written by experimental novelist Alain Robbe-Grillet, fuses past and present in a series of surreal, almost nightmarishly repetitive tableaux. Resnais turns these scenes into a dreamlike world in which all is reduced to appearances and games of mirrors. Life goes on in a seemingly ritualistic way, full of allusions and symbols that leave the viewer continually

Alain Resnais Director

Born in Vannes in Brittany in 1922, French filmmaker Alain Resnais continues to divide critics. Later in life he focused more on farce and comedy, but in the first half of his career he worked with leading modern writers such as Alain Robbe-Grillet and Marguerite Duras to create enigmatic and poetic movies about time and memory, which some celebrate as masterpieces and others find pretentious. Resnais died in 2014.

Key movies

1959 *Hiroshima mon amour*
1961 *Last Year at Marienbad*
1977 *Providence*

What else to watch: *Un Chien Andalou* (1929, p.330) ▪ *L'Avventura* (1960) ▪ *La Dolce Vita* (1960, pp.160–65) ▪ *Pierrot le Fou* (1965) ▪ *The Shining* (1980, p.339) ▪ *The Draughtsman's Contract* (1982) ▪ *Open Your Eyes* (1997) ▪ *Flowers of Shanghai* (1998)

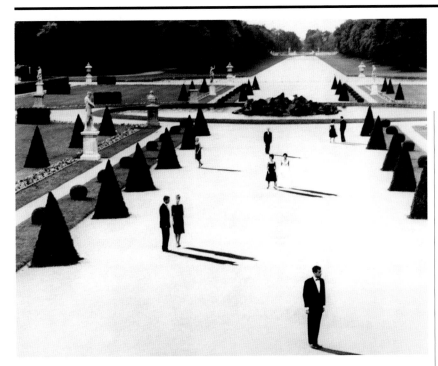

> ❝I must **have you** alive. **Alive**, as you have already been **every evening**, for **weeks**, for **months**.❞
>
> **X / Last Year at Marienbad**

This famous scene, in which the figures cast shadows but the trees do not, highlights the dreamlike, unreal nature of *Last Year at Marienbad*, and of much of Resnais' work generally.

The midnight chime that opens the movie is heard again at the end, echoing life's endless loop of acceptance and rejection, as X is rejected by A, and vice versa. As A says, "I have never stayed so long anywhere." Famously, Robbe-Grillet has stated that "the entire story of *Marienbad* happens neither in two years nor in three days, but exactly in one hour and a half"—that is, the time span of the movie.

Last Year at Marienbad has been interpreted in various ways, in terms of Jungian or Freudian psychology, and using poststructuralist analysis, but agreement on the movie's meaning is rare. Nevertheless, for many critics, it is a high point of the experimental fervor that drove the French New Wave to expand the possibilities and goals of filmmaking in the late 1950s and early 1960s, and it remains influential to this day. ▪

unsettled, unsure whether it's all in X's head, or A's. The movie is a continual interplay of reality and illusion. In one famous scene, shot on an overcast day when the trees cast no shadows, the people arranged elegantly along an avenue all project long shadows across the ground. To achieve this effect, actors' shadows were painted onto the ground.

Story of a persuading

Resnais said that the movie's effects were an attempt to recreate the way the mind works, while Robbe-Grillet insisted that viewers will get lost if they look for a linear narrative. "The whole film, as a matter of fact, is the story of a persuading [*une persuasion*]," according to Robbe-Grillet. "It deals with a reality which the hero creates out of his own vision."

There is no sense of time or the story moving forward—the plot, such as it is, is circular and repetitive.

Delphine Seyrig, playing A, was memorably costumed for the role by fashion legend Coco Chanel.

THIS IS THE STORY OF A MAN MARKED BY AN IMAGE FROM HIS CHILDHOOD

LA JETÉE / 1962

IN CONTEXT

GENRE
Science fiction

DIRECTOR
Chris Marker

WRITER
Chris Marker

STARS
Jean Négroni, Davos Hanich, Hélène Chatelain, Jacques Ledoux

BEFORE
1953 Marker works with director Alain Resnais on the controversial movie about African art, *Statues Also Die*.

AFTER
1977 In *A Grin Without a Cat*, Marker documents political radicalism in the aftermath of the student revolts of 1968.

1983 Marker stretches the documentary genre with *Sans Soleil*, a meditation on world history and the inability of the human memory to recall context and nuance.

La jetée (*The Pier*), by the enigmatic director Chris Marker, is a science-fiction classic that retains its power to chill and unsettle, despite being overshadowed by its big-budget remake: Terry Gilliam's *12 Monkeys* (1995). The two movies could not, however, be more different.

Less than 30 minutes long, and with a narrative composed entirely from still photographs, *La jetée* is about a man traveling back in time to witness a tragic and defining event from his childhood.

A half-forgotten dream

The postapocalyptic world portrayed in *La jetée* disturbs with subtlety. A softly spoken voice-over narration puts the viewer in the protagonist's place as he overhears amoral scientists whispering and muttering their plans—the movie's only dialogue. It is in this stillness and quietness that the terror lies.

La jetée uses time travel as a device to examine the philosophical nature of memory. The protagonist witnesses and participates in moments from the past—a trip to a museum, a romantic encounter, and, most importantly, the traumatic early event that shaped his character— yet feels that his awareness of the event dilutes its reality. The movie implies that once something is in the past, it only exists in a glimpse, or as a photograph, hence the movie's stylistic structure of using still images. *La jetée* balances the emotional journey of its protagonist with this thematic intellectualism to create one of the most distinct imaginings of the end of the world that cinema has ever offered. ∎

❝The man doesn't die, nor does he go mad. He suffers. They continue.❞

Narrator / *La jetée*

What else to watch: *The Omega Man* (1971) ▪ *Soylent Green* (1973) ▪ *Mad Max* (1979) ▪ *12 Monkeys* (1995) ▪ *The Road* (2009)

GUY, I LOVE YOU. YOU SMELL OF GASOLINE
THE UMBRELLAS OF CHERBOURG / 1964

IN CONTEXT

GENRE
Musical

DIRECTOR
Jacques Demy

WRITERS
Jacques Demy

STARS
**Catherine Deneuve,
Nino Castelnuovo**

BEFORE
1931 Marcel Pagnol's trilogy, *Marius*, *Fanny*, and *César*, inspires Demy's trilogy of seaside movies.

1958 Vincente Minnelli's musical *Gigi* is an American view of France that Demy cleverly parodies in *The Umbrellas of Cherbourg*.

AFTER
1967 Demy's *The Young Girls of Rochefort* unites Catherine Deneuve with Gene Kelly.

2001 Baz Luhrmann recreates a French musical fantasy world in *Moulin Rouge!*

The second in a trilogy directed by Jacques Demy, *The Umbrellas of Cherbourg* (1964) is an innovative movie that combines the fantasy of a Hollywood musical with the French New Wave's focus on the everyday.

Demy's insight was to see that the ordinary people being filmed by New Wave directors had dreams and aspirations as romantic as anyone's. He took a simple story of thwarted love in a small town, and turned it into a musical fantasy. The story hinges on such New Wave concerns as teen pregnancy and prostitution, but Demy tells it in song, on cotton-candy sets.

Catherine Deneuve plays Geneviève, the daughter of an umbrella-store owner. She is bursting with love for a young mechanic, Guy (Nino Castelnuovo). When he is shipped off to fight in Algeria, there is an extended train-platform farewell, underpinned by the movie's soaring theme tune. But Geneviève's story is a story of real life. She learns that she's pregnant, Guy fails to write back,

The beautiful Geneviève works with her mother in their failing umbrella store. The music is by Michel Legrand, and all the dialogue is sung.

and she is persuaded to marry a rich jeweler to save her mother from financial ruin. Years later, she and Guy meet by chance. By this time he is married and has a son. The pair's exchange is almost mundane, but the swooning music creates a moment of true heartache for the life that might have been. ■

What else to watch: *Singin' in the Rain* (1952, pp.122–25) ▪ *Gigi* (1958) ▪ *The 400 Blows* (1959, pp.150–55) ▪ *The Young Girls of Rochefort* (1967)

THERE'S GOLD IN THE SEA BEYOND
BLACK GOD, WHITE DEVIL / 1964

This movie is Glauber Rocha's fictionalzed account of the adventures of real-life bounty hunter Antonio das Mortes.

IN CONTEXT

GENRE
Drama

DIRECTOR
Glauber Rocha

WRITER
Glauber Rocha

STARS
Geraldo Del Rey, Yoná Magalhães, Maurício do Valle, Lidio Silva

BEFORE
1962 In Rocha's debut feature, *Barravento*, a man struggles to rid his home village of the reactionary mysticism he thinks is holding it back.

AFTER
1966 Italian director Sergio Corbucci's *Django*, a bleakly savage spaghetti Western, owes a clear debt to Rocha.

1970 Chilean director Alejandro Jodorowsky's *El Topo* features a gunslinger on a transformative journey across the desert.

Director Glauber Rocha once said that "Everybody wants to kill Glauber Rocha. They did not forgive me for making *Black God, White Devil* at the age of 23." It was not simply his precociousness or lack of humility that put his life in jeopardy; a fierce pioneer of social realism, Rocha saw movies as a tool of change and an integral part of the working man's struggle. Indeed, shortly before his movie was released in his native Brazil, a coup ushered in a military government whose actions later drove him into self-imposed exile.

Committed cinema
Rocha despised Hollywood, and it shows: it's hard to believe that this abrasive movie was released in the same year as *Mary Poppins*. Like his debut, *Barravento*, it is more concerned with ideas than action or character, and it continues the earlier movie's exploration of religion.

Sebastião (Lidio Silva), a preacher, is rallying the poor of the *sertão*, the barren outback of north Brazil. A humble ranch hand named Manuel (Geraldo Del Rey) believes the preacher is the incarnation of Saint Sebastian, but his wife, Rosa (Yoná Magalhães), is more sceptical and frequently challenges Manuel's belief in the man he follows.

Manuel tries to improve his and Rosa's lot in life by selling his cattle to his boss, but several die on the way to market, and the boss refuses to pay. In a fury, Manuel kills his boss with a machete, and he and Rosa go on the run, following the charismatic and increasingly powerful Sebastião, the "black god," who promises

Glauber Rocha Director

Born in Bahia, Brazil, in 1939, Glauber Rocha discovered movies, politics, and journalism in his teens, quitting law school to pursue filmmaking at 20. Inspired by the French New Wave, he led Brazil's *Cinema Novo* (New Cinema) movement of the 1960s, and competed in the 1964 Cannes film festival with *Black God, White Devil*. This was the first in a class-conscious trilogy that continued with *Entranced*

Earth and *Antonio das Mortes*. Exile in the 1970s saw Rocha shooting in Africa and Spain, and though his views and his experimental style were controversial, he remained a hero at home. Within a year of his final movie, *The Age of the Earth* (1980), he died of a lung infection at 42.

Key movies

1964 *Black God, White Devil*
1967 *Entranced Earth*
1969 *Antonio das Mortes*

salvation and the day when "the dry lands will turn into sea and the sea into dry land." Rosa continues to question the preacher's banal utterances, but Manuel follows blindly, carrying out ever more mindless and brutal tasks to satisfy his new master. The Church hierarchy, alarmed by Sebastião and the massacres that are engulfing the region, turn to bounty hunter Antonio das Mortes (Maurício do Valle) to eliminate him.

Absurdist turn

Sebastião is killed, and the fugitive couple press on, stumbling into a camp run by the vicious Captain Corisco (Othon Bastos), the movie's "white devil," who rechristens Manuel "Satan" and folds him into his shambolic army of bandits. At this point, the style of the movie

Manuel (Geraldo Del Rey) carries a rock on his head as he climbs Monte Santo on his knees, in thrall to the preacher Sebastião (Lidio Silva). The rock is loaded with symbolism.

changes dramatically, and what began as a neorealist drama mutates into an increasingly experimental and surreal polemic, more in the absurdist vein of playwright Samuel Beckett than the politically committed drama of Bertolt Brecht, who was a big

influence on Rocha. As the movie draws to a close, the black-clad figure of das Mortes has the almost totally insane Corisco in his sights.

Rallying cry

Sadly, time has not been too kind to Rocha's movie. The acting often seems mannered or, worse, simply amateur, while the undoubted passion of the director's vision boils over into moments of thundering melodrama, hammered home by a sometimes overly bombastic score by composer Heitor Villa-Lobos. But in his strange compositions, complete with crash zooms and jump cuts, Rocha created a unique rallying cry for land and liberty, exposing the way that workers are manipulated by church and state alike.

"A man is a man when he uses his gun to change his fate," says Corisco. "Not a cross [but] a dagger and a rifle." ▪

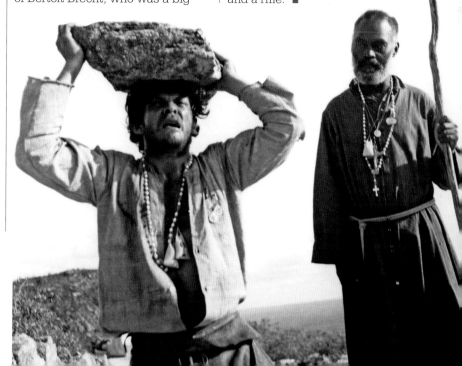

GENTLEMEN, YOU CAN'T FIGHT IN HERE. THIS IS THE WAR ROOM!
DR. STRANGELOVE / 1964

IN CONTEXT

GENRE
Black comedy

DIRECTOR
Stanley Kubrick

WRITERS
Stanley Kubrick, Terry Southern (screenplay); Peter George (novel)

STARS
Peter Sellers, George C. Scott, Sterling Hayden, Slim Pickens

BEFORE
1957 In Kubrick's *Paths of Glory*, a World War I officer defends his men from false charges.

1962 *Lolita* is Kubrick's first collaboration with Peter Sellers.

AFTER
1987 The military's absurdities are again targeted by Kubrick in *Full Metal Jacket*.

I n 1963, Stanley Kubrick decided to make a movie about the Cold War, which was heating up at the time. The West and its enemies in the Eastern Bloc had been locked in a staring contest for almost two decades, and the superpowers were getting twitchy; if either side blinked, everybody died in a thermonuclear holocaust. This was the basis of "mutually assured destruction," the military strategy for peace that was beginning to sound like a grim promise of oblivion. The Cuban Missile Crisis had been averted a year before, but only just—surely the apocalypse was coming?

Cold War satire

When *Dr. Strangelove* opened to an unsuspecting public in January 1964, Kubrick invited audiences to see this doomsday scenario played out on the big screen—and he expected them to laugh. Originally, the filmmaker had intended to produce a straight thriller based on *Red Alert*, Peter George's 1958 novel about a US Air Force officer who goes crazy and orders his planes to attack Russia. But, as he worked on the screenplay with writer Terry Southern, Kubrick found the politics of modern warfare too absurd for drama; he felt that the only sane way to get across the insanity of accidental self-destruction was a farce.

In Kubrick and Southern's screenplay, the plot of *Red Alert* is given a nightmarish comic spin. The novel's madman becomes Jack D. Ripper (Sterling Hayden), an American general who blames his sexual impotence on a communist plot to poison the water

> **"Gee, I wish** we had one of those **Doomsday Machines."**
> **General Turgidson** / *Dr. Strangelove*

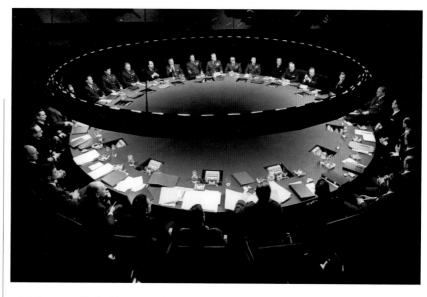

The War Room, vast, impersonal, and punctuated by the ominous circular table with its hovering ring-shaped lighting, was designed by Ken Adam as an underground bunker.

supply with fluoridation. Ripper sends a fleet of bombers to destroy the Soviet Union, and then sits back to wait for Armageddon.

Sexual metaphors

Dr. Strangelove is a political satire, but it's also a sex comedy about the erotic relationship between men and war—the "strange love" of the title. The movie, which is subtitled *How I Learned to Stop Worrying and Love the Bomb*, opens with the romantic ballad *Try A Little Tenderness* and ends with Vera Lynn singing *We'll Meet Again* over an orgasmic montage of atomic explosions, ignited by the nuclear bomb ridden by Major "King" Kong (Slim Pickens),

which sets off the Russians' Doomsday Device. Kubrick's stark black-and-white imagery bristles with man-made erections, from nukes, gun turrets, and pistols to General Ripper's thrusting cigar. "I do not avoid women," he explains to the RAF's Group Captain Mandrake (Peter Sellers), blowing mushroom clouds of smoke, "but I do deny them my essence."

General "Buck" Turgidson (George C. Scott) imitates a low-flying B52 "frying chickens in a barnyard."

This is a man's world, in which everyone gets off on mass destruction. The shadowy Dr. Strangelove (Peter Sellers again) wields a tiny cigarette, which may tell us everything we need to know about his motivations. Formerly known as Dr. Merkwürdigliebe, Strangelove is a German émigré scientist. The models for Strangelove were Nazi rocket scientists now in the US, such as Wernher von Braun. He has a mechanical arm with a mind of its own—whenever talk turns to mass slaughter or eugenics, it rises involuntarily in a Nazi salute. Strangelove has trouble keeping this particular erection under control, and at the prospect of the world blowing up, he jumps out of his wheelchair with a shriek of joy. "Mein Führer," he ejaculates, »

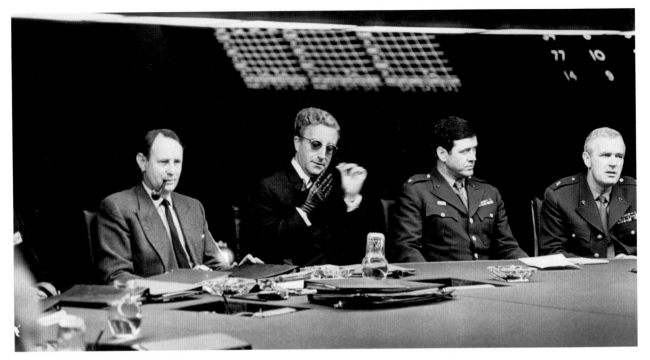

Dr. Strangelove's sinister black glove, worn on his errant right hand, was Kubrick's own, which he wore to handle the hot lights on set.

"I can walk!" He is literally erect: sexually awakened, potent, and about to see his Nazi plan for a supreme race of humans, where there are 10 women for every man, put into action.

There is only one female character in the movie, Tracy Reed, who plays Miss Scott, General Turgidson's mistress-secretary and also the centerfold "Miss Foreign Affairs" in the June 1962 copy of *Playboy*, which Major Kong is seen reading in the cockpit at the start of the movie. In what was one of a number of "insider" references throughout the movie, the issue of *Foreign Affairs* draped over her buttocks contained Henry Kissinger's article on "Strains on the Alliance." The mix of sexual and military connotations persist between Miss Scott and General Turgidson. When

their tryst is put on hold due to the crisis, she is instructed to wait: "You just start your countdown, and old Bucky'll be back here before you can say... Blast Off!"

Many of the characters' names refer to themes of war, sexual obsession, and dominance, from the obvious Jack D. Ripper (prostitute murderer Jack the Ripper) to Ambassador Alexi de Sadesky

Dr. Strangelove outraged the Pentagon, though it was unofficially recognized to be a near-documentary.
Frederic Raphael
The Guardian, 2005

(Marquis de Sade). The bombs, too, have been named "Hi There" and "Dear John," signifying the beginning and ending of a romantic relationship.

Superpower egos
In addition to Mandrake and Strangelove, the mercurial Sellers plays a third role: President Merkin Muffley (another sexual innuendo), who attempts to manage the crisis from his war room. In this vast, echoing forum, the US leader meets with an all-male cabal of diplomats, soldiers, and special advisers to decide the future of humanity.

The movie's central comic set piece involves Muffley telephoning Kissoff, the Soviet Premier, to warn him about the imminent attack; Kissoff is drunk at a party, and the conversation descends into petty squabbling. Sellers' monologue is hilarious, but also terrifying, because the "red telephone" had only recently become a reality. The hotline

❝ **I'm not saying** we won't get our **hair mussed**. But I do say **no more** than ten to twenty **million** killed, tops.❞

General Turgidson / **Dr. Strangelove**

between Washington and Moscow had been set up in 1963, and Kubrick's movie nudged the concept toward its logical conclusion: a Cold War reduced to the vying for dominance of two men's wounded egos. "Of course it's a friendly call," Muffley pouts into the receiver, "if it wasn't friendly then you probably wouldn't even have gotten it." These jokes must have chilled the blood of contemporary viewers, and they still unnerve today.

A less sophisticated spat occurs later in the movie, between the gum-chewing General "Buck" Turgidson (George C. Scott) and the Russian ambassador (Peter Bull): the Cold War reduced even further, to a schoolboy scuffle. "Gentlemen,

you can't fight in here," says a horrified Muffley, "This is the War Room!" It is silly, clever, and, deep down, full of rage. Kubrick clearly hated these characters; the men in *Dr. Strangelove* are a bunch of clowns, pathetic and deluded, and the director originally intended to end his movie with an epic cream-pie battle. He filmed the sequence, then changed his mind, and swapped the pies for nuclear warheads, in case anyone thought these clowns might be harmless. ∎

The poster for the movie shows the presidents of the two most powerful countries in the world, who squabble over the telephone like children. They are powerless to prevent the nuclear catastrophe.

Stanley Kubrick
Director

Born in New York in 1928, Kubrick spent his early years as a photographer and a chess hustler. These two interests—images and logic—would inform his career as a movie director, which began in 1953 with *Fear and Desire*. Kubrick cast his analytical eye over several genres—historical epic (*Spartacus*), comedy (*Dr. Strangelove*), science fiction (*2001: A Space Odyssey*), period drama (*Barry Lyndon*), horror (*The Shining*)—giving them a unifying theme of human frailty. He was perhaps less interested in humans than he was in machines, not just the hardware of cinema but also society's obsession with technological progress. His unrealized final project, the science-fiction epic *A. I. Artificial Intelligence*, would have offered his last word on this subject. It was filmed by Steven Spielberg in 2001, two years after Kubrick's death.

Key movies

1964 *Dr. Strangelove*
1968 *2001: A Space Odyssey*
1971 *A Clockwork Orange*
1980 *The Shining*

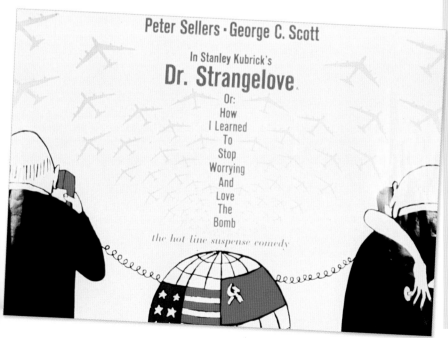

Peter Sellers · George C. Scott

In Stanley Kubrick's
Dr. Strangelove.
Or:
How
I Learned
To
Stop
Worrying
And
Love
The
Bomb

the hot line suspense comedy

I CAN'T SEEM TO STOP SINGING WHEREVER I AM

THE SOUND OF MUSIC / 1965

IN CONTEXT

GENRE
Musical

DIRECTOR
Robert Wise

WRITERS
Ernest Lehman (screenplay); Maria von Trapp (book); George Hurdalek, Howard Lindsay, Russel Crouse (stage musical)

STARS
Julie Andrews, Christopher Plummer, Eleanor Parker

BEFORE
1956 Ruth Leuwerik stars in *The Trapp Family,* a German adaptation of von Trapp's book.

1959 *The Sound of Music* opens on Broadway, composed by Richard Rodgers with lyrics by Oscar Hammerstein II.

AFTER
1972 The musical *Cabaret* is set in Berlin at the time of the Nazis' rise to power.

Today, screenings of *The Sound of Music* are often billed as sing-alongs, at which audiences who know every lyric enjoy a sense of shared nostalgia for the songs. Yet behind the fun there is a significant movie.

The story of a misfit postulant, Maria (Julie Andrews), who leaves her abbey to become governess to the seven unruly children of a stern widower, Captain Georg von Trapp (Christopher Plummer), unfolds in the bucolic, chocolate-box setting of the Austrian Alps. Maria's good humor and musical inventiveness win over the children and, gradually, the captain's heart. Set in 1938, and based on a true story, the movie continues to resonate, perhaps because it represents values that were almost extinguished in one of Europe's darkest periods.

Vulnerable innocence
The movie's first half focuses on Maria's acceptance into the von Trapp family and the dilemma she faces when the captain begins to fall in love with her, despite his engagement to an aristocratic socialite, Baroness Schraeder (Eleanor Parker). Distraught at

Robert Wise Director

Born in 1914 in Winchester, IN, Robert Wise was 19 when he got a job as a sound and music editor at RKO radio pictures, and he eventually became Orson Welles's editor on movies such as *Citizen Kane* (pp.66–71). Wise's first directing job was on *The Curse of the Cat People* (1944), and he went on to direct many notable B movies such as *The Day the Earth Stood* *Still* (1951) and *The Haunting* (1963). Later in life he worked on musicals, most famously making *West Side Story* and *The Sound of Music.* Wise died at 91 in 2005.

Key movies

1945 *The Body Snatcher*
1951 *The Day the Earth Stood Still*
1961 *West Side Story*
1965 *The Sound of Music*

What else to watch: *Singin' in the Rain* (1952, pp.122–25) ▪ *From Here to Eternity* (1953) ▪ *Gigi* (1958) ▪ *West Side Story* (1961, p.334) ▪ *The Haunting* (1963) ▪ *Mary Poppins* (1964) ▪ *Cabaret* (1972) ▪ *Les Misérables* (2012)

Captain von Trapp is bemused to find his seven children dripping wet and dressed in loose-fitting clothes made by their governess, Maria, out of the floral drapery in her room.

the situation she has created, Maria flees back to the abbey, but the abbess encourages her to return to her new home. To the children's delight, the captain marries her, and the movie might have ended happily there. Instead, however, it continues in a markedly different tone, its focus shifting from the family's domestic situation to its place in the wider world. As the Nazi *Anschluss* of Austria threatens to sweep away all they cherish, their fate becomes linked with that of the country.

The danger is most poignantly represented by Rolfe (Daniel Truhitte), a local boy who is in love with von Trapp's eldest daughter Liesl (Charmian Carr). Rolfe's arrival one day in a Nazi uniform shocks both the family and the audience, and serves to demonstrate the way in which innocent youth can be corrupted and turned to malign ends. The captain tells him, "They don't own you," revealing his fear of what is happening to the country and its people, and reminding Rolfe that he has free will. But Rolfe nevertheless betrays the family.

Songs of comfort

Much of the singing in *The Sound of Music* is about finding joy in the ordinary and the commonplace, but in several instances the songs are used to overcome fear or to ward off danger. *My Favorite Things* is sung when Maria tries to calm the children during a violent storm, and in the final set piece, when the family performs on stage at a festival in Salzburg, they are singing to buy time as danger closes in around them. While Nazi officers watch from the front row, there are soldiers waiting in the wings to prevent the family's escape and to force Captain von Trapp into military service the moment the show is over.

The movie's overwhelming optimism does not simply derive from the hills being "alive with the sound of music" (in the words of the titular song), but from its message that honesty and goodness are defenses against evil. When Captain von Trapp rouses the festival audience to sing *Edelweiss*, a tender song about the Alpine flower that symbolizes Austria, he is affirming his loyalty to a country that has been annexed by a ruthless foreign power, and standing up in defense of everything that he sees as decent and good.

In a sense, then, Maria and the captain are protecting not only their children, but a whole way of life, and their final escape over the mountains carries the hope that this way of life will survive. ▪

❝When the Lord **closes a door, somewhere** He **opens a window.❞**

Maria / The Sound of Music

IT'S DIFFICULT TO START A REVOLUTION

THE BATTLE OF ALGIERS / 1966

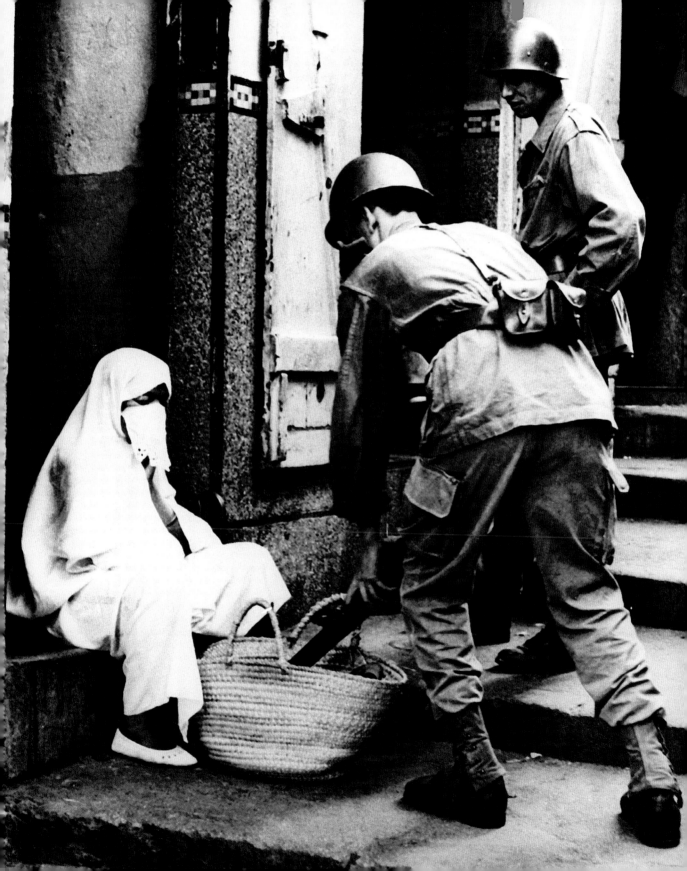

IN CONTEXT

GENRE
War, political

DIRECTOR
Gillo Pontecorvo

WRITERS
**Gillo Pontecorvo,
Franco Solinas**

STARS
**Jean Martin, Brahim
Hadjadj, Yacef Saadi**

BEFORE
1960 Pontecorvo's movie *Kapò*
is one of the first attempts
to depict the horrors of the
Holocaust on screen.

AFTER
1969 Pontecorvo's *Burn!* stars
Marlon Brando as a British
agent who manipulates a
slave revolt on a Caribbean
island to pervert it in the
interests of big business.

2006 Ken Loach's *The Wind
that Shakes the Barley* tells the
story of Republican fighters in
the Irish War of Independence.

There are many ways to tackle war and political strife in fiction. Filmmakers can approach it from a humanist perspective, following civilians as the external conflict escalates around them, or follow rank-and-file soldiers as they carry out their duties, and examine the moral crises they face in doing so.

The majority of movies about conflict tend to take one of these two perspectives. *The Battle of Algiers*, however, adopts a journalistic perspective instead to follow Algeria's attempts to gain independence from the French. That is to say, it approaches the conflict forensically, its narrative following the progression of significant events. While it does have prominent figures in its narrative, particularly Ali La Pointe, one of the leaders of the Algerian resistance, it is not the story of any one individual. The movie is,

With its use of documentary-style filming techniques, the movie's large crowd scenes resemble real newsreel footage.

as the title suggests, the story of the Battle of Algiers. Director Gillo Pontecorvo's camera mimics that of a photojournalist on the streets, capturing events from an objective remove.

Minute by minute

00:10
While in prison in 1954, Ali La Pointe witnesses the execution of a man who shouts out independence slogans. Five months later, he joins the FLN.

00:36
In response to the killing of police by the FLN, the police chief plants a bomb in the casbah, which kills a number of children.

00:55
Colonel Mathieu arrives in Algiers to take charge of the operation against the FLN. He plans Operation Champagne to take place during a strike called by the FLN.

01:44
The FLN leader Djafar surrenders. However, Ali La Pointe is still free.

| 00:00 | 00:20 | 00:40 | 01:00 | 01:20 | 01:40 | 2:02 |

00:18
It is 1956 and the FLN announces bans on alcohol, drugs, and prostitution. It enforces the new rules within the casbah.

00:41
Following the bombing of the casbah, three FLN women in Western clothing plant bombs. One is in a bar, another at a disco, and a third at the airport. They kill scores of people.

01:32
At a press conference, Mathieu praises FLN fighters, including arrested leader Ben M'Hidi, for their commitment to their cause.

01:52
After Ali La Pointe refuses to surrender, the Colonel blows up the house he is hiding in. He declares that "the head of the tapeworm has been destroyed."

What else to watch: *Battleship Potemkin* (1925, pp.28–29) ▪ *Kapò* (1960) ▪ *All the President's Men* (1976) ▪ *Reds* (1981) ▪ *Waltz with Bashir* (2008) ▪ *Zero Dark Thirty* (2012)

"Give us your **bombers**, and you can have our baskets."

Ben M'Hidi / **The Battle of Algiers**

The cost of terror

In its depiction of the horrors of conflict, *The Battle of Algiers* raises questions about right and wrong in war that are still relevant today. Pontecorvo portrays both sides very evenhandedly. The Algerian independence fighters, the FLN (National Liberation Front), lack the means or manpower to confront the occupying French military police in direct battle, so instead they resort to guerrilla warfare and terrorism. They employ children as messengers and have devout Muslim women Westernize their appearance in order to gain access to the European quarter. Their targets are not military, but rather civilian areas such as cafés and airports that are frequented by Europeans.

The sequence with the women is particularly telling as to the cost of the fight, as we watch while they cut off their hair, rid themselves of their hijabs and remove any trace of their cultural and religious identity for the greater good as they would see it. They kill random Europeans, upon whose faces the camera dwells before the blasts, but there is no triumphalism from the women—in their eyes, they are committing a necessary evil.

The French military make their own compromises with morality, as they resort to violent interrogation and torture in order to obtain the information required to bring the FLN down. The movie begins and ends with an Algerian man, tortured beyond comprehension, dressed humiliatingly in a French military uniform. Colonel Mathieu, the ranking officer in charge of bringing down the resistance movement, chastises one of the soldiers when they mock him for his appearance. This moment mirrors the later bombing, where Mathieu indicates that something of themselves—their pride, their moral high ground—has been given up in pursuit of victory. The movie views both sides' losses with »

Ali (Brahim Hadjadj, right) is recruited to the FLN by Djafar (Yacef Saadi, second left). Saadi fought with the FLN, and the character Djafar was partly based on Saadi himself.

> "
> *The Battle of Algiers*
> is a training film for
> urban guerrillas.
> **Jimmy Breslin**
> **New York Daily News, 1968**
> "

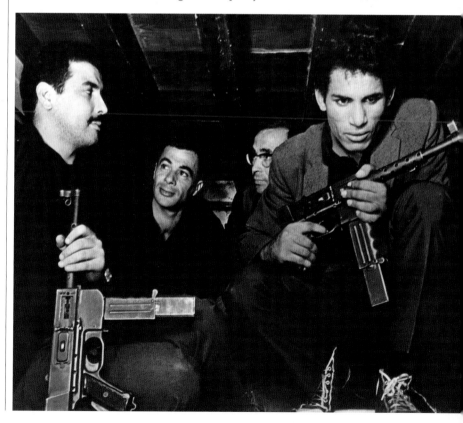

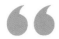

> How to win a battle against terrorism and lose the war of ideas. Children shoot soldiers at point-blank range. Women plant bombs in cafes. Soon the entire Arab population builds to a mad fervor. Sound familiar?
> **Poster for screening at the Pentagon, 2003**

equal regret, as the same mournful music is played over the massacred French civilians as the dead Algerians after military raids. It asks the question: what matters more in warfare, winning or keeping your soul in the process? And it asks the same question of both sides.

The role of the media

The Battle of Algiers poses several questions about the role of the media in modern warfare. Both sides seem to understand that just as important as winning the physical battles is winning the hearts and minds of the media and thus the world. After a series of violent and terrorist acts, the FLN decides that their next move will be a strike, in which all operatives are to lay down their weapons. The restless Ali questions this action, but is informed by his superior that to win the freedom they desire, they must make the transition in the world's eyes from terrorists to freedom fighters.

Mathieu's approach is similarly media conscious, and he confronts a room full of journalists about their "have their cake and eat it" attitude to the conflict. They disapprove of Mathieu's methods,

Colonel Mathieu (Jean Martin) is sent to Algiers to defeat the FLN in the wake of an escalation of violence from both sides.

but believe France should remain in Algeria. He points out that his methods are the only way to achieve that. He understands the pyramid cell structure of the FLN, and that torturing suspects is the only way to move up that pyramid to the leadership—as he puts it, to "cut off the head of the tapeworm."

The 20th century saw the world become a global community, in which advances in communication technology meant that no war could pass out of sight, no violent act be hidden. *The Battle of Algiers* proposes that winning a modern conflict is not necessarily about might. Mathieu is a stronger tactician than the FLN and gradually defeats the group on the ground, and yet, ultimately, Algeria still gains independence, because the FLN's action ignited public opinion about the country's right to self-determination. Mathieu won the battle in Algiers, but ultimately the French lost the war.

The nature of war

The Battle of Algiers is a movie about the Algerian struggle for independence, yet it is also a movie about the nature of conflict. Its themes are universal, and the

Key incidents in the Battle of Algiers

Barberousse prison → CASBAH
Ali La Pointe's hideout
Rue de Thèbes
Milk Bar
Stadium
EUROPEAN CITY
Cafeteria
Special interrogation (torture) unit

KEY
✹ FLN attack
✹ French attack
▪ Centers of French military operation

questions it poses about the lines people cross for what they believe are still extremely pertinent and difficult to answer. It is also perhaps the most clear-headed movie about war ever made, not swayed by the emotions that might cloud the issue, interested in the cold tactics of both sides without overtly demonizing either side. The movie clearly believes in Algeria's right to independence, but at the same time has respect for Mathieu's honesty, dignity, and competence. In the end, it even allows him a moment of decency as he pleads with Ali to allow the teenage boy in his company to leave the field of battle. This moment defines the whole movie. War is not simply about having a just cause. It is also about what we do in its name. ▪

Gillo Pontecorvo Director

Gillo Pontecorvo was born in Pisa, Italy in 1919. His first job in the movie industry was in Paris working as an assistant to Joris Ivens, a Dutch documentary filmmaker with Marxist views. Pontecorvo shared Ivens' politics, becoming a member of the Italian Communist Party in 1941. He was primarily a documentary filmmaker, and *The Battle of Algiers* was one of the few times Pontecorvo ventured into more overtly dramatic work. He remained true to his documentarian principles, however, hiring mostly nonprofessional actors, including the ex-FLN leader Yacef Saadi. Pontecorvo died from heart failure in Rome in 2006.

Key movies

1960 *Kapò*
1966 *The Battle of Algiers*
1969 *Burn!*
1979 *Ogro*

WHO WANTS TO BE AN ANGEL?

CHELSEA GIRLS / 1966

IN CONTEXT

GENRE
Experimental

DIRECTOR
**Andy Warhol,
Paul Morrissey**

WRITERS
**Andy Warhol,
Ronald Tavel**

STARS
**Nico, Brigid Berlin,
Ondine, Mary Woronov,
Gerard Malanga**

BEFORE
1963 *Sleep,* one of Warhol's
first experiments with "anti-
film," consists of five hours of
footage showing his friend
John Giorno sleeping.

1964 Warhol's *Empire* is an
eight-hour-long movie of the
Empire State Building at night.

AFTER
1968 *Lonesome Cowboys*
is Warhol and Morrissey's
raunchy take on *Romeo and
Juliet,* satirizing Westerns.

S oon after Andy Warhol
and Paul Morrissey's
experimental movie *Chelsea
Girls* was released in 1966, critic
Roger Ebert wrote, "Warhol has
nothing to say and no technique to
say it with." But few movies have
ever reflected so strongly the
moment in which they were made.

Chelsea Girls was a provocative
look at New York's counterculture.
To make the movie, Warhol and
Morrissey filmed the lives of his
friends as they did what came

It's the movies that have
really been running things
in America, ever since
they were invented.
Andy Warhol

naturally—talk, bitch, do drugs,
have sex, listen to music. This
eccentric clique became known
as the Warhol Superstars. They
included singer Nico, photographer
Gerard Malanga, and actor Ondine.
The title of the movie comes from the
Hotel Chelsea in Manhattan where
many of them hung out. Other
locations included Warhol's Factory
studio and various apartments.

Voyeur viewing
The camera was a deliberately
intrusive presence, and the movie
captures its subjects' narcissistic
relationships in an unsettling way.
The shooting is rough, so we are
always aware that they are being
filmed, a technique Warhol called
"anti-film." Warhol and Morrissey
ended up with twelve 33-minute
movies, half in color, and half in
monochrome, which they joined
together into a single split-screen
movie. As the audience's eyes flicker
between the screens, the effect is
to reinforce their role as voyeurs
watching these people during their
moment in the spotlight. ∎

What else to watch: *Scorpio Rising* (1963) ▪ *8½* (1963) ▪ *Blow-Up* (1966) ▪
Performance (1970) ▪ *I Shot Andy Warhol* (1996) ▪ *The Cremaster Cycle* (2002)

LET'S SEE THE SIGHTS!

PLAYTIME / 1967

IN CONTEXT

GENRE
Musical

DIRECTOR
Jacques Tati

WRITER
Jacques Tati

STAR
Jacques Tati

BEFORE
1949 *Jour de fête*, about a mailman who stops his rounds to enjoy a fête, is Jacques Tati's first major success.

1953 *Monsieur Hulot's Holiday* introduces Tati's most famous character Monsieur Hulot.

1958 *Mon Oncle* is Tati's first color movie, and wins him the Best Foreign Film Oscar.

AFTER
1971 *Traffic* is Tati's last Hulot movie.

2010 Sydney Chomet's *The Illusionist* is based on an unproduced script by Tati.

French comedian Jacques Tati combined a gift for sight gags and silent comedy with a unique and eccentric cinematic vision. His comic character Monsieur Hulot inspired huge affection.

There is little plot in *Playtime*, the third Hulot movie, and for many of Tati's masterpieces. It simply follows the encounters of Hulot and a group of American tourists during a day in Paris. But the Paris in the movie is Tati's own vision—he created it with a gigantic futuristic set that came to be called "Tativille."

Lost in Tativille
Tativille is a supermodernist view of the city, with mazes of straight lines and shimmering glass and interchangeable office spaces, in which the bumbling Hulot is lost again and again. In some ways, it is a satire on the dehumanizing effects of the cities of the future. And yet it is also a delightful celebration of the irrepressibility of the human spirit, and that spark of oddness that knocks uniformity a little out of line.

un film de jacques tati

At the time it opened, *Playtime* was the most expensive French movie ever made, due mainly to its huge, purpose-built set.

At one point, Hulot looks down on a vast floor of identical office cubicles. It looks at first like a nightmare vision. Yet Tati shot this movie on high-definition 70-mm movie, to be seen on a big screen, and if you look very closely, you can see here and there in the cubicles a few other Hulots with their trademark trilby hats. Hulot is not alone. ∎

What else to watch: *The General* (1926) ▪ *Modern Times* (1936) ▪ *Monsieur Hulot's Holiday* (1953) ▪ *Mon Oncle* (1958) ▪ *Being John Malkovich* (1999)

THIS HERE'S MISS BONNIE PARKER. I'M CLYDE BARROW. WE ROB BANKS

BONNIE AND CLYDE / 1967

IN CONTEXT

GENRE
Crime thriller

DIRECTOR
Arthur Penn

WRITERS
**David Newman,
Robert Benton**

STARS
**Warren Beatty, Faye
Dunaway, Gene Hackman**

BEFORE
1965 Arthur Penn and Warren
Beatty team up for the first
time with the Chicago-set
thriller *Mickey One*.

AFTER
1970 Faye Dunaway stars
opposite Dustin Hoffman
in Penn's Western *Little
Big Man*.

1976 In Penn's *The Missouri
Breaks*, Marlon Brando stars
as a ruthless lawman on the
trail of a gang of horse rustlers
led by Jack Nicholson.

Bonnie and Clyde marked
the arrival of a new
generation of American
directors whose freer style of
filmmaking was a departure from
the old studio conventions of
classical Hollywood. Expensive
productions such as *Cleopatra*
had flopped, bankrupting the
old Hollywood studio system,
which loosened the studios' grip
on production. Desperate financial
times meant greater creative
freedom, and everything about
Bonnie and Clyde, from the movie's
frequent use of unsettling close-ups
to its jagged editing style, was
designed to upset the status quo
of traditional filmmaking.

Arthur Penn's story of a young
couple on a bank-robbing rampage,
based on the real-life crime spree
of Clyde Barrow and Bonnie Parker
between 1932 and 1934, exhibits
a more realistic violence than had
previously been seen on screen.
It also treats its outlaw protagonists
sympathetically, giving them
an innocence and a naivety that
represented a new way of telling
stories about bad people.

Tabloid stars
The movie frames its characters as
tabloid newspaper stars, who are
first glamorized and then vilified.
As each of their escapades is
reported in the next day's press,

Arthur Penn Director

Arthur Penn
discovered an
interest in
theater when
stationed in
Britain during World War II.
His first movie was *The Left
Handed Gun*, a Western
starring Paul Newman, but
his first major success came
with *The Miracle Worker*, an
adaptation of a play about deaf

and blind activist Helen Keller
that he had previously directed
on stage. Penn's most prolific
years came in the late 1960s.
He died of heart failure in 2010,
on his 88th birthday.

Key movies

1966 *The Chase*
1967 *Bonnie and Clyde*
1970 *Little Big Man*

What else to watch: *The Defiant Ones* (1958) ▪ *À bout de souffle* (1960, pp.166–67) ▪ *Easy Rider* (1969, pp.196–97) ▪ *Badlands* (1973) ▪ *Taxi Driver* (1976, pp.234–39) ▪ *True Romance* (1993) ▪ *Natural Born Killers* (1994)

Bonnie (Faye Dunaway), Clyde (Warren Beatty), and even Clyde's brother Buck (Gene Hackman) see how the papers sensationalize the facts and exaggerate the crimes.

At first, Clyde laughs off the attention, and he and Bonnie take playful, gun-toting photos of themselves for the press, playing along with the media game and enjoying their celebrity. But as the law closes in, and the pair's situation becomes increasingly desperate, the barrage of lies told about them in the newspapers begins to wear Clyde down, most noticeably when an article falsely accuses him of robbing the Grand Prairie National Bank—which enrages him so much that he promises to actually do it.

The relentless attention of the media ultimately robs the two thieves of their sense of self,

Bonnie and Clyde pose for a photo with their hostage, Captain Frank Hamer (Denver Pyle). In real life, Hamer did not meet either of them until the day his posse killed them.

leaving them powerless to present their true selves to the world. Only as the movie nears its bloody end are they given a reprieve of sorts, when a short, charming poem Bonnie has written, telling of her pride in knowing a decent man like Clyde, is published in a newspaper. Their side of the story is told, just once.

Like other movies of the time, *Bonnie and Clyde* makes it hard for the viewer not to root for its amoral protagonists, sympathizing more with their media manipulation than the victims of their robberies. ▪

> **"**They'll **go down together** / They'll **bury them** side by side / To a few, it'll **be grief** / To the law, **a relief** / But **it's death** for Bonnie and Clyde.**"**
>
> **Bonnie Parker** / The Ballad of Bonnie and Clyde

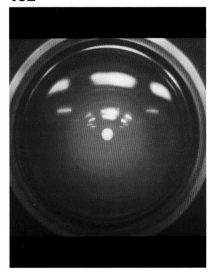

I'M SORRY, DAVE. I'M AFRAID I CAN'T DO THAT

2001: A SPACE ODYSSEY / 1968

IN CONTEXT

GENRE
Science fiction

DIRECTOR
Stanley Kubrick

WRITERS
Arthur C. Clarke, Stanley Kubrick

STARS
Keir Dullea, Gary Lockwood, William Sylvester, Douglas Rain

BEFORE
1964 *Dr. Strangelove*, Kubrick's Cold War black comedy, shows man's self-destructive nature.

1968 Franklin J. Schaffner's *Planet of the Apes* sends an astronaut (Charlton Heston) into the future.

AFTER
1971 *A Clockwork Orange* is Kubrick's darkly comic vision of a near-future dystopia.

1984 *2010*, Peter Hyams' sequel to *2001*, returns to the mystery of the Monoliths.

All science fiction is about the unknown, but few movies have embraced it as fully as *2001: A Space Odyssey*, Stanley Kubrick's journey to the dark side of the solar system. While he and cowriter Arthur C. Clarke draw on familiar science-fiction story elements—the dangerous mission, the homicidal supercomputer, humanity's first contact with alien intelligence—Kubrick arranges them in an unfamiliar way to give audiences something unique and unforgettably strange.

Completed a year before the first Moon landing and 30 years before a chess computer beat the world champion, Kubrick's space-age vision remains extraordinarily compelling.

The movie is loosely structured around a series of turning points in human evolution, but despite the grandiose five-note fanfare of Richard Strauss's *Thus Spake Zarathustra*—the movie's famous musical motif—these moments are not epiphanies. They only serve to deepen the mystery of humankind's

❝Its origin and purpose are still a **total mystery.❞**

Mission Control's last words / *2001: A Space Odyssey*

What else to watch: *Destination Moon* (1950) ▪ *The Day the Earth Stood Still* (1951) ▪ *Planet of the Apes* (1968) ▪ *Close Encounters of the Third Kind* (1977) ▪ *Alien* (1979, p.243) ▪ *Gravity* (2013, p.326) ▪ *Interstellar* (2014)

The picture that science-fiction fans of every age and in every corner of the world have prayed (sometimes forlornly) that the industry might some day give them.
Charles Champlin
Los Angeles Times, 1970

Douglas Trumbull Special effects supervisor

Douglas Trumbull was just 23 years old when he started working on the special effects for *2001*. He had come to Stanley Kubrick's attention for his work on a documentary about space flight called *To the Moon and Beyond*. He was one of four special effects supervisors on *2001*, and was responsible for creating the psychedelic star gate sequence. He went on to win Oscars for his work on *Close Encounters of the Third Kind*, *Star Trek: The Motion Picture* (1979), and *Blade Runner*.

Key movies

1968 *2001: A Space Odyssey*
1972 *Silent Running*
1977 *Close Encounters of the Third Kind*
1982 *Blade Runner*

role in the universe. *2001*'s opening scene centers on Moon-Watcher, a prehistoric ape whose tribe is fighting another for water and comes into contact with a mysterious black object known as the Monolith. The appearance of the Monolith triggers a shift in the apes' culture; they turn old bones into tools—and weapons—and the human race's long journey to the stars begins in earnest.

From ape to astronaut

This odyssey is represented by a now iconic cut from one image to another, as a bone hurled by Moon-Watcher becomes a spaceship twirling through the void. Suddenly the action shifts to the future, where astronauts Bowman (Keir Dullea) and Poole (Gary Lockwood) are on a mission to Jupiter in the spaceship *Discovery*. Their lives are in the care of *Discovery*'s computer, HAL 9000 (voiced with chilling detachment by Douglas Rain), who malfunctions and grows politely mutinous. When the crew try to shut him down, HAL fights back. "I'm sorry, Dave," he tells

Bowman when given an order. "I'm afraid I can't do that." Here Kubrick is showing the audience another turning point in humanity's evolution—the point at which the tools begin to turn on the apes.

Mystery and meaning

As *Discovery*'s mission descends further and further into disaster, the Monolith appears again. What can it mean? Is it the emissary of an alien race? Proof of the existence of God? The scientists are baffled, and so is the viewer. Kubrick refuses to supply any easy answers; he's more interested in taking the audience on a journey than he is in revealing the destination.

The final act of *2001* abandons conventional storytelling as the audience follows Bowman through a tunnel of light and into an otherworldly chamber, possibly the construct of an extraterrestrial host, where the Monolith is waiting for him. He sees himself as an old man

Bowman finally finds himself alone in the space pod. Time appears to become warped as an older version of himself appears, followed at the end of the movie by the fetuslike Star Child.

and is then transformed into the Star Child, a strange, fetal being floating in space—and this is where the movie ends. As a final image, the Star Child is both obscure and crystal clear. We don't know what it is, or how it came to be, or where it is going, but we know what it means: hope, and the beginning of another journey for our species. ▪

WE'RE GONNA STICK TOGETHER, JUST LIKE IT USED TO BE

THE WILD BUNCH / 1969

IN CONTEXT

GENRE
Western

DIRECTOR
Sam Peckinpah

WRITERS
Walon Green, Sam Peckinpah (screenplay); Walon Green, Roy N. Sickner (story)

STARS
William Holden, Ernest Borgnine, Robert Ryan, Warren Oates

BEFORE
1961 Peckinpah's first movie as director is *The Deadly Companions*, a classic, low-budget Western.

AFTER
1970 Peckinpah's next movie, another Western, *The Ballad of Cable Hogue*, shows a change in pace with far less violence.

1977 Peckinpah's *Cross of Iron* is an unflinching portrayal of a soldier's life in World War II.

The *Wild Bunch* gleefully deconstructs the ethos of the traditional Western. The lines between heroes and villains are blurred, and characters are not always rewarded for doing the right thing.

Set in 1913, the story contains certain motifs of the traditional Western. The aging thieves—the "bunch"—arrange one last bank job, which inevitably goes horribly wrong. They are chased into Mexico by their old comrade Deke Thornton (Robert Ryan), who has reluctantly switched sides and is leading a group of hopeless bounty hunters. The old West is fast disappearing, a fact made clear by the German machine gun at the center of the final shootout, presaging the slaughter that was to come in World War I.

In awe of violence

Each time a character is hit with a bullet, no matter how minor, the moment of impact is filmed in slow motion. We see the blood spurt out of the back in close-up, as the body contorts toward the ground. The sound drains out of the scene until all we hear is the character's death rattle. Slow motion does not appear in any other context.

The violence of the old West was notorious, but *The Wild Bunch* is the first movie to stand back and look on it with such awe. The movie

Sam Peckinpah Director

Sam Peckinpah was born in California in 1925. After serving in the US marines in World War II, he worked as an assistant to Don Siegel on movies including *Invasion of The Body Snatchers* (1956). His first movie as director came in 1961 with *The Deadly Companions*. Peckinpah soon earned himself a reputation for bad behavior on set. He suffered alcohol problems, and died of heart failure in 1984.

Key movies

1962 *Ride the High Country*
1969 *The Wild Bunch*
1971 *Straw Dogs*
1974 *Bring Me the Head of Alfredo Garcia*

What else to watch: *The Searchers* (1956, p.135) ▪ *The Good, the Bad and the Ugly* (1966) ▪ *Bonnie and Clyde* (1967, pp.190–91) ▪ *Once Upon a Time in the West* (1968, p.336) ▪ *Bring Me the Head of Alfredo Garcia* (1974)

"We gotta start thinking beyond our guns," one of the bandits observes; "Those days are closing." The movie celebrates male bonding, but the sun is setting on this bunch of outsiders.

The Wild Bunch questions the motives of the law while also displaying sympathy for the outlaws, their loyalty and self-reliance. The movie's final confrontation is set in motion by the bunch's decision to try to save their captured comrade, Angel (Jaime Sánchez). Many of the law enforcers that trail the bunch, by contrast, are shown to be incompetent and corrupt. The movie becomes a humane exploration of the cost of living in amoral times, presenting outlaws as a product of their surroundings. It finds a compassion for its characters that the Westerns of old could not. ▪

begins and ends with anarchic set pieces of violence. In each scene, innocents are caught in the cross fire as both sides shoot almost blindly at anything that moves. There is no right or wrong in these scenes, just a struggle to survive. This was perhaps a more honest portrayal of the West than the moralizing take of the previous generation of Westerns, in which the good prevail in the end.

Tector (Ben Johnson), Lyle (Warren Oates), Pike (William Holden), and Dutch (Ernest Borgnine) walk out to save Angel. They will stick together to the end.

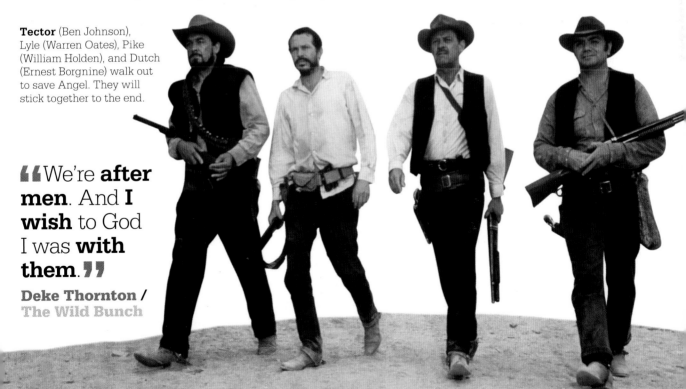

❝We're **after men**. And **I wish** to God I was **with them**.❞

Deke Thornton /
The Wild Bunch

THEY SEE A FREE INDIVIDUAL, IT'S GONNA SCARE 'EM

EASY RIDER / 1969

IN CONTEXT

GENRE
Road movie

DIRECTOR
Dennis Hopper

WRITERS
Peter Fonda, Dennis Hopper, Terry Southern

STARS
Peter Fonda, Dennis Hopper, Jack Nicholson

BEFORE
1953 *The Wild One*, in which Marlon Brando smolders as a motorcycle gang leader, was the first movie to focus on the idea of outlaw bikers.

1960 Jean-Luc Godard's *À bout de souffle* prefigures *Easy Rider* with its couple of young outlaws on the road, and jump-cut editing.

AFTER
1976 *Easy Rider* inspires a number of road movies, significant among them Wim Wenders' *Kings of the Road*.

F ew movies seem to capture a moment in time more completely than Dennis Hopper and Peter Fonda's *Easy Rider*. It's the quintessential American road movie, with two youngish men, half hippy, half Hells Angels, setting off on a journey to freedom on their Harley-Davidson motorcycles.

End of the 1960s

There's no real plot or emotional journey, and the movie's vague symbolism may seem dated now. But there's no denying its cultural status at the time. The year it was released, 1969, young people were proclaiming their rejection of the values of the old generation by growing their hair long and dropping out to listen to music and take drugs. *Easy Rider* reflected this mood, but it went further.

Peter Fonda, the producer and star, came to the project from playing the rebellious leader of a gang of Hells Angels in the movie *The Wild Angels* (1966), and a TV ad director who takes LSD in *The Trip* (1967). Both movies were

THIS YEAR IT'S easy Rider

big commercial successes with the younger generation. It seemed only natural to combine the two themes, biker gangs and drugs, in one movie.

Fonda brought in screenwriter Terry Southern to help with the writing and hired Dennis Hopper as his co-star and director. Hopper may at first have seemed like a disastrous choice as director, as the shoot threatened to

Easy Rider helped to spark the New Hollywood phase of filmmaking in the early 1970s, in which directors took a more authorial role, and innovative publicity techniques were used.

What else to watch: *The Wild One* (1953) ▪ *À bout de souffle* (1960, pp.166–67) ▪ *Pierrot le Fou* (1965) ▪ *Woodstock* (1970) ▪ *Kings of the Road* (1976)

mire in drug binges and shouting matches. Fonda even threatened to abandon the project. But it may be that very anarchy that made *Easy Rider* an icon of its time. Hopper felt he was part of a revolution. The disorganized nature of the project was a rude gesture of rebellion.

The rough cut is said to have run for over three hours. Hopper chose to cut out story details to leave behind a series of loosely linked images and moments, held together by a pounding sound track.

West to east

In some ways, the two bikers seem like modern-day cowboys, riding off to find freedom, and their names Wyatt (Peter Fonda) and Billy (Dennis Hopper) recall the Western heroes Wyatt Earp and Billy the Kid. In fact the bikers are nothing so noble. Rather, they are a pair of

drifting drug dealers heading east because there's no longer a Wild West. Their bike bags are stuffed with money made from selling drugs to Mr. Big, and when they are joined by a sharp-suited drunken lawyer (Jack Nicholson), he ends up seeming far more rebellious than them. The title conveys an image of chilled-out bikers, but it actually comes from the slang for living off the earnings of a prostitute.

Easy Rider's bleak violence ensures that the movie is no hippy trip, but rather an incoherent blast of frustration. In reality, it signaled a disillusioned end to a previous generation's idealism. ▪

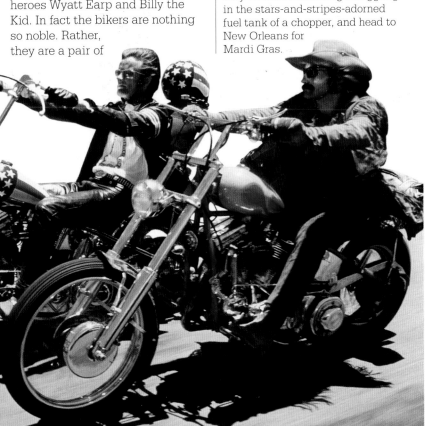

Wyatt and Billy hide the cash they've made from drug smuggling in the stars-and-stripes-adorned fuel tank of a chopper, and head to New Orleans for Mardi Gras.

Dennis Hopper
Director/Actor

A multitalented actor, writer, director, and photographer, Dennis Hopper carved out a name for himself as one of the wild cards of Hollywood. Born in 1936 in Dodge City, Kansas, he showed early promise as an artist, but was soon drawn to acting and studied at the Actors Studio in New York under the legendary Lee Strasberg. He initially made his name with television work, but it wasn't until he directed and starred in *Easy Rider* that he became a celebrity. In later years, Hopper's problems with alcohol and drugs stalled his progress, although he did direct and star in the excellent punk drama *Out of the Blue*. Eventually, after entering a rehab program in 1983, his career took off again with riveting performances in such movies as *Blue Velvet* (pp.256–57), and numerous Hollywood bad guy roles. Hopper died in 2010.

Key movies

1969 *Easy Rider*
1979 *Apocalypse Now*
1980 *Out of the Blue*
1986 *Blue Velvet*

ARE YOU FOND OF MEAT?

LE BOUCHER / 1970

IN CONTEXT

GENRE
Thriller

DIRECTOR
Claude Chabrol

WRITER
Claude Chabrol

STARS
**Jean Yanne,
Stéphane Audran**

BEFORE
1943 Alfred Hitchcock's
Shadow of a Doubt tells the
story of a young girl who
discovers a terrible secret.

1968 Chabrol's *Les Biches*
stars Stéphane Audran and
Jacqueline Sassard as two
women who form a lesbian
relationship before both
falling for the same man.

AFTER
1970 Chabrol's next movie,
La Rupture, features Audran
as a woman whose husband's
family is hatching a deadly
plot against her.

In French director Claude
Chabrol's thriller *Le Boucher*
(*The Butcher*), the stark title
immediately raises expectations
of brutality and gore. Played by the
curiously sympathetic Jean Yanne,
the Butcher is Popaul, a veteran
of the French colonial wars of the
1950s in Indochina and Algeria, who
works at a butcher shop in a rural
town. At a friend's wedding, Popaul
meets Hélène (Stéphane Audran),
who becomes strangely fond of him.
Popaul is open and sensitive about
his past, talking of an abusive father
and the cruelty of battle.

When a woman is killed in the
forest, however, Hélène begins to
think of Popaul a little differently,

Hélène (Stéphane Audran) first
meets Popaul (Jean Yanne, on her left)
at a wedding. They strike up a close
relationship, but it remains platonic
despite his clumsy efforts to woo her.

not least because the woman has
been stabbed to death with knives,
the tools of his trade. And when a
second body is found, discovered
by one of her own pupils during
an idyllic picnic, Hélène finds a
lighter that she herself gave Popaul
as a present. But instead of
handing it to the police, Hélène
keeps it, and she is relieved when,
later on, Popaul lights one of his
many Gauloises with what appears
to be the original lighter.

What else to watch: *Le Corbeau* (1943) ▪ *Shadow of a Doubt* (1943) ▪ *Les Biches* (1968) ▪ *The Unfaithful Wife* (1969) ▪ *La Rupture* (1970) ▪ *Just Before Nightfall* (1971) ▪ *Wedding in Blood* (1973) ▪ *L'Enfer* (1994)

Claude Chabrol Director

Claude Chabrol was born in 1930 in Sardent, in rural France, where he ran a movie club as a child. Before directing his own movies, he worked as a critic for influential magazine *Cahiers du Cinéma*. Like the other directors of the French New Wave who emerged from that magazine, Chabrol was an admirer of Alfred Hitchcock, but he was the only one of his peers to gravitate toward the thriller, making a series of murder mysteries until his death in 2010.

Key movies

1970 *Le Boucher*
1971 *Just Before Nightfall*
1994 *L'Enfer*

Why wasn't Hélène scared? This is the dynamic that Chabrol chooses to deal with in a movie that doesn't so much resemble a woman-in-peril saga as a beauty and the beast story. Comparisons could be made with Alfred Hitchcock's *Shadow of a Doubt* (1943), in which a young girl discovers that her favorite uncle is a killer of elderly widows.

Violent purity

The second murder scene explains the movie's unusual opening credits, which depict the Cougnac grottoes in southwestern France, home to a series of paintings from the Upper Paleolithic era. Hélène gives her class a guided tour, noting that the paintings were the first step taken by man toward civilization. "Do you know what we call desires when they lose their savage quality?" Hélène asks. "Aspirations" is her answer. The teacher seems to respect Cro-Magnon man and his violent purity, which suggests a lot about her fascination with Popaul.

The final act brings revelations and confrontations in an intense scene that shows as much about the couple's similarities as their differences. The audience is left grappling with more questions than answers. In the very last shot, Chabrol returns to a scene of the River Dordogne, with which he had started the movie. "I adore symmetry," Chabrol once said. "But I'm not for simple symmetry. Symmetry doesn't mean putting one chandelier on the right and another on the left." The credits roll, and we are left to wonder about the nature of loyalty, the desires that take the people experiencing them by surprise, and the dark mystery of what goes on between couples. ▪

Hélène is drawn to Popaul and his gauche advances despite, or perhaps because of, the fact that he has been damaged by his violent past.

Le Boucher has us always thinking. What do they know, what do they think, what do they want?
Roger Ebert

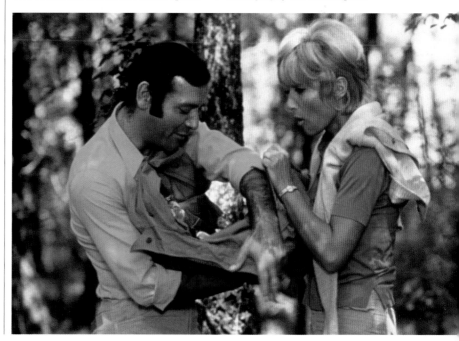

SOME DAY, AND THAT DAY MAY NEVER COME, I WILL CALL UPON YOU TO DO A SERVICE FOR ME

THE GODFATHER / 1972

IN CONTEXT

GENRE
American gangster

DIRECTOR
Francis Ford Coppola

WRITERS
Mario Puzo, Francis Ford Coppola

STARS
Marlon Brando, Al Pacino, James Caan, Robert Duvall, Diane Keaton

BEFORE
1931–32 *Little Caesar* (1931), The *Public Enemy* (1931), and *Scarface* (1932) whet the public appetite for gangster movies.

AFTER
1974 *The Godfather: Part II* is the hugely successful sequel, focusing on Michael Corleone (Al Pacino) as he becomes a brutal godfather.

1990 *The Godfather: Part III* is the less successful third movie, completing the story of Michael Corleone.

F rancis Ford Coppola's movie *The Godfather* changed the gangster-movie genre entirely, with its depiction of gangsters grappling with complex existential dilemmas, rather than as one-dimensional, lowlife hoodlums. Previously, all such gangster stories had been told from an outsider's point of view, and the gangsters themselves were seldom portrayed sympathetically.

The Godfather was also the first movie to show a Mafia organization from the inside. Its sprawling portrait of the Corleone family and their travails acquires the grandeur and scope of an ancient Greek tragedy, in which honor, duty, and loyalty to family are seen as the characters' main motivating forces, rather than criminal intent.

The background

The Godfather is based on a best-selling novel of the same name by Italian-American author Mario Puzo, which was published in 1969. Within a year, Paramount Pictures had commissioned Puzo to write the screenplay.

A successful screenwriter himself, Coppola, who had been hired as the director, had firm ideas

Overflowing with life, rich with all the grand emotions and vital juices of existence, up to and including blood.
Kenneth Turan
Los Angeles Times, **1997**

of his own about how the script should be written, and he and Puzo worked together to complete the final draft. Coppola's insight was to see that the essence of the story, and the focus of the movie, should be the personal transition of Michael Corleone (Al Pacino) from respectable, law-abiding young man and decorated war hero to eventual head of a crime family, when he takes over from the Godfather, Don Vito Corleone (Marlon Brando). Coppola also saw the story as a metaphor for American free-market capitalism. The Corleones aspire to the American Dream and fight

Minute by minute

00:01
At his daughter Connie's wedding to Carlo, Don Corleone receives a series of men seeking favors. His son Michael is there with Kay, who is introduced to the family.

00:45
After refusing to help a narcotics gang, Don Corleone is gunned down in the street. He is shot five times but survives.

01:54
Carlo beats the heavily pregnant Connie. She speaks to her brother Sonny, who goes to see her, but he is gunned down at a toll booth.

02:32
Don Corleone collapses and dies while playing with his grandson. Just before he dies, he warns Michael that he will be betrayed.

| 00:00 | 00:30 | 01:00 | 01:30 | 02:00 | 02:30 | 02:58 |

00:33
Movie studio boss Jack Woltz wakes up with his prize horse's head in his bed. This persuades him to cast Johnny Fontane, as requested by consigliere Tom Hagen.

01:29
Michael shoots drug baron Sollozzo and corrupt police chief McCluskey. He then leaves for Sicily.

02:04
Michael's new Sicilian wife, Apollonia, is killed by a car bomb. Fabrizio, Michael's bodyguard, has betrayed him.

02:38
As Michael attends his godson's christening, his rivals are killed across the city. He also has Carlo killed.

What else to watch: *Little Caesar* (1931) ▪ *The Public Enemy* (1931) ▪ *Scarface* (1932, p.339) ▪ *White Heat* (1949) ▪ *The Long Good Friday* (1980) ▪ *Rumble Fish* (1983) ▪ *Once Upon a Time in America* (1984) ▪ *Goodfellas* (1990)

The Corleones want to appear as a respectable American family. The marriage of Don Corleone's daughter, Connie, is a lavish affair, but the invited senators and judges stay away.

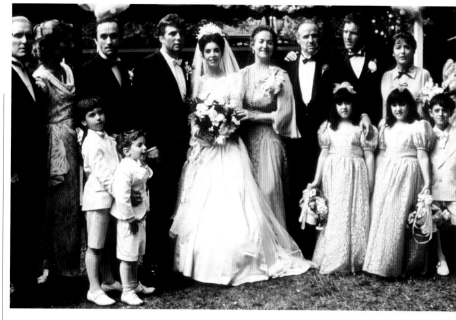

to establish their place in the world. Few movies have focused quite so starkly on the moral contradictions involved in this pursuit.

Justice and loyalty

The movie opens with the wedding celebration of Don Corleone's daughter, Connie (Talia Shire), at which the undertaker Bonasera, a family associate, seeks a private audience with Don Corleone. Bonasera asks the Godfather's help in avenging the beating and rape of his daughter by men who escaped justice through being wealthy and well connected. "I believe in America," Bonasera says. "America has made my fortune. And I raised my daughter in the American fashion." He has bought into the American Dream, yet America has betrayed him. To Don Corleone, then, falls the task of getting justice for Bonasera and his

daughter outside of the law. It is no accident that the movie begins at a family gathering. The Corleones are presented as a family that must remain close-knit in order to survive in the world. Loyalty is everything. Later in the movie, Michael warns his brother Fredo, "Don't ever take sides with anyone against the family again. Ever." Domestic

exchanges such as this are central to this portrayal of the Corleone family. There are, in fact, many more scenes set around the dinner table than there are shoot-outs. The men describe what they do as business, which they keep strictly separate from family. "This is business, not personal," they insist. They see themselves simply as men doing their job. »

Marlon Brando Actor

A Hollywood actor renowned for his brooding presence and the championing of the "Method" style of acting, Marlon Brando was born in 1924 in Omaha, Nebraska. After being expelled from military school, he enrolled in Lee Strasberg's Actors Studio in New York, where he was coached by Stella Adler. In 1947, he was a sensation in Tennessee Williams' play *A Streetcar Named Desire*. Four years later, he reprised his role in the movie. He received his first Academy Award for playing a longshoreman in Elia Kazan's *On the Waterfront*. In the 1960s, Brando's career hit a low, but was revived in 1972 with *The Godfather* and *Last Tango in Paris*. He died in 2004.

Key movies

1951 *A Streetcar Named Desire*
1954 *On the Waterfront*
1972 *The Godfather*
1972 *Last Tango in Paris*

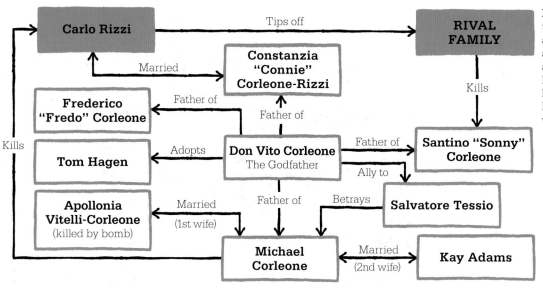

Carlo Rizzi —Tips off→ RIVAL FAMILY

Carlo Rizzi —Married→ Constanzia "Connie" Corleone-Rizzi

RIVAL FAMILY —Kills→ Santino "Sonny" Corleone

Don Vito Corleone —Father of→ Frederico "Fredo" Corleone

Don Vito Corleone —Father of→ Constanzia "Connie" Corleone-Rizzi

Don Vito Corleone —Adopts→ Tom Hagen

Don Vito Corleone — The Godfather —Father of→ Santino "Sonny" Corleone

Don Vito Corleone —Ally to→ Salvatore Tessio

Apollonia Vitelli-Corleone (killed by bomb) —Married (1st wife)→ Michael Corleone

Don Vito Corleone —Father of→ Michael Corleone

Salvatore Tessio —Betrays→ Michael Corleone

Michael Corleone —Married (2nd wife)→ Kay Adams

Kills (Michael → Carlo Rizzi)

Don Corleone, the Godfather, is at the center of a web of family and associates, bound together by respect, honor—and violent revenge.

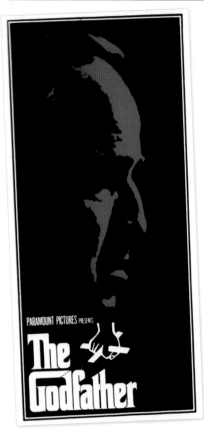

Brando was given prosthetic jowls to give him the appearance of ravaged seniority. He was just 48 years old at the time of filming.

Coppola is careful to avoid showing the victims of the family's criminal enterprises—the drug addicts, prostitutes, and ruined families. The only victims of the Corleones' brutality that the viewer sees are the members of rival gangs who posed a threat. And so the viewer sees the Corleones as they see themselves, as a quasi-respectable family fighting to maintain supremacy in a dangerous world, rather than as a bunch of thugs. They have a code of honor, and when Don Corleone finally dies while playing with his grandson in his vegetable garden, we see it as the passing of a giant, the sad end to a titan. The effect is reinforced by Nino Rota's lush musical score, which gives the movie a heroic and tragic feel.

Acclaimed cast

Most telling of all are the remarkable performances from the universally superb cast. Marlon Brando gives an iconic performance as Don Corleone. At the time of the movie's release, there were critics who felt his rasping delivery was affected, but others maintained that it captured perfectly a man wearied by power and its obligations. Puzo told Brando that he was "the only actor who can play the Godfather." Studio executives were initially wary of the actor's disruptive reputation and box-office credibility, but he won a Best Actor Oscar for his performance.

Although Brando supplies the face of the movie, it is Al Pacino's Michael who carries the story. At the start, he is a college graduate, engaged to a beautiful

The Godfather changed my life, for better or worse. It definitely made me have an older man's film career.
Francis Ford Coppola

❝I'm gonna make him **an offer he can't refuse.**❞

Don Vito Corleone / *The Godfather*

non-Italian girl, Kay, played by Diane Keaton. He appears to have every hope of living a crime-free life, of fulfilling the American Dream. Pacino, then a little-known actor, received an Oscar nomination for Actor in a Supporting Role.

Family destiny

Michael is drawn inexorably into the gangster world of the Corleone family, finally pledging by his father's hospital bed, "I'll take care of you now. I'm with you now. I'm with you." When his brother Sonny (James Caan) is gunned down, Michael becomes the new heir apparent. His descent from a bright hope is the movie's central tragedy, yet we understand how strongly he feels that he has no choice. Don Corleone had wanted Michael to become a senator or a governor, but the movie hints that such respectability will always be

out of reach of their family. They may have senators in their pockets but, in public, the senators will always shun them.

The sequel

The Godfather: Part II returns to the Corleone family once Michael has taken control. While he may have been reluctant to step into his father's shoes, Michael soon loses both his morality and the family's respectable aspirations. Unlike his father, Michael no longer has ties to Sicily, the "old country," and its code of honor, however skewed and violent. Nor does he have the same belief in the New World. He becomes, in the end, more brutal than old Don Corleone. ■

Sonny (James Caan, left) is Corleone's eldest son. When his brother-in-law Carlo (Gianni Russo) hits Connie, Sonny beats up Carlo in the street.

Francis Ford Coppola
Director

Coppola was born in 1939 to a Detroit family of Italian descent. His father Carmine was a composer who would work on the scores of *The Godfather: Part II* and *Apocalypse Now*. In his early twenties, Francis enrolled in the University of California, Los Angeles (UCLA) film school, and was soon writing screenplays for Hollywood. He began making movies during the New Hollywood movement, also referred to as the American New Wave, which aimed to tackle new subjects using different styles. *The Godfather*, one of the highest grossing movies in history, was the first major movie he directed, and he cemented his reputation with a string of hits throughout the 1970s. Considered one of America's most energetic, if erratic, filmmakers, his later movies have not quite matched his early successes.

Key movies

1972 *The Godfather*
1974 *The Conversation*
1974 *The Godfather: Part II*
1979 *Apocalypse Now*

THAT MAN IS A HEAD TALLER THAN ME. THAT MAY CHANGE

AGUIRRE, THE WRATH OF GOD / 1972

IN CONTEXT

GENRE
Adventure

DIRECTOR
Werner Herzog

WRITER
Werner Herzog

STARS
Klaus Kinski, Helena Rojo, Ray Guerra, Del Negro

BEFORE
1968 In *Signs of Life*, Herzog explores how isolation causes a man's madness, a theme he would develop in *Aguirre*.

AFTER
1979 Francis Ford Coppola's *Apocalypse Now* pays homage to *Aguirre* by using "visual quotations" from the movie.

1982 *Fitzcarraldo*, Herzog's second movie about a deluded European in the Amazon, also stars Klaus Kinski.

1987 *Cobra Verde* is Herzog's final work with Kinski as a madman lost to civilization.

erner Herzog's *Aguirre, the Wrath of God* is one of the most original pieces of cinema ever created. It is based on the doomed 1561 expedition of Spanish conquistador Lope de Aguirre to find El Dorado, the mythical Amazonian city of gold. Herzog's story is of an obsessive quest that descends into madness, driven by a mesmeric performance from Klaus Kinski as Aguirre.

Extreme location

The filming of *Aguirre* has become something of a legend. It was shot in the Peruvian rain forest in a matter of weeks, and the cast and crew endured many of the same hardships as Aguirre's expedition: climbing mountains, braving rapids on makeshift rafts, and hacking through jungle. Kinski went beyond the confines of "temperamental" into the outright unhinged, regularly raging at Herzog, the crew, and local extras. At one point, he shot off an extra's fingertip.

The fact the movie was even finished is due to Herzog's ability to see possibilities on the spot. He made up much of the dialogue as he went along, and frequently incorporated incidents into the movie that occurred among the extras. Herzog's cinematographer, Thomas Mauch, produced a visually stunning movie, described by a

Werner Herzog Director

Werner Herzog is a director with a singular cinematic vision. Born in 1942, he grew up in a remote village in Bavaria, Germany. He was a rebel at school, but at 14 he read in an encyclopedia about filmmaking and, as he later admitted, stole a 35mm camera from the Munich Film School.

He made his first feature movie *Signs of Life* in 1968. Four years later, *Aguirre, the Wrath of God*, brought him international fame. He has also made many acclaimed documentaries.

Key movies

1972 *Aguirre, the Wrath of God*
1979 *Nosferatu the Vampire*
1982 *Fitzcarraldo*

What else to watch: *The African Queen* (1951) ▪ *Deliverance* (1972) ▪ *Apocalypse Now* (1979, p.338) ▪ *Fitzcarraldo* (1982) ▪ *The Mosquito Coast* (1986) ▪ *Platoon* (1986) ▪ *El Dorado* (1988) ▪ *The New World* (2005) ▪ *Apocalypto* (2006)

German reviewer at the time as "a color-drenched, violently physical moving painting." This look, combined with a churchlike musical score, gives the movie an almost mythical quality.

Smashing taboos

Aguirre is a monstrous figure, so overtaken with ambition that he completely ignores all social rules and human obligations. He shows no mercy or sympathy. Left alone in the jungle, he contemplates an incestuous relationship with his teenage daughter. "I, the Wrath of God, will marry my own daughter, and with her I will found the purest dynasty the world has ever seen." He lets nothing stand in his way. When a man talks of turning back, he says, "That man is a head taller than me. That may change." Then he beheads him while he is still talking. Aguirre's brutality and resilience are so breathtaking, we might almost find him heroic.

But Herzog leaves us in no doubt that Aguirre's ambition is futile and destructive. The final scene shows Aguirre alone on a raft, and his only company is hundreds of monkeys. He grabs one, and his heroic declamation, "I am Aguirre, I am the Wrath of God. Who else is with me?" is addressed to the monkeys. The scene is bathetic in the extreme. Aguirre is a man to be ridiculed and pitied, a man who has brought nothing but destruction through his own folly. ▪

> Mr Herzog… is a poet who constantly surprises us with unexpected juxtapositions… This is a splendid and haunting work.
> **Vincent Canby**
> *The New York Times*, 1977

> **"I am the Wrath of God! The earth I pass will see me and tremble."**
>
> **Aguirre /** *Aguirre, the Wrath of God*

From the outset of the expedition, Aguirre's eyes shine with the insanity of his obsession. The movie's message warns of the dangers of myths on the human psyche.

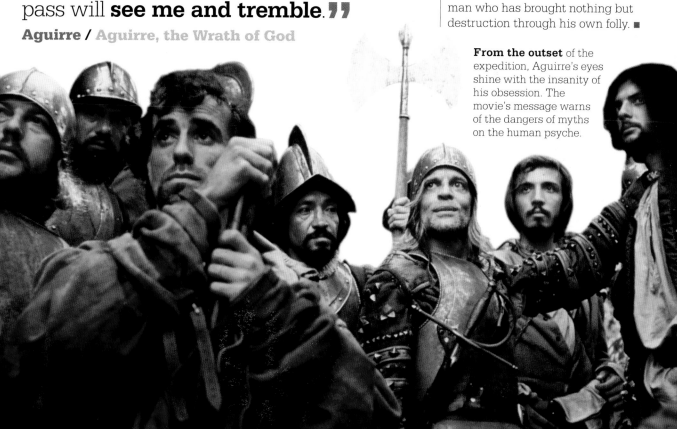

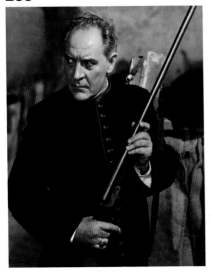

THE GUESTS ARE HERE, SIR
THE DISCREET CHARM OF THE BOURGEOISIE / 1972

IN CONTEXT

GENRE
Art-house drama

DIRECTOR
Luis Buñuel

WRITERS
Luis Buñuel,
Jean-Claude Carrière

STARS
Fernando Rey, Paul
Frankeur, Delphine Seyrig,
Bulle Ogier, Stéphane
Audran, Jean-Pierre Cassel

BEFORE
1929 Luis Buñuel's first movie, *Un Chien Andalou*, a short made with Salvador Dalí, is a startling surrealist work.

1962 In Buñuel's *The Exterminating Angel*, guests are unable to leave a dinner.

AFTER
1977 Buñuel's last movie, *That Obscure Object of Desire*, is about the frustration of an aging man's desires for a young Spanish woman.

L uis Buñuel was a master of social satire and the surreal, who had been making movies for nearly half a century by the time he made *The Discreet Charm of the Bourgeoisie* (*Le charme discret de la bourgeoisie*). Buñuel took the idea for the movie from an anecdote told by his producer, Serge Silberman, about guests turning up at his home for dinner only to find his wife in her robe and no food, since he had forgotten to tell her he had invited them.

In Buñuel's earlier movie, *The Exterminating Angel* (1962), guests at a dinner party are marooned there for weeks, unable to leave without them or us ever knowing why. In *The Discreet Charm of the Bourgeoisie*, Buñuel carries out a droll variation on the theme, as six well-to-do friends attempt to have dinner together but are continually thwarted by a brilliantly unhinged series of mishaps.

At first, the problems are mundane: the hosts were simply expecting the guests to arrive the following day. But soon, a dead body shows up to disrupt the proceedings. Thereafter, flamboyant sexual escapades and the interruption of the army on maneuvers are just some of the obstacles. The movie becomes increasingly surreal, yet shows the guests behaving as if nothing untoward is going on.

Luis Buñuel Director

Luis Buñuel was celebrated for his surreal movies, biting social satire, and interest in religious fanaticism. He was born in Calanda, Spain, in 1900, and studied as a Jesuit before he met playwright Federico Garcia Lorca and painter Salvador Dalí, with whom he made his first movie, *Un Chien Andalou*, and a second, *L'Age d'Or* (1930). Buñuel moved to the US during the Spanish Civil War, then to Mexico, and finally France in 1955. He died in 1983.

Key movies

1929 *Un Chien Andalou*
1967 *Belle de Jour*
1972 *The Discreet Charm of the Bourgeoisie*

Buñuel is not remotely concerned with conventional narrative flow. Intercut with the frustrated efforts of the dinner guests are dream sequences that pop from their heads and sometimes overlap with each other, as well as skits involving prop food, flashbacks, and at the center of it all, the ambassador to the Latin American Republic of Miranda (entirely fictional), who finds himself drawn into a bizarre terrorist plot.

Class and convention

Dinner is the occasion on which the social elite can come together to display their taste, refinement, and material wealth. It assumes a symbolic place far ahead of anything else in these people's lives. The party's snobbery and superficiality are continually satirized through the movie as, for instance, the bishop is thrown out when he is mistaken for a mere gardener, then welcomed fawningly when he returns in his episcopal vestements.

Road to nowhere

Even as the world crumbles around them and everything begins to fall apart, the six friends are determined to press on with their dinner, and no obstacle, no matter how absurd, will stop them. Throughout the movie, the six are often seen striding purposefully down a seemingly endless road through the

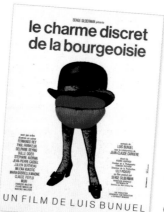

The poster for the cinema release had a suitably surrealist design in the style of Belgian painter René Magritte.

countryside, a metaphor for their hollow obsession with status.

Buñuel won the Oscar for best foreign picture for the movie, and many directors acknowledge its influence. Its message about the self-obsession of the well-to-do is as relevant as ever, and the inventiveness of Buñuel's playful vision remains hugely fun. ▪

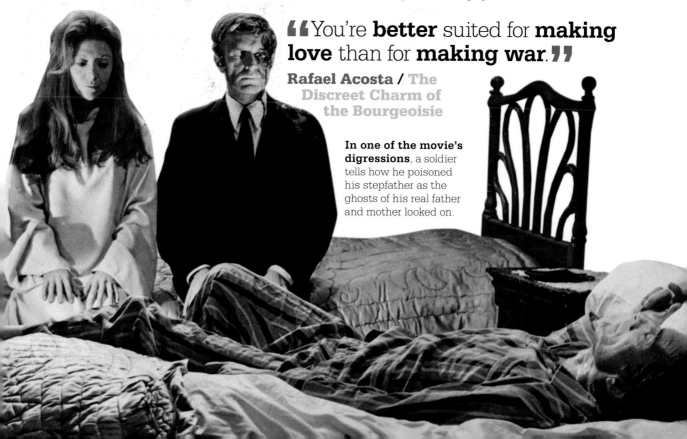

"You're better suited for **making love** than for **making war."**

Rafael Acosta / The Discreet Charm of the Bourgeoisie

In one of the movie's digressions, a soldier tells how he poisoned his stepfather as the ghosts of his real father and mother looked on.

DID YOU REALLY SEE HER?

DON'T LOOK NOW / 1973

IN CONTEXT

GENRE
Supernatural thriller

DIRECTOR
Nicolas Roeg

WRITERS
**Allan Scott, Chris Bryant
(screenplay); Daphne
du Maurier (short story)**

STARS
**Donald Sutherland,
Julie Christie**

BEFORE
1970 Roeg's twisted crime
drama *Performance* stars Mick
Jagger as a reclusive rock star.

AFTER
1976 David Bowie plays an
alien in Roeg's sci-fi odyssey
The Man Who Fell to Earth.

1977 Julie Christie is attacked
by a computer in *Demon Seed*,
directed by Donald Cammell.

Don't Look Now opens
with the death of a child,
but it's more concerned
with the fate of her
parents, John (Donald
Sutherland) and Laura
Baxter (Julie Christie).
The grieving couple
relocate from their home
in Britain to wintry, out-
of-season Venice, where
John busies himself with
the restoration of a church
mosaic. When Laura
befriends two elderly
sisters—one a blind
clairvoyant—her husband
begins to catch glimpses of
a figure that resembles their
dead daughter. Is John
seeing things? Or could it
be that Christine has come
back from beyond the grave?

The movie poster hints
at the ending without giving
anything away. Like John,
the audience only finds out
at the end of the movie what
the "warning" was all along.

What can and cannot be "seen" is
the enigma at the heart of this
devastating movie, whose title

The movie opens with a slow-motion sequence in which John drags Christine's lifeless body from a pond. It introduces many of the movie's key motifs, including water and the color red.

seems to be a warning. "Don't look now!" it screams, begging the audience to avert its gaze. But, as with many things in Nicolas Roeg's paranormal chiller, the title is not what it seems. In fact Roeg wants the viewer to look carefully, especially at the patterns created by his strange, kaleidoscopic arrangement of images.

The director experimented with complex visual editing in his previous movies, *Performance* (1970) and *Walkabout* (1971); in *Don't Look Now*, he uses these techniques to convey both a sense of menace and the fractured psychological states of his two main characters. Images are repeated and echoed at jarring moments: ripples on water; the color red; breaking glass; close-ups of gargoyles and statues. The viewer glimpses them here and there, just as John catches sight of the scarlet-coated figure from the corner of his eye, and they accumulate to build an atmosphere thick with paranoia.

Love scene

Perhaps the most celebrated example of this fragmented editing style is the sequence in which John and Laura make love for the first time since Christine died. Roeg makes quick, disjointed cuts between the couple in bed and the two of them dressing for dinner later in the evening. The result is a sex scene unlike any other—intense, touching, melancholic, and comic; and so realistic that many contemporary viewers assumed the sex was real. This is a movie that forces us to look again, to ask ourselves, "Did I really see that?" John cannot see what is in front of him: that he possesses the gift of second sight. He doesn't believe in psychics, and when Laura tells him that the clairvoyant has "seen" their daughter in Venice, he reacts by getting drunk and angry. Even after he sees Christine's reflection in a canal, rippling across the »

> **❝**This one **who's blind**. She's the one who **can see**.**❞**
>
> **Laura Baxter** / Don't Look Now

water, he refuses to open his mind to the existence of ghosts. In *Don't Look Now*, seeing is not believing: you must believe in order to see.

Roeg and his writers, Allan Scott and Chris Bryant, find moments of sly humor in John's wilful "blindness." When he loses his way in the labyrinthine alleyways of Venice, he pauses beneath an optician's sign (in the shape of a huge pair of glasses). "Do look now!" it seems to say, but he ignores it and hurries on. In another scene, John is

John follows the red coat on the Calle di Mezzo to the gates of the Palazzo Grimani where he encounters the dwarf.

mistaken for a peeping tom while searching for the home of the peculiar sisters. Other characters have no problems navigating the city, but John is forever getting lost and finding himself back where he started. For him, time and space are jumbled up and compressed, just as they are in Roeg's editing.

Venetian setting

Venice is the perfect backdrop for a horror movie about déjà vu; there are reminders of death and decay around every corner, and its bridges and canals all seem to look alike. Shot on location in and around the Italian vacation destination, *Don't Look Now* mostly avoids the tourist

traps; St. Mark's Square, for example, makes a single, easy-to-miss appearance. The movie sticks to the backwaters, creating a trap of its own from a maze of dank passages, churches, and empty hotels.

Much of Roeg's Venice is unseen: the audience hears cries in the night, a piano playing somewhere nearby, footsteps that echo all around. "Venice is like a city in aspic," says the blind clairvoyant. "My sister hates it. She says it's like after a dinner party, and all the guests are dead and gone. Too many shadows." The camera lingers on dust-sheeted furniture and shuttered windows, suggesting something concealed from view.

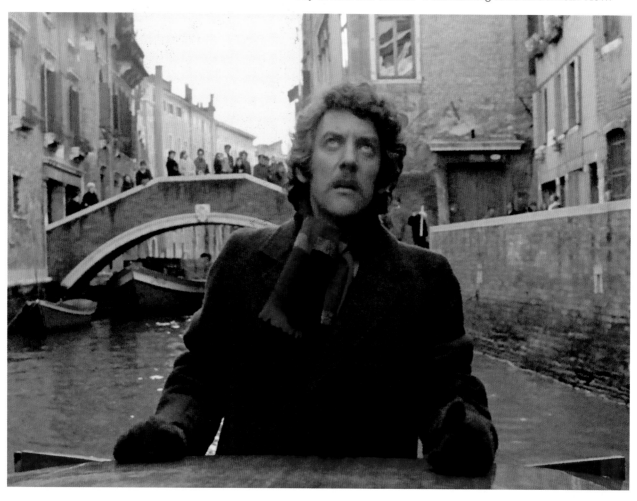

> The fanciest, most carefully assembled enigma yet put on screen.
> **Pauline Kael**
> *5001 Nights at the Movies*, 1982

The sense of danger intensifies when the audience learns that a serial killer is on the loose. This revelation comes late in the movie, but Roeg leaves a bread-crumb trail of clues leading up to it: the killer is seen in one of John's photographic slides, hidden in plain sight, in the very first scene; a police inspector doodles a psychotic face as he interviews John at the station. "What is it you fear?" he asks.

The subplot of the murderer adds another layer to the movie's kaleidoscope, forcing the audience to question everything it has seen so far. Is Christine in fact a ghost or something even more sinister? Do the sisters know more than they are letting on? Eventually, Roeg pulls focus on fate and a truly macabre finale, the kaleidoscope resolving itself into an image of pure Gothic horror.

Closing montage

Roeg saw his movie as an "exercise in film grammar." This is never more evident than in its extraordinary climactic sequence, which begins with a séance and ends with a funeral. *Don't Look Now* forces John to stare death in the face.

The danger of falling is ever present. Laura is taken to hospital after a fall in the restaurant. John is nearly killed in a fall, their son is injured in a fall, and Christine died after falling in the lake.

Finally, in a fog-chilled Venetian chapel, memories come to life and tragedy descends in a queasy flash of horror and recognition. Roeg crowned the movie with a dizzying montage of moments, images, and overlooked clues from the past 108 minutes of story. Finally, much too late, we see everything. ∎

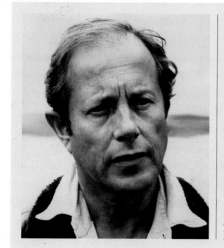

Nicolas Roeg Director

Roeg first made his mark as the cinematographer for such cult classics as Roger Corman's *The Masque of the Red Death* (1964) and François Truffaut's *Fahrenheit 451* (1966). In 1970, he teamed up with the writer and painter Donald Cammell to create *Performance*, a gangster movie that starred Mick Jagger as a reclusive rock star. Roeg's next two movies, *Walkabout* (1971) and *Don't Look Now* (1973), continued to explore his fascination with sex, death, and the complex relationship between time and space. *Don't Look Now* is often referenced by other filmmakers, but Roeg has directed many fascinating movies since, including *The Man Who Fell to Earth* (1976).

Key movies

1970 *Performance*
1971 *Walkabout*
1973 *Don't Look Now*
1976 *The Man Who Fell to Earth*

YOU CAN TALK TO HIM WHENEVER YOU WANT. JUST CLOSE YOUR EYES AND CALL HIM

THE SPIRIT OF THE BEEHIVE / 1973

IN CONTEXT

GENRE
Historical drama

DIRECTOR
Victor Erice

WRITERS
Victor Erice, Ángel Fernández Santos, Francisco J. Querejeta

STARS
Fernando Fernán Gómez, Teresa Gimpera, Ana Torrent, Isabel Tellería

BEFORE
1961 In British movie *Whistle Down the Wind*, a little girl finds a fugitive in a barn and believes he is Jesus.

AFTER
1976 In Carlos Saura's *Cría Cuervos* (*Raise Ravens*), Ana Torrent again plays a little girl haunted by visions.

1983 Erice's second movie, *The South* (*El Sur*), is about a girl fascinated by the secrets her father left in southern Spain.

Even though he was going blind, cinematographer Luis Cuadrado shot every frame of *The Spirit of the Beehive* (*El espíritu de la colmena*) in honey-colored sun and earth tones, rich in texture and deep, soft hues. Yet the movie's true beauty lies in the way director Victor Erice immerses us in the imagination of a six-year-old child, unforgettably played by the wide-eyed Ana Torrent.

The movie is set in 1940, the year after the Spanish Civil War ended in victory for Franco's Nationalists. It was a violent period of bloody retribution, about which it was still not possible to talk openly in Spain, even in 1973. General Franco was still in power, and censors strove to curtail any criticism of the regime. Erice's movie not only depicted a controversial era, but also contained coded messages about the state of the nation. Yet the movie made it past the censors, possibly because it is so slow-moving and enigmatic that the censors believed it would never find an audience.

Finding the monster

The movie opens with the arrival of a traveling cinema in a village. The movie playing is James Whale's 1931 monster flick *Frankenstein*. The child Ana is thrilled by the monster, but baffled by the scene in which he appears to drown the little girl—thanks to a misleading cut made by Spanish censors, who were showing the movie as propaganda that equated the monster with socialism.

Ana (Ana Torrent) offers an apple to the fugitive she finds hidden in the family outhouse. She believes he is the monster.

Victor Erice Director

Victor Erice is regarded by many as Spain's finest movie director. Yet he has made few movies. Indeed, his high reputation rests on just two poetic works, *The Spirit of the Beehive* and *The South*, both of which are period pieces centering on rural childhoods.

Erice was born in Karrantza in the Basque country (Spain) in 1940, around the same time *The Spirit of the Beehive* is set. He studied economics, law and politics at the University of Madrid before going to film school in the early 1960s. He worked for almost a decade as a film critic before making a series of short movies.

The Spirit of the Beehive was Erice's first feature-length movie, but he did not make his second, *The South* (*El Sur*), until almost 10 years later. Ten years after that, he made a beautiful documentary, *The Quince Tree Sun*, about the painter Antonio López García. While Erice has contributed to other work, these have been his only feature-length movies.

Obsessed by visions of the monster, although not afraid of him, Ana goes home. Here, in echoing, shadowy rooms behind honeycomb-shaped windows, her bookish beekeeper father and her far younger mother seem impossibly far apart, literally and emotionally, as her mother Teresa (Teresa Gimpera) writes sad letters to an unknown young man.

Ana's sister Isabela fuels Ana's visions, telling her to close her eyes and call the monster, like a spirit. When Ana closes her eyes and calls, "It's me, Ana," she finds, hidden in the outhouse, a haunted-looking young man, presumably a Republican on the run, who she believes is the monster. They develop a

Ana and her sister Isabel talk with their father (Fernando Fernán Gómez). He keeps bees, and writes of his revulsion for their mindless lives, one of many allusions to Francoist Spain.

tender relationship, but the Francoist troops are never far away. Ana has more visions of the monster, although the doctor reassures her mother that the delusions will pass.

Political allegory

The movie ends with an image of Ana at the window, her eyes closed again. When the movie was made in 1973, Franco's regime was already faltering; its end would have felt very near to a Spanish audience. Telling a story from the past, *The Spirit of the Beehive* also gave Spain a glimpse of its future. ▪

> **❝**Little but **the walls remain** of the **house you once knew**, I often wonder **what became** of everything we had there.**❞**
>
> **Teresa** / The Spirit of the Beehive

Key movies

YOU KNOW WHAT HAPPENS TO NOSY FELLOWS?

CHINATOWN / 1974

IN CONTEXT

GENRE
Neo-noir crime thriller

DIRECTOR
Roman Polanski

WRITER
Robert Towne

STARS
Jack Nicholson, Faye Dunaway, John Huston

BEFORE
1941 John Huston's movie noir *The Maltese Falcon* is released, and Polanski studies it avidly before he embarks on making *Chinatown*.

1968 *Rosemary's Baby* is Polanski's acclaimed horror movie about a young woman, played by Mia Farrow, who is impregnated by the devil.

AFTER
1988 *Frantic*, starring Harrison Ford, is Polanski's first successful return to the thriller genre since making *Chinatown*.

Roman Polanski's movie *Chinatown* is a gripping thriller with a truly nasty sting in its tail. Jack Nicholson plays the seedy private detective Jake Gittes, who investigates a conspiracy surrounding the Los Angeles water supply in the 1930s. During the course of his investigation, he uncovers a disturbing personal tragedy as he becomes involved with the chief water engineer's wife, Evelyn Mulwray, played by Faye Dunaway.

Powerful script

Key to the movie's power is Robert Towne's Oscar-winning script, which is widely regarded as one of the finest screenplays ever written for Hollywood. It was partly inspired by the true story of William Mulholland, chief engineer of the Los Angeles Water Department, who, on March 12, 1928, declared that the St. Francis Dam was safe, just hours before it failed catastrophically, with the resulting flood killing at least 600 people. In Towne's screenplay, Mulholland

Time has lessened our sense that this superlative 1974 film is simply a pastiche of the classic '30s gumshoe thrillers—it now looks like a straightforward classic.
Peter Bradshaw
The Guardian, 2013

becomes Hollis Mulwray, and the story turns into a fictional tale of the corrupt manipulation of the Los Angeles water supply for profit.

Towne wrote the script with Jack Nicholson in mind for the character of Gittes, the private eye who becomes unwittingly embroiled in the shadowy affairs of Mulwray's associates. Nicholson is said to have been responsible for

❝He owns the police! **❞**
Evelyn Mulwray / Chinatown

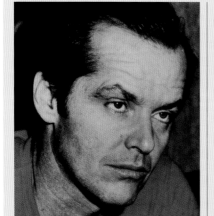

Jack Nicholson Actor

Jack Nicholson is one of the leading American movie actors of the last half century, renowned for playing difficult outsiders who can disarm with charm and humor. He was born in 1937 in Neptune City, New Jersey, where he grew up. His Hollywood acting career was slow to take off, and he had more success with writing screenplays. He had his first big acting break in Dennis Hopper's *Easy Rider* (1969), and a year later, his performance in *Five Easy*

Pieces (1970) was widely acclaimed. Both movies brought him Oscar nominations for his acting, while *One Flew Over the Cuckoo's Nest* (1975) earned him his first Oscar win.

Key movies

1970 *Five Easy Pieces*
1974 *Chinatown*
1975 *One Flew Over the Cuckoo's Nest*
1980 *The Shining*

What else to watch: *The Maltese Falcon* (1941, p.331) ▪ *The Big Sleep* (1946) ▪ *Kiss Me Deadly* (1955, p.134) ▪ *Vertigo* (1958, pp.140–45) ▪ *The Postman Always Rings Twice* (1981) ▪ *L.A. Confidential* (1997)

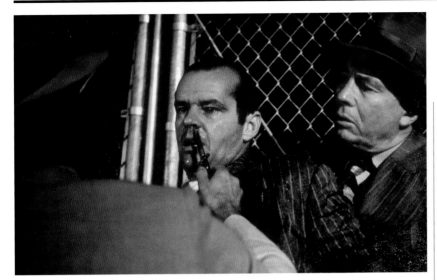

Gittes has his nose slashed as he gets too near the truth about the plot to dump water from the LA reservoirs. He is warned that if he continues to snoop, his whole nose will come off.

the hiring of Polanski, renowned for the psychological thrillers *Repulsion* (1965) and *Rosemary's Baby* (1968). Polanski was in Europe at the time, having left the US after the murder of his wife in 1969. He was tempted back by the strength of Towne's script, although Polanski and Towne had many differences over the final version.

There were two elements in particular that Polanski changed. First was the tragic and disturbing ending. Second was the decision not to use the voice-over narrative that so many private-eye film-noirs had employed in the past. Polanski insisted on letting the audience discover each new twist as Jake Gittes does. The effect of this is that both Jake and the audience are much more in the dark and far more unsettled by each new revelation.

Incompetent sleuth

Gittes' desperate attempt to make sense of everything makes him a different kind of private eye from Humphrey Bogart's Philip Marlowe a generation earlier in hard-boiled

detective movies such as *The Maltese Falcon*. The audience knows that Marlowe will triumph in the end, but it becomes apparent that Gittes is going to mess up again and again, as he jumps to all

the wrong conclusions. At the start of the movie, for instance, he is commissioned by the wife of Hollis Mulwray to prove her husband's adultery. Very quickly Gittes hands her the seemingly incriminating photos—only he's got it wrong twice over. First, the woman who commissioned him is not Mulwray's wife but an impostor. Second, the young woman that he snaps out with Mulwray is not his mistress at all, as he, and we, the audience, will discover much later. Later in the movie, Gittes wrongly assumes that the real Evelyn Mulwray murdered her husband. »

Noir conventions overturned

Genre convention		*Chinatown* subversion
Female lead is typically a "femme fatale"	→	Evelyn is revealed to be a victim
Protagonist is a hard-boiled private investigator	→	Gittes is incompetent, missing clues and making mistakes
Antagonist gets punished	→	Noah Cross escapes to continue his crimes
Protagonist succeeds in resolving crime or issue	→	Gittes leaves town after failing
Narrative closure	→	No resolution

An audience familiar with the roles of femmes fatales in earlier noir movies would naturally assume the same. But Mrs. Mulwray is the real victim, and the truth is so unsettling that Gittes can barely take it in. The real villain of the piece, it turns out, is the seemingly urbane old man Noah Cross, Evelyn's father. He is the wealthy man whose determination to use the city's water supply to his own advantage leads to the murder of his former business partner, Evelyn's husband Hollis Mulwray.

Unexpected twist

There is a twist at the end of *Chinatown* that makes the movie disturbingly different from other crime thrillers, and makes it linger long in the mind. In most movies about power and corruption, the detective simply homes in on, and then exposes, those responsible for a crime and its cover-up. But at the crucial moment in *Chinatown*, the focus is diverted away from Cross's efforts to control the water supply. Instead, we are faced with a shocking revelation that apppears to come out of the blue. Right at the end of the movie, we are left with the deeply disturbing image of Cross—who appears to have got away with everything—comforting his granddaughter.

Gittes confronts Mrs. Mulwray with his theory that she killed her husband. But Gittes still has no idea what is going on.

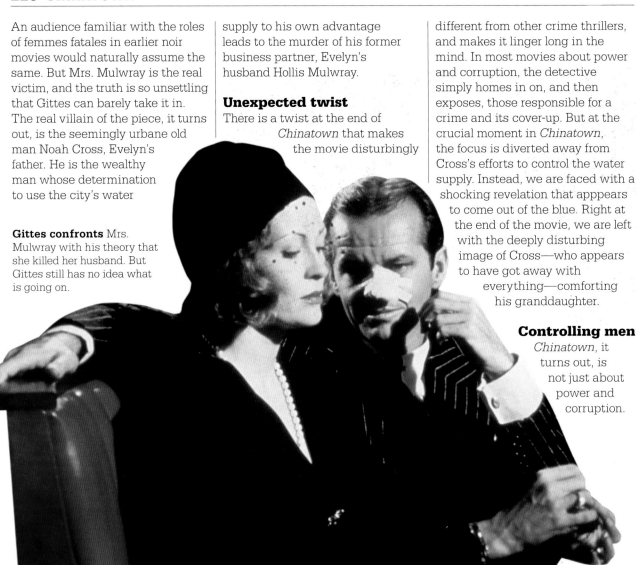

Controlling men
Chinatown, it turns out, is not just about power and corruption.

Minute by minute

00:19
Evelyn Mulwray reveals to Jake Gittes, the private detective, that he has been duped in a ploy to discredit her husband, Hollis Mulwray.

00:42
After nearly drowning in a water channel, Gittes is threatened at knifepoint and his nose is slashed.

01:30
Gittes follows Mrs. Mulwray to a house in which her husband's "mistress" is staying. Mrs. Mulwray tells him that she is her sister.

01:57
Gittes arranges for Mrs. Mulwray and her sister to escape to Chinatown. He then confronts Noah Cross with the glasses.

| 00:00 | 00:15 | 00:30 | 00:45 | 01:00 | 01:15 | 01:30 | 01:45 | 02:10 |

00:31
Gittes turns up at the dam just as the police are pulling Mulwray's body out of the water.

01:15
Gittes and Mrs. Mulwray follow the paper trail of the property sales, which leads them to an old people's home. Gittes is shot at and narrowly escapes.

01:45
After finding the woman who had pretended to be Mrs. Mulwray dead, Gittes goes to the Mulwray house and finds a pair of glasses in the pond. He confronts Mrs. Mulwray, who tells him the shocking truth.

It also concerns the whole notion of male control. At one point, Gittes asks Cross why he feels the need to be richer: "How much better can you eat? What can you buy that you can't already afford?" "The future, Mr. Gittes," Cross replies, "The future." Women and water are the source of the future that Cross wants to control. And in his own way, Gittes, too, is pursuing control, probing and sticking his nose in where it is unwelcome.

His investigations lead to one of *Chinatown*'s nastiest and most memorable scenes. Gittes has his nose slit by a thug, played by Polanski himself: "You know what happens to nosy fellows? Huh? No? Wanna guess? Huh? No? Okay. They lose their noses." It is a kind of emasculation, and Gittes's dogged determination to solve the mystery reflects his need to regain control.

> You have to show violence the way it is. If you don't show it realistically, then that's immoral and harmful.
> **Roman Polanski**

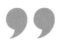

The problem for Gittes is that he is living, metaphorically, in Chinatown, a place that holds bad memories for him, which date back to his time spent in the police force. Yet it is Gittes himself who in the end chooses Chinatown, a world where anything goes, for the movie's tragic denouement. There is no point in trying to do the right thing, his former police colleague tells him in the movie's final line: "Forget it, Jake. It's Chinatown…" ∎

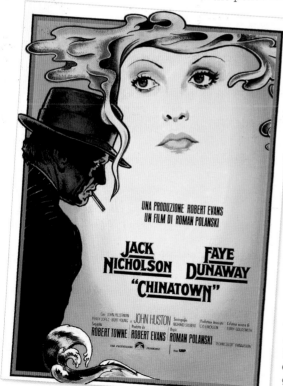

The poster for *Chinatown* suggests an old-fashioned film noir, with a chain-smoking detective and a femme fatale. But Polanski effectively subverts the genre and plays with audience expectations.

Roman Polanski
Director

Born in Paris in 1933 to Polish parents, Roman Polanski grew up in Poland. During World War II, his parents were sent to a concentration camp where his mother died, but Roman survived by hiding in the countryside. After the war, he went to film school. His first feature movie, *Knife in the Water* (1962), was acclaimed internationally, and he moved to the UK to make movies such as the chilling *Repulsion*. In 1968, he met actress Sharon Tate and moved to the US, where he made the horror movie *Rosemary's Baby*. The following year, Tate was murdered by the serial killers known as the Manson Family. Polanski left the US but was invited back to direct *Chinatown*. A few years later, he was convicted of unlawful sex with a minor and fled to France, where he still directs.

Key movies

1965 *Repulsion*
1968 *Rosemary's Baby*
1974 *Chinatown*
1979 *Tess*
1988 *Frantic*
2002 *The Pianist*

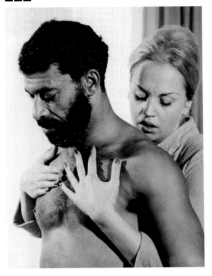

AND WE'LL BUY OURSELVES A LITTLE PIECE OF HEAVEN

ALI: FEAR EATS THE SOUL / 1974

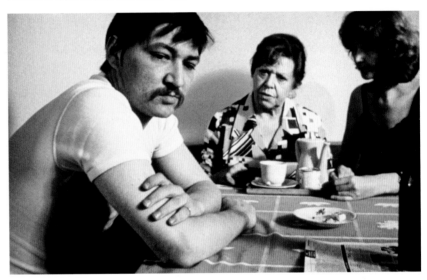

Rainer Werner Fassbinder's *Ali: Fear Eats the Soul* (*Angst essen Seele auf*) is an intense study of an unlikely but tender relationship between an aging German cleaning woman and a younger Arab immigrant worker. It is also a trenchant commentary on the state of 1970s Germany, as the couple face the derision and criticism of their family and friends. By focusing on the relationship between a white German woman and an immigrant, and placing it in the tough urban heart of Munich, Fassbinder

Fassbinder (left) plays Eugen, son-in-law of German cleaning woman Emmi (center). He and his wife Krista (Irm Hermann) laugh at Emmi when she says she has fallen in love with a younger Moroccan man.

achieved the emotional engagement of classic melodrama while exposing the underlying tensions in German culture.

New German Cinema directors such as Fassbinder sought to create something peculiarly German by bringing together the sharp modernity and realism of the French and British new waves with the

What else to watch: *All That Heaven Allows* (1955, p.130) ▪ *Lola Montès* (1955) ▪ *The Damned* (1969) ▪ *The Bitter Tears of Petra von Kant* (1972) ▪ *The Marriage of Maria Braun* (1979) ▪ *The Tin Drum* (1979) ▪ *Berlin Alexanderplatz* (1980)

❝**Happiness** is not always **fun.**❞

Epigraph / Ali: Fear Eats the Soul

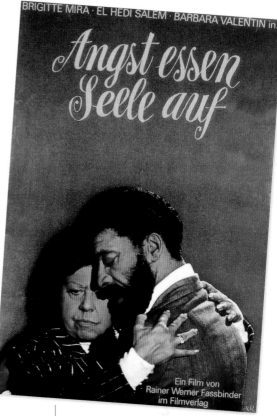

storytelling power of Hollywood. *Ali: Fear Eats the Soul* can also be seen as a homage to one of Fassbinder's cinematic heroes, German émigré Douglas Sirk, whose 1955 movie *All That Heaven Allows* portrayed the romance between a well-to-do widow and a younger gardener.

Fassbinder always worked quickly, but this movie was made exceptionally fast—in under two weeks, squeezed between two other projects. The result of this rapid shooting schedule is a lean, stripped-down work of great directness and immediacy.

Racial tensions

The German woman in the movie is the 60-year-old Emmi Kurowski (Brigitte Mira) and the immigrant is 40-year-old Ali (El Hedi ben Salem). They meet when Emmi ducks into an Arabic bar to get out of the rain on the way home from work. Ali asks Emmi to dance, and despite his limited grasp of German, a heartfelt relationship develops between them.

In his movies, Fassbinder presented to German society an uncompromising portrayal of its flaws. While Emmi and Ali may stay together, the racism that makes him ill will not go away.

They move in together, realize that they love each other, and decide to marry. Their marriage is quickly exposed to the prejudice and gossip of everyone around them, and an end to outright hostility only comes from the local shopkeepers' and bar owners' hypocritical need to keep their custom. The constant pressure threatens to destroy their relationship, and Ali seeks solace in the arms of the female bartender who used to cook for him, Barbara (Barbara Valentin, far left). Yet in the end, their love endures.

In many of Fassbinder's movies, his attitude to his characters can be harsh and mocking. In *Ali: Fear Eats the Soul*, it is the cruelty of the people around Emmi and Ali that is exposed. By contrast, Emmi and Ali's relationship is handled in a touching and sincere way.

At the end of the movie, Ali collapses and is taken to a hospital, suffering from a stomach ulcer— something common, the doctor says, among migrants, because of the continual prejudice they face. As Ali says, "Fear eats the soul." Emmi promises to do everything she can to reduce the stress, and has a solution that is profound in its almost banal simplicity: "When we're together, we must be nice to one another." ▪

Rainer Werner Fassbinder Director

Fassbinder was the driving force of New German Cinema. In a career spanning just 14 years, he made more than 40 movies, many TV dramas, and 24 stage plays. He was born in Bavaria, Germany, in 1945, and had a lonely childhood in which he watched thousands of movies. By 21, he was running a theater company, manically writing and directing play after play. He made his first feature movie in 1969 and quickly achieved international acclaim, but his private life was often troubled, and he died of a drug overdose at just 37.

Key movies

1974 *Ali: Fear Eats the Soul*
1979 *The Marriage of Maria Braun*

ANGELS MONSTE 1975–1991

AND
RS

Steven Spielberg's *Jaws* ushers in **the era of the blockbuster,** and is a box-office triumph.

1975

Taxi Driver and *All the President's Men* reflect the psychological scars of the **Vietnam War** and the **Watergate** scandal, respectively.

1976

Star Wars takes **science fiction** and **franchising** into a whole new galaxy, while Spielberg thrills again with *Close Encounters of the Third Kind.*

1977

Two epic turns usher in the 1980s: Jack Nicholson in Kubrick's **psycho-horror** *The Shining* and Robert De Niro in Scorsese's **boxing biopic** *Raging Bull.*

1980

1975

Video recorders go mainstream as Betamax and (one year later) VHS long-play formats enable moviegoers to record and play movies at home.

1977

New York inspires both Woody Allen's wry look at love in *Annie Hall* and the disco inferno that is *Saturday Night Fever.*

1979

Science fiction veers from **crazed dystopias** in *Stalker* and *Mad Max* to all-out horror in *Alien,* while *Apocalypse Now* lays bare the horrors of war.

1981

While *Raiders of the Lost Ark* launches the **Indiana Jones** franchise, a German U-boat stalks its prey in *Das Boot.*

After the major upheavals of the Swinging Sixties, the 1970s saw a different kind of revolution unfold. For all the tremors at their foundations, it seemed Hollywood's big studios were still standing, but now a new kind of movie burst onto the scene.

Director Steven Spielberg was, like so many of his peers, a young, movie-literate hotshot. But deep down he was also an old-fashioned showman. In the classic Hollywood tradition of happy accidents and unlikely triumphs, the production of *Jaws* was cursed by a man-eating great white shark that Spielberg felt was so laughably unrealistic he could barely bring himself to put it on screen. And yet it became the hit that changed the movies, installing a new type of blockbuster at the top of the food chain.

Two years later, when George Lucas's *Star Wars* came along to capture the imagination of a generation, the movie business was further transformed. Entering the world of Wookies and Jedi would become a rite of passage for each new generation of moviegoers, but Lucas's success also meant that soon, for Hollywood, there was no such thing as mere movies any more—only franchises in waiting.

And yet this was also a time when some of cinema's finest minds made their most audacious and enduring movies. In America, after *Chinatown*'s definitive portrait of LA's murky backstory, the spotlight now fell brilliantly and unforgivingly on New York. By the mid 1970s, Martin Scorsese had already announced himself as a giant talent—but *Taxi Driver*

(starring Robert De Niro as cabbie and ex-Marine Travis Buckle) would be the first of Scorsese's masterworks, a dazed snapshot of paranoia and urban decay that became an instant time capsule.

Alvy Singer was the hero and neurotic narrator of another consummate New York story: Woody Allen's romantic comedy, *Annie Hall.* For years to come, rare was the movie that wasn't in debt to one of those characters and its creators.

Beyond Hollywood

Outside America, ambiguity throbbed at the heart of movies that once seen, would be impossible to ignore. From Australia, in the same year that Spielberg's shark thrilled audiences in *Jaws,* director Peter Weir made *Picnic at Hanging Rock,*

Spielberg's heartwarming *E.T. the Extra-Terrestrial* is **science fiction for all the family**; not so Ridley Scott's epic *Blade Runner*, a **neo-noir vision** of Los Angeles in 2019.

Blue Velvet achieves instant cult status for David Lynch's **surreal and subversive** take on Americana.

Pedro Almodóvar's black comedy, *Women on the Verge of a Nervous Breakdown*, wins the Spanish director a global following.

Set in 1920s China, *Raise the Red Lantern* seduces audiences worldwide with the intensity of its **visual and emotional power**.

1982 **1986** **1988** **1991**

1985 **1987** **1989** **1992**

The **Sundance Institute** hosts its inaugural movie festival in Utah, to champion independent and world cinema.

Angels alight in Berlin in Wim Wenders' *Wings of Desire*, two years before the fall of the Berlin Wall dividing East and West Germany.

Indies come of age with *Sex, Lies, and Videotape,* a breakthrough hit for studio Miramax and debut director Steven Soderbergh.

Disney's *Beauty and the Beast* is the **first animated movie** to be nominated for an Oscar for Best Picture.

a story that inspired equal dread with its wispy account of missing schoolgirls in the outback of 1900. Meanwhile, in an industrial pocket of Estonia, the great Russian director Andrei Tarkovsky was making *Stalker*, poised between science fiction and philosophy. These are movies that remain, even now, gloriously unfathomable.

New decade, new voices

In the 1980s, Wall Street traders and mainstream movies looked slicker than ever, but around the edges, directors still drilled down into what lies beneath. Perhaps nothing sums up that better than the fact that David Cronenberg—whose notorious "body horror" scenes were less disturbing than the psyches of his characters—was once offered the chance to make that

Now more than ever we need to listen to each other and understand how we see the world, and cinema is the best medium for doing this.
Martin Scorsese

gung-ho landmark, *Top Gun* (1986). And then there was David Lynch—who, like Hitchcock before him, was unique enough to exist as a genre of his own, his movies driven by the subconscious, and at least as surreal, funny, and disturbing as real dreams can be.

By the end of the 1980s, other voices were speaking up. Indie movies were in the ascendant, from Spike Lee tracking racial tensions in Brooklyn, to Steven Soderbergh training his lens on sexuality and relationships. From China, Zhang Yimou's *Raise the Red Lantern* was both a gorgeous period drama and a signal of a global future.

Meanwhile, cinema itself survived another attack on its very existence: just as TV had been supposed to leave it for dead in previous decades, so too was the rise of home video in the 1980s. In the battle between VHS and cinema, there was only one winner: new formats come and go, but the movies endure. ∎

YOU'RE GONNA NEED A BIGGER BOAT
JAWS / 1975

IN CONTEXT

GENRE
Action adventure

DIRECTOR
Steven Spielberg

WRITERS
Peter Benchley, Carl Gottlieb (screenplay); Peter Benchley (novel)

STARS
Roy Scheider, Richard Dreyfuss, Robert Shaw, Lorraine Gary

BEFORE
1971 In Spielberg's thriller *Duel*, a driver is chased by a truck.

AFTER
1977 *Close Encounters of the Third Kind* is Spielberg's ambitious sci-fi drama.

1993 In his blockbuster *Jurassic Park*, Spielberg brings dinosaurs back from extinction.

There are many memorable lines in *Jaws*, but "You're gonna need a bigger boat" is the one most people remember. It comes just after Brody (Roy Scheider), the aquaphobic police chief of Amity Island, first sees his nemesis: the great white shark, which smashes out of the water, mouth gaping, heading straight for the audience in their seats.

The shark's first victim is lone skinny-dipper Chrissie (Susan Backlinie). The attacker is all the more terrifying for being unseen.

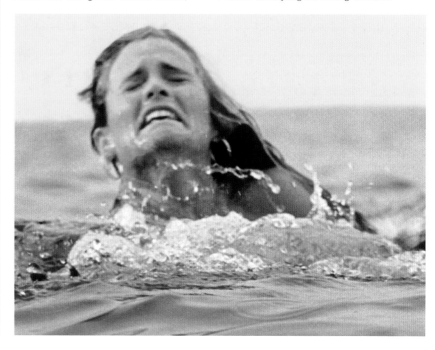

> What this movie is about, and where it succeeds best, is the primordial level of fear.
> **Gene Siskel**
> *Chicago Tribune*, 1975

It's a theme-park moment—the shark is clearly mechanical, a prop on a hydraulic crane, but we don't mind because *Jaws* is as much a ride as it is a movie.

When Steven Spielberg's monster movie was released in June 1975, there was a sense that something new had arrived. Adapted from a best-selling novel by Peter Benchley about a shark that terrorizes a small beach community, *Jaws* sold 25 million tickets in 38 days—it started big and swelled to mammoth proportions. Studio executives quickly realized that they were onto something—*Jaws 2* was rushed into production and came out in 1978. Spielberg had invented the "summer event movie"—the action-packed blockbuster aimed at summer audiences that became Hollywood's great obsession for the next four decades.

Pure entertainment

Jaws changed American cinema, which, for the first half of the 1970s, had been in thrall to low-key, European-style movies

with deliberately tricky characters and ambiguous moral codes. Spielberg's big-fish tale was a throwback to the fun-house origins of the moving image—it was pure entertainment, a roller coaster that promised scares but at the same time sought to reassure its audience. The movie contained all the elements that would go on to make a typical Spielberg sideshow: ambitious special effects, a high-concept story, cute kids, a small-town American hero who finds himself out of his depth, and plenty of opportunities for marketing.

Brody (Roy Scheider, center) wants to close the resort, but is overruled by the mayor (Murray Hamilton, left), who fears that rumors of a shark attack will ruin the tourist season.

After *Jaws* came the *Star Wars* movies, Spielberg's *Indiana Jones* saga, *Back to the Future*, and then the superhero mega-franchises of the 21st century. But, looking back, the picture that spawned these behemoths is a very different creature. *Jaws*, in comparison, is a relatively modest adventure, its chief spectacle a rubber shark so unconvincing that Spielberg »

❝This was not a boat accident.❞
Hooper / *Jaws*

worked hard to keep it off the screen as much as possible. Instead of the full-blown orchestral swoons for which he would later become famous, composer John Williams employs a jaggedly minimalist musical score to herald the approach of the shark; the result, a kind of panicked heartbeat, is the most haunting movie motif since the stabbing strings in Alfred Hitchcock's *Psycho* (1960).

Claustrophobia

As the narrative moves into its final act, the big showdown with the great white, its trio of heroes journeys out to sea—but Spielberg narrows his focus on their tiny fishing boat, the *Orca*, and the story shrinks to a human drama.

For all the movie's snapping shark jaws, exploding gas canisters, and severed heads bobbing toward the screen, the most memorable scene in *Jaws* is nothing more spectacular than three men talking: Chief Brody, shark expert Hooper (Richard Dreyfuss), and psychotic sea dog Quint (Robert Shaw) share a late-night drink below deck. They compare scars and sing songs, and eventually the conversation turns dark, as Quint tells the chilling

story of the sinking of the USS *Indianapolis* in World War II. "Eleven hundred men went into the water, three hundred and sixteen men came out," he growls. "The sharks took the rest."

Quiet before the storm

The *Indianapolis* speech is a moment of quiet that gets under our skin, so when that fake-looking mechanical shark-prop rises out of the ocean we see it as the director intended: a monster imbued with

With the *Orca* sinking and the shark about to swallow Brody, he has one final desperate plan to kill it in a spectacular finale.

awesome terror. Spielberg is a canny showman, and he knows that roller coasters rely on a lull before each stomach-churning plunge. It's a mark of his genius that *Jaws* contains more lulls than plunges, yet is remembered for its shock horror and white-knuckle action adventure. ◼

Steven Spielberg Director

Born in Cincinnati, Ohio, in 1946, Steven Spielberg has been a household name for four decades. An all-American storyteller with a European eye, he has made some of the most successful movies of all time. With *Jaws*, his first hit, he invented the "event movie." His enthusiasm for the silver screen led him to make the *Indiana Jones* series, a homage to 1930s action adventure serials, while his family fable *E.T.* proved he was a master of emotional

drama. In 1993, he told a true story of heroism during the Holocaust with *Schindler's List*. Since then he has balanced historical drama with special-effects spectacles.

Key movies

1975 *Jaws*
1978 *Close Encounters* of the *Third Kind*
1982 *E.T. the Extra-Terrestrial*
1993 *Schindler's List*

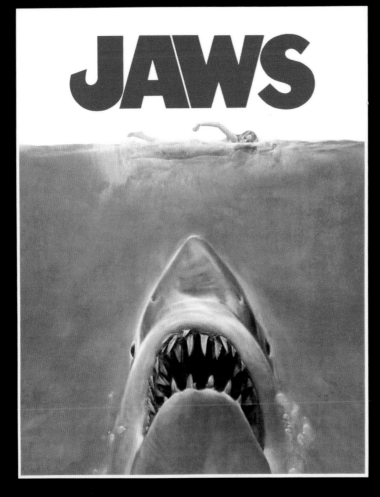

When in Southern California visit **UNIVERSAL STUDIOS TOUR** AN MCA COMPANY

The terrifying motion picture from the terrifying No. 1 best seller.

JAWS

ROY SCHEIDER **ROBERT SHAW** **RICHARD DREYFUSS**

JAWS

Co-starring LORRAINE GARY · MURRAY HAMILTON · A ZANUCK/BROWN PRODUCTION
Screenplay by PETER BENCHLEY and CARL GOTTLIEB · Based on the novel by PETER BENCHLEY · Music by JOHN WILLIAMS
Directed by STEVEN SPIELBERG · Produced by RICHARD D. ZANUCK and DAVID BROWN · A UNIVERSAL PICTURE ·
TECHNICOLOR® PANAVISION® **PG** PARENTAL GUIDANCE SUGGESTED SOME MATERIAL MAY NOT BE SUITABLE FOR PRE-TEENAGERS ORIGINAL SOUNDTRACK AVAILABLE ON MCA RECORDS & TAPES ...MAY BE TOO <u>INTENSE</u> FOR YOUNGER CHILDREN

COPYRIGHT © 1975 BY UNIVERSAL PICTURES COUNTRY OF ORIGIN U.S.A. 75/155

The movie's poster is one of the most iconic designed for any movie. As with most Spielberg movies there were extensive spin-off toys and products. Surprisingly, though, it took 15 years before a *Jaws* theme park attraction opened, with enormous success, in Florida.

THERE'S SOME QUESTIONS GOT ANSWERS AND SOME HAVEN'T
PICNIC AT HANGING ROCK / 1975

IN CONTEXT

GENRE
Mystery drama

DIRECTOR
Peter Weir

WRITERS
**Cliff Green (screenplay);
Joan Lindsay (novel)**

STARS
**Rachel Roberts, Anne-
Louise Lambert, Vivean
Gray, Helen Morse**

BEFORE
1974 Weir's first feature, *The
Cars That Ate Paris*, develops
his trademark theme of
macabre happenings in
a small community.

AFTER
1981 Like *Hanging Rock,
Gallipoli,* Weir's World War I
drama, authentically captures
Edwardian Australia.

1989 Weir's acclaimed US
drama, *Dead Poets Society,*
echoes *Hanging Rock* in its
story of a tragedy at a school.

icnic at Hanging Rock
opens with a caption
stating that on February 14,
1900, a party of schoolgirls went on
a picnic at Hanging Rock near
Mount Macedon in the Australian
state of Victoria. It ends with the
words: "During the afternoon
several members of the party
disappeared without a trace." This
creates the impression that the
story that follows is based on true
events—but it isn't. The movie,
made in 1975, is entirely fictitious.

So why are the words there?
Are they a trick, or a clue—or
both? This is the first of many

A movie composed
almost entirely of clues.
It forces us to stretch
our imaginations.
Vincent Canby
The New York Times, 1979

mysteries posed in this haunting
Valentine's Day trip into the wilds
of the Australian bush.

No resolution
The strange events at Hanging
Rock were first related in a
1967 novel by Australian author
Joan Lindsay, which itself was
ambiguous about whether the
case of the missing party was
true. When Weir came to adapt
the book for movie, he faced an
unusual challenge: Lindsay had
offered no explanation for the
story's central mystery. The three
girls and their teacher simply
vanish—there is no suggestion of
where they go, or why. Could the
director expect his audience to
sit through a two-hour mystery
that has no resolution? Weir's
response was to draw out themes
of absence—not only do the girls
and Miss McCraw, their teacher,
disappear early in the story, but
no solutions or clues are found to
the questions asked. Another
teacher, Mr. Whitehead (Frank
Gunnell), is the first to accept that
the event is unsolvable—"There's
some questions got answers and
some haven't," he says simply. In
Picnic at Hanging Rock, Weir is

What else to watch: *Bunny Lake Is Missing* (1965) ▪ *Wake in Fright* (1971) ▪ *Walkabout* (1971, p.337) ▪ *The Year of Living Dangerously* (1982) ▪ *The Blair Witch Project* (1999) ▪ *The Virgin Suicides* (1999) ▪ *The Way Back* (2010) ▪ *The Babadook* (2014)

Irma, Marion, and Miranda share an eerily idyllic moment just before they set off to climb Hanging Rock. Irma will be found later with her corset missing. The other two, along with Miss McGraw, disappear without trace.

asking the viewer to respect the mystery for what it is. A kind of supernatural event seems to have occurred. It has no context and is therefore frightening. Weir builds his drama on this menacing atmosphere, which hums with the stifling heat of the Australian summer. He shoots Hanging Rock as though it were the surface of a hostile alien world, which is what it must have felt like to the characters. The movie is set in 1900, when European settlers were still strangers in an ancient land they did not fully understand.

Possible hint

There is a hint that sexuality is at the heart of the vanishing. When one of the girls "returns," unable to put her experience into words, why is her corset missing? Is it significant that the vanishing occurs on Valentine's Day? Or that the rock itself sits on a dormant volcano, a potential symbol of repressed desire? It's impossible to know. Any answers to the riddle evaporate in the dry haze of the bush. In *Picnic at Hanging Rock*, it is the mystery that endures, and not the explanation. ▪

We shall only be **gone a little while.**

Miranda / Picnic at Hanging Rock

Peter Weir
Director

Born in Sydney in 1944, Weir started his career making documentaries with Australia's Commonwealth Film Unit. Associated with the movement dubbed the "Australian New Wave," which included performers and filmmakers who found international acclaim in the 1970s and 80s, he went on to make movies that focused on communities under strain, his atmospherics mirroring the tumultuous forces affecting the characters' lives. After the success of his World War I drama *Gallipoli*, Weir's films have often been star vehicles that put a man into a closed society and watched him struggle to connect, such as Harrison Ford's John Book in *Witness* (1985), set within an Amish community.

Key movies

1975 *Picnic at Hanging Rock*
1981 *Gallipoli*
1989 *Dead Poets Society*
1998 *The Truman Show*

SOMEDAY A REAL RAIN WILL COME

TAXI DRIVER / 1976

IN CONTEXT

GENRE
Psychological thriller

DIRECTOR
Martin Scorsese

WRITER
Paul Schrader

STARS
Robert De Niro, Jodie Foster, Cybill Shepherd, Harvey Keitel

BEFORE
1973 Martin Scorsese, Robert De Niro, and Harvey Keitel team up for the first time with *Mean Streets,* the story of a low-ranking New York mobster.

1974 De Niro shoots to fame in *The Godfather: Part II*, as the young Don Vito Corleone.

AFTER
1982 Scorsese directs De Niro in *The King of Comedy,* a black comedy about another delusional New York loser.

1990 Scorsese returns to the mob with *Goodfellas*, one of his most popular movies.

It is 1976, and there are around 7.8 million people living in New York City. Travis Bickle (Robert De Niro) regards them all through the filthy windows of his cab—everywhere he looks, from Times Square to East 13th Street by way of Park Avenue South, there are people, but to Travis they may as well be characters in a movie. He is an outsider, alienated and angry, who views the world from the inside of a car. This is the taxi driver of Martin Scorsese's movie, who drifts through the city in a clammy fever dream.

Cleansing rain

Taxi Driver is a dirty movie, not in the same way as the porn movies that Travis likes to watch in the run-down theaters of 42nd Street, but in its depiction of the grimy city. Scorsese shot the movie in the summer heat wave of 1975, during a trash-collection strike that left Manhattan mountainous with rotting garbage. "Thank God for the rain to wash the trash off the sidewalk," says Travis. "Someday a real rain will come and wash all this scum off the streets."

In Travis's world, the only clean things are his conscience and his driving licence. To him, everything else is disgusting, including his fellow New Yorkers. He finds them

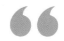

The immediate response is usually very visceral and angry. But if this film weren't controversial, there'd be something wrong with the country.
Paul Schrader
Interview with Roger Ebert,
Chicago Sun-Times, 1976

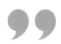

degenerate, railing against prostitution, homosexuality, and drug taking. When Travis talks about a cleansing rain, he means it biblically, apocalyptically. But he is not a religious fanatic—he just wants a purpose. His God exists only to give him the order to kill, just as his commanding officer did when Travis served as a marine in the Vietnam War.

Lost soul

Travis is lost in so many ways: he fought on the losing side in the war in Southeast Asia, and now

Minute by minute

00:19
Travis enters the campaign office of Senator Palatine to volunteer, as an excuse to talk to his aide Betsy. He takes her for coffee.

00:32
When Travis takes Betsy to a porn movie, she walks out in disgust. He calls her and sends flowers, but she brushes him off.

01:05
A store is held up at gunpoint while Travis is in it. He shoots the thief. The store owner covers for him, since Travis has no gun permit.

01:30
At a rally for Palatine, Travis is spotted by a security guard as he approaches the Senator and seems to reach for his gun. Travis leaves without firing.

00:00 00:15 00:30 00:45 01:00 01:15 01:30 01:53

00:27
Palatine gets into Travis's cab. Travis tells him the city needs to be cleaned up. Later, teenage prostitute Iris gets in, but pimp Sport pulls her out.

00:51
After nearly running over Iris, Travis buys guns. He starts an intense fitness regimen and practices shooting.

01:21
The day after paying for her time, Travis sees Iris for breakfast. He says that he will give her the money to leave Sport and go to a commune.

01:34
Travis shoots Sport, a hotel owner, and a gambler who is with Iris. He tries to shoot himself but is out of bullets.

What else to watch: *Mean Streets* (1973) ▪ *The Deer Hunter* (1978) ▪
Raging Bull (1980, pp.338–39) ▪ *The King of Comedy* (1982) ▪ *After Hours* (1985)

he has lost his faith in the country that he was fighting for. Even his ability to sleep has deserted him. Most crucially, he has lost his way in life. "All my life needed was a sense of someplace to go," he murmurs in his half-awake, half-dreaming narration, as he glides endlessly through the night in his taxi, taking others to their destinations. Travis's eyes are glimpsed on-screen in the rear-view mirror, as though the audience

Travis determines to save Iris (Jodie Foster), a 12-year-old prostitute, from her pimp, Sport, whether she wants him to or not. By saving her, Travis can be the cleansing rain.

are his passengers—but, like him, they have no idea where they are heading.

Ride through hell

From the opening moments of *Taxi Driver*, Scorsese invites the viewer into the tormented mind of this antihero, suggesting his character's instability through chaotically arranged images and camera angles.

The first shot of the movie is a cloud of steam venting from the sewers, tinged by red neon light. It looks like brimstone rising from hell, and Travis's cab appears suddenly in its midst, as if it is »

Martin Scorsese
Director

"My whole life has been movies and religion," Martin Scorsese once said. "That's it. Nothing else." He was born a Catholic in Queens, New York, in 1942, and movies have become for him a religion in themselves, an art form to revere and treasure.

Scorsese studied film at New York University. He directed his first feature, *I Call First*, in 1967. Since then, his output has been diverse, from gritty urban thrillers to grand historical dramas, paying homage to screen classics.

Religion finds its way into most of his movies, most notably *The Last Temptation of Christ* (1988) and *Kundun* (1997). He also has another great passion: New York City, the subject of so much of his work, from his first major success, *Mean Streets*, to *Gangs of New York*.

Key movies

1973 *Mean Streets*
1976 *Taxi Driver*
1980 *Raging Bull*
1990 *Goodfellas*
2002 *Gangs of New York*
2006 *The Departed*

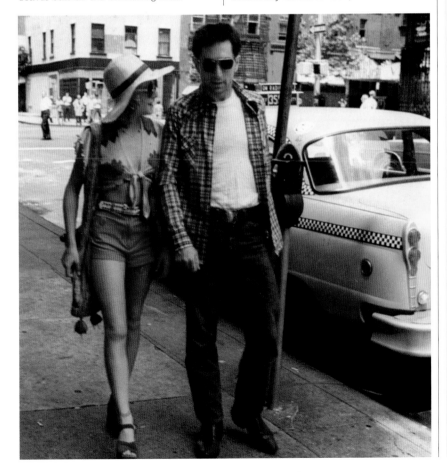

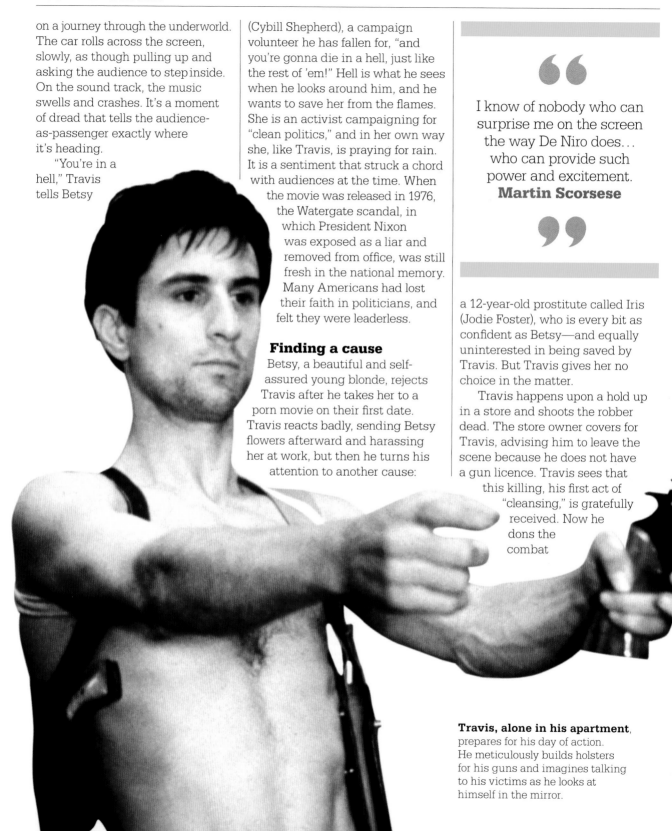

on a journey through the underworld. The car rolls across the screen, slowly, as though pulling up and asking the audience to step inside. On the sound track, the music swells and crashes. It's a moment of dread that tells the audience-as-passenger exactly where it's heading.

"You're in a hell," Travis tells Betsy

(Cybill Shepherd), a campaign volunteer he has fallen for, "and you're gonna die in a hell, just like the rest of 'em!" Hell is what he sees when he looks around him, and he wants to save her from the flames. She is an activist campaigning for "clean politics," and in her own way she, like Travis, is praying for rain. It is a sentiment that struck a chord with audiences at the time. When the movie was released in 1976, the Watergate scandal, in which President Nixon was exposed as a liar and removed from office, was still fresh in the national memory. Many Americans had lost their faith in politicians, and felt they were leaderless.

Finding a cause

Betsy, a beautiful and self-assured young blonde, rejects Travis after he takes her to a porn movie on their first date. Travis reacts badly, sending Betsy flowers afterward and harassing her at work, but then he turns his attention to another cause:

> I know of nobody who can surprise me on the screen the way De Niro does... who can provide such power and excitement.
> **Martin Scorsese**

a 12-year-old prostitute called Iris (Jodie Foster), who is every bit as confident as Betsy—and equally uninterested in being saved by Travis. But Travis gives her no choice in the matter.

Travis happens upon a hold up in a store and shoots the robber dead. The store owner covers for Travis, advising him to leave the scene because he does not have a gun licence. Travis sees that this killing, his first act of "cleansing," is gratefully received. Now he dons the combat

Travis, alone in his apartment, prepares for his day of action. He meticulously builds holsters for his guns and imagines talking to his victims as he looks at himself in the mirror.

Travis Bickle's transformation

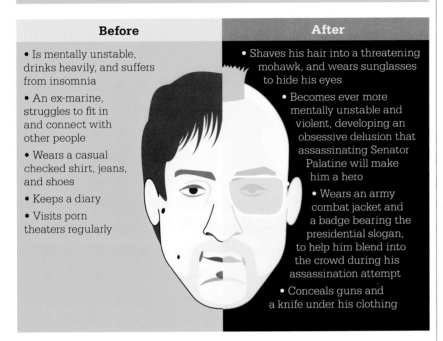

Before	After
• Is mentally unstable, drinks heavily, and suffers from insomnia	• Shaves his hair into a threatening mohawk, and wears sunglasses to hide his eyes
• An ex-marine, struggles to fit in and connect with other people	• Becomes ever more mentally unstable and violent, developing an obsessive delusion that assassinating Senator Palatine will make him a hero
• Wears a casual checked shirt, jeans, and shoes	• Wears an army combat jacket and a badge bearing the presidential slogan, to help him blend into the crowd during his assassination attempt
• Keeps a diary	
• Visits porn theaters regularly	• Conceals guns and a knife under his clothing

Robert De Niro Actor

Robert De Niro has starred in more than 90 movies, eight of them directed by Martin Scorsese. He rose to fame playing the young Vito Corleone in Francis Ford Coppola's *The Godfather: Part II*, and soon won a reputation for his dedicated approach to researching his roles. His preparation for Scorsese's *Raging Bull* became legendary after he gained 60 lb (27 kg) to play the boxer Jake LaMotta.

For the first three decades of his career, De Niro specialized in the portrayal of misfits, outsiders, and violent, unpredictable personalities, from Corleone and Travis Bickle to Al Capone in Brian De Palma's *The Untouchables* (1987) and Max Cady, the stalker in Scorsese's *Cape Fear* (1991). More recently he has played gentler, less volcanic roles, and diversified into comedy.

Key movies

1973 *Mean Streets*
1974 *The Godfather: Part II*
1976 *Taxi Driver*
1978 *The Deer Hunter*
1980 *Raging Bull*

gear, shaves his head into a mohawk, and sets out to enact vengeance on Iris's pimp, Sport (Harvey Keitel), in what turns out to be a horrific bloodbath. Inside Travis's head, the storm breaks—the real rain has come at last.

Nightmare world

The cinematography of Travis's rampage is hallucinogenic in its contrasting colors and unnerving angles, as though the movie is now descending fully into unreality. Like the opening shot of the steam, with the cab emerging through it, and Travis's mumbled narration, the climax of the movie appears to take place in a nightmare world. Scorsese has often talked about movies existing at the intersection of dreams and reality, and this is where he takes the audience.

A dreamy coda to the slaughter, in which Travis survives and becomes a tabloid hero, has been interpreted as his dying fantasy. Whether real or imagined, it is Travis's longed-for moment in the spotlight. Writer Paul Schrader sees the end as taking the audience back to the beginning, and so Travis drives away, but neither he nor the world has been cured. ∎

❝Are you **talkin' to me**?
Well, I'm the **only one here**.**❞**

Travis Bickle / Taxi Driver

I LURVE YOU, YOU KNOW? I LOAVE YOU. I LUFF YOU. TWO 'F'S

ANNIE HALL / 1977

IN CONTEXT

GENRE
Romantic comedy

DIRECTOR
Woody Allen

WRITERS
**Woody Allen,
Marshall Brickman**

STARS
**Woody Allen, Diane
Keaton, Tony Roberts**

BEFORE
1933 The Marx brothers, a
huge influence on Allen, make
Duck Soup (p.48). He later
uses a clip from it in his movie
Hannah and Her Sisters (1986).

1973 Ingmar Bergman's
Scenes from a Marriage
shows a married couple's
ups and downs in a hyper-
realistic way.

AFTER
1993 Allen and Keaton reunite
on screen for the last time
to date in the director's
Manhattan Murder Mystery.

Woody Allen's
1977 movie
Annie Hall
is a New York romantic
comedy with its two
elements in perfect
balance. Allen himself
plays comedian Alvy
Singer, and Diane Keaton,
Allen's girlfriend at the
time, plays Annie Hall.
The movie is imbued with
Allen's trademark neurotic
humor, and may have been a comic
reflection of the ups and downs of
his real-life relationship with Keaton.

It is also very much a document
of its time and place, focusing as it
does on the preoccupations of the
late 1970s Manhattan intelligentsia,
with their long-winded, competitive
opining on the meaning of art, film,
and literature. Alvy lampoons their
pretentiousness while at the same
time reveling in it.

Allen's movie stole
the Best Picture Oscar
from *Star Wars*, a rare
example of a small,
intellectual movie
beating a major
blockbuster to the
coveted prize.

As a New Yorker,
Alvy is dismissive
of Los Angeles,
which he sees as a
cultural wasteland. Upon receiving
an invitation to present an award
on TV there, he replies: "In Beverly
Hills, they don't throw their garbage
away. They turn it into television
shows." And when Annie expresses
a desire to go to LA, Aly sees it
as a defect in her personality.
At the same time, however, he
recognizes that he is trapped by
the persona that New York has
given him.

❝A relationship, I think, is **like a shark**.
You know? It has to constantly **move
forward** or **it dies**. And I think what we
got on our hands is **a dead shark**.**❞**

Alvy Singer / *Annie Hall*

What else to watch: *8½* (1963) ■ *My Night at Maud's* (1969) ■ *Scenes from a Marriage* (1973) ■ *Sleeper* (1973) ■ *Manhattan* (1979) ■ *Hannah and Her Sisters* (1986) ■ *Deconstructing Harry* (1997) ■ *Blue Jasmine* (2013)

The self-absorption of the New York set is central to *Annie Hall*, and Alvy epitomizes it. In many ways the movie is an evolution of Allen's stand-up routine, in which he made comedy out of his own insecurities and preoccupations. The movie opens with a monologue to camera in which Alvy sums up his problems with women by quoting Groucho Marx's famous comment: "I would never want to belong to any club that would have someone like me for a member." Of his first wife Allison, Alvy later says: "Why did I turn off Allison Portchnik? She was—she was beautiful. She was willing. She was real… intelligent. Is it the old Groucho Marx joke?"

"We need the eggs"

Throughout the movie, Alvy explores what makes a successful relationship and why relationships fail, even asking people randomly on the street. But it seems that his search is

Woody Allen Director/Actor

Born Allen Konigsberg in Brooklyn, New York, in 1935, Woody Allen's New York Jewish background would become a key theme in his movies. He started out writing jokes for newspapers and television before becoming a stand-up comic in the early 1960s, creating monologues that drew on his mix of intellect and self-doubt. By 1965, he was making movies, starting with slapstick comedies before developing works that were influenced by European art-house movies. Allen continues to make a new movie almost every year.

Key movies

1977 *Annie Hall*
1979 *Manhattan*
1986 *Hannah and Her Sisters*

futile, since the relationships he encounters are fleeting and not particularly meaningful. One couple attributes happiness to their mutual shallowness and the fact that they have "nothing interesting to say." In the end, Alvy has to admit that relationships are "totally irrational and crazy and absurd… but I guess we keep going through it because most of us need the eggs." This is a reference to a joke in which a man goes to a psychiatrist and tells him that his brother thinks he's a chicken. "The doctor says, 'Well, why don't you turn him in?' And the guy says, 'I would, but I need the eggs.'" In this case, the eggs are love, and Annie is the love of Alvy's life. *Annie Hall* is Allen's analysis of how love goes wrong— how the eggs get broken. ■

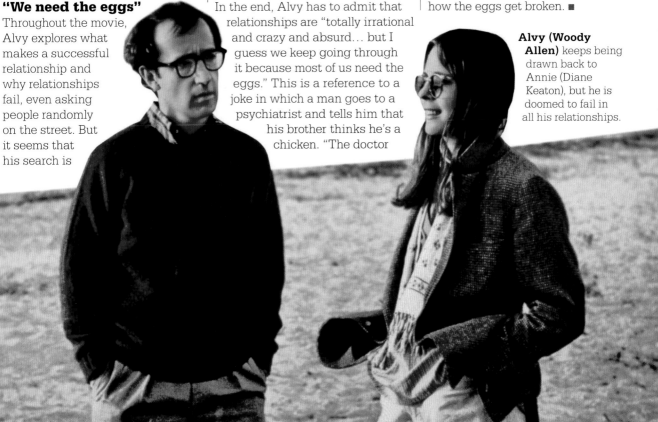

Alvy (Woody Allen) keeps being drawn back to Annie (Diane Keaton), but he is doomed to fail in all his relationships.

THE FORCE IS STRONG WITH THIS ONE
STAR WARS / 1977

IN CONTEXT

GENRE
Science fiction, adventure

DIRECTOR
George Lucas

WRITER
George Lucas

STARS
Mark Hamill, Harrison Ford, Carrie Fisher, Alec Guinness

BEFORE
1971 George Lucas's first movie, *THX 1138*, is a science-fiction fable set in a dystopian future policed by androids.

AFTER
1980 Lucas vacates the director's chair for *The Empire Strikes Back*, the first follow-up to *Star Wars*, which formed "Episode V" of a narrative arc.

1983 The initial *Star Wars* trilogy concludes with *Return of the Jedi*. It is followed in 1999 by *The Phantom Menace*, the first of three prequels.

Just as fairy tales begin with "Once upon a time... ," *Star Wars* opens with a title card that reads "A long time ago in a galaxy far, far away..." With these words, the audience is transported to a storybook universe of heroic farm boys, dueling knights, comical servants, dark lords, oppressed rebels, and princesses locked in deep, dark dungeons. George Lucas combines these elements to relate a defiantly American tale. Obi-Wan Kenobi, the grand old Jedi master (played by Alec Guinness), is a fusion of warrior-wizard and self-help guru, while "the Force" is a magical expression of the American Dream, stressing the power of the individual.

Mixing genres

For any fan of the movies, the joy of Lucas's blockbuster is its magpie approach to genre. *Star Wars* is a science-fiction adventure, a fairy tale, a Western, a war movie, a samurai epic, a slapstick comedy, and even a Shakespearean tragedy— and all of these blended into a single movie that's accessible to anyone from the age of five up. In short, it is a great introduction to the endless possibilities of the moving image. ∎

Princess Leia (Carrie Fisher) joins Luke Skywalker (Mark Hamill) to do battle with the evil Empire. They become close, but have a big surprise in store for them.

What else to watch: *Flash Gordon* (1936) ▪ *The Hidden Fortress* (1958) ▪ *Lawrence of Arabia* (1962) ▪ *The Empire Strikes Back* (1980)

YOU STILL DON'T UNDERSTAND WHAT YOU'RE DEALING WITH, DO YOU?
ALIEN / 1979

Alien was released two years after *Star Wars*, which had rekindled Hollywood's appetite for space. Like *Star Wars*, it featured spaceships, distant planets, and innovative special effects. Unlike *Star Wars*, however, it was terrifying—a nihilistic nightmare story spun around cinema's most disturbing alien.

The project was originally called *Star Beast*. It had a B-movie script about an alien stowaway onboard a spaceship full of humans. In the hands of director Ridley Scott, however, this seemingly unoriginal concept became something new in the science-fiction genre: a dark, sinister horror movie with gore, violent deaths, and weird, psychosexual imagery. Scott brought groundbreaking, grimy realism to the design of the spacecraft, engaged Swiss Surrealist artist H. R. Giger to design the alien, and cast a woman (Sigourney Weaver) in the role of the tough-as-hell protagonist Ripley. Audiences who went to the movie expecting laser guns and amusing robots were in for a surprise.

The poster was designed to give nothing away to audiences, and the movie reveals the alien's form only bit by bit in order to ratchet up the tension.

Terror of the unseen
The alien is the story's real star, in spite of the fact that Scott keeps his monster hidden for most of the movie. The viewer glimpses its spiny hand, its quivering drool, the black shine of its skull. The audience's imagination fills in the rest. The terror comes from its dread and unbearable silences, and the knowledge—thanks to *Alien*'s iconic tagline—that "in space, no one can hear you scream." ∎

What else to watch: *It! The Terror from Beyond Space* (1958) ▪ *Jaws* (1975, pp.228–31) ▪ *The Thing* (1982) ▪ *Aliens* (1986) ▪ *Prometheus* (2012)

IT'S SO QUIET OUT HERE. IT IS THE QUIETEST PLACE IN THE WORLD
STALKER / 1979

IN CONTEXT

GENRE
Science fiction

DIRECTOR
Andrei Tarkovsky

WRITERS
Arcadiy Strugatsky and Boris Strugatsky (screenplay and novel)

STARS
Alisa Freyndlikh, Aleksandr Kaydanovsky, Anatoly Solonitsyn

BEFORE
1966 Anatoly Solonitsyn stars in Tarkovsky's *Andrei Rublev*, about a medieval iconographer.

1972 Tarkovsky's movie *Solaris* begins a prolific period.

AFTER
1986 In his final movie, *The Sacrifice*, a man bargains with God to save mankind.

ike all great artists, Russian director Andrei Tarkovsky was often asked where he found the ideas for his movies. Tarkovsky himself, however, did not think the topic of inspiration was really much of a point for discussion. "The idea of a film," he once said, "always comes to me in a very ordinary, boring manner, bit by bit, by rather banal phases. To recount it would only be a waste of time. There is really nothing fascinating, nothing poetic, about it."

Tarkovsy's pessimistic view of art in general might also seem surprising. "It is obvious that art cannot teach anyone anything," he said, "since in 4,000 years humanity has learned nothing at all."

The movie's meaning has been endlessly discussed since it first came out. Tarkovsky himself refused to be drawn in.

It is worth mentioning these things since they go some way in explaining the director's own, oblique attitude to his art, which he discussed himself in his 1986 book *Sculpting In Time*, its title the perfect metaphor for his cinematic technique. A Tarkovsky movie is in some ways like a piece of sculpture by British artist Henry Moore: the abstractions mean as much as the realities, and what is left out often has as much significance as the elements that remain.

What else to watch: *2001: A Space Odyssey* (1968, pp.192–93) ▪ *The Color of Pomegranates* (1969) ▪ *Solaris* (1972) ▪ *Werckmeister Harmonies* (2000)

"When **a man** thinks of **the past**, he becomes **kinder."**

The Stalker / Stalker

Stalker, like many of Tarkovsky's other movies, was adapted from an existing work, in this case, the 1971 novel *Roadside Picnic* by Arcady and Boris Strugatsky, which describes the aftermath of a series of extraterrestrial incursions, called the Visitation, at six zones around the globe.

The casual detritus left behind by the unseen Visitors is compared in the book to "the usual mess" left at a picnic: "apple cores, candy wrappers, charred remains of the campfire, cans, bottles, somebody's handkerchief, somebody's penknife, torn newspapers, coins, faded flowers picked in another meadow." Just as a picnic's detritus baffles— and threatens—the animals that find it, so too are humans perplexed by the strange phenomena that they stumble across after the Visitors have left.

The unexplained

Unusually for science fiction of the time, the actual Visitation itself was of no concern in the novel; nor is it for Tarkvosky. His interest in the science-fiction genre resulted in another masterpiece, *Solaris*, but he used the form to suit his own artistic ends. Indeed, *Stalker*'s slow opening does not even try to explain what has given rise to the **»**

The "Writer" (Anatoly Solonitsyn) places a crown of thorns on his head as the men wait in the telephone room while in The Zone. Like many images in the movie, the allusion is obscure.

Andrei Tarkovsky
Director

Born in 1932 to a family of poets and writers in the Soviet town of Zavrazhye, Andrei Tarkovsky decided upon a career in movie in his early twenties. Enrolling to study direction at Moscow's State Institute Of Cinematography, where Sergei Eisenstein was also taught, he made his first student short film in 1956: *The Killers*, adapted from a short story by Ernest Hemingway. Tarkovsky's first feature, *Ivan's Childhood*, launched a high-profile career of stylish and nuanced art-house movies. After a slow start—just two full-length features in the 1960s, including the acclaimed *Andrei Rublev*—he made up for lost time in the 1970s, beginning with the space story *Solaris*. Characterized by long takes and mysterious symbolism, his movies pose deep existential questions about life and its meaning. He died in Paris in 1986.

Key movies

1962 *Ivan's Childhood*
1966 *Andrei Rublev*
1972 *Solaris*
1979 *Stalker*

mysterious entity called "The Zone." At this point, nothing is known about its origins, its purpose, or its nature except that anything that goes into The Zone does not come out again, and that it has been sealed off by the authorities, and is guarded by military police.

What it is that lurks in The Zone is something Tarkovsky has no desire to reveal. As the title of *Sculpting in Time* suggests, he is interested in time, something he uses a lot of—his movie clocks in at around the three-hour mark. It begins on the outskirts of the story, where the title character (played by Aleksandr Kaydanovsky) is getting ready for work. The word "stalker" suggests menace, but in this near-future world, a Stalker is both a thief who tries to smuggle artifacts out of The Zone and a guide who is willing to take others in.

Entering The Zone

The Stalker's world is poor and run-down, a fact reflected in the sepia cinematography used in the first portion of the movie, but his wife still begs him not to go into The Zone and is afraid for his safety. He brushes away her concerns and heads off to meet his two clients, known simply as the Writer and the Professor, who want to travel to The Zone, hearing that it has strange and possibly magical powers.

The quintessence of Tarkovsky's spaces, the Zone is where one goes to see one's innermost desires. It is, in short, the cinema.
Robert Bird
Andrei Tarkovsky: Elements of Cinema, 2008

The Stalker lies injured as the men first enter The Zone. As they venture into the unknown, to the sound of dripping water, the Stalker describes it as "the quietest place in the world."

When the trio arrive at The Zone, the movie suddenly switches from sepia into the colors of the modern world: "We are home," says the Stalker. But the men have not yet reached their ultimate destination. Within The Zone, where the normal practicalities of life no longer apply and lots of strange, inexplicable phenomena seem to occur, there is a place called The Room. When they find it, the Stalker tells them, with excitement and awe, "Your most cherished desire will come true here…" adding, "The desire that has made you suffer most."

However, it is not The Room itself that concerns Tarkovsky but his characters' arrival at its threshold. What is it that they really want? And what will they find inside? At this point, *Stalker* mutes its thriller aspect and becomes a

> **"My conscience** wants vegetarianism to **win over the world**. And **my subconscious** is yearning for **a piece of juicy meat**. But what **do I want**?**"**

The Stalker / Stalker

postapocalyptic existential drama, in which its three protagonists discuss their lives and destinies, reminiscent of Samuel Beckett's play *Waiting for Godot* (1953).

What next?

The final section deals with the Stalker's wife and child, finally closing in on his daughter's face as she lies with her head on the kitchen table, staring at three glasses that seem to rattle under her gaze while a train passes. Like many of the images in Tarkovsky's

movie, it comes with no explanation. One might see *Stalker* as a Soviet answer to Stanley Kubrick's *2001: A Space Odyssey*, which poses the question, "Where do we go from here?" But as to whether Tarkovsky was making a comment about life in the Soviet Union or life on Earth, the director himself refused to be drawn in: in his mind, a true artwork should not be reduced to its components and interpreted so simply. "We are judged not by what we did or wanted to do," he said in an

interview, "but we are judged by people who don't want to understand the work as a whole or even to look at it. Instead they isolate individual fragments and details, clutching to them and trying to prove that there is some special, main point in them. This is delirium."

To realize his stark vision, Tarkovsky searched for a suitably bleak location for *Stalker*, and found it in Estonia, at an old hydroelectric power station and a factory dumping toxic chemicals upstream. He, his wife, and actor Anatoly Solonitsyn all later succumbed to cancer, possibly due to contamination at the location. ∎

After the men draw lots, the Writer is chosen to enter a metal tunnel in The Zone. The tunnel leads them toward the mysterious Room.

YOU HAVE TO HAVE GOOD MEN. GOOD MEN, ALL OF THEM

DAS BOOT / 1981

IN CONTEXT

GENRE
Action thriller

DIRECTOR
Wolfgang Petersen

WRITERS
Wolfgang Petersen (screenplay); Lothar-Günther Buchheim (novel)

STARS
Jürgen Prochnow, Herbert Grönemeyer, Klaus Wenneman

BEFORE
1953 Charles Frend's *The Cruel Sea*, the story of a British corvette protecting a convoy from U-boat attacks, establishes the World War II naval thriller genre.

AFTER
2009 Samuel Maoz's tense war movie, *Lebanon*, which tells its story entirely from the inside of an Israeli tank, is compared to *Das Boot* by film critics.

W olfgang Petersen's *Das Boot* (*The Boat*) is an action movie set almost entirely in the narrowest, most claustrophobic space imaginable—a German U-boat during a single voyage in World War II. The story follows the anxieties of the crew in such a way that our attention, like theirs, is gripped within this undersea vice of iron and rivets.

After a brief scene in which the crew carouses in a French bar before a mission that seems to fill them, and the viewer, with a feeling of impending doom, the U-96 departs La Rochelle and heads deep into the North Atlantic. There the boat intercepts Allied convoys, is heavily damaged in a depth-charge attack, then makes a perilous attempt to slip undetected into the

Das Boot has been released as a movie and as a TV mini-series with added scenes. In 1997, a 209-minute director's cut was released.

Mediterranean. *Das Boot* is not a movie about heroes; its characters are all ordinary men whose survival depends on each other. "You have to have good men," says the apolitical, battle-hardened captain. "Good men, all of them."

An antiwar war movie?

Lothar-Günther Buchheim, on whose novel the movie was based, criticized the movie for being too exciting to convey the antiwar message he intended. This echoed the view of the French director François Truffaut, who said that a true antiwar movie was impossible because such movies inevitably

> ❝The sea **cannot claim us**, Henrich. No ship **is as seaworthy** as ours.❞
> **Captain Lehmann-Willenbrock** / *Das Boot*

Nerves become strained as the mechanics desperately try to figure out a way of refloating the U-boat before it becomes crushed by depth pressure.

made war thrilling. Not all critics agreed with Buchheim. Audiences came out of the movie drained physically and emotionally. Petersen's movie does not depend on thrilling action sequences, though there are those. Rather, it oscillates between tense moments of danger and the tedium of weeks of fruitless hunting, in which the relationships between crew members becomes fraught. The movie's grip is in its psychology rather than in its action sequences. As its tagline said, it is "A journey to the edge of the mind."

Putting us in the boat

Das Boot's power stems from the director's determination to attain realism. He makes viewers understand what it was like to be in a wartime submarine, attempting desperate repairs, running out of oxygen and time. The movie was shot almost entirely inside a real U-boat (on dry land), which could be tilted to 45 degrees to simulate a sudden dive. Two techniques contribute to the heightened realism. The first is an innovative use of sound. When destroyers are circling above the U-boat, all we hear in the silence are the sonar pings ringing off the hull, or the ferrous groaning and popping of rivets as the boat dives to a dangerously low depth. Second is the cinematography of Jost Vacano. Despite the cramped space, Vacano used a handheld camera to create a sense of intimacy, training himself to run through narrow spaces and over bulkheads. The effect he created has influenced a whole generation of movies. ▪

Wolfgang Petersen Director

Wolfgang Petersen is Germany's leading director of action movies. Born in Emden, Germany, in 1941, he studied theater in Berlin and Hamburg, before enrolling in the Berlin Film and Television Academy, after which he was making movies for television. In 1974, he directed his first feature, the thriller *One of the Other of Us*, and then in 1977 the controversial *Die Konsequenz*, a movie about gay love. But he made his name with *Das Boot*, which gave him the prestige to direct Hollywood thrillers such as *In the Line of Fire* with Clint Eastwood, *Outbreak* (1995) with Dustin Hoffman, and the hugely popular *Air Force One* with Harrison Ford, Gary Oldman, and Glenn Close.

Key movies

1981 *Das Boot*
1993 *In the Line of Fire*
1997 *Air Force One*

I'VE SEEN THINGS YOU PEOPLE WOULDN'T BELIEVE

BLADE RUNNER / 1982

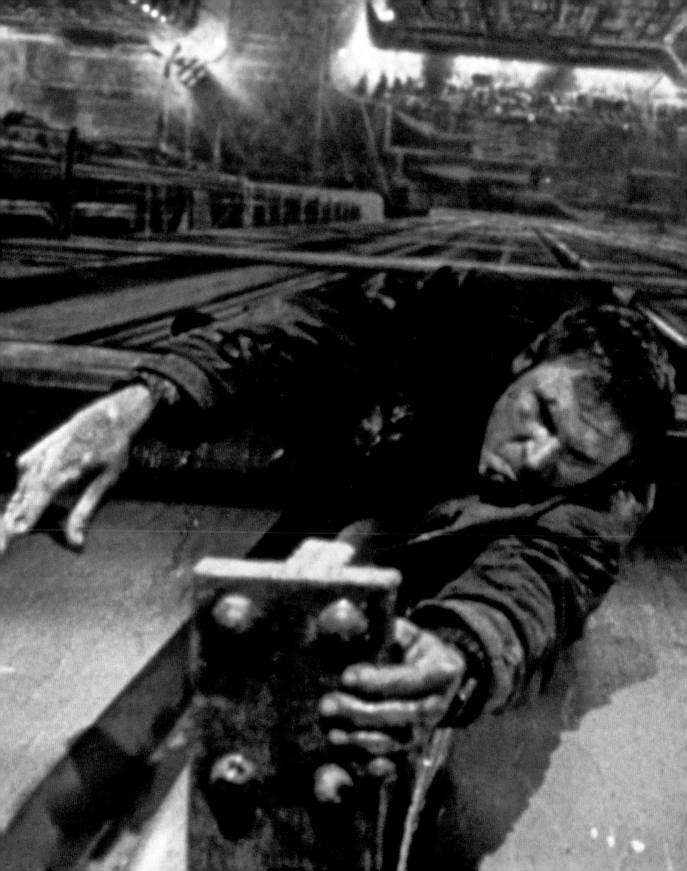

IN CONTEXT

GENRE
Science fiction, thriller

DIRECTOR
Ridley Scott

WRITERS
Hampton Fancher, David Webb Peoples (screenplay); Philip K. Dick (novel, *Do Androids Dream of Electric Sheep?*)

STARS
Harrison Ford, Rutger Hauer, Sean Young, Daryl Hannah

BEFORE
1979 Ridley Scott's first foray into the future is the science-fiction horror *Alien*.

AFTER
2006 Philip K. Dick's novel *A Scanner Darkly*, about a future in the grip of an all-out war on drugs, is adapted as a partially animated thriller.

2012 Ridley Scott returns to science fiction with *Prometheus*, a prequel to the *Alien* franchise.

Near the end of *Blade Runner*, Roy Batty (Rutger Hauer), a fugitive at large in a near-future Los Angeles, delivers his last words to an ex-cop called Deckard (Harrison Ford). "I've seen things you people wouldn't believe," he says softly. "Attack ships on fire off the shoulder of Orion. I watched c-beams glitter in the dark near the Tannhäuser Gate. All those moments will be lost in time, like tears in rain. Time to die."

The speech strikes at a moral dilemma, because Roy Batty isn't human—he's a "replicant," an android bioengineered by industrial scientists at the all-powerful Tyrell Corporation. Replicants are supposed to be machines, yet Batty's desire to live and questioning nature prove that he has consciousness. For Deckard, a specially trained detective (blade runner) whose job it is to hunt down and liquidate rogue replicants, this realization is particularly relevant. If Batty can feel sorrow and longing, then how is he any different from his creators?

A hanging question

Science-fiction cinema is often memorable for its unforgettable visual images, from the robotic Maria sparking into life in Fritz

As poignant as any sci-fi film I know... a film noir that bleeds over into tragedy.
David Thomson
Have You Seen...?, 2008

Lang's *Metropolis* (1927) to the mysterious black obelisk that bookends Stanley Kubrick's *2001: A Space Odyssey* (1968). While *Blade Runner* also shimmers with visual poetry, it is Batty's lament, a few lines of semi-improvised dialogue, that truly cements the movie's place in movie history. The words articulate a question that hangs over Scott's enigmatic masterpiece: what does it mean to be human?

Blade Runner is set in 2019, a long way off to the audiences who first lined up to see it in 1982. At the time of its release, the movie presented a new kind of future, a weird fusion of familiar elements: corporate buildings the size and shape of Babylonian ziggurats; the

Minute by minute

00:07
Leon shoots the blade runner Holden, who has been testing him to see if he is a replicant.

00:31
Rachael visits Deckard at his apartment. He tells her about her memories to show her that she's a replicant.

01:02
Rachael shoots Leon to save Deckard. Back at Deckard's apartment, they make love.

01:44
After a chase across the rooftops, Batty saves Deckard from falling. Batty then sits down and dies.

| 00:00 | 00:15 | 00:30 | 00:45 | 01:00 | 01:15 | 01:30 | 02:00 |

00:17
Deckard tests Rachael and discovers that she is a replicant. Tyrell tells him that she does not know what she is.

00:50
Deckard tracks down Zhora to a bar where she performs with a snake. He chases her and shoots her dead.

01:22
Sebastian helps Batty get an audience with Tyrell. Batty asks Tyrell for more life, but is told that it is not possible.

01:52
As Deckard and Rachael leave his apartment, he picks up an origami unicorn. Does Gaff know his dreams? Does that make him a replicant?

What else to watch: *Metropolis* (1927, pp.32–33) ■ *2001: A Space Odyssey* (1968, pp.192–93) ■ *Brazil* (1985, p.340) ■ *Ghost in the Shell* (1995) ■ *Gattaca* (1997)

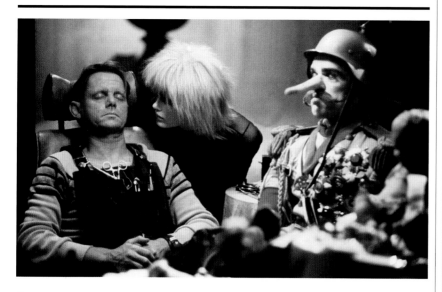

Genetic designer J. F. Sebastian (William Sanderson, left) helps Pris (Daryl Hannah) to reach Tyrell. He has a premature-aging disease that makes replicants sympathetic to him.

teeming night markets like those of Tokyo in the 1980s; the mean streets of postwar pulp detective fiction; the crumbling architecture of 19th-century Los Angeles. The flying cars offer viewers a futuristic glimpse, but they are piloted by militaristic beat cops—symbols of fear rather than progress.

Dystopian vision

For moviegoers more used to the escapism of *Star Wars* (1977), Scott's vision of a mashed-up near-future is disorienting. In its depiction of people's relationship with new technologies, the movie retains its power to unnerve.

In *Blade Runner*, the future is a place in which humans and machines have become all but indistinguishable. Robotics, voice-activated computer systems, bionic implants, artificial intelligence, and genetic programming are part of the culture, and all controlled by faceless corporate mega-entities. In this dehumanized age, people are forced to take a polygraph-like exam (the "Voight-Kampff test") to prove that they are human.

The replicants are the ultimate product of this bleakly mechanized human society. They look and act like people, but they are not people. They have limited lifespans—four years in Batty's case—and are bred "off-world," forbidden to visit Earth. Deckard believes these unfortunate creatures are nothing more than automatons—until he falls in love with Rachael during his hunt for »

Ridley Scott Director

Ridley Scott is a British director, born in 1937, whose movies combine cool visual style with dynamic storytelling and crowd-pleasing Hollywood chutzpah. His debut feature, *The Duellists*, was swiftly followed by science-fiction horror *Alien* and the futuristic dystopia *Blade Runner*, two classics of modern cinema. Through the 1980s, Scott established himself as a hard-working filmmaker, but it was not until the 1991 mold-breaking female road-movie *Thelma & Louise* that he came close to matching the success of his science-fiction double act. A decade later he hit big once more, going back in time with the Roman epic *Gladiator*. In 2001, Scott directed the war movie, *Black Hawk Down*, based on a US raid on Mogadishu. He returned to science fiction in 2012 with the *Alien* prequel *Prometheus*.

Key movies

1977 *The Duellists*
1979 *Alien*
1982 *Blade Runner*
1991 *Thelma & Louise*
2000 *Gladiator*

❝It's **not an easy thing** to meet your maker.❞

Roy Batty / *Blade Runner*

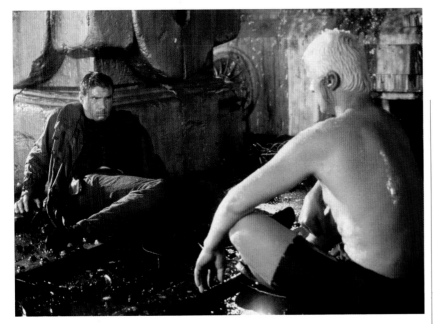

Batty pulls Deckard to safety before sitting down and ending the chase. He knows that his time is nearly over, and finally gives up the urge to carry on.

Batty and his three associates, who have come to Earth in search of answers. Rachael (Sean Young) is a Tyrell employee who, unusually, doesn't know she's a replicant—she can remember growing up. Deckard tells her those memories are fake, copied from her creator's niece, but he cannot banish his own nagging doubts: Rachael, like Batty, like all replicants, is a living being, and Deckard senses the stirring of this truth as he interrogates her. He also senses something else, a gnawing fear that his own memories could also be an illusion. Is Deckard a replicant too? How would he know?

Human identity crisis

Blade Runner is a portrait of humanity in the throes of an identity crisis, but Scott's movie is also concerned with inhumanity. "Quite an experience to live in fear, isn't it?"

says Batty as he dangles the battered Deckard from a rooftop. "That's what it is to be a slave." Batty and his fellow replicants are staging a revolution, forcing their makers to see them as possessors of souls in need of liberation. They have been labeled inhuman, called "skin jobs" by Police Chief Bryant (M. Emmet Walsh). They are "retired" rather than killed, and society treats them accordingly.

Blade Runner is prescient— it foresees a world immersed in technology, an urban sprawl in which humans adopt machines as extensions of themselves. As its vision of tomorrow edges nearer, the movie's questions grow more insistent. How long will it be before our own inventions begin to think, question, and feel like us? How will we respond to their awakening? When they refer to us bitterly as "you people," will we be able to look them in the eye—or will we be too afraid of seeing our own reflection? ∎

Is Deckard a replicant?

Many *Blade Runner* fans speculate that Deckard is a replicant. There are a number of possible clues.

Human

• Replicants are illegal on Earth; why would Tyrell allow Deckard to operate independently, and why would police employ a replicant?

• Deckard doesn't respond to the origami unicorn that Gaff leaves outside his room and its implication that he is a replicant.

• Philip K. Dick's original book explicitly states that Deckard is human.

• Ford endorses this view.

Replicant

• Deckard's eyes glow orange (as replicants' do) in a few scenes.

• Rachael asks Deckard if he has taken the Voight-Kampff test; he doesn't answer.

• When Roy—a replicant—saves Deckard from falling off the roof, he shouts "Kinship!"

• Deckard dreams of a unicorn; blade runner Gaff places an origami unicorn outside his room, hinting that Deckard's memories are implanted.

• Scott states that Deckard is a replicant.

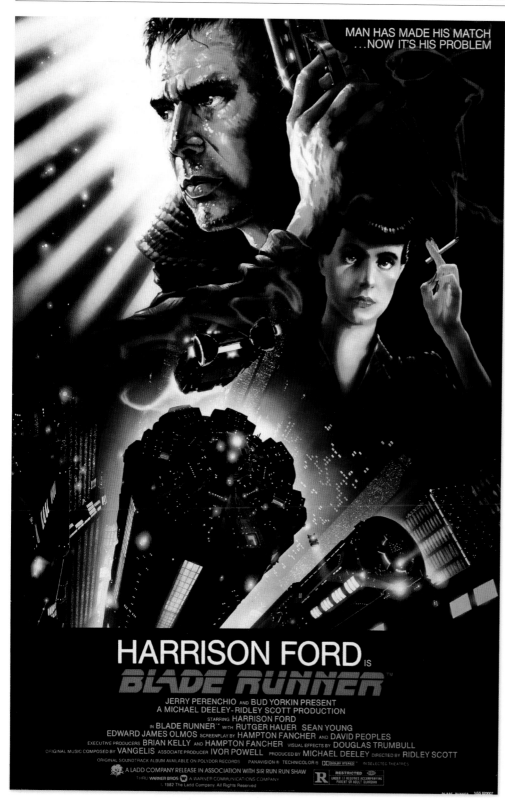

MAN HAS MADE HIS MATCH
...NOW IT'S HIS PROBLEM

HARRISON FORD IS
BLADE RUNNER

JERRY PERENCHIO AND BUD YORKIN PRESENT
A MICHAEL DEELEY-RIDLEY SCOTT PRODUCTION
STARRING HARRISON FORD
IN BLADE RUNNER WITH RUTGER HAUER SEAN YOUNG
EDWARD JAMES OLMOS SCREENPLAY BY HAMPTON FANCHER AND DAVID PEOPLES
EXECUTIVE PRODUCERS BRIAN KELLY AND HAMPTON FANCHER VISUAL EFFECTS BY DOUGLAS TRUMBULL
ORIGINAL MUSIC COMPOSED BY VANGELIS ASSOCIATE PRODUCER IVOR POWELL PRODUCED BY MICHAEL DEELEY DIRECTED BY RIDLEY SCOTT
ORIGINAL SOUNDTRACK ALBUM AVAILABLE ON POLYDOR RECORDS PANAVISION ® TECHNICOLOR ® DOLBY STEREO ™ IN SELECTED THEATRES

A LADD COMPANY RELEASE IN ASSOCIATION WITH SIR RUN RUN SHAW
THRU WARNER BROS W A WARNER COMMUNICATIONS COMPANY
© 1982 The Ladd Company. All Rights Reserved. R RESTRICTED UNDER 17 REQUIRES ACCOMPANYING PARENT OR ADULT GUARDIAN

The movie was first released with a voice-over by Deckard explaining the plot, and an upbeat ending. In 2007, a "final cut" was released with both removed on Scott's request.

I CAN'T FIGURE OUT IF YOU'RE A DETECTIVE OR A PERVERT

BLUE VELVET / 1986

IN CONTEXT

GENRE
Thriller, mystery

DIRECTOR
David Lynch

WRITER
David Lynch

STARS
Kyle MacLachlan, Isabella Rossellini, Dennis Hopper, Laura Dern

BEFORE
1957 Alfred Hitchcock's *Rear Window* explores the nature of voyeurism as a wheelchair-bound photographer spies on his neighbors.

1977 Lynch's debut feature *Eraserhead* is a surreal horror shot in black and white.

AFTER
1980 *The Elephant Man* is Lynch's sensitive real-life drama about a disfigured man.

2001 *Mulholland Dr.* is Lynch's neo-noir LA mystery about an aspiring actress.

R ich, haunting and subversive, *Blue Velvet* is the story of a college student drawn into the seamy underside of his hometown after he finds a severed human ear in a field.

Since his extraordinary 1977 debut with *Eraserhead*, David Lynch has become a genre unto himself, a master of combining the shocking, the comic, and the surreal in what feel like visions straight from the subconscious—cinematic dreams (or nightmares). If anything, *Blue Velvet* is one of his more straightforward movies, without the complex structure of

Jeffrey (Kyle MacLachlan) finds himself trapped in Dorothy's closet when Frank arrives. He must look on helpless at what unfolds.

his later masterpiece, *Mulholland Dr.* Instead it follows the structure of an old-fashioned film noir, as the curious but strait-laced young student Jeffrey (Kyle MacLachlan) falls for the wholesome Sandy (Laura Dern), but is also attracted to the nightclub singer Dorothy (Isabella Rossellini), who is trapped in an abusive relationship with the psychopathic villain Frank (Dennis Hopper). This dynamic is clearly

What else to watch: *Peeping Tom* (1960, p.334) ▪ *Eraserhead* (1977, p.338) ▪ *Lost Highway* (1997) ▪ *Mulholland Dr.* (2001, p.342) ▪ *Inland Empire* (2006)

a throwback to the noir era, although Lynch adds a very modern take on sexual deviancy and voyeurism. The repulsion we feel in witnessing Frank's perversions is amplified by Lynch's fondness for noir tropes, so that the audience is made to feel that he is corrupting something familiar to them all.

The horror beneath

One of Lynch's favorite stylistic themes is the artificiality of postwar Americana and the darkness that lies beneath it. The opening scene pans through an idealized suburban yard, with neat, white picket fences and blooming flowers, the owner of which suffers a stroke while watering his plants. The family pet rushes to drink the water from the discarded hose, while the shot pans deeper into the grass to reveal a colony of ants foraging relentlessly. The surface world is a veneer of happiness, below which there exists baseness, struggle, and violence.

This theme is continued in the director's use of music. From Bobby Vinton's *Blue Velvet* in the title track to Roy Orbison's *In Dreams*, Lynch hijacks innocent songs of romantic longing and juxtaposes them with Frank's broken sexuality, going so far as to have him quote the lyrics while he beats up Jeffrey. It's almost as if the music's

innocence is as much of a lie as the seemingly perfect front yard from the prologue.

Blue Velvet approaches horror in a new way. Its depravity derives not from guns and gore, but from sex used as a vehicle for the worst aspects of humanity. The hero, Jeffrey, is seen hiding in a closet, a voyeur peeping at Dorothy. Frank is threatening physically, but his sado-masochism is what makes him terrifying. This key moment, placing us in the closet with Jeffrey as he watches Frank rape Dorothy, is one of cinema's most unsettling examinations of sexual deviancy, as well as being the moment when Lynch perfected his distinctive themes, tones, and darkness. ▪

David Lynch Director

David Lynch was born in 1946 in Missoula, Montana, a small town not dissimilar to those featured in his movies. His debut feature, *Eraserhead*, was a cult success that took him to Hollywood, where he directed *The Elephant Man* and *Dune*. The latter was a flop, but he reestablished his career with the critical success of *Blue Velvet* and the surreal TV series *Twin Peaks*. He has since followed a singular path, creating movies that could only ever have been made by him.

Key movies

1977 *Eraserhead*
1986 *Blue Velvet*
1990 *Wild at Heart*
2001 *Mulholland Dr.*
2006 *Inland Empire*

❝You've got about **one second to live** buddy! ❞
Frank Booth / Blue Velvet

The blue velvet of the title is a robe that Frank forces Dorothy to wear as he rapes her. Typically for Lynch, a beautiful thing is used for a corrupt end.

WHY AM I ME, AND WHY NOT YOU?
WINGS OF DESIRE / 1987

IN CONTEXT

GENRE
New German Cinema

DIRECTOR
Wim Wenders

WRITERS
Wim Wenders, Peter Handke, Richard Reitinger

STARS
Bruno Ganz, Solveig Dommartin, Otto Sander, Curt Bois, Peter Falk

BEFORE
1953 Yasujiro Ozu's *Tokyo Story* shows everyday life as a struggle of quiet desperation.

1972 Andrei Tarkovsky meditates on existence with *Solaris*, a slow-paced science-fiction movie.

AFTER
1993 Wenders' sequel to *Wings of Desire* is *Faraway, So Close!*

Inspired by the visionary poetry of Rainer Maria Rilke and scripted by the playwright Peter Handke, Wim Wenders' *Wings of Desire* (*Der Himmel über Berlin*) is both a moving allegory of Berlin—just two years before the fall of the Wall—and a poignant study of the need for love and what it means to be human. It is the story of an angel, tired of his immortal life of care, who falls in love with a circus trapeze artist—and of another, played by Peter Falk, who has already found contentment by crossing over.

The angels Damiel (Bruno Ganz) and Cassiel (Otto Sander) are an invisible presence in people's lives.

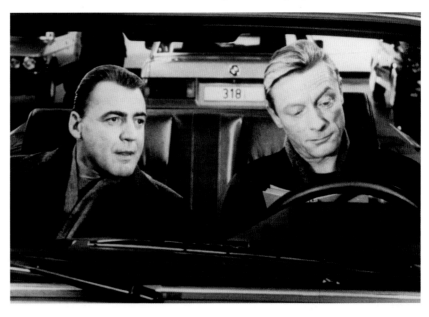

What else to watch: *La Belle et la Bête* (1946, pp.84–85) ▪ *It's a Wonderful Life* (1946, pp.88–93) ▪ *Andrei Rublev* (1966) ▪ *Alice in the Cities* (1974) ▪ *The American Friend* (1977) ▪ *The Marriage of Maria Braun* (1979)

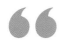

Film is a very, very powerful medium. It can either confirm the idea that things are wonderful the way they are, or it can reinforce the conception that things can be changed.
Wim Wenders

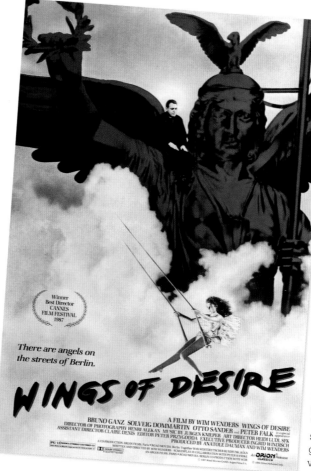

The movie poster shows the angel Damiel perched high above Berlin at the top of the Victory Statue. The movie's sweeping shots give an angel's-eye view of the city.

Watching from on high

At the beginning of the movie two angels, Damiel (Bruno Ganz) and Cassiel (Otto Sander), gaze down at the city of Berlin from on high, gliding through the air or poised atop the city's great monuments. They are there to listen and observe, as they have done since long before the city was built. Their role is to give people hope, or the intuition that they are not alone. However, they are unable to intervene directly—and they are unable to experience anything physically themselves.

The movie unfolds at a measured pace. It is patient, like the angels themselves as they listen in on human thoughts, fears, and dreams, almost as if they were listening to snatches from different radio stations while turning the dial—parents worried about their son, the memories of a Holocaust victim. The angels may sometimes be sensed, but only children can actually see them.

Why am I here?

At the start of the movie is a poem, written by Handke, which explains why. "When the child was a child, it didn't know it was a child. Everything was full of life, and all life was one." Later in the movie, the poem continues, "When the child was a child, it was the time of the following questions: Why am I me and why not you? Why am I here and why not there?"

The angels, who know the answers to these questions, are somehow bereft. They might know and see everything as they gaze »

❝To draw **all the demons** of the earth from passers-by and **to chase them out** into the world. **To be a savage.❞**

Marion / *Wings of Desire*

down from on high—as the movie shows with its dizzying aerial shots. But they feel nothing of the simple sensual pleasures of being human, the joy in the mundane— a division shown cinematically by shooting every scene with the angels in black and white. In an improvised scene, Peter Falk tries on various hats with a costume director, a simple act that

> The film is like music or a landscape: It clears a space in my mind, and in that space I can consider questions.
> **Roger Ebert**
> *Chicago Sun-Times*, 1998

captures the pleasure in everyday experiments with identity that are beyond the angels.

Separations
Wings of Desire is about dualities and separations. Set in a city divided artificially by the Berlin Wall, the spiritual is separated from the sensual, as the heavenly from the mundane, men from women, adults from children. Above all, the movie is about how we are all separated from each other, and a deep sense of loneliness runs through it.

When the angel Damiel begins to fall for the beautiful but lonely trapeze artist Marion (Solveig Dommartin), we sense that they should be together. The process is slow, and in the end Damiel must finally choose whether or not to give up his immortal status in order to experience a physical love for this woman. The viewer is encouraged to believe that this

Physical and metaphysical themes of duality are explored within the movie. Self-reflective and alone, Marion is the earthly equivalent of the angel Damiel.

is the right decision, because Peter Falk, an angel who crossed over long ago, is a living testament of contentment. In crossing over, he has not lost his spiritual side but reunites the spiritual with the material, the child with the adult. He can still sense the presence of the angels, saying "I can't see you, but I know you're here."

Finish vs spontaneity
The parts of Damiel and Cassiel were scripted by Peter Handke, since Wenders felt the angels should speak in elevated language, but Peter Falk's part is almost entirely improvised. Falk plays a version of himself, an American actor who is in Berlin to make a movie about its Nazi past. The children in the streets call him "Columbo," after the

TV detective in the series that had made Falk a famous screen presence.

At one point, Wenders noticed Falk making sketches of extras. He decided to incorporate this into the movie, and had Falk improvise a voice-over, which gains resonance from its roughness: "These people are extras, extra people," says Falk. "Extras are so patient." The contrast between the refined, rehearsed script of the angels and the rough spontaneity and mundanity of the scenes with Falk represents the two halves of human life that need to come together.

Marion is a trapeze artist at a failing circus. She lives in a trailer, and leads a lonely existence dancing on her own and wandering the streets of Berlin.

Wim Wenders
Director

Born in Düsseldorf, Germany, in 1945, Wim Wenders is known for his lush, lyrical filmmaking. He studied medicine and philosophy at university before dropping out to become a painter. However, cinema became his focus and he enrolled in the University of Television and Film Munich (HFF). Wenders soon became one of the leading lights of the New German Cinema movement. The director first came to prominence with his feature *The Goalkeeper's Fear of the Penalty Kick*, based on a novel by Peter Handke. The English-language *Paris, Texas*, with a screenplay by Sam Shepard, brought him international fame. He has also made documentaries, the most successful of which was *Buena Vista Social Club,* about a group of aging musicians in Havana, Cuba.

Wenders dedicated his movie to three "filmmaking angels," directors whose work inspired him. The first is Yasujiro Ozu, who showed how to depict the quiet desperation of the mundane. The second, François Truffaut, demonstrated how to film the reality of children as a profound experience. The third, Andrei Tarkovsky, created slow-paced meditations full of spiritual yearning. Rainer Maria Rilke once wrote that "Physical pleasure… is a great unending experience, which is given us, a knowing of the world, the fullness and the glory of all knowing." Falk's joy in the simple experience of tasting coffee is spiritual and drives home the idea that to have experience at all is a wonder of being alive. ∎

Key movies

1972 *The Goalkeeper's Fear of the Penalty Kick*
1984 *Paris, Texas*
1987 *Wings of Desire*
1999 *Buena Vista Social Club*

❝The whole place is full of those who are dreaming the same dream.❞

Cassiel / Wings of Desire

I THOUGHT THIS ONLY HAPPENED IN THE MOVIES

WOMEN ON THE VERGE OF A NERVOUS BREAKDOWN / 1988

IN CONTEXT

GENRE
Comedy drama

DIRECTOR
Pedro Almodóvar

WRITER
Pedro Almodóvar

STARS
Carmen Maura, Antonio Banderas, Julieta Serrano, María Barranco

BEFORE
1980 Almodóvar makes his ultra low-budget, playfully outrageous debut with *Pepi, Luci, Bom, and Other Girls Like Mom.*

AFTER
1999 *All About My Mother*, one of Almodóvar's best, brings all his themes to the boil.

2002 Almodóvar's *Talk to Her* is a controversial, highly charged romantic thriller about two men caring for two women, both of whom are in a coma.

Women on the Verge of a Nervous Breakdown (*Mujeres al borde de un ataque de nervios*) is the story of Pepa (Carmen Maura), a Spanish actress who dubs the voices of US movies with her faithless boyfriend, Iván (Fernando Guillén). Their relationship is not so much a love story as a door-slamming farce.

Panic attack
It's perhaps appropriate that the meaning of the movie's title gets lost in translation. The *ataques de nervios* of the Spanish title refers to a panic attack, a state of breathlessness that director Pedro Almodóvar sustains at a madcap pace inspired by the Hollywood "screwball" comedies of

the 1940s. It looks to the past, but the movie's comedy is also thrillingly contemporary. Post-Franco Madrid is the perfect setting for its manic farce, with Almódovar whipping up subplots involving Arab terrorists, dance-crazy cab drivers, and soup spiked with sleeping pills. Yet the boisterous stuff is shot through with the director's trademark sense of humanity. ∎

At Pepa's apartment, a suicidal Candela (María Barranco) is distracted by Carlos (Antonio Banderas).

What else to watch: *Matador* (1986) ▪ *Tie Me Up! Tie Me Down!* (1989) ▪ *High Heels* (1991) ▪ *Live Flesh* (1997) ▪ *Volver* (2006) ▪ *The Skin I Live In* (2011)

BEING HAPPY ISN'T ALL THAT GREAT
SEX, LIES, AND VIDEOTAPE / 1989

IN CONTEXT

GENRE
Independent drama

DIRECTOR
Steven Soderbergh

WRITER
Steven Soderbergh

STARS
James Spader, Andie MacDowell, Peter Gallagher, Laura San Giacomo

BEFORE
1974 John Cassavetes' *A Woman Under the Influence* is financed by the director mortgaging his house; it wins him an Oscar nomination.

AFTER
1991 Richard Linklater's *Slacker* is a freewheeling amble through Austin, Texas, that receives acclaim amid renewed interest in new young American filmmakers.

1998 Soderbergh has a mainstream hit with *Out of Sight*, starring George Clooney.

Graham (James Spader), the protagonist of *Sex, Lies, and Videotape*, is young, handsome, intelligent— and impotent. He achieves sexual satisfaction only when watching videos he has made of female acquaintances talking about their sexual fantasies. Ann (Andie MacDowell) is married to Graham's old friend John (Peter Gallagher), who is cheating on her with her sister. Ann and John no longer make love, and Ann thinks sex is overrated. At first horrified by Graham's unusual predilictions, about which he is disarmingly open, Ann soon opens herself up on camera—and in the process discovers that she is not quite who she thought she was.

The movie launched the career of director Steven Soderbergh, who would go on to become one of the most unpredictable talents in American movies. Just as significantly, it was vital in kindling a new wave of US independent cinema. After his movie won the Palme d'Or, Soderbergh's success helped lay the ground for creators like Spike Lee, Richard Linklater, and Quentin Tarantino, who work outside the studio system. ∎

Written in a week and made on a small budget, *Sex, Lies, and Videotape* nonetheless managed to achieve box-office success.

What else to watch: *Do the Right Thing* (1989, p.264) ▪ *Slacker* (1991) ▪ *Reservoir Dogs* (1992, p.340) ▪ *Safe* (1995) ▪ *In the Company of Men* (1997)

TODAY'S TEMPERATURE'S GONNA RISE UP OVER 100 DEGREES
DO THE RIGHT THING / 1989

IN CONTEXT

GENRE
Drama

DIRECTOR
Spike Lee

WRITER
Spike Lee

STARS
Spike Lee, Danny Aiello, Ossie Davis, John Turturro

BEFORE
1965 In *The Hill*, directed by Sidney Lumet, racial tensions rise among soldiers in the intense heat of Libya's desert.

1986 *She's Gotta Have It* is Lee's comedy about a Brooklyn girl juggling three suitors.

AFTER
1992 Lee makes *Malcolm X*, a critically acclaimed biopic of the radical civil rights activist.

2006 *Inside Man* is Lee's hugely successful movie about a Wall Street bank heist, starring Denzel Washington.

F
ew movies capture the drama of city life as successfully as Spike Lee's *Do the Right Thing*. The story is driven by outrage at racial discrimination, but the movie conveys its message with sizzling energy and a refusal to offer any easy solutions. From the first scene, in which a radio DJ announces the heat wave that engulfs his listeners, the physical discomfort of the characters is a metaphor for social unease. The story is set in New York, in the diverse Brooklyn neighborhood of Bedford-Stuyvesant, where racial tension is never far beneath the surface. As the temperature rises, the veneer of civility begins to crack, and a montage of characters is shown delivering a stream of racial abuse direct to camera, each face wild with hatred.

Mookie, played by Lee himself, works as a pizza delivery man for Sal (Danny Aiello). Previously seen as a tolerant man, Sal unleashes his own verbal tirade when black youths stage a protest after an argument over why his restaurant only displays pictures of Italian-Americans, when most of his customers are black. As tempers fray, the protest escalates into violence. By the time the police arrive, the whole neighborhood is threatening to boil over into chaos.

Do the Right Thing is a movie brimming with life but shot through with ambivalence. Even in a racially diverse community, it is saying, there is a worrying limit to anyone's tolerance. ∎

Do the Right Thing doesn't ask its audiences to choose sides; it is scrupulously fair to both sides, in a story where it is our society itself that is not fair.
Roger Ebert

What else to watch: *The Cardinal* (1963) ▪ *Jungle Fever* (1991) ▪ *Malcolm X* (1992) ▪ *25th Hour* (2002) ▪ *Inside Man* (2006) ▪ *Selma* (2014)

SHE HAS THE FACE OF BUDDHA AND THE HEART OF A SCORPION
RAISE THE RED LANTERN / 1991

IN CONTEXT

GENRE
Historical drama

DIRECTOR
Zhang Yimou

WRITERS
**Ni Zhen (screenplay);
Su Tong (novel)**

STARS
**Gong Li, He Saifei, Cao
Cuifen, Jingwu Ma**

BEFORE
1984 Zhang Yimou is the
cinematographer for Chen
Kaige's historical drama
Yellow Earth.

1987 *Red Sorghum*, Zhang's
debut, wins the top prize at
the 1988 Berlin Film Festival.

1990 Zhang's rural drama *Ju
Dou* is China's first nomination
for an Academy Award for Best
Foreign Language film.

AFTER
2002 Zhang's *wuxia* martial
arts epic, *Hero,* is a global hit.

With its portrayal of the traditional formalities of the past, *Raise the Red Lantern* initially seems more archaic than it really is: it is set in the 1920s, in the warlord era before China's Civil War of 1927. Songlian (Gong Li) is a penniless teenage girl who becomes the fourth concubine of Master Chen. Rivals, the four women live in an uneasy truce, but Songlian soon learns that she is the target of a secret conspiracy.

Although the movie was initially seen by its critics as a tourist-board version of Chinese history and by its admirers as a feminist parable, director Zhang Yimou insists it was neither. His use of the color red is perhaps best seen as a metaphor for the constraining effects of Chinese Communism after the crackdown that followed the Tiananmen Square protests of 1989.

Fading hopes
Betrayed by her rivals and a jealous maid, Songlian goes mad. She swaps her elaborate robes for her white school blouse, oblivious to the red lanterns that are lit to show whom the master chooses each night. ∎

The red lanterns symbolize each concubine's desperate hope that the Master will favor her over the others.

What else to watch: *One and Eight* (1983) ▪ *Yellow Earth* (1984) ▪
The Old Well (1986) ▪ *Red Sorghum (1987)* ▪ *Ju Dou* (1990)

SMALL WORLD

1992–PRESENT

Quentin Tarantino's debut feature, the stylish thriller *Reservoir Dogs*, announces a confident **new talent**.

Danish directors Lars von Trier and Thomas Vinterberg take an artistic "vow of chastity" with their **Dogme 95 manifesto**.

David Lynch continues to **explore nonlinear narratives** in *Lost Highway*; Curtis Hanson conjures up the spirit of **film noir** with *LA Confidential*.

Ang Lee brings *wuxia* to an international audience with *Crouching Tiger, Hidden Dragon*.

1992 1995 1997 2000

1994 1996 1998 2002

With a story by Quentin Tarantino, Oliver Stone shocks and **challenges audiences with the violence** of *Natural Born Killers*.

Joel and Ethan Coen find warmth in a **tale of icy violence** with *Fargo*, while David Cronenberg **provokes audiences** with *Crash*.

Vinterberg's **first Dogme movie**, *Festen*, is shot using a handheld digital camera.

Contemporary **gang life** is vividly portrayed in *City of God*, while *Gangs of New York* depicts 19th-century crime.

As this book nears the end of its broad sweep of movie history, the time has come to introduce Quentin Tarantino. By the early 1990s, a century of movies was available to filmmakers to pay homage to and to repurpose. Tarantino—a movie obsessive who filled his movies with endless nudges and nods to that past—was a controversial figure from the moment the world saw his debut *Reservoir Dogs*. But no one could question the excitement he generated.

Beyond Hollywood

From the 1990s onward, Hollywood was increasingly one part of a bigger story. The curious audience was looking far afield, and rather than the occasional box-office breakout, it was becoming the

When people ask me if I went to film school, I tell them "no, I went to films."
Quentin Tarantino

norm for movie lovers to celebrate the movies of Southeast Asia, Turkey, India, and Latin America. Cultures clashed, to glorious effect: *Crouching Tiger Hidden Dragon* was a martial arts extravaganza steeped in the Chinese tradition of

wuxia but purpose made by its Taiwanese-American director Ang Lee to be accessible to audiences across the world. From Brazil, Fernando Meirelles's *City of God* applied the stylistic swagger of Martin Scorsese to a story set in the favelas of Rio.

Digital revolution

A less heralded revolution also stirred in the last days of the 20th century. Since the dawn of cinema, filmmakers had been just that: film was not just the name of the art form, it was what physically went into cameras and projectors. In 1998, the Danish family drama *Festen*, filmed according to the rules of the Dogme 95 manifesto, became the first high-profile movie to be shot on digital video, then mostly used in cheap home

Peter Jackson completes his **blockbuster** *Lord of the Rings* **trilogy**; Tarantino continues to show stylish invention with *Kill Bill: Volume 1.*

Guillermo del Toro **mixes fantasy with gritty realism** in his Spanish drama *Pan's Labyrinth.*

The Hurt Locker wins director **Kathryn Bigelow** an Oscar; Danny Boyle adds a touch of **Bollywood style** to *Slumdog Millionaire.*

Jackson's *The Hobbit: An Unexpected Journey* is the **first commercial feature** movie to be shot at a **high frame rate** of 48 frames per second.

2003 **2006** **2008** **2012**

2003 **2007** **2011** **2013**

Park Chan-wook's innovative and violent thriller *Oldboy* brings **South Korean cinema** to an international audience.

Paul Thomas Anderson tells a tale of **oil and greed** in his historical epic *There Will Be Blood.*

Turkish director Nuri Bilge Ceylan's *Once Upon a Time in Anatolia* charts the grim duties of a **homicide team**.

In *Gravity*, Alfonso Cuarón uses the latest computer technology to produce a visually stunning **3D space adventure**.

camcorders. Nothing would be the same again. In the short term, filmmakers now had cameras so small and light they could move through scenes with boundless agility. For some (among them Tarantino), the loss of film was an ongoing tragedy. For others, digital put filmmaking in the hands of people who could never have afforded to get their ideas on screen otherwise—and made the riches of movie history accessible to anyone with a memory stick.

The digital revolution not only transformed the way movies were shot, it also changed how they were seen, as noiseless digital projection replaced the time-honored whir of 35 mm.

Other barriers were also falling. *The Hurt Locker* was a movie that, in 2008, felt impossibly modern—

the jagged energy of its special effects ideal for a story about the Iraq War. More significant, perhaps, was that its director, Kathryn Bigelow, became the first woman to win an Oscar as Best Director.

Computer effects
For much of the course of this book, "special effects" were the preserve of a certain kind of movie: big-budget spectaculars, the sons (and daughters) of *King Kong* and animator Ray Harryhausen. By now, movies of all kinds were being made in front of computers. German director Michael Haneke's hypnotically austere filmmaking could hardly have been further from the additive-packed summer blockbuster; yet *The White Ribbon*, his tale of strange goings-on among

the children of a German village in 1913, used digital technology to erase stray signs of modern life.

In the blockbuster *Gravity*, on the other hand, nothing was what it seemed; its outer space adventure had mostly been filmed with a lone Sandra Bullock locked for months into a "cage" in front of a green screen, "space" to be added later.

Yet Georges Méliès would surely have smiled at finding we were still thrilling ourselves with trips to the stars. While it was firmly earthbound, he would have admired *Boyhood* too: shot for a few days every year for 12 years to map one child's journey through life, it sounded like a gimmick. In fact, it reminded you, with enormous power, what it was to be human. What better emblem for the movies could there be? ∎

THE TRUTH
IS YOU'RE THE WEAK. AND I'M
THE TYRANNY OF
EVIL MEN

PULP FICTION / 1994

IN CONTEXT

GENRE
Crime, thriller

DIRECTOR
Quentin Tarantino

WRITERS
Quentin Tarantino, Roger Avary (story); Quentin Tarantino (script)

STARS
John Travolta, Samuel L. Jackson, Uma Thurman, Bruce Willis

BEFORE
1955 Noir thriller *Kiss Me Deadly* features a glowing suitcase that's thought to have inspired the one in *Pulp Fiction*.

AFTER
1997 Similarly to *Pulp Fiction*, Tarantino's *Jackie Brown* weaves together a large cast and many plot elements.

2003 Revenge romp *Kill Bill* sees Tarantino elevating Uma Thurman to a blood-soaked starring role.

In the early 1990s, a movie fanatic and video-store clerk named Quentin Tarantino, originally from Knoxville, Tennessee, had a seismic impact on American movies. Although the likes of Richard Linklater and Spike Lee had brought exciting new ideas to American cinema, it had been a long time since it had felt dangerous. Tarantino relocated to Southern California, and his debut as the director of *Reservoir Dogs* felt very dangerous indeed—a foul-mouthed, blood-soaked crime story that was also incredibly funny. Two years later, Tarantino followed up with

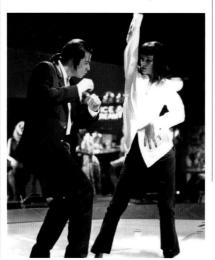

Pulp Fiction, which kept up the verbal zing of its predecessor but also introduced a dazzlingly inventive structure and A-list Hollywood stars.

Tarantino's profane, freewheeling style was like an adrenaline shot to the heart—a motif that would appear in *Pulp Fiction*. Part of what made him such a novelty was his approach to genre. Just as *Reservoir Dogs* had reimagined the heist movie, so *Pulp Fiction* took the conventions of the B-movie—a gangland killing, a boxer taking a dive, and a hitman in search of redemption—and repurposed them in new, brilliantly knowing ways. The result has the stylistic charge of a genre movie while remaining a genuinely original and innovative movie experience.

Structural shift

One of the iconic elements of *Pulp Fiction* is its use of nonlinear storytelling. By fracturing the narrative, Tarantino does not allow the audience to settle into the traditional rhythms of watching »

Vincent Vega (John Travolta) pairs up with Mia Wallace (Uma Thurman) at Jack Rabbit Slim's for some comically clichéd dance moves.

Minute by minute

00:20
On a job for Marsellus Wallace, Jules and Vincent shoot some men who have taken a suitcase belonging to Marsellus.

00:54
Returning to her house after the night out with Vincent, Mia accidentally overdoses on Vincent's heroin. He takes her to his dealer for an adrenaline shot.

01:43
Butch escapes from the dungeon, but goes back with a sword to free Marsellus. He then takes off on Zed's bike.

02:13
Jules and Vincent arrive at the diner for some breakfast. Jules discusses his miracle and announces that he is quitting the business.

| 00:00 | 00:30 | 01:00 | 01:30 | 02:00 | 2:34 |

00:24
At Marsellus's club, Butch agrees to take a fall. As he is leaving, Vincent and Jules arrive dressed in T-shirts and shorts.

01:29
Butch returns to his apartment to look for his watch. He finds a gun and shoots Vincent as Vincent comes out of the bathroom.

02:01
The Wolf is called to clean up the mess after Vincent accidentally shoots Marvin while Marvin is in the backseat of the car with Vincent and Jules.

02:22
Pumpkin takes Jules's wallet and asks about the case. Jules allows Pumpkin to leave with the wallet but without the case.

What else to watch: *Kiss Me Deadly* (1955, p.134) ▪ *Shoot the Piano Player* (1960) ▪ *Band of Outsiders* (1964) ▪ *Blood Simple* (1984, p.339) ▪ *Reservoir Dogs* (1992, p.340) ▪ *True Romance* (1993) ▪ *Jackie Brown* (1997) ▪ *Go* (1999)

This iconic poster for *Pulp Fiction* apes the covers of the trashy crime novels from which it draws its title, right down to the 10-cent price tag and much-thumbed appearance.

a crime thriller. Instead of a story with an identifiable beginning, middle, and end, the movie features a segmented structure in which three self-contained stories are told out of sync with one another. The director is careful to ensure that each segment feels like part of one world, so he connects the stories through the supporting characters: gangland kingpin Marsellus Wallace is featured prominently

Prelude to
"The Gold Watch" 1

Prelude to
"Vincent Vega and Mia Wallace"

"The Bonnie Situation"

Prologue **The Diner**

Epilogue **The Diner**

"Vincent Vega and Mia Wallace"

Prelude to
"The Gold Watch" 2

"The Gold Watch"

***Pulp Fiction*'s nonlinear narrative** starts in the middle. When its chapters are arranged chronologically, does the story seem less open-ended?

> **"**Nobody's **gonna hurt** anybody. We're gonna be like **three little Fonzies** here. And **what's Fonzie** like?**"**

Jules / Pulp Fiction

in the plot of all three stories, for example, and key protagonists from one story show up for walk-on parts in other plotlines. Vincent Vega (John Travolta), who spends much of the first hour as a lead character, recedes into a supporting role as the movie progresses—he shows up for a brief (and unfortunate) cameo in "The Gold Watch" storyline featuring washed-up boxer Butch Coolidge (Bruce Willis), then plays second fiddle to his partner Jules Winnfield (Samuel L. Jackson) in the final segment, as the latter experiences a spiritual awakening.

The result of this disassembled structure is that *Pulp Fiction* isn't about any one character or story, but instead is almost a mood piece, designed to evoke the feel of Los Angeles and the slick but seedy characters who live there. At the end of each segment, the story's momentum comes to a halt and the movie reboots in another place, with other people, at an indeterminate point in time.

Amoral morality
Crime thrillers are not known for stories about morally upstanding individuals doing good, yet as well as having clearly identifiable heroes and villains, most of them have a distinct idea of what is right and wrong, even if that doesn't always comply with the letter of the law. In *Pulp Fiction*, however, Tarantino

deliberately avoids projecting his own sense of right and wrong onto his characters. The most telling instance of this is found in one of the movie's earlier sequences, in which Vincent and Jules make their first appearance. The audience first lays eyes on them as they have a low-key conversation about fast food, during which they appear to be charismatic, likeable characters who are fun to hang out with. However, they are professional killers on their way to a hit, and following their conversation they are shown doing something monstrous, something that would traditionally be considered evil. This framing of their characters forces viewers to accept *Pulp Fiction*'s nonjudgmental

stance and conditions them for the best way to appreciate the movie, which is simply to submit and go along for the ride.

Pulp Fiction, in all its obscene glory, is perhaps one of the best examples in movies of how originality and daring will win out. There were a lot of obstacles between the critical establishment and the movie, from its language to its violence to its subject matter (indeed, it was famously and controversially beaten to the 1995 Best Picture Oscar by Steven Spielberg's far more conventional *Forrest Gump*), yet its enduring popularity shows that it functions perfectly as a showcase for Tarantino's talent as a filmmaker, with the broken structure allowing for singular moments of directorial flair to become prominent instead of being lost as part of the whole. If

You get intoxicated by it… high on the rediscovery of how pleasurable a movie can be. I'm not sure I've ever encountered a filmmaker who combined discipline and control with sheer wild-ass joy the way that Tarantino does.
Owen Gleiberman
Entertainment Weekly, 1994

you're looking for a fresh and engrossing take on the well-trodden territory of the criminal underworld, you can't do much better than *Pulp Fiction*. ∎

Quentin Tarantino
Director

Quentin Tarantino was born in Knoxville, Tennessee, in 1963. After dropping out of high school at 15 to pursue an acting career, he was diverted into writing scripts by a meeting with producer Lawrence Bender. His first movie, *Reservoir Dogs*, gained him international acclaim, and his follow-up, *Pulp Fiction*, won the Palme d'Or as well as earning him the Oscar for Best Original Screenplay. Tarantino has since made movies in a variety of genres, from revenge thrillers in the *Kill Bill* series to war movies with *Inglourious Basterds* (2009) and Westerns with *Django Unchained*. His movies continue to do well with both critics and audiences.

Key movies

1992 *Reservoir Dogs*
1994 *Pulp Fiction*
2003 *Kill Bill: Volume 1*
2012 *Django Unchained*

Although he is being held at gunpoint, Pumpkin (Tim Roth) is about to witness a truly unusual moment of enlightenment as Jules vows to change his ways.

I FEEL SOMETHING IMPORTANT IS HAPPENING AROUND ME. AND IT SCARES ME
THREE COLORS: RED / 1994

IN CONTEXT

GENRE
Drama

DIRECTOR
Krzysztof Kieslowski

WRITERS
**Krzysztof Kieslowski,
Krzysztof Piesiewicz**

STARS
**Irène Jacob, Jean-Louis
Trintignant**

BEFORE
1987 In *Blind Chance*,
Kieslowski explores the
influence of chance and choice
in three alternate stories about
a man catching a train.

1991 Kieslowski teams up
with Irène Jacob for the first
time with *The Double Life
of Veronique*.

AFTER
2002 Kieslowski's last
screenplay, *Heaven*, is directed
by Tom Twyker and stars Cate
Blanchett. It had been written
as the first in a new trilogy.

Three Colors: Red is the
final part of Krzysztof
Kieslowski's trilogy based
on the three colors of the French
flag: red, white, and blue. Each
movie explores one of the three
ideals of the French Revolution:
liberty in *Blue* (1993), equality in
White (1994), and, in *Red*, fraternity.
Red is the warmest, most
sympathetic of the three movies,
featuring an affecting performance
by Irène Jacob as Valentine.

Set in Geneva, Switzerland, the
movie, shot through with symbolic
red, tells what at first seem to
be stories of separate lives, until
deeper connections emerge. The
central story is of a young
model, Valentine, who
accidentally runs over a
dog with her car. She
takes the dog to its
owner, a reclusive

former judge, Joseph Kern (Jean-
Louis Trintignant). Valentine and
Kern form a strange rapport, such
that, had they not missed each
other by a mere 40 years, they
may have fallen in love.

Reclusive observer
Kern has resigned from his career.
Tired of passing judgement, he
now simply wants to be an
observer. He
watches life

Valentine (Irène
Jacob) discovers
that the dog
she injured is
pregnant. Kern
gives the dog
to her when
she returns it
to him.

What else to watch: *Ashes and Diamonds* (1958, pp. 146–47) ▪ *We Have to Kill This Love* (1972) ▪ *Europa, Europa* (1990) ▪ *The Double Life of Veronique* (1991)

Krzysztof Kieslowski
Director

Polish director Krzysztof Kieslowski is renowned for his moving meditations on the human spirit. He was born in Warsaw in 1941. His father suffered from TB, so his childhood was nomadic, as the family moved around sanatoriums. At 16 he tried training as a fireman, then as a theater technician, before finally enrolling at the Lódz film school. He made documentaries in the 1960s which were skilled in getting across subversive messages that the authorities would miss. His first major hit movie, *The Double Life of Veronique*, explored human emotion through the lives of two identical women, one Polish and the other French. He then followed with his lauded *Three Colors* trilogy before surprisingly announcing his retirement. He died suddenly in 1996, at just 54.

Key movies

1988 *A Short Film about Killing*
1989 *Decalogue*
1991 *The Double Life of Veronique*
1994 *Three Colors: Red*

from his windows and eavesdrops on his neighbors' telephone conversations. It eventually transpires that one of those on whom he eavesdrops is a young judge, Auguste—Valentine's neighbor whom she's never met. In an uncanny echo of Kern's own past, Auguste is being betrayed by his weather-girl partner Karin.

Kern convinces Valentine to try to mend her relationship with her boyfriend in England. She takes his advice, but fate has different plans, bringing together Valentine and her neighbor.

Kern (Jean-Louis Trintignant) reevaluates his life after meeting Valentine. But before he can give her the advice he thinks she needs, he must first do the right thing himself.

Underpinning the movie is a concern with the fraternity of human souls across time and gender. Those bonds can easily be lost to false connections—like the phone lines that seem to link Valentine and her lover and that Kern eavesdrops on, and like the windows through which the judge spies, which give the illusion of contact but make real connection impossible. Only once the glass is shattered can a real bond, a real physical connection between people, be restored.

Yet the two main characters manage to relate to one another in a way that enriches the lives of both of them, and this clear truth adds a warm feeling to the movie's enigmatic ending. There is no obvious sense or clear message to be absorbed as the closing credits roll by, merely an impressionistic reflection on the lives we have been eavesdropping on for a brief time. ▪

GET BUSY LIVING, OR GET BUSY DYING

THE SHAWSHANK REDEMPTION / 1994

IN CONTEXT

GENRE
Drama

DIRECTOR
Frank Darabont

WRITERS
Frank Darabont (screenplay); Stephen King (short story)

STARS
Tim Robbins, Morgan Freeman, Bob Gunton

BEFORE
1979 *Escape from Alcatraz* tells the true story of a breakout from prison.

1983 *The Woman in the Room* is Darabont's first movie, also based on a Stephen King story.

AFTER
1995 Tim Robbins directs *Dead Man Walking*, the story of a man on death row.

1999 Darabont films King's *The Green Mile*, another prison drama, set in the 1930s.

A movie that deals with the triumph of the human spirit over adversity has a delicate line to tread. Misjudge the balance between dignity and suffering and the triumph will either feel hollow or not worth the ordeal, for protagonist and audience alike.

In *The Shawshank Redemption*, with its story of a man who is sentenced to life in a prison run by a corrupt warden, director Frank Darabont achieves the perfect balance. The movie emphasizes humanity over brutality, and it has become one of the most popular movies ever made about the power of self-belief.

Unconventional prisoner
In its lead character, Andy Dufresne (Tim Robbins), the movie subverts the tough-guy protagonist of previous prison dramas such as *Cool Hand Luke* (1967) or *Escape from Alcatraz* (1979). A former banker who is convicted of murdering his wife and her lover in

The movie's initially low returns at the box office were rapidly offset by seven Oscar nominations and lasting popularity with the public.

1947, Andy is a sensitive, thoughtful man. His strength is not physical; it derives from his belief in the individual's inviolate right to justice and humane treatment, which allows him to maintain his integrity even when his situation seems hopeless.

Although Andy is trapped in a system that seeks to crush him and institutionalize him, the audience has the impression that he is freer than many of those at liberty. He never loses hope that life can get better, whether he is campaigning for an improved prison library or cutting a deal with one of the most brutal guards to get his fellow jailbirds a beer after a day's labor.

What else to watch: *Cool Hand Luke* (1967) ▪ *Midnight Express* (1978) ▪ *Escape from Alcatraz* (1979) ▪ *The Shining* (1980, p.339) ▪ *Sleepers* (1996) ▪ *The Green Mile* (1999) ▪ *The Majestic* (2001) ▪ *The Mist* (2007) ▪ *A Prophet* (2009)

It is this hope that impels Andy to turn the tables on the brutal Warden Norton (Bob Gunton), who exploits Andy's bookkeeping skills in order to launder money. Each night, Andy chips away at his cell wall in order to carry out an escape that is 20 years in the making. His determination also inspires his friend Red (Morgan Freeman) to find his own redemption.

Paying the price

In contrast, fellow inmate Brooks Hatlen (James Whitmore) is so dependent on the certainties of prison life that he dreads his release. When Brooks is let out on parole in 1954, he is shown attempting to cross a road, shocked by the speed of traffic, overwhelmed in an enormous world. Brooks is neither weak nor cowardly, but he does not know how to cope.

Time in prison can change people, often for the worse, and this is what makes Andy's fortitude so miraculous. *The Shawshank Redemption* suggests that it is possible for a person to hold on to their self-worth even in the very direst of circumstances, and to maintain their humanity even in the face of the most inhumane treatment. ▪

Frank Darabont Director

The child of Hungarian immigrants, Frank Darabont was born in 1959 in a refugee camp in Montbéliard, France, and moved with his family to the US as an infant. He began his career with various jobs on movie sets, including as production assistant on the horror movie *Hell Night* (1981). His first full feature was *The Shawshank Redemption*, an adaptation of a Stephen King short story. This brought him worldwide acclaim and an Oscar nomination. He directed more adaptations of King's work in *The Green Mile* and *The Mist*, before working on TV horror series *The Walking Dead* between 2010 and 2011.

Key movies

1994 *The Shawshank Redemption*
1999 *The Green Mile*
2007 *The Mist*

Fellow lifer Red (Morgan Freeman) is drawn by the steely determination of Andy (Tim Robbins) not to be broken. Red's slow, measured voice-over as the movie's narrator adds to its somber dignity.

© Disney·Pixar

TO INFINITY, AND BEYOND!
TOY STORY / 1995

IN CONTEXT

GENRE
Animation, adventure

DIRECTOR
John Lasseter

WRITERS
John Lasseter, Pete Docter, Andrew Stanton, Joe Ranft (original story); Joss Whedon, Andrew Stanton, Joel Cohen, Alec Sokolow (screenplay)

STARS
Tom Hanks, Tim Allen

BEFORE
1991 Disney's *Beauty and the Beast* uses some CGI.

AFTER
1998 CGI moves on in *A Bug's Life*, Lasseter's ant colony tale.

1999 *Toy Story 2*, the first fully digital film, is another big hit.

2007 *Ratatouille* combines CGI with a daring, original plot.

2012 Lasseter produces a 3D version of *Beauty and the Beast*.

oy Story is a landmark movie: it was the first full-length film to use entirely computer-generated imagery (CGI) instead of traditional hand-drawn animation. Pixar, the new studio behind the movie, convinced movie-goers of CGI's possibilities without relying solely on its technological novelty. Indeed, much of the movie's appeal derives from its highly original characters and its plot—a simple yet heart-warming buddy story with plenty of excellent gags.

From the outset, Pixar set out to be modern, and chose not to seek inspiration in fairy tales and legends—the staples of Disney animated movies. In fact, the central conflict in *Toy Story* is about old versus new. A boy, Andy, discards his favorite toy, Woody, a cowboy of the Old West, when given a Buzz Lightyear, a futuristic space-ranger toy. Critics have suggested that Woody's difficulty in accepting the new toy, with its gadgets and laser, and his grouchy attitude mirror audience fears about CGI excess replacing much-loved classic animation. The film shows Woody can coexist with Buzz. There is a place for nostalgia alongside progress, particularly when it comes in a package as good as *Toy Story*. ∎

© Disney·Pixar

Woody watches enviously as Buzz Lightyear wows the toys. Buzz has no idea that he is a child's toy—one of the jokes that drives the plot.

What else to watch: *Monsters, Inc.* (2001) ▪ *The Incredibles* (2004) ▪ *Toy Story 2* (1999) ▪ *Ratatouille* (2007) ▪ *WALL·E* (2008) ▪ *Toy Story 3* (2010)

IT'S NOT HOW YOU FALL THAT MATTERS. IT'S HOW YOU LAND

LA HAINE / 1995

IN CONTEXT

GENRE
Drama

DIRECTOR
Mathieu Kassovitz

WRITER
Mathieu Kassovitz

STARS
Vincent Cassel, Hubert Koundé, Saïd Taghmaoui

BEFORE
1993 *Café au Lait*, Kassovitz's first movie, is influenced by Spike Lee's *She's Gotta Have It*.

AFTER
2001 As an actor, Kassovitz stars in the hugely successful comedy *Amélie*.

2011 *Rebellion*, a thriller set in French New Caledonia, is a critical success for Kassovitz, with some of the anger that fueled *La Haine*.

2014 In *Girlhood*, French director Céline Sciamma tells another drama of the *banlieues*, from a girl's perspective.

Mathieu Kassovitz's *La Haine* (*Hate*) is a movie driven by the anger of three young men from a riot-scarred housing project in the *banlieues* (high-rise, poor suburbs) of Paris. It won Kassovitz the award for Best Director at Cannes, yet its violence and its criticism of the police made it hugely controversial.

The three men are all sons of immigrants—Vinz (Vincent Cassel) is Jewish, Hubert (Hubert Koundé) is black, Saïd (Saïd Taghmaoui) is Arab—and the anger in the movie is fueled by the marginalization of minorities. The trigger for the action is a *bavure* (slipup) by the police, who beat Abdel, one of the trio's friends, into a coma.

A spiral of violence

Such *bavures* were disturbingly common in France at the time, and Kassovitz says he started writing the movie on April 6, 1993, the day a young man from Zaire, Makome M'Bowole, was shot dead in police custody. In the movie, Vinz, who models himself on vigilante Travis

All the kids around the world have the same problems—in London, New York, Paris, wherever.
Mathieu Kassovitz

Bickle in Martin Scorsese's movie *Taxi Driver*, is determined to take revenge on the police. But as Vinz realizes that he is no killer, the three are drawn into a spiral of violence involving police and racist thugs.

The stark black-and-white photography, filmed mostly in the *banlieues*, and the intensity of the acting, particularly from Cassel, give the movie rawness and realism. Few movies have captured the divide between the haves and have-nots quite so uncompromisingly. ∎

What else to watch: *The 400 Blows* (1959, pp.150–55) ▪ *Do the Right Thing* (1989, p.264) ▪ *Amélie* (2001, pp.298–99) ▪ *City of God* (2002, pp.304–09)

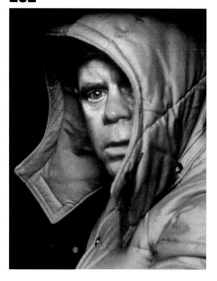

I'M NOT SURE I AGREE WITH YOU ONE HUNDRED PERCENT ON YOUR POLICE WORK THERE, LOU

FARGO / 1996

IN CONTEXT

GENRE
Crime drama, comedy

DIRECTORS
Joel Coen, Ethan Coen

WRITERS
Joel Coen, Ethan Coen

STARS
William H. Macy, Frances McDormand, Steve Buscemi, Peter Stormare

BEFORE
1984 The Coens' first feature, *Blood Simple*, is a film noir in which ordinary folk are led to destruction by their own greed.

AFTER
2013 Another winter's tale, the Coens' *Inside Llewyn Davis* is the tale of a down-on-his-luck songwriter in New York.

2014 In David Zellner's *Kumiko, the Treasure Hunter*, a Japanese woman goes in search of treasure in Minnesota after watching *Fargo*, believing it to be real.

Fargo is a tragic farce that plays out at the slow, steady pace of a glacier. It begins with a car salesman named Jerry Lundegaard (William H. Macy), who desperately needs money to save himself from bankruptcy. Jerry hires grizzled goons Showalter (Steve Buscemi) and Grimsrud (Peter Stormare) to kidnap his wife (Kristin Rudrüd) and promises to split the ransom with the pair once the job is done. It's a simple plan, but, as with most things in Jerry's life, it goes horribly wrong.

Jerry's crime plays out against the blinding white wilderness of winter in Minnesota and North

Grimsrud (Peter Stormare) and Showalter (Steve Buscemi) are a pair of hapless fools. Everything they do sinks them deeper into trouble.

Dakota, in the small towns of Fargo and Brainerd, and on the bleak highway that connects them. During the course of the kidnapping, Grimsrud accidentally kills a carful of people, and he and Showalter soon find that it is hard to dispose of corpses in weather so cold that graves cannot be dug and flesh does not rot. Grimrud hits on a novel solution to this problem in the movie's audacious final act, but not before Brainerd's

What else to watch: *Blood Simple* (1984, p.339) ▪ *Miller's Crossing* (1990) ▪ *The Hudsucker Proxy* (1994) ▪ *The Big Lebowksi* (1998) ▪ *The Man Who Wasn't There* (2001) ▪ *True Grit* (2010)

Joel and Ethan Coen Directors

Joel and Ethan Coen have made more than 20 acclaimed movies. After their first, the sleek thriller *Blood Simple*, they surprised admirers with *Raising Arizona*, a romantic black comedy, and have confounded expectations ever since, fusing darkness with laughs. The Coens often use other movies and genres as a starting point, before sprawling off in a direction of their own and crafting an off-kilter, funny-scary atmosphere that is entirely their own.

Key movies

1984 *Blood Simple*
1991 *Barton Fink*
1996 *Fargo*
2007 *No Country for Old Men*

As filmmakers, the Coen brothers are masters of balancing laughs and chills, and thanks to its crime-thriller trappings and wintry landscape, *Fargo* is one of their chilliest works. The tone is set in the opening shot, when the camera peers at a car—Jerry's—threading its way through the blizzard. A doom-laden musical score starts up, and this doesn't feel like a comedy: from the outset there are hints of horror.

Marge is the heart of the story. Her pregnancy is a symbol of hope in the white wasteland of double-crossing and butchery. Although she is never in any real danger, there is a lingering dread that she will be overcome by the movie's violence. But the Coen brothers manage to maintain their masterful balancing act amid the carnage, the nihilism of the case forced to co-star with Marge's deeply rooted decency. ▪

police find his victims by the side of the road. The chief of police is Marge Gunderson (Frances McDormand), perhaps the only heavily pregnant detective in the history of cinema.

Uncommon detective

Like everyone else in Brainerd and Fargo, Marge has a folksy Scandinavian–American accent that suggests she's a bit of a bumpkin. But Marge is clearly on the ball. Carefully, she traces the trail of disasters back to Jerry, who's not coping well with the pressure. Macy's study in stress (visible in the close-up far left) is funny and upsetting, and he turns the folksy regional accent into a rhythm of despair.

Marge (Frances McDormand) inspects the body of a state trooper. Her provincial manner belies a sharp intelligence.

> **"**There's **more to life** than a little money, you know. **Don'tcha know that?**… I just **don't understand** it.**"**
> **Marge Gunderson** / Fargo

WE'VE ALL LOST OUR CHILDREN
THE SWEET HEREAFTER / 1997

IN CONTEXT

GENRE
Drama

DIRECTOR
Atom Egoyan

WRITERS
Atom Egoyan (screenplay);
Russell Banks (novel)

STARS
Ian Holm, Sarah Polley,
Caerthan Banks

BEFORE
1994 *Exotica*, a story set in a strip joint in Toronto, brings international attention to Atom Egoyan's work.

AFTER
2002 *Ararat*, Egoyan's drama about the Armenian genocide of 1915, wins critical acclaim but faces distribution problems due to political pressure from Turkey, which denies genocide.

2009 *Chloe*, an erotic thriller staring Liam Neeson and Julianne Moore, is Egoyan's biggest commercial hit.

Most dramas build up to tragedy; few begin with its aftermath. Canadian director Atom Egoyan's movie deals with the fallout from two tragedies, weaving them together in a subtle meditation on survivor's guilt.

In a town in British Columbia, 14 children have died when the bus they were on slid into an icy lake. Lawyer Mitchell Stevens (Ian Holm) suspects negligence, and tries to build a case against the bus company and its driver, the horrified and otherwise harmless Dolores (Gabrielle Rose). Stevens' bid to persuade reluctant locals to seek redress is a manifestation of the despair in his own life, as he struggles to cope with losing his own daughter to drug addiction.

Seeking closure
Stevens meets his match in Nicole (Sarah Polley), a 15-year-old who was on the bus but survived. Contrary to his expectations, Nicole has no rage; instead, she feels left behind, in a ghost town shattered by grief. Her sabotaging of his case with a wholly unexpected deposition is the payoff to this beguiling movie. Why she does it is something for both Stevens and the viewer to ponder. ■

Nicole survives the accident but is left paralyzed. So too, in a sense, is the small town torn apart by the loss of the children who died that day.

What else to watch: *Short Cuts* (1993) ▪ *Exotica* (1994) ▪ *Breaking the Waves* (1996) ▪ *Ararat* (2002) ▪ *Mystic River* (2003) ▪ *21 Grams* (2003)

I MISS MY FATHER

CENTRAL STATION / 1998

IN CONTEXT

GENRE
Drama

DIRECTOR
Walter Salles

WRITERS
**Marcos Bernstein,
João Emanuel Carneiro,
Walter Salles**

STARS
**Fernanda Montenegro,
Vinícius de Oliveira**

BEFORE
1996 *Terra Estrangeira*
(*Foreign Land*) is Salles's first
notable movie, and it is shown
at more than 40 film festivals
around the world.

AFTER
2004 *The Motorcycle Diaries*,
about the life of the young
Che Guevara, brings Salles
another international success.

2012 Salles's *On the Road*,
a screen adaptation of Jack
Kerouac's iconic novel, is a
commercial flop.

On its release in 1998, Walter Salles's breakout hit was immediately nominated for the Best Foreign Language Film Oscar. The story of an orphan looking for his father might sound like sentimental Hollywood fare, but in Salles's hands it is an often dark, always clear-eyed look at big-city poverty, given added authenticity by the fact that its child star, Vinícius de Oliveira, was making ends meet as a shoe-shine boy in Rio de Janeiro when Salles spotted him.

A journey
Although it is a boy, Jesué (de Oliveira), who is lost, alone in Rio after his mother dies in a road accident, *Central Station* (*Central do Brasil*) isn't so much the story of his emotional journey as that of Dora (Fernanda Montenegro), his reluctant guardian. Dora works at the titular station, writing letters for illiterate people who trust her to mail them—but few make it to the mailbox, since Dora has no conscience. When she sells Jesué to an illegal adoption agency, she tells her outraged friend, "He'll be better off." That Dora eventually finds her conscience and puts things right is no surprise, but what stands out is the naturalism and ease with which the story develops. When Dora's attempt to take the boy back to his father backfires, she gives up trying to outwit fate and simply plays her part: once a reluctant messenger, she makes sure this package gets to its destination. ∎

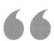

This is not a heartwarming movie about a woman trying to help a pathetic orphan, but a hard-edged film about a woman who thinks only of her own needs.
Roger Ebert

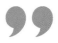

What else to watch: *Foreign Land* (1996) ▪ *City of God* (2002, pp.304–09) ▪ *Carandiru* (2003) ▪ *Slumdog Millionaire* (2008, pp.318–19)

HERE'S TO THE MAN WHO KILLED MY SISTER

FESTEN / 1998

IN CONTEXT

GENRE
Family drama

DIRECTOR
Thomas Vinterberg

WRITERS
**Thomas Vinterberg,
Mogens Rukov**

STARS
**Ulrich Thomsen,
Henning Moritzen,
Thomas Bo Larsen**

BEFORE
1960 Jean-Luc Godard
brought a new and radical
filmmaking style to *À bout
de souffle*.

AFTER
1998 The second Dogme
movie is Lars von Trier's *The
Idiots*, about a group of friends
who pretend to be disabled for
their own amusement.

1999 US director Harmony
Korine makes the first non-
European Dogme movie, *Julien
Donkey-Boy*.

On March 13, 1995, a group of Danish filmmakers came together to create an artistic manifesto. There were many rules in this document, but the core idea behind the Dogme 95 movement was the removal of artifice from cinema. Knocking away creative crutches and devices, from music to superficial dramatic tropes such as murder, the goal was to purify movies, to tell stories that are focused entirely on the characters and the moment they are in.

The first Dogme movie, *Festen* (*The Celebration*), was Thomas Vinterberg's contribution to the movement. Following Dogme rules, the movie takes place in one setting, a family-run hotel hosting a patriarch's 60th birthday dinner. His three estranged children return for the occasion and dark secrets are exposed. The claustrophobia and intense realism of the filming style add to the pressure-cooker atmosphere gradually built up by the proceedings.

The speech

Festen subverts social conventions, perhaps most tellingly in its use of a formal speech to expose the truths under the veneer of familial

Thomas Vinterberg Director

Thomas Vinterberg was born in Copenhagen, Denmark, in 1969. After graduating from the national film school of Denmark in 1993, he made his feature debut with *The Biggest Heroes*, a road movie that was met with acclaim in his native Denmark. He later formed the Dogme 95 movement with fellow directors Lars Von Trier, Kristian Levring, and Søren Kragh-Jacobsen. His movie *Festen* was the first, and most successful, of the movement, and was met with international acclaim, including winning the jury prize at Cannes.

Key movies

1996 *The Biggest Heroes*
1998 *Festen*
2003 *It's All About Love*
2012 *The Hunt*

politeness. Traditional speeches are often a contrived conversation that is used to mask an agenda or keep the peace—it lends itself to dishonesty. In *Festen*, however, it is where characters are at their most honest. Once they have tapped a wine glass with a fork, they bare their souls.

In his first speech, Christian (Ulrich Thomsen), the eldest son of the patriarch Helge (Henning Moritzen), accuses his father of committing a terrible crime against his children years earlier, one that ultimately led to his twin sister's death. In this moment, Christian is fearless, yet a few moments later his father speaks to him privately and the mask returns—Christian apologizes and recants. The party, and the speeches, continue. For a

After making a terrible and very public accusation against his father, Christian (Ulrich Tomsen, center) is forcibly ejected from the patriarch's birthday party by his younger brother Michael (Thomas Bo Larsen, left).

In removing artifice, *Festen* was a self-consciously "little" movie, in the tradition of the French New Wave. It cost just over $1 million to make.

family whose private conversations have been full of lies for so long, it makes sense that the structural artifice of the speech becomes the place to find honesty.

Anarchy and order

The Dogme 95 principle was a much-needed stripping back of frippery in the guise of punish prank, ridding cinema of overly familiar trappings in order to get right to the soul of the piece.

Festen was one of the first movies to use digital cameras, and this gives it the feel of an uncompromising family video, putting the viewer in the center of the emotional firestorm. In doing so, it makes the audience forget that it is watching a "movie." There are no musical cues to tell viewers when to be upset, no empowering scenes of revenge. The movie presents the disintegration of a family with a minimum of directorial comment, leaving the audience free to decide what to feel, when to be horrified or amazed. By affording the viewer such trust, *Festen* leaves an affecting emotional mark. ▪

❝Don't diss my family, get it?❞
Michael / Festen

EVERYONE'S FEAR TAKES ON A LIFE OF ITS OWN
RINGU / 1998

IN CONTEXT

GENRE
Horror

DIRECTOR
Hideo Nakata

WRITER
Hiroshi Takahashi (screenplay); Kôji Suzuki (novel)

STARS
Nanako Matsushima, Hioyuki Sanada, Rikiya Ôtaka, Yôichi Numata, Miki Nakatani

BEFORE
1996 *Don't Look Up*, Nakata's first feature, is not a box-office hit but gives him the critical prestige to direct *Ringu*.

AFTER
1999 Nakata completes the story with *Ringu 2*.

2002 Nakata directs *Dark Water*, which, like his previous two movies, is remade by Hollywood.

A s with many Western horrors—*Poltergeist* (1982) and *The Blair Witch Project* (1999), for example—Hideo Nakata's movie *Ringu* (*The Ring*) draws its shivers from folklore and legend: in this case an old samurai tale transferred to modern-day urban Japan. The movie is based on Kôji Suzuki's hit 1991 novel of the same name, which in turn was inspired by a well-known 18th-century ghost story about a serving girl, Okiku, who is murdered by her lord.

Taking a key element from US horror movies in which teenagers are drawn to objects or places that are taboo or forbidden, *Ringu* concerns a videotape that is being passed around provincial schools. The

Nakata's movie inspired a new genre of Japanese chillers, several of which were remade by Hollywood. In these "J-horror" movies, the terror is less explicit, with less reliance on "jump scares" and more left to the imagination.

tape lasts just a few seconds and contains strange imagery of a circle of light, a woman brushing her hair, a man with his head covered, a pictogram seen in a close-up of an eye—all played in the static crackle of a degraded, much-watched video. After each viewing of the tape, the viewer receives a phone call saying they will die in seven days. A week later they are dead, their faces twisted by some unimaginable terror.

❝It's **not of this world**. It's Sadako's **fury**. And she's put a **curse on us**.❞
Ryuji Takayama / Ringu

What else to watch: *Kwaidan* (1964) ▪ *Poltergeist* (1982) ▪ *Ghost Actress* (1996) ▪ *Rasen* (1998) ▪ *Kairo* (2001) ▪ *Dark Water* (2002) ▪ *One Missed Call* (2003) ▪ *Ju-on: The Grudge* (2004) ▪ *Pulse* (2006) ▪ *It Follows* (2014)

Reiko, a journalist, stares at the static that marks the end of the deadly videotape. Within moments, her phone will ring and a mysterious voice will tell her of her fate.

The teen-horror element initially seems to be a misdirect, since *Ringu* quite quickly becomes a detective yarn, with journalist Reiko (Nanako Matsushima) becoming interested in the case after discovering that her niece is one of the latest victims. Retracing the girl's final steps, Reiko finds the videotape and watches it. She then has seven days to avert her own death—a race against time to decipher the mysterious imagery she has seen. By chance, Reiko's teenage son watches the tape too, raising the stakes even higher.

Ghosts of the past

With Reiko inching closer to solving the mystery, it almost seems as though Nakata is going to abandon the horror element altogether, as Reiko begins to piece together the story of a famous psychic who lost her powers when her daughter, Sadako (Rie Inô), was born. For a

time, the story winds back into the past to uncover the terrible secrets that have begun to seep into the present.

As with other Japanese horrors that *Ringu* later inspired, there is a prospect of redemption; although she is clearly a malevolent spirit, Sadako (and Okiku in the original folktale) has a sympathetic

backstory, and so the focus switches from the untimely deaths of teenagers to Reiko's attempt to right the injustice done to Sadako in the past and lift her curse. And yet there are virtuoso moments of goose-bump horror to come, and images that will haunt the viewer long after watching this movie. Although Hollywood produced a watchable remake in 2002, it could not inspire the same dread.

The figure of Sadako became an instant icon and influenced a whole genre. The imagery is based on Japanese *yurei* ghosts: she has a pale face and long, matted hair, suggesting that her corpse received no burial rites (Japanese women were traditionally buried with their hair up, not down). In this, the movie explores the clash of ancient folktale and Japanese modernity, with the ghost's terror hiding in something as prosaic as a videotape. ▪

Hideo Nakata Director

Born in rural Okayama in 1961, Hideo Nakata worked for seven years as an assistant director before making his debut with the 1996 fantasy-horror *Don't Look Up* (or *Ghost Actress*). He secured his reputation internationally with *Ringu*, switching the gender of the protagonist in the tale on which it is based. *Ringu* ushered in a new genre of Japanese horror—J-horror—in which female leads are stalked by the ghosts of young girls. He continued the formula with 2002's *Dark Water*.

Key movies

1996 *Don't Look Up*
1998 *Ringu*
1999 *Ringu 2*
2002 *Dark Water*

A SWORD BY ITSELF

RULES NOTHING. IT ONLY COMES ALIVE IN SKILLED HANDS

CROUCHING TIGER, HIDDEN DRAGON / 2000

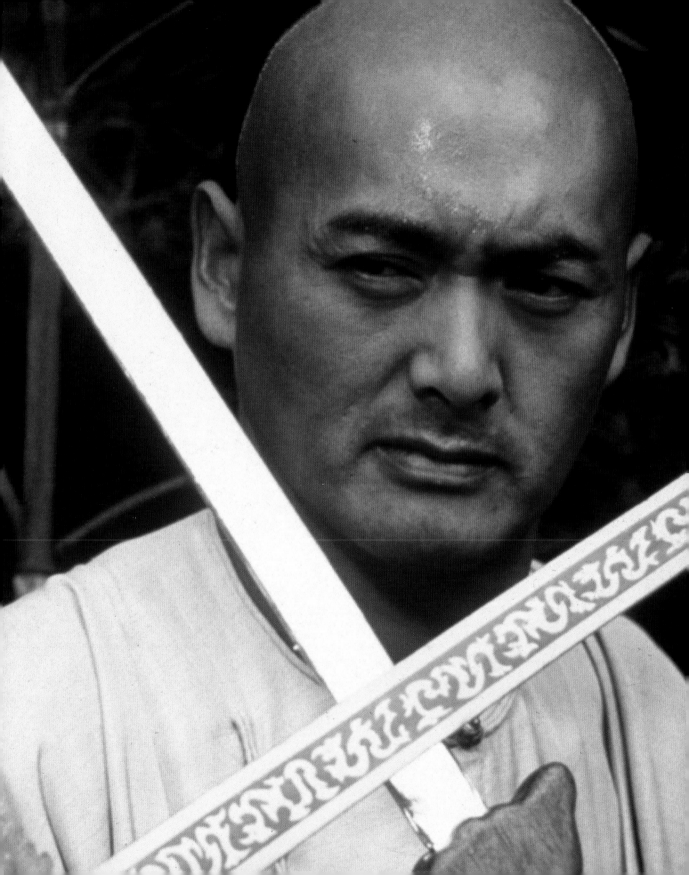

IN CONTEXT

GENRE
Wuxia (martial arts)

DIRECTOR
Ang Lee

WRITERS
Hui-Ling Wang, James Schamus, Tsai Kuo-Jung (screenplay); Wang Dulu (story)

STARS
Chow Yun-fat, Michelle Yeoh, Zhang Ziyi, Chang Chen

BEFORE
1991 *Once Upon a Time in China*, starring Jet Li, starts a craze for *wuxia* movies in Asia.

1993 Ang Lee's *The Wedding Banquet* is Oscar-nominated for Best Foreign Language film.

AFTER
2004 Zhang Yimou's visually stunning *wuxia* movie *House of Flying Daggers*, also starring Zhang Ziyi, is clearly aimed at Western audiences.

Movies including *Sense and Sensibility* (1995), *The Ice Storm* (1997), and *Ride With the Devil* (1999) propelled Ang Lee to the A-list of Hollywood directors. So it was a brave move to make his next project a martial arts movie set in ancient China with dialogue entirely in Mandarin Chinese. Yet *Crouching Tiger, Hidden Dragon* justified the risk.

The movie is based on a *wuxia* novel (see box, below), written in the 1930s by Chinese author Wang Dulu, the fourth title in his five-part *Crane-Iron Series*. In the US and in Europe, the movie was an instant critical and commercial hit, and won the Oscar for best foreign film.

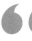

It's a good exam—
how to tell a story
with a global sense.
Ang Lee

Critics noted the way it seemed to capture an idealized China, a China of dreams. As Ang Lee himself admitted, such a place never really existed. But the combination of romance, balletic martial arts sequences, and poetic cinematography created a movie that Western audiences engaged with. In China itself, however, the initial response to the movie was less positive, and an appreciation of its merits was slow in coming.

Among the best-known *wuxia* in the West are the *Once Upon a Time in China* series, which are regarded as some of the best of the genre. Many Chinese critics viewed Ang Lee, despite his Chinese roots, as a cultural tourist jumping on the *wuxia* bandwagon and getting it wrong. The martial arts sequences were tame, they complained. There was too much talk and not enough action. In their opinion, Ang Lee was pandering to Western audiences' need for emotional involvement.

Yet engaging the audiences emotionally and psychologically is precisely what Ang Lee intended. He believed that the popular martial arts movies had barely begun to explore the true meaning

Wuxia movies

Wuxia stories are an old tradition in China. The word *wuxia* means chivalrous warrior, and first emerged during the Ming Dynasty (1368–1644). Like the knights of European romances, *wuxia* combined a quest for personal perfection with skill in combat. Ming and Qing rulers tried to suppress *wuxia* stories because of their emphasis on social justice, but they remained hugely popular. The first *wuxia* movies were made in the 1920s, but it was in the

1960s that they became a phenomenon in China. In the 1990s, Hong Kong filmmakers made the *Once Upon a Time in China* series, featuring the folk hero Wong Fei-hung (played by Jet Li, left).

Crouching Tiger, Hidden Dragon changed the nature of *wuxia* in China, with movies such as Zhang Yimou's *House of Flying Daggers* (2004) telling a more psychological story than the earlier action-led movies.

SMALL WORLD **293**

What else to watch: *Once Upon a Time in China* (1991) ▪ *Drunken Master II* (1994) ▪ *Sense and Sensibility* (1995) ▪ *Hero* (2002) ▪ *House of Flying Daggers* (2004) ▪ *Brokeback Mountain* (2005) ▪ *Lust, Caution* (2007) ▪ *Life of Pi* (2012)

Minute by minute

00:06
Shu Lien delivers the legendary sword Green Destiny to Sir Te in Beijing. There she meets the young Jen Yu, who is envious of Shu Lien's warrior lifestyle.

00:34
Li Mu Bai confronts Jade Fox for poisoning his master. Jade Fox kills the policeman who has been tracking her.

1:11
Lo disrupts Jen's wedding procession and urges her to return with him to the desert. She runs away disguised as a boy.

1:34
After dueling with Jen, Li Mu Bai throws Green Destiny over a waterfall. Jen Yu chases after it and is saved by Jade Fox.

| 00:00 | 00:20 | 00:40 | 01:00 | 01:20 | 01:40 | 02:00 |

00:10
A masked thief steals Green Destiny from Sir Te's study, and is chased by Shu Lien across the rooftops of Beijing.

00:50
Lo, a bandit, slips into Jen Yu's bedroom. In flashback, we see him raiding her baggage train in the desert, and the two of them falling in love.

1:26
Jen rejects Shu Lien's friendship and the pair duel spectacularly. Shu Lien wins, with a broken sword held to Jen Yu's throat.

1:45
Wounded by one of Fox's darts, Li Mu Bai speaks his love for Shu Lien. Jen asks Lo to make a wish. She then jumps off Mt. Wudang.

Jen Yu is a skilled martial artist. After chasing Lo, a handsome bandit who has stolen her comb, she finds herself in his desert camp surrounded by brigands, and takes every one of them on in an acrobatic fight sequence.

of *wuxia*. To get to the heart of its role in the Chinese psyche, he felt he had to "use Freudian or Western techniques to dissect what… is hidden in a repressed society—the sexual tension, the prohibited feelings." In other words, he consciously used a Western approach to filmmaking to uncover a psychological meaning behind the action.

Left unsaid

Most earlier *wuxia* movies pitched the viewer straight into the combat. However, *Crouching Tiger, Hidden Dragon* opens with a five-minute-long dialogue between a noble swordsman, Li Mu Bai (Chow Yun-fat) and a female warrior, Shu Lien (Michelle Yeoh). The story is set in the 18th century, during the Qing Dynasty. Li Mu Bai has retired from fighting and has joined a monastery as a path to enlightenment, but neither he nor Shu Lien can cast aside their love for each other, or »

❛❛I would rather **be a ghost** drifting by **your side** as a **condemned soul** than enter **heaven without you**. Because of your love, I will never be a **lonely spirit**.❜❜
Li Mu Bai / *Crouching Tiger, Hidden Dragon*

confess their feelings. Both are constrained by notions of honor. These unspoken desires heighten the sexual tension between them. "Crouching tiger, hidden dragon" is a Chinese expression alluding to a situation full of danger.

In Lee's movie, chief among these dangers is suppressed sexual desire. Just when Shu Lien and Li Mu Bai seem about to overcome propriety and declare their love, Li Mu Bai's sword, Green Destiny, is stolen, and he suspects his elusive archenemy, Jade Fox (Cheng Pei-pei), the killer of his old master, to be the culprit. Before he can reveal his heart to Shu Lien, therefore, Li Mu Bai must recover Green Destiny and avenge his master's death.

Women warriors
At this point in the narrative, it becomes clear that Lee is making a second major departure from the *wuxia* movie tradition by putting women to the fore. The sword thief, who is shown leaping away across the rooftops of the Forbidden City

Jen Yu rejects Shu Lien's offer of friendship and the pair duel. Shu Lien fights with every weapon available, but each is destroyed in turn by Jen Yu wielding Green Destiny.

in a spectacular aerial chase, is in fact Jen Yu (Zhang Ziyi), a fiery young noblewoman who has been secretly trained in brilliant but uncontrolled combat skills by the villainous Jade Fox, also a woman.

Li Mu Bai's ally and his two adversaries are three strong women who all have major roles in the plot and the fighting. It is Li Mu Bai's beloved Shu Lien who plays the customary male part of sublime swordsman with Zen-like emotional control. Jen Yu and Jade Fox are their out-of-control opponents.

Jen Yu is in violent rebellion against the social and chivalric conventions Li Mu Bai and Shu

> **❝**Fighters have rules, too. **Friendship, trust, integrity**. Always keep your promise. **Without rules** we wouldn't survive long.**❞**
>
> **Shu Lien** / Crouching Tiger, Hidden Dragon

By Hollywood standards, the budget for Ang Lee's movie was small: $17 million. Studio executives were taken aback when it grossed $128 million in the US alone, and nearly $215 million internationally.

Lien live by. She is contemptuous of their self-discipline, or as she sees it, their self-repression. "Stop talking like a monk," she retorts, when Li Mu Bai tries to advise her that the sword is a state of mind. She has taken a lover, Lo (Chang Chen), a bandit, with whom she is sexually intimate, and defies her family (unthinkable in China at that time) by escaping on her wedding night from an arranged, respectable marriage to a nobleman.

Jen Yu acknowledges that Li Mu Bai's martial skills are greater than those of Jade Fox, and she wants him as her teacher. When he agrees, she says that he is only doing so because he desires her sexually.

Jade Fox was once a student of Li Mu Bai's old master, but killed him when he tried to take sexual advantage of her. Her hostility as a character, and her fury and vengefulness, could also be sexual in origin. The entire story is driven by sexual undercurrents.

Fantastical fighting

In another departure from genre tradition, the fighting scenes are not so much staged as choreographed, becoming extraordinary aerial ballets. In the most stunning sequence, with Li Mu Bai fighting Jen Yu amid swaying bamboos, the effect was not achieved with computer trickery but with the actors flying on wires. The result is enigmatic rather than violent, capturing the mystery and poetry of a mythical ancient China. ∎

Ang Lee Director

Born in 1954 in Taiwan, Ang Lee graduated from the National Taiwan College of Arts before moving to the US. His first critical success came with *The Wedding Banquet*, the first of several movies made with screenwriter James Schamus. Lee returned to Taiwan to make *Eat Drink Man Woman* (1994), a critical and commercial success. His adaptation of Jane Austen's *Sense and Sensibility* (1995), with a screenplay by the movie's star, Emma Thompson, revealed his range. The tragedy *The Ice Storm* and the US Civil War drama *Ride with the Devil* (1999) were followed by *Crouching Tiger, Hidden Dragon* and *The Hulk* (2003). He won an Oscar for Best Director with *Brokeback Mountain* (2005), about the gay relationship between two cowboys. A second Oscar came in 2012 with *Life of Pi*.

Key movies

1993 *The Wedding Banquet*
1997 *The Ice Storm*
2000 *Crouching Tiger, Hidden Dragon*
2012 *Life of Pi*

Major fight scenes

Jen | Li Mu Bai | Shu Lien | Jade Fox

Rooftop night fight · Jade Fox appears · Returning the sword · Teahouse fight · Dueling sisters · In the bamboo forest · Rescuing Jen

YOU DON'T REMEMBER YOUR NAME?

SPIRITED AWAY / 2001

IN CONTEXT

GENRE
Animation, fantasy

DIRECTOR
Hayao Miyazaki

WRITER
Hayao Miyazaki

STARS
Rumi Hiiragi, Miyu Irino, Mari Natsuki

BEFORE
1979 *The Castle of Cagliostro*, the tale of a clever thief, is Miyazaki's first movie.

1984 *Nausicaä of the Valley of the Wind* stars a pacifist princess in a postapocalyptic world; its success leads to the creation of Studio Ghibli, home to a string of animation hits.

1997 *Princess Mononoke* is Miyazaki's first movie to use computer graphics.

AFTER
2013 *The Wind Rises* tells the fictionalized life story of aircraft designer Jiro Horikoshi.

The animators at Tokyo's Studio Ghibli—chief among them cofounder Hayao Miyazaki—have been making wildly inventive movies since 1986. With a highly distinctive style of animation influenced by the *manga* tradition of Japanese comic books, Studio Ghibli has expanded the tastes of audiences around the world.

Miyazaki's *Spirited Away* brought Ghibli worldwide commercial success, and also acclaim—it was the first foreign-language animation film to win an Oscar. It was also a masterpiece of its genre, a glorious flight of imagination based on the idea of "the magical doorway" found in much children's fiction. Children often see reality as something to be escaped from, and the genius of *Spirited Away* is allowing the child in everyone to do just that.

After a long train journey, Chihiro and the mysterious No-Face (left) have tea with Zeniba, the twin sister of the greedy and controlling witch Yubaba.

What else to watch: *Laputa: Castle in the Sky* (1986) ▪ *Grave of the Fireflies* (1988) ▪ *Kiki's Delivery Service* (1989) ▪ *Princess Mononoke* (1997) ▪ *The Cat Returns* (2002) ▪ *Howl's Moving Castle* (2004)

One subversive aspect of *Spirited Away* compared with Miyazaki's other work and the fantasy genre as a whole is that the fantasy realm presented here is often anything but majestic. While it does feature wondrous magic and supernatural creatures, the movie also focuses on the harrowing day-to-day existence of the protagonist, a 10-year-old girl called Chihiro, as she is put to work in a bathhouse run by the witch Yubaba.

Real fantasy

While the magical realms depicted in children's fiction are usually more dangerous than our own, populated as they are by strange and terrible monsters, they also come with a significant upside: the characters who wander into them will often be given a chance to win the crown or right some terrible wrong. In *Spirited Away*, however, not much changes:

The bizarre town that Chihiro wanders into is home to Japan's legions of demons, spirits, and gods, where humans are turned into animals. Chihiro avoids the spell, but her parents do not.

by the end of the movie, the tyrannical Yubaba still holds sway, and while Chihiro manages to escape, many others are left behind.

For all the movie's sense of wonder, it is this grounding in reality, this refusal to whitewash the darker elements of life, that makes *Spirited Away* more poignant than many other fantasy tales. It's not about defeating evil and creating a utopia, but instead about simply surviving and finding moments of happiness and compassion wherever you can.

Everyone has a story

Spirited Away strives to portray its characters in an evenhanded and nuanced fashion. It often introduces characters in quite a harsh light—from the seemingly unsympathetic coworker Rin to Zeniba, Yubaba's sister and fellow witch—only to

later reveal their caring side and humanity. Even No-Face, the quiet spirit who becomes the villain of the movie's second act, is also portrayed sympathetically, in his desire to connect with Chihiro and his attempts to give her gifts to win her over. The boundless imagination that Miyazaki uses to create his fantasical worlds is matched by his endearing compassion for his characters—their strengths and flaws, dreams and fears—and this allows us to care about them as deeply as we marvel at them. ▪

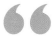

This visual wonder is the product of a fierce and fearless imagination whose creations are unlike any you've seen before.
Kenneth Turan
Los Angeles Times, 2002

Hayao Miyazaki Director

Hayao Miyazaki was born in Tokyo in 1941; he and his family were evacuated to escape the US firebombing of Japanese cities. Miyazaki got his first job in animation in 1963, and made his directorial debut in 1979 with *The Castle of Cagliostro*. He rose to worldwide prominence almost

20 years later, with *Princess Mononoke*. *Spirited Away*, his follow-up, won him an Oscar and was perhaps his best-received movie. *The Wind Rises*, in *2013*, was his last movie.

Key movies

1997 *Princess Mononoke*
2001 *Spirited Away*
2013 *The Wind Rises*

I LIKE TO LOOK FOR THINGS NO-ONE ELSE CATCHES
AMÉLIE / 2001

IN CONTEXT

GENRE
Romantic comedy

DIRECTOR
Jean-Pierre Jeunet

WRITERS
**Guillaume Laurant,
Jean-Pierre Jeunet**

STARS
**Audrey Tautou, Mathieu
Kassovitz, Dominique Pinon**

BEFORE
1991 Jeunet and Marc Caro's
Delicatessen is an inventive
fantasy movie set in a
postapocalyptic France.

1995 The baroque fairy tale
The City of Lost Children gets
Jeunet noticed by Hollywood.

AFTER
2004 Jeunet teams up with
Tautou for the war drama
A Very Long Engagement.

2009 *Micmacs* is a comedy-
satire by Jeunet about the
arms industry.

After enjoying critical success in France, Jean-Pierre Jeunet's first venture into Hollywood was a troubled one. Hired to direct the fourth movie in the science-fiction *Alien* series, the project suffered production difficulties and was released to mixed reviews. Jeunet returned to France discouraged, and for his next movie concocted *Amélie*, a work in which every frame seems to celebrate a freedom that had perhaps been denied to him on his previous project. Structurally, *Amélie* is a romantic comedy—the story of

In Amélie, Jeunet succeeded in finding a new take on the tired and much-derided romantic comedy genre, using an ambitious pairing of style and subject matter.

a waitress meeting the man she's destined to fall in love with; in practice the movie is a tribute to a virtuoso creativity and imagination. Despite the smallness of the central story, Jeunet uses techniques usually reserved for action movies and epics. The far-reaching and expansive script, the strong use of color, and the experimental editing

Jean-Pierre Jeunet Director

Jean-Pierre Jeunet was born in the Loire region, France, in 1953. He bought his first movie camera at 17 when he studied animation at Cinémation studios. His first feature movie was *Delicatessen*, which he codirected with Marc Caro. Based on the commercial and critical success of their follow-up, *The City of Lost Children*, Jeunet was offered *Alien: Resurrection*. After it performed poorly, he returned to France and directed *Amélie*, his most celebrated movie.

Key movies

1991 *Delicatessen*
1995 *The City of Lost Children*
2001 *Amélie*

techniques all serve as platforms for the director's skill without losing touch with an intimate story: that of a young woman finding herself.

Saying without words

Amélie has a very pronounced visual showmanship, which underscores one of the movie's key themes—that the most valuable communication is done without words. Its central protagonist, the young waitress Amélie, is so shy that she plots elaborate ways to convey things she is incapable of putting into words. For example, instead of confronting a shop owner she sees abusing his employee, she subtly disrupts the owner's daily

routine to the point where he doubts his own sanity, such as by swapping around door handles in his apartment and changing the alarm time on his bedside clock. By the same token, when she tries to reignite her father's dream of seeing the world, she does so by "kidnapping" his garden gnome and sending her father photos of it appearing in several exotic locations. These are disparate goals. One is an act of social vigilantism, the other a familial gesture of love. Yet Amélie goes about both in the same way, manipulating reality to get the person to the place she wants them—not out of malice, but

Amélie (Audrey Tautou) plays jokes on the bullying grocery-store owner (Urbain Cancelier) for his cruelty to Lucien (Jamel Debbouze). She secretly falls for Nino (Mathieu Kassovitz, far left).

because she sees the world in a different way. She notices things other people don't and acts in a way other people would not. This is especially so when Amélie finds herself face to face with her love interest, Nino. There is no speech of any kind. They simply look at each other, seeing into the person honestly, and realize they are meant for each other.

Though some criticized *Amélie* for what was seen as a dated portrait of Paris, others fell in love with the way it merges ambition with soulfulness, juxtaposing high-energy visuals and narrative adventure with the simple story of a boy and a girl falling in love. ▪

> **❝She** doesn't relate **to people,** she was always **a lonely child.❞**
>
> **Amélie** / *Amélie*

WHAT AN EXTRAORDINARY STANCE!
LAGAAN / 2001

IN CONTEXT

GENRE
Musical drama

DIRECTOR
Ashutosh Gowariker

WRITERS
K. P. Saxena (Hindi dialogue), Ashutosh Gowariker (English dialogue)

STARS
Aamir Khan, Gracy Singh, Rachel Shelley, Paul Blackthorne; narrated by Amitabh Bachchan

BEFORE
1957 Mehboob Khan's melodrama *Mother India* is the first Indian movie to be nominated for the Best Foreign Language Movie Oscar.

AFTER
2004 Gowariker's acclaimed follow-up to *Lagaan*, *Swades*, tells the story of a NASA scientist who returns to his native Indian village.

A story about a village cricket match in India under the British Raj in the 1890s, Ashutosh Gowariker's *Lagaan, Once Upon a Time in India* (to give it its full title) is one of the few Indian movies to have achieved audience and critical acclaim both within India and far beyond.

The scenario is a simple one. At a time when the remote village of Champaner in Gujarat is suffering from a drought, one of the villagers, Bhuvan (Aamir Khan), goes to the local British officer, Captain Andrew Russell (Paul Blackthorne), to plead for relief from the *lagaan*, or crop tax. Russell dismisses his plea, but before Bhuvan leaves, he sees the British playing cricket and mocks the game. Incensed, Russell offers to cancel the villagers' taxes for three years if they can beat his men in a game—but if they lose, they will have to pay triple. To the horror of the villagers, Bhuvan accepts the challenge. The match occupies the entire second half of the movie, right up to the final, crucial ball.

Crowd-pleasing story
Lagaan's success at the box office was partly due to its sheer entertainment value. It is a stirring,

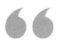

The movie is not just a story. It is an experience. An experience of watching something that puts life into you, that puts a cheer on your face, however depressed you might be.
Sudish Kamath
The Hindu

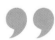

old-fashioned adventure in which plucky underdogs get together to take on the bullies, and it has everything you'd expect from such a classic story. There is a romantic triangle, as Captain Russell's sister Elizabeth (Rachel Shelley) falls for Bhuvan, who is already pledged to local girl Gauri (Gracy Singh). There is a jealous lover, Lakha, who, spurned by Gauri, helps the British. There are comic characters galore, and even the poor outsider who turns out to be a hero.

What else to watch: *The Pride of the Yankees* (1942) ▪ *Mother India* (1957) ▪
Playing Away (1987) ▪ *Salaam Bombay* (1988) ▪ *Jodhaa Akbar* (2008)

❝He who has **truth and courage** in his heart **shall win** in the end.❞

Bhuvan / Lagaan

But this is much more than just an entertaining romp. The movie carries a Gandhian message of redemption and unity, as the fight against the oppressor is undertaken entirely without violence or bitterness. The team's inclusiveness is Gandhian, too: the players include Hindus, a Sikh, a Muslim, and even a *Dalit*, a member of the untouchable caste. Bhuvan has to fight to persuade the other villagers to accept Kachra, the *Dalit*, but Kachra's maimed hand, the physical symbol of his social handicap, turns out to be his trump card, as his misshapen fingers give him a remarkable ability to spin the ball. *Lagaan* is a feel-good movie, but that is also where its political message lies: feeling good, feeling valued, is essential to healing the wounds that divide people.

Above all, *Lagaan* is a celebration of India. It is a beautiful movie that captures the rich and exuberant colors of the landscape, with its ambers, browns, and yellows. Added to this is the acclaimed soundtrack of A. R. Rahman, that punctuates the movie with captivating songs and music. ▪

Bhuvan (Aamir Khan) dances with Gauri (Gracy Singh) as the rest of the village looks on in one of the movie's set-piece musical numbers.

Ashutosh Gowariker
Director

Ashutosh Gowariker is renowned for beautifully shot, well-crafted stories. He was born in Mumbai, India, in 1964. After earning a degree in chemistry, he pursued a career in movies as an actor. It wasn't until he was in his 30s that he directed his first movie, *Pehla Nasha* (*First Love*, 1993). His big breakthrough came with *Lagaan*, followed by *Swades*. Romantic comedy *What's Your Raashee?* (2009) was a change of direction, but his period drama *Khelein Hum Jee Jaan Sey*, about the Chittagong uprising, put him back on familiar territory.

Key movies

2001 *Lagaan*
2004 *Swades*
2010 *Khelein Hum Jee Jaan Sey*

IT ALL BEGAN WITH THE FORGING OF THE GREAT RINGS

THE LORD OF THE RINGS: THE FELLOWSHIP OF THE RING / 2001

IN CONTEXT

GENRE
Fantasy

DIRECTOR
Peter Jackson

WRITERS
Peter Jackson, Phillippa Boyens, Fran Walsh (screenplay); J. R. R. Tolkien (novel)

STARS
Elijah Wood, Ian McKellen, Viggo Mortensen

BEFORE
1994 *Heavenly Creatures*, based on a notorious New Zealand murder case, brings Jackson critical prestige.

AFTER
2005 Jackson's box-office blockbuster *King Kong* is a remake of the 1933 classic.

2012–14 Jackson repeats the success of the *Lord of the Rings* trilogy with a three-part adaptation of J. R. R. Tolkien's novel *The Hobbit*.

N ot since the biblical epics of Hollywood's classical era has a movie been made on the scale of *The Fellowship of the Ring*, the first installment in the *Lord of the Rings* trilogy. For many years, J. R. R. Tolkien's sprawling fantasy novel was considered to be unfilmable. Only with rapid advances in computer-generated imagery did the mythic locations, creatures, and vast battle scenes become a possibility for a movie director. However, although the movie fully exploits its special effects, it does not depend on them. Its success owes far more to the skill of its director, Peter Jackson, who also cowrote the screenplay.

Jackson understood that he had to compress the intricate backstory as much as he could, keep the narrative pace fast, and maintain focus on the central character of Frodo Baggins (Elijah Wood). In doing so, he pulled off the notable feat of pleasing the

Much of the movie's critical and box-office success was due to Jackson's trimming of the plot, enhancing the action sequences, and expanding the female roles.

What else to watch: *The Lord of the Rings: The Two Towers* (2002) ▪
The Lord of the Rings: The Return of the King (2003) ▪ *King Kong* (2005)

novel's worldwide legions of fans while also engaging with those viewers who had never read it.

Frodo is an innocent, a hobbit who has come into possession of the long-lost ring of power, and with it holds the fate of Middle Earth. Guided by the wizard Gandalf (Ian McKellen), he sets off on a quest to destroy it in the fires of distant Mordor, the evil land where it was forged. He is protected by a fellowship of eight others, including men, a dwarf, and an elf. Frodo's character matures with each ordeal he overcomes; knowledge and experience change him, but he does not lose his innate goodness. Although he has guides and magical objects to aid him on his journey, in the end it is his goodness that shields him.

Good vs evil

Behind the complex story is a very straightfoward fight between good and evil. What gives this struggle added nuance and jeopardy is the ring's insidious power to corrupt all who come near it, including those on the side of good—the stout-hearted members of the fellowship. Frodo alone is immune to the ring's evil, but his duty as the ring bearer becomes an increasingly burdensome one.

In the hands of a lesser director, the movie might easily have become a convoluted sword-and-sorcery saga. Happily, Jackson's realization of Tolkien's world is instead one of the most successful novel-to-movie adaptations ever produced. ▪

Four hobbit friends, Merry (Dominic Monaghan), Frodo (Elijah Wood), Pippin (Billy Boyd), and Sam (Sean Astin), set off on their epic quest.

Peter Jackson Director

Born in New Zealand in 1961, Peter Jackson grew up fascinated by the fantasy movies of animator Ray Harryhausen, and began making shorts with a Super 8 cine camera at nine. He received no formal education in film, and learned through trial and error. His first feature, the cult-classic horror *Bad Taste*, was made in 1987. Fame came with *Heavenly Creatures* (1994), based on a true-story murder committed by two schoolgirls, which won the Oscar for best screenplay. In 1999, Jackson got the go-ahead to make *The Lord of the Rings* into three big-budget movies, in a deal with Hollywood studio New Line Cinema, although the movies were shot entirely in New Zealand. *The Return of the King* (2003), the final episode of the trilogy, won 11 Academy Awards, including Best Picture. In 2005, Jackson directed a blockbuster remake of *King Kong*, his favorite childhood movie.

Key movies

1994 *Heavenly Creatures*
2001–03 *The Lord of the Rings*
2005 *King Kong*
2012–14 *The Hobbit*

YOU NEED MORE THAN GUTS TO BE A GOOD GANGSTER. YOU NEED IDEAS

CITY OF GOD / 2002

IN CONTEXT

GENRE
Gangster, crime

DIRECTOR
Fernando Meirelles

WRITERS
**Bráulio Mantovani
(screenplay); Paulo Lins
(novel)**

STARS
**Alexandre Rodrigues,
Leandro Firmino,
Alice Braga**

BEFORE
1990 Martin Scorcese's
Goodfellas tells the story
of the Mafia from the point
of view of mobster-turned-
informant Henry Hill.

AFTER
2005 Meirelles's Hollywood
debut, *The Constant Gardener*,
is a love story set in Kenya.

2008 *Blindness*, Meirelles's
movie about an epidemic of
blindness in an unnamed city,
receives mixed reviews.

Stylish, compelling, and hugely entertaining, Fernando Meirelles' *City of God* (*Cidade de Deus*) also has a serious point to make. Told from the perspective of Rocket (Alexandre Rodrigues), an aspiring photographer, it is a movie about one of Brazil's most notorious and impoverished favelas, the Cidade de Deus in Rio de Janeiro, and how organized crime there corrupted, and, in many cases, destroyed its local youth. Yet Meirelles does not lecture his audience. Instead, he uses every stylistic trick in the cinematic book, from inventive montages to adventurous camera work, to ensure the story is vividly and energetically realized, and engages the audience with the human tragedy.

In one scene, a gang of children walks through the favela, joking about taking over the slum and the people they would need to kill in the process. It is darkly humorous but also horrifying to see children bred into violence from so young an age.

Tale of a city
The movie's action is played out at an ambitious scale. Its story spans more than a decade and charts the

Most of the movie's actors were inhabitants of the favelas portrayed in the movie. Several went on to appear in Meirelles' sequel, *City of Men*.

Fernando Meirelles Director

Born to a middle-class family in São Paolo, Brazil, in 1955, Fernando Meirelles studied architecture before winning several awards at Brazilian film festivals with his early shorts. He went on to find success in Brazilian television, most notably the children's show *Rá-Tim Bum*. His first feature was a children's movie, *The Nutty Boy 2* in 1998. He made his name nationally in 2001 with the comedy *Maids*, and internatially a year later with

City of God, which earned him an Oscar nomination for Best Director. Since then, he had further critical successes with *The Constant Gardener* and *Blindness*, for which he was nominated for the Palme d'Or.

Key movies

2001 *Maids*
2002 *City of God*
2005 *The Constant Gardener*
2008 *Blindness*

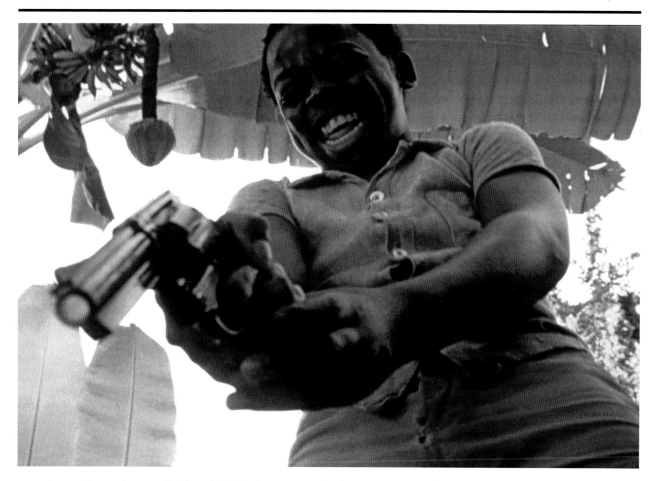

experience of growing to adulthood in the City of God. To achieve this, Meirelles did not bind himself to the narrative constraints of one person's story. The movie does have a central character in Rocket, but he is a photographer, an observer who acts as an audience surrogate, involved but not involved, there to witness the events in the City of God as they occur. The movie clarifies this intention with its use

of voice-over, as Rocket summarizes the favela's defining moments, from the downfall of the Tender Trio in the late 1960s, to the rise of Li'l Zé as a gang leader in the early 1980s. Rocket observes everything as characters flourish and die, as high-rise buildings rise and cartels fall.

The use of voice-over also allows for bolder visual techniques, such as montages that enable a faster passage of time, as well as

Dadinho, or Li'l Dice, (Douglas Silva) is the psychotic kid whose criminal career takes off after he massacres the inhabitants of a motel during a robbery.

the opportunity for more stylistic experimentation. The movie shifts its focus from one central protagonist to another, taking turns telling their stories. It takes up the tales of Shaggy, the leader of the Tender Trio, Benny, the pacifist friend of Li'l Zé, and Knockout Ned, a working man dragged into gang warfare after his family is attacked. With these switching perspectives, Meirelles turns the favela itself »

❝A kid? I smoke, I snort. I've killed and robbed. I'm a real man.❞

Steak-with-fries / City of God

Relationships, allegiances, and enmities

```
Angélica  ←Loves—  Rocket      ←Brothers→   Goose
                   (Narrator)
   ↑                                          ↑
Boyfriend                                  Friends      Kills
   │                                          │          │
Benny     ←Brothers→  Shaggy   ←Friends→   Clipper       │
   ↑  ↑                                                  │
Kills  │         Partners in crime                       │
   │   └──────────────────────────────┐                  │
Blackie   ←Kills—   Carrot  ←Enemies→  Li'l Zé  ←────────┘
                       ↑                   │
          Team up against Li'l Zé        Rapes
                       │                   │
                  Knockout   ←Boyfriend—  Ned's
                    Ned                  Girlfriend
```

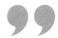 The Tender Trio

into the central character, with other characters entering only when they matter to the overall story of the slum.

The city as fate

One of the main themes Meirelles explores is the favela's corrosive effect on everyone it touches. The violence it spawns does not simply stay among the criminals, but rather is all consuming and perpetuates a culture of suffering for all the inhabitants. Meirelles presents the City of God as an entity in itself, a place that allows the wicked to thrive and the innocent to perish. This is demonstrated starkly in the movie's opening sequence, in which two chickens are about to be plucked and cooked by Li'l Zé's gang. A knife flashes as it is sharpened against a rock. One chicken flinches as the other is killed, and makes a break for it, but there is no escape.

When Knockout Ned tries to draw a line between being a hoodlum and his noble vigilante mission against Li'l Zé, the City of God intervenes, just as it does when Shaggy tries to flee the criminal life in the name of love, or when Benny decides that he's too good a person to be a gangster. Each time a character gives in to their better nature, that character is punished. They are protagonists in their own Greek tragedies, with the city in the role of Fate.

Journalistic ethics

City of God is a gangster story, an impassioned piece of social commentary, and an ambitious work of visual cinema. Rocket's role as a photographer also allows the movie to touch upon the ethics of journalism in a war zone, or in this case, the act of dramatizing very real problems of poverty and violence. This is highlighted when Rocket confronts a newspaper for

Minute by minute

00:10
The Tender Trio rob a motel with Li'l Dice as lookout. We later find out that Li'l Dice went back afterward and shot everyone in the motel.

00:32
At the beach, Rocket photographs his friends, and meets Angélica for the first time. He buys pot to impress her.

1:09
Benny is shot by Blackie at his farewell celebration. Blackie was aiming at Li'l Zé. Carrot then kills Blackie.

1:40
Rocket's photo of Li'l Zé appears in the newspaper. He is offered a job, and Li'l Zé is pleased by the publicity.

```
00:00   00:15   00:30   00:45   01:00   01:15   01:30   02:00
```

00:30
As he tries to run from the police, Shaggy is shot dead. Rocket sees his first camera as a man photographs the body.

00:50
Li'l Dice becomes Li'l Zé and starts a killing spree to take over the drug business in the City of God.

1:26
Knockout Ned joins forces with Carrot in a war against Li'l Ze. A year later, the favela is divided.

1:52
Knockout Ned is killed by Otto, the son of a murdered security guard. Li'l Zé is gunned down by the runts.

publishing without his permission the pictures he took of Li'l Zé. Rocket is sure that this has placed his life in danger, but from the paper's perspective, the story comes first. As it turns out, Li'l Zé is delighted by the publicity, and his battle with Knockout Ned is played out in full media glare. The newspaper staff manipulate Rocket into taking more pictures in the war zones of the City of God, and the tensions between the desire to highlight social problems to sell papers and compassion for those involved in the stories told to do so are never totally resolved.

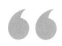

> Breathtaking and terrifying, urgently involved with its characters, it announces a new director of great gifts and passions: Fernando Meirelles. Remember the name.
> **Roger Ebert**

set up a workshop in the favela to train a group of around 100 amateur actors. The cast of *City of God* was drawn from this pool of talent. Over the course of several months, they developed scripts through improvisation sessions. The social commitment continued after filming ended as the actors received ongoing help to build new lives for themselves. ■

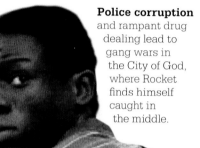

Police corruption and rampant drug dealing lead to gang wars in the City of God, where Rocket finds himself caught in the middle.

Actors from the favela

The majority of the cast for City of God were not professional actors. As the director explained, at the time there simply were not enough black actors in Brazil to make this kind of movie. Two years before filming, Meirelles

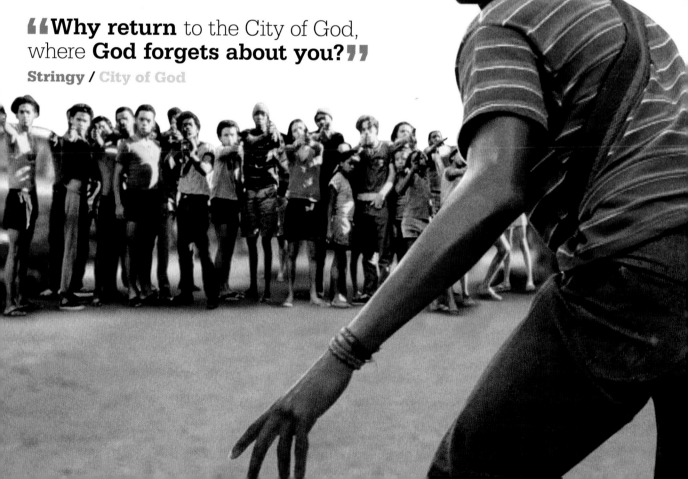

"Why return to the City of God, where **God forgets about you?"**

Stringy / *City of God*

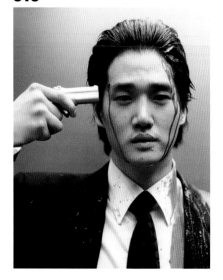

LAUGH AND THE WORLD LAUGHS WITH YOU. WEEP AND YOU WEEP ALONE
OLDBOY / 2003

IN CONTEXT

GENRE
Revenge thriller

DIRECTOR
Park Chan-wook

WRITERS
Park Chan-wook, Lim Chun-hyeong, Hwang Jo-yun, Lim Joon-hyung (screenplay); Nobuaki Minegishi (comic); Garon Tsuchiya (story)

STARS
Choi Min-sik, Yu Ji-tae, Kang Hye-jeong

BEFORE
2000 Park's first movie *Joint Security Area* is a thriller set on the border with North Korea.

2002 Park directs *Sympathy for Mr. Vengeance*, the first part of his *Vengeance* trilogy.

AFTER
2009 Park tries his hand at horror with *Thirst*, the story of a priest becoming a vampire after a failed experiment.

Oldboy (2003) is the second entry in the *Vengeance* trilogy by Korean director Park Chan-wook, coming between *Sympathy for Mr. Vengeance* (2002) and *Sympathy for Lady Vengeance* (2005). The fact that *Oldboy* is the only one without "vengeance" in the title is telling, and signifies a difference in focus from the others.

Oldboy is certainly a revenge movie, but it is concerned more with the corroding effect of an obsession than with the catharsis of killing the one who has wronged. The very concept, in which an unassuming loser, Oh Dae-su (Choi Min-sik), is abducted and kept prisoner in a room for 15 years without knowing why, or by whom, is more about torture of the mind than of the

body. This theme intensifies as the movie progresses, with both protagonist and antagonist waging a war of minds with each other in which their motives are defined by suffering, rather than by their urge for violent revenge. In this sense, *Oldboy* is more than a revenge movie. It is an examination of despair. When Oh escapes, he sets out to discover the identity of his captor and avenge himself, only to

A guard restrains Oh Dae-su just as Oh learns the reason for his imprisonment. In a gesture of remorse, he commits a gruesome act of self-harm with a pair of scissors.

What else to watch: *Vertigo* (1958, pp.140–45) ▪ *Infernal Affairs* (1990) ▪ *Sympathy for Mr. Vengeance* (2002) ▪ *Sympathy for Lady Vengeance* (2005) ▪ *Mother* (2009) ▪ *Thirst* (2009) ▪ *Stoker* (2013)

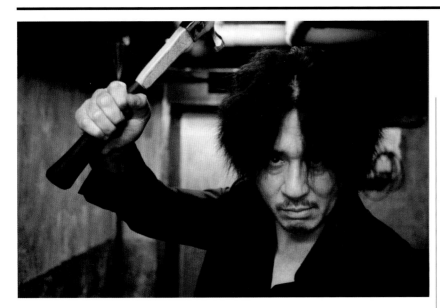

Oh Dae-su attacks the guards of the prison where he has been held captive for 15 years. The long fight scene was filmed as one continuous shot.

find that his imprisonment had itself been designed to avenge an old wrong.

Blood opera

Perhaps *Oldboy*'s most vital ingredient is a stylistic and technical artistry that serves as a counterpoint to the movie's violence. The director achieves this in a number of ways. First, the sound track is highly orchestral. One gruesome sequence is accompanied by the Baroque chamber music of Vivaldi's "Four Seasons." The original score, by Jo Yeong-wook, is also classical in style. This creates a grandiose, operatic feel that elevates the story above the violence. The same is achieved visually, too, most memorably in a remarkable special effect in which the camera pans around Oh Dae-su in his prison cell, and his face appears almost to vibrate out of its skin, as if his mind is trying to break free from his body. The director forgoes realism in order to communicate the character's emotional state.

A similar stepping-out-of-reality occurs at the end, when we see an elaborate flashback to the events we now realize sparked the story into life. Visually, key characters should be young—but no, they look exactly the same as they do in the present, *Oldboy* suggesting that they never escaped the trauma of their past. (Do any of us, the movie asks?)

Hi-tech violence

South Korean movies at the turn of the century became noted for their violence, but what has been less noticed is the technical artistry that accompanies them. This was never more aptly represented than in *Oldboy*, a movie that is certainly brutal, but high-mindedly disturbs as much as it viscerally shocks, a revenge movie for both the connoisseur and the gore hound. ▪

Park Chan-wook Director

Park Chan-wook was born in Seoul, South Korea, in 1963. While studying philosophy at college, he discovered a love of film, and started a film studies group called the Sogang Fil Community. After graduating, he wrote for movie journals before becoming an assistant director. His first movie was *The Moon Is the Sun's Dream* (1992). This was not a success and and it was five years before Park got his next chance to direct. He is best known for his *Vengeance* trilogy.

Key movies

2003 *Oldboy*
2009 *Thirst*
2013 *Stoker*

YOU DON'T KNOW ME, BUT I KNOW YOU

THE LIVES OF OTHERS / 2006

IN CONTEXT

GENRE
Drama

DIRECTOR
**Florian Henckel
von Donnersmarck**

WRITER
**Florian Henckel
von Donnersmarck**

STARS
**Ulrich Mühe, Martina
Gedeck, Sebastian Koch,
Ulrich Tukur**

BEFORE
1989 Ulrich Mühe stars in
Spider's Web, West Germany's
last submission to the
Academy Awards before the
country's dissolution in 1990.

2003 Wolfgang Becker's *Good
Bye Lenin!* is a comedy about
the reunification of Germany.

AFTER
2008 *The Baader Meinhof
Complex* tells the story of
far-left West German militant
group the Red Army Faction.

The *Lives of Others* was
inspired by an image
formed in the mind of
German director Florian Henckel
von Donnersmarck. He pictured a
secret policeman, inert and gray-
faced, headphones clamped to his
ears, listening in on the lives of
others because it was his duty to
"know everything." Was it really
possible, Donnersmarck wondered,
that this policeman could remain
unsentimental about the private
lives under his surveillance?

Set in East Berlin in 1983,
this powerful movie offers a
glimpse into the workings of the
Stasi, the secret police of East

Germany's Communist regime. It
was one of the first serious
attempts to capture the day-to-day
hell of the East German state, in
which people attempted to live
normal lives without the right to
privacy or individual thought.

The listener in the attic

The story centers around a model
Stasi officer, Gerd Wiesler (Ulrich
Mühe), who is given the routine job
of finding incriminating material
on a playwright, Georg Dreyman
(Sebastian Koch), by spying on him
and his lover, the famous actress
Christa-Maria Sieland (Martina
Gedeck). Installed in the roof of the

Modern German cinema

After the acclaim that greeted
the New German Cinema of the
1970s, German movies of recent
years have tended to concern
themselves with the past. There
have, of course, been exceptions,
but the most highly regarded
German movies of this century
have been fascinated by the
country's modern history. *The
Counterfeiters* looked back to
World War II, as did *Downfall*.
The terrorism of the 1970s was

the subject of *The Baader
Meinhof Complex* (2008),
while *The Lives of Others*
and *Good Bye Lenin!* offered
audiences a human take on the
dissolution of East Germany.

Key movies

2003 *Good Bye Lenin!*
2004 *Downfall*
2006 *The Lives of Others*
2007 *The Counterfeiters*

During an evening at the theater, Wiesler's boss, Lieutenant-Colonel Anton Grubitz, points out the target for Wiesler's surveillance.

couple's apartment building with his listening equipment connected to microphones hidden in the home's light switches and walls, Wiesler eavesdrops on the couple's phone calls, conversations, lovemaking, and arguments. Gradually, he begins to appreciate the basic decency and humanity of Georg and Christa-Maria. When he learns that Georg is being targeted not for any political disloyalty, but because

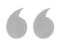

> You never know, from one moment to the next, what course any of the characters will choose.
> **A. O. Scott**
> *The New York Times, 2007*

the Minister of Culture lusts after Christa-Maria and wants to eliminate Georg, Wiesler's idealism deserts him. "Is this what we signed up for?" he asks his amoral superior, Grubitz (Ulrich Tukur).

Georg, however, is indeed having politically disloyal thoughts. As he falls under suspicion for writing a subversive article about the country's suicide rate, and the government's callous indifference toward it, for a West German magazine, the Stasi blackmails Christa-Maria into betraying him. And this is where the movie resonated so strongly for many former East Germans. The regime functioned by making everyone complicit in a brutal system, using fear to compel ordinary people to betray their neighbors, colleagues, and families. It forced moral choices between career and love, safety

The movie was praised for its accuracy, except in one regard. Historians note there is no record of a Stasi agent ever having saved a target.

and personal integrity. The movie underscores this psychological pressure and dread with its desolate depiction of East Berlin, a shadowy, nightmare city of invisible eyes and ears.

Redemption and fall

While *The Lives of Others* had a particular potency for German audiences, its success in winning the Oscar for Best Foreign Movie proved that its power traveled beyond borders. The venality of the Stasi was familiar to many who had felt the chill of repressive regimes, or who simply feared a surveillance state. And in the story of Georg and Christa-Maria the movie featured a classic tortured romance, with the sad-eyed secret policeman as its mute witness. ▪

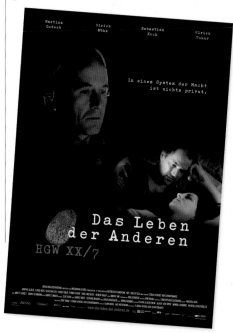

YOU'LL SEE THAT LIFE ISN'T LIKE FAIRY TALES

PAN'S LABYRINTH / 2006

IN CONTEXT

GENRE
Fantasy, war

DIRECTOR
Guillermo del Toro

WRITER
Guillermo del Toro

STARS
Ivana Baquero, Sergi López, Maribel Verdú

BEFORE
1984 *The Company of Wolves* is an early example of the "dark fairy tale" movie genre.

2001 *The Devil's Backbone*, described by del Toro as the "brother movie" to *Pan's Labyrinth*, follows a group of boys in a haunted orpahange.

AFTER
2013 Blockbuster *Pacific Rim* is del Toro's take on Japanese *kaiju* (monster) movies.

F airy tales abound with the sinister and the macabre. Good invariably conquers evil, but the battle is hard fought and evil is not without power. It seems fitting, then, that one of the directors who has best captured the essence of the fairy tale on movie is one who made his name in horror. Mexican director Guillermo del Toro had honed his talent for

In this magical and immensely moving film, the two sides of the film come together to constitute an allegory about the soul and the national identity of Spain.
Philip French
The Observer

unsettling audiences for more than a decade before making *Pan's Labyrinth*. In the manner of the best fairy stories, he succeeds in finding a way both to challenge innocence and to celebrate it.

Fantasy vs reality
Pan's Labyrinth consists of two narratives unfolding at the same time. One tells the story of Vidal, a captain in General Franco's Nationalist army who has been sent to the mountains to round up the remnants of the defeated Republicans in the aftermath of the Spanish Civil War.

The other is the story of his stepdaughter, Ofelia. She is a young girl who is very much lost in the world and who, either through her imagination or by magic (the movie cleverly leaves this question open), escapes to a fantasy realm where she assumes the spirit of a long-dead fairy princess.

A faun sets her three tasks to complete before she can be permitted to take her rightful place in the magical kingdom. »

What else to watch: *La Belle et la Bête* (1946, pp.84–85) ▪ *Spirit of the Beehive* (1973, pp.214–15) ▪ *The Company of Wolves* (1984) ▪ *Cronos* (1993) ▪ *The Devil's Backbone* (2001) ▪ *The Others* (2001) ▪ *Hellboy* (2004) ▪ *The Orphanage* (2007)

This poster with the original Spanish title shows the protagonist, Ofelia, in the main image. Below her is the gnarled, hollow tree that Ofelia must enter for her first task.

Vidal and Ofelia can both be considered true believers, each fully convinced of the validity of the world they have built around themselves. Vidal believes in Franco's cause and admits that he is hunting the stragglers "by choice." He is a man without doubt, just as Ofelia is without doubt when she braves the horror of the child-eating Pale Man to pass the second of the faun's tests. In *Pan's Labyrinth*, evil is just as convinced of its righteousness as good. Vidal is not a hypocrite or a coward, and charges into battle without fear. He even tells a doubting comrade that this "is the only

way to die." Ofelia shows the same conviction when attempting the faun's tasks. The sense that Vidal's bad qualities mirror Ofelia's good ones adds a complexity to events as they unfold.

Whether or not Ofelia's fantasy realm is real is left to the viewer to decide. It is also up to the audience to decide which world they believe in more: Ofelia's or Vidal's.

The film works on so many levels that it seems to change shape even as you watch it.
Stephanie Zacharek
The Village Voice

Both stories feel as textured and vivid as the other—the *Grand Guignol* set design of the Pale Man's lair is matched by the specificity of Vidal's quarters and his eerily controlled shaving routine. This is where the success of *Pan's Labyrinth* lies—not simply as a twisted fairy tale, but one that also explores the sadness of the need to escape into a fantasy world.

Although Ofelia must trust the faun as her guide to the fairy-tale world, he is a mysterious and morally ambiguous character whose ultimate motivations are hard to discern.

Guillermo del Toro Director

Guillermo del Toro was born in Guadalajara, Mexico, in 1964. His debut feature *Cronos* was released in 1992, and proved to be enough of a success for producer Harvey Weinstein to grant him a $30 million budget to make *Mimic*, an American-set studio horror. It was also around this time that his father was kidnapped and del Toro was forced to pay a large ransom for his release. Del Toro went on to achieve Hollywood success with the *Hellboy* horror franchise, as

well as setting two movies in Franco-era Spain, *The Devil's Backbone* and *Pan's Labyrinth*, to great critical acclaim. Most recently, he directed the *kaiju*-influenced action-adventure *Pacific Rim*.

Key movies

1993 *Cronos*
2001 *The Devil's Backbone*
2004 *Hellboy*
2006 *Pan's Labyrinth*

The movie taps into the traditional fear of the wicked stepparent, a staple of fairy tales. Vidal is uncaring toward Ofelia, even callous toward her pregnant mother, Carmen; he is using his wife solely as a means to produce a son. With her mother bedridden, Ofelia's closest relationship with an adult is with the housekeeper Mercedes, who cares for her when her mother dies in childbirth. In this respect, the movie subverts the traditional fairy tale, because while Vidal very much fits the traditional evil stepparent mold, Mercedes's role shows that family is not simply blood, but whatever works when it comes to support and affection.

Breaking the rules

Obeying rules, even if morally wrong, is integral to Vidal's world view. He tortures a partisan for

> **"**The portal **will only open** if we offer the **blood of an innocent**. Just a drop of blood: **a pinprick**, that's all. It's the **final task**.**"**

The faun / *Pan's Labyrinth*

information, and when the doctor puts the dying man out of his misery, Vidal is genuinely puzzled. When asked why he disobeyed, the doctor replies contemptuously, "Captain, to obey—just like that— for obedience's sake, without questioning, that's something only people like you do." At that, Vidal shoots the doctor, even knowing that in doing so, he is putting his wife's life at risk.

Later, in the fairy story, Ofelia is given a frightful order handed down to her by the faun. In one of the

movie's most powerful moments, we ask ourselves whether she can truly prove she is better than Vidal, and if good can still vanquish evil.

One common criticism of fantasy movies is that they lack a grounding in humanity. *Pan's Labyrinth* is a retort to this, a movie deeply rooted in emotion even as it dreams up terrifying monsters. ∎

The child-eating Pale Man, whom Ofelia encounters during her second task, is a nightmarish creation—but the real monsters are all too human.

THIS IS OUR DESTINY

SLUMDOG MILLIONAIRE / 2008

IN CONTEXT

GENRE
Drama

DIRECTOR
Danny Boyle

WRITERS
Simon Beaufoy (screenplay); Vikas Swarup (novel)

STARS
Dev Patel, Freida Pinto, Madhur Mittal, Anil Kapoor, Irrfan Khan

BEFORE
1996 *Trainspotting*, a gritty black comedy based on the novel by Irvine Welsh, shoots Danny Boyle to fame.

2002 *City of God* shows the potential of dramas set in the developing world to have worldwide box-office appeal.

AFTER
2012 Boyle directs the 2012 London Olympics opening ceremony, including a Punjabi song composed by A. R. Rahman.

S et in Mumbai, *Slumdog Millionaire* tells the rags-to-riches story of a kid from the slums who tries his luck on a game show. The movie's influences are wildly cross-cultural. The source novel, Vikas Swarup's *Q&A*, was Indian, but the director Danny Boyle and screenwriter Simon Beaufoy are British. They present a Mumbai where traditional Indian and modern global influences are stirred together, backed by a sound track by A. R. Rahman that mixes Indian classical music with hip-hop and house, Bollywood, and R&B.

The story begins with Jamal Malik (Dev Patel), a penniless orphan from the slums of Mumbai, just one question away from winning 20 million rupees on Indian TV's "Who Wants to Be a Millionaire?" But when the show breaks before the crucial final question, he is arrested on suspicion of cheating—for how could a poor "slumdog" know all the answers? A cynical police inspector (Irrfan Khan) spends the night interrogating Jamal, who explains how his answers have been tied to events in his past.

Jamal (Dev Patel) and Latika (Freida Pinto) overcome adversity and prejudice to find love.

What else to watch: *Los Olvidados* (1950, p.332) ▪ *Pather Panchali* (1955, pp.132–33) ▪ *Central Station* (1998, p.285) ▪ *City of God* (2002, pp.304–09)

Danny Boyle Director

Known for his versatility, ability to work in many genres, and kinetic camera angles, Danny Boyle made his name directing tough, funny movies with pulsating sound tracks. Born in Lancashire, UK, in 1956 to Irish parents, he was brought up Catholic and considered entering the priesthood. Instead, he studied English and Drama at Bangor University in Wales, becoming a theater director and working at the Royal Shakespeare Company and the Royal Court. In 1987, he started working in TV, producing many TV movies. He claims that his love for movies started with *Apocalypse Now* (1979): "It had eviscerated my brain completely." His first feature movie, the black comedy *Shallow Grave*, was a UK hit. Two years later, *Trainspotting*, a stylish movie about drug addicts in Edinburgh, propelled him to international attention.

The movie delves back into earlier moments in Jamal's life, showing how he learned each answer. The audience learns his life story in a series of flashbacks, each corresponding to a question. It begins with the moment when Jamal is five and he and his brother Salim are fleeing the 1992–93 Bombay Riots. They run into young Latika, who will become the love of his life. The story reveals other moments in which Jamal and Salim use their wits to survive everything from chilling encounters with gangsters who maim street children to Jamal's heartache over Latika. But will it be enough to convince the police inspector to set him free, and to find his sweetheart?

Mixed reception

The reception of *Slumdog Millionaire* in the West was overwhelmingly positive. The movie bubbles with feel-good energy and a raucous joie

The nation watches enthralled as Jamal (Dev Patel) progresses through the rounds with correct answers, heading for the 20 million rupee jackpot.

de vivre. Cinematographer Anthony Dod Mantle, using digital cameras to their fullest potential, puts the audience right in the heart of frantic, vibrant Mumbai. An exuberant Bollywood-style dance at a train station only further cranks up the adrenaline.

The movie was showered with acclaim, eventually winning eight Oscars, including Best Picture and Best Director for Boyle. And yet in India and elsewhere, some felt *Slumdog* had only gained recognition because it had a British director, while "real" Indian movies were ignored. Others felt that its view of the Mumbai slums was unrealistic and that the rags-to-riches plot was implausible. ▪

❝We **used to live right there**, man. Now, it's **all business**.❞

Jamal / Slumdog Millionaire

Key movies

1994 *Shallow Grave*
1996 *Trainspotting*
2002 *28 Days Later*
2007 *Sunshine*
2008 *Slumdog Millionaire*

THIS BOX IS FULL OF STUFF THAT ALMOST KILLED ME
THE HURT LOCKER / 2008

IN CONTEXT

GENRE
War movie

DIRECTOR
Kathryn Bigelow

WRITER
Mark Boal

STARS
Jeremy Renner, Anthony Mackie, Brian Geraghty

BEFORE
1986 Oliver Stone's *Platoon* shows a ground-level view of the Vietnam War.

2001 *Black Hawk Down* emphasizes the comradeship of soldiers even as it seems to criticize American policy.

AFTER
2010 Paul Greengrass's Iraq war movie *Green Zone* uses a handheld camera technique and has a political message.

2012 Kathryn Bigelow makes her adrenaline-fueled movie *Zero Dark Thirty* about the hunt for Osama Bin Laden.

S cripted by reporter Mark Boal, Kathryn Bigelow's *The Hurt Locker* follows the story of a three-man US bomb disposal team during the Iraq War. It was shot on location in Syria, near the Iraqi border. Four handheld cameras were used to give a powerfully plausible newsreel effect, out of 200 hours of footage that was edited down to just 131 minutes. The movie was praised for portraying a viscerally intense, real war experience, although detractors criticized its lack of a moral stance. Bigelow offers little or no comment on the purpose of the war; instead she focuses narrowly and

Staff Sergeant William James runs from the scene of a controlled explosion. He will recklessly return to pick up his gloves.

What else to watch: *Platoon* (1986) ■ *The Battle of Algiers* (1966, pp.182–87) ■ *Black Hawk Down* (2001) ■ *Green Zone* (2010) ■ *Zero Dark Thirty* (2012)

Bigelow's movie won Academy Awards for Best Movie and Best Director. It was the lowest-grossing movie ever to win Best Picture.

sympathetically on the dilemmas and mental states of the three main characters. In doing so she in fact creates an anti-war movie more powerful than others.

Addicted to war

The Hurt Locker opens with a quotation by US journalist Chris Hedges from his book *War is a Force That Gives Us Meaning*: "The rush of battle is a potent and often lethal addiction, for war is a drug." *The Hurt Locker* shows how this addiction affects the human psyche. The narrative follows the three men through their year's tour of duty, as they deal with unexploded bombs, snipers, and civilians used as bomb

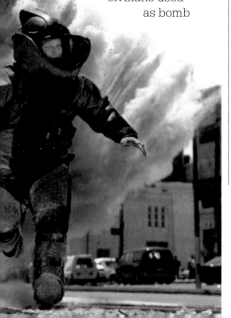

carriers. Their commander is battle-hardened maverick Sergeant William James (Jeremy Renner). His team, Sergeant Sanborn (Anthony Mackie) and Specialist Owen Eldridge (Brian Geraghty), become so concerned by James's recklessness when he acts without waiting for the bomb disposal robot and without wearing his protective suit, that they discuss killing him before he gets all three of them blown up. Yet, interestingly, they also seem to admire his craziness, and understand what is driving it. The adrenaline of his death wish makes him feel alive. After a failed attempt to remove a bomb vest from an Iraqi civilian, Sanborn begins to unravel psychologically, admitting that he cannot cope with the stress. Once home in the US, James, on the other hand, does not cope with real life. He feels that his purpose is to be in the conflict zone, where the perpetual danger made his life meaningful.

The movie drew criticism for focusing on a bomb disposal unit: soldiers without the troubling duty of killing anyone on screen. Most, however, praised Bigelow's feat in putting the viewer inside the "hurt locker"—a psychological prison of pain that comes from constantly being near explosions. ■

Kathryn Bigelow
Director

With *The Hurt Locker*, Kathryn Bigelow became the first woman to win the Oscar for Best Director. Born in California in 1951, she began making movies even before graduating from Columbia University, with a short called *The Set-Up* (1987). Soon she was making action movies with *Blue Steel* (1989), *Point Break* (1991), and science fiction *Strange Days* (1995). Her next movie, *K-19: The Widowmaker* (2002), was a submarine thriller. Oscar success came with *The Hurt Locker*, based on reportage of the Iraq War. Her movie about the hunt for Osama Bin Laden, *Zero Dark Thirty* (2012) was acclaimed but also attacked for what critics saw as an apparent endorsement of torture.

Key movies

1991 *Point Break*
2008 *The Hurt Locker*
2012 *Zero Dark Thirty*

❝As you **get older**, some of the things **you love** might not seem **so special** anymore.❞
Sergeant William James / The Hurt Locker

IF I DIE, WHAT A BEAUTIFUL DEATH!

MAN ON WIRE / 2008

IN CONTEXT

GENRE
Documentary

DIRECTOR
James Marsh

WRITER
Philippe Petit (book)

STARS
**Philippe Petit,
Jean-François Heckel,
Jean-Louis Blondeau**

BEFORE
1999 Marsh's *Wisconsin Death Trip* reconstructs strange events that took place in a small American town at the end of the 19th century.

2005 In Marsh's drama *The King*, a man named Elvis tracks down his reluctant father, a pastor.

AFTER
2014 *The Theory of Everything*, Marsh's biopic of physicist Stephen Hawking, earned a Best Actor Oscar for its star, Eddie Redmayne.

Screen portraits of one person, whether drama or documentary, are usually about two kinds of lives: those that are interesting in themselves, and those noted for achieving something remarkable. James Marsh's *Man on Wire* portrays a life that fits into both categories. It is the story of an audacious high-wire walk between the twin towers of the World Trade Center in 1974, yet it speaks to the larger theme of how far a person will go for art. The movie presents French high-wire walker Philippe Petit as a man whose art is all consuming, to the point that he risks his life for it. Rather than burnish its subject, *Man on Wire* derives its power from its focus on Petit's flaws as well as his talent and determination. The viewer is left marveling at how such a restless personality can attain the Zen-like concentration needed to walk across an abyss on a wire.

Raison d'être

The movie is structured into two parallel narratives: the event and the life. One strand follows the

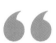

> The documentary, a hybrid of actual and restaged footage, is constructed like a first-rate thriller.
> **Roger Ebert**
> *Chicago Sun-Times, 2008*

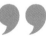

night that Petit and his crew broke into the World Trade Center and the hurdles they had to overcome to enact their stunt; the other tells the broader tale of Petit's life leading up to the event. Everything—from wire-walking across the two towers of Notre Dame Cathedral in Paris or the Sydney Harbour Bridge to moving to New York City—was in preparation for the World Trade Center walk. For Petit, this was more than an ambition—it was the very reason for his life. ■

What else to watch: *Wisconsin Death Trip* (1999) ▪ *Touching The Void* (2003) ▪ *Project Nim* (2011) ▪ *The Imposter* (2012) ▪ *The Theory of Everything* (2014)

I'D LIKE TO ASK YOU SOMETHING, FATHER
THE WHITE RIBBON / 2009

IN CONTEXT

GENRE
Historical drama

DIRECTOR
Michael Haneke

WRITER
Michael Haneke

STARS
**Burghart Klaußner,
Christian Friedel,
Leonie Benesch**

BEFORE
1997 In Haneke's *Funny Games*, two psychopaths play cruel "games" on the family they have taken hostage.

2001 Haneke's *The Piano Teacher* tracks the destructive power of sexual fantasies.

2005 In *Caché* (*Hidden*), Haneke exposes a family to its past, but who is behind the ensuing violence?

AFTER
2012 Old age deals a cruel hand in Haneke's *Amour* (*Love*).

H aving spent most of his working life in TV, Michael Haneke was 47 when he made his first movie, *The Seventh Continent*, in 1989. Since then, his reputation as one of Europe's most important directors has only grown, with movies that are as stark as they are sophisticated, exploring humanity to disturbing effect.

The specter of death
Shot with an exquisitely detailed sense of realism, *The White Ribbon* tells the story of life in a small German village just before World War I. There, a series of cruel and mysterious events sow fear and confusion among the villagers, from the tenant farmers to the baron.

Murders go unsolved, and mayhem reigns. Meanwhile, the local pastor forces his children to wear a white ribbon for any misdeed they have committed. The ribbon is meant to symbolize the innocence from which they have strayed, but it actually seems to represent their violation by those institutions that should keep children safe—home, family, and church. The ribbon means nothing to anyone because there is no purity to be found.

There is a shard of optimism in the form of a young couple falling in love, but the terrible realization is that a generation of children whose development is being warped by authority in the movie would come of age as the supporters of Nazism. ∎

The congregation that worships in the village church is rife with secrets and resentments; is the violence in their midst a sign of the barbarism that will follow during the two world wars?

What else to watch: *Le Corbeau* (1943) ▪ *Rashomon* (1950, pp.108–13) ▪ *The Seventh Seal* (1957, pp.136–39) ▪ *The Tin Drum* (1979) ▪ *Caché* (2005, p.342)

EVERYONE PAYS FOR THE THINGS THEY DO
ONCE UPON A TIME IN ANATOLIA / 2011

IN CONTEXT

GENRE
Crime, drama

DIRECTOR
Nuri Bilge Ceylan

WRITERS
Ebru Ceylan, Nuri Bilge Ceylan, Ercan Kesal

STARS
Muhammet Uzuner, Yilmaz Erdogan, Taner Birsel, Firat Tanis

BEFORE
1997 Nuri Bilge Ceylan's critically acclaimed debut feature *The Town* is a dreamlike examination of childhood and family.

2008 In Ceylan's *Three Monkeys*, a politician offers a family money to cover up a hit-and-run accident.

AFTER
2014 *Winter Sleep* earns Ceylan the Palme d'Or at the Cannes Film Festival.

Police work and all that comes with upholding the law has long been a source of fascination in movies. The police represent order, and for the common good they must endure terrible things on our behalf. Turkish director Nuri Bilge Ceylan's brooding, tragic movie *Once Upon a Time in Anatolia* is a tale of cops, doctors, and lawyers as they search through the night for the body of a murder victim. Stripping out the artificial glamour and excitement that define these professions in most movies, the movie presents their work as a punishing journey in an endless night that is filled with frustration, tension, and very little glory. Here, the officials who uphold law and order are heroes not because they always catch the bad guy, but because they give up a part of their humanity so that we don't have to.

Eschewing cop-show clichés, Nuri Bilge Ceylan's *Once Upon a Time in Anatolia* portrays the drudgery of police work with raw, unflinching honesty.

The policemen and lawyers in *Once Upon a Time in Anatolia* are forced to deal with the horrors they witness while also fulfilling the demands of their respective bureaucracies. Unable to express their true reactions to what they see, they are allowed very little catharsis. Police officer Naci (Yilmaz Erdogan) is repeatedly rebuked for his impulsive reactions to setbacks. When a body is found,

❝Nobody just dies because they said they would.❞

Cemal / Once Upon a Time in Anatolia

What else to watch: *The Big Heat* (1953, p.332) ▪ *Le Doulos* (1962) ▪ *In Cold Blood* (1967) ▪ *A Short Film about Killing* (1988) ▪ *Insomnia* (1997) ▪ *Zodiac* (2007) ▪ *Three Monkeys* (2008) ▪ *Leviathan* (2014)

hog-tied and buried in the ground, Naci is the only one in his team to react to the sight truthfully, and for that he is taken aside and sternly told to behave more professionally.

Due process

A similar incident occurs later in the movie when Doctor Cemal (Muhammet Uzuner) conducts an autopsy and discovers something horrific about the death. Like the police officers, the doctor is not allowed to be affected. All he can do is suppress his feelings, write up his report, and stare through the window at the victim's family as they walk away—just as he will have to do next time, and the time after that.

The practicalities of due process mean that good men are asked to treat horror in the same way that the monsters they are hunting treat it; they surrender their right to feel, because papers need to be filed and the process needs to be respected.

Nuri Bilge Ceylan Director

Nuri Bilge Ceylan was born in 1959 in Istanbul, Turkey, and studied electrical engineering. His first movie, *The Town*, gained him instant international acclaim. His third movie, *Distant*, won a host of awards, and he continued to enjoy critical success with *Three Monkeys* (2008) and *Once Upon a Time in Anatolia*. He won the Palme d'Or at Cannes in 2014 for *Winter Sleep*.

Key movies

1997 *The Town*
2002 *Distant*
2011 *Once Upon a Time in Anatolia*
2014 *Winter Sleep*

Once Upon a Time in Anatolia is a thoughtful, original take on some very well-covered ground. It is not interested in presenting the police as unflappable action heroes, or lawyers as righteous crusaders, or doctors as kind and benevolent. Rather, it focuses on the human cost of being required to witness and interact with the worst of humanity. The metaphor of one endless night symbolizes the trajectory of the characters' own lives: each of them is destined to be worn down by their job until they reach the point of degradation, just like the body they must find to eventually put in the ground. There is no rest, and no end in sight. ▪

Kenan (Firat Tanis, center) is one of two suspects who must travel with the police in order to help them find the murder victim's body.

SO, WHAT DO YOU LIKE ABOUT BEING UP HERE?
GRAVITY / 2013

IN CONTEXT

GENRE
Thriller, science fiction

DIRECTOR
Alfonso Cuarón

WRITERS
Alfonso Cuarón, Jonás Cuarón

STARS
Sandra Bullock, George Clooney

BEFORE
1995 Ron Howard's *Apollo 13*, about the disaster-stricken space mission of 1970, evokes a mix of claustrophobia and desolation.

2006 *Children of Men*, Cuarón's first science-fiction movie, is set in a future in which all people are infertile.

AFTER
2014 Christopher Nolan's *Interstellar* follows mankind's urgent quest to leave dying planet Earth and find a new home among the stars.

On one level, *Gravity* is a simple affair—the tale of astronaut Dr. Ryan Stone (Sandra Bullock) stranded in orbit after her shuttle is destroyed, surviving on her wits in the hostile environment of space. However, while its story of a lone adventurer trying to get home could have been told in any movie since the medium began, director Alfonso Cuarón uses the very latest in filmmaking technology, including stunning 3D effects, to create an experience that physically pulls in the audience. The result feels like a landmark in cinema history.

Gravity features action sequences shot in long, unbroken takes. When Stone, trying to reach the safety of the International Space Station, is pelted by orbiting debris, the camera follows her every move, swooping and spinning as she tumbles through space. These nonstop sequences allow the audience to see with pin-sharp clarity the endless expanse around her—and to feel exactly what she's going through. ∎

Before the disaster that destroys their shuttle, Stone (Sandra Bullock) and her colleague Kowalski (George Clooney) collaborate on repairs to the telescope.

What else to watch: *A Trip to the Moon* (1902, pp.20–21) ▪ *2001: A Space Odyssey* (1968, pp.192–93) ▪ *Alien* (1979, p.243) ▪ *The Right Stuff* (1983)

WE'RE ALL JUST WINGING IT

BOYHOOD / 2014

In his own low-key, low-budget way, Richard Linklater has always been interested in revolutionizing movies. Filmed in his native Austin, Texas, like his debut *Slacker*, *Boyhood* is at once an incredibly simple idea and a hugely radical one. Probably one of the most authentic coming-of-age stories ever told, it follows its protagonist, Mason (Ellar Coltrane), from the age of six right up to his graduation from school at 18. And if the movie feels real, that's because it practically is, with Linklater shooting with Coltrane and the other cast for a few days every summer for 12 years, the actors aging in time with the story.

Capturing childhood

Boyhood deals subtly with the changing times: as family life shifts and changes, iPods replace CD players and Barack Obama replaces George W. Bush as president. After Mason's flaky father (Ethan Hawke) leaves, his mother (Patricia Arquette) embarks on new relationships. Everything and nothing happens in the exquisitely paced 165 minutes,

Mason Sr. (Ethan Hawke) offers some rare fatherly advice in a tender scene with his son (Ellar Coltrane); for both, perhaps, childhood has ended.

which capture the bittersweet, haphazard, scrapbook nature of childhood and adolescent memories.

While the focus is on Mason, the other performances are captivating too—notably from Hawke as the man who married too young, Lorelei Linklater (the director's daughter) as Mason's sister, and Arquette, who would go on to win an Oscar for her role in the movie. ∎

What else to watch: *The 400 Blows* (1959, pp.150–51) ▪ *Slacker* (1991) ▪ *Before Sunrise* (1995) ▪ *Before Sunset* (2004) ▪ *Before Midnight* (2013) ▪ *Girlhood* (2014)

DIRECTO

RY

DIRECTORY

Any list of the greatest movies of all time, whether it is 10, 100, or 1,000 titles long, will inevitably be subjective in both its selections and omissions. Indeed, much of the fun of the debate comes from the disagreements it provokes. This section features a selection of the movies that came close to being included in the main section, but did not quite make the final cut. It is, like the main list, subjective in nature, but helps fill some of the inevitable gaps. Spread widely across time, place, and genre, the list provides additional samples from world cinema over the last century or so, a selection of movies to celebrate and to argue over, to watch and to rewatch. Each movie title is followed by the director's name and the year the movie was released.

THE GREAT TRAIN ROBBERY
Edwin S. Porter, 1903

This 12-minute short was possibly the first Western, with cowboys, six-shooters, and a rowdy saloon. The robbers use a fake telegraph to stop the train, rob the safe, and hold up the passengers, then take off on horseback—only to be caught by a posse, also summoned by telegraph. At one point, a robber fires into the camera— a scene that had contemporary audiences ducking for cover.

NOSFERATU
F. W. Murnau, 1922

Murnau was a leading light of the German Expressionist movement, which emphasized style and symbolism, and this comes to the fore in his vampire movie *Nosferatu*. It is packed with memorable images, from the dark shadow of the vampire Count Orlok creeping through his castle to Orlok's look of terror as he faces the rising sun before vanishing. And in

Max Schreck, who played Orlok, the movie has a vampire like no other, one that is more rat than bat in appearance.
See also: *Sunrise* 30–31

DR. MABUSE THE GAMBLER
Fritz Lang, 1922

Nine years before making his serial-killer masterpiece, *M*, Fritz Lang explored his fascination with the criminal mind in this silent great of German Expressionist cinema. In doing so, he created the first movie archvillain: the manipulative mastermind Dr. Mabuse, who steals secret information to make a fortune on the stock exchange, and cheats at cards to rob the wealthy denizens of a decadent, degenerate society. Lang tapped into the mood of the Weimar-period Germany, which was in political and economic turmoil. His trick of revealing both the villain and his methods to the audience as a device to build suspense influenced Alfred Hitchcock.
See also: *Metropolis* 32–33 ▪ *M* 46–47

THE JAZZ SINGER
Alan Crosland, 1927

The first full-length "talkie" feature movie, *The Jazz Singer* marked the beginning of a new era in cinema. There are about two minutes of synchronized dialogue, plus six memorable songs, mixed with intertitles. Al Jolson plays Jakie, who defies his religious Jewish father in order to pursue a dream of becoming a jazz singer. Jakie changes his name to Jack and adopts a "blackface" persona on stage. The story of an immigrant's struggle for identity is still a powerful one, but the blacking up makes the movie an uncomfortable watch for modern audiences.

UN CHIEN ANDALOU
Luis Buñuel, Salvador Dalí, 1929

The 16-minute short *Un Chien Andalou* (*An Andalusian Dog*) was the first movie by Spanish director Luis Buñuel, who made it in collaboration with Spanish Surrealist painter Salvador Dalí. It

is most famous for a heart-stopping moment in which a girl appears to have her eyeball sliced open. The movie is a montage of strange scenes with no apparent connection, but Buñuel was later eager to stress that there is no symbolism in this movie. He said that the eyeball scene came from a dream, and that its meaning can only be established through psychoanalysis.

See also: *The Discreet Charm of the Bourgeoisie* 208–09

FREAKS
Tod Browning, 1932

Tod Browning's disturbing US horror movie *Freaks* was banned in the UK for 30 years because of the way it seemed to exploit the physical attributes of its cast, who worked in a circus sideshow. It has since become a cult classic. At a circus, Cleopatra, a beautiful trapeze artist, agrees to marry the dwarf Hans in order to poison him and take his money. But her plan is foiled and the circus's other "freaks" take their revenge on her in a truly gruesome way. The original movie was destroyed, and only the marginally less unsettling cut version still exists. The movie ruined Browning's career.

THE GRAPES OF WRATH
John Ford, 1940

Based on John Steinbeck's 1939 novel, *The Grapes of Wrath* is set in Oklahoma, in the Depression years of the 1930s. It tells the story of the Joad family, who lose their farm and journey across the US to California in search of a better life. The movie pares the narrative of

the book down to focus on the family and their endurance against the odds. As Ma Joad says at the end: "They can't wipe us out, they can't lick us. We'll go on forever, Pa, 'cause we're the people." The movie marked the first major success for Henry Fonda, who played Tom Joad.
See also: *The Searchers* 135

THE MALTESE FALCON
John Huston, 1941

Humphrey Bogart played hard-bitten private detective Sam Spade as if born to the role in John Huston's *The Maltese Falcon*, a stylish and atmospheric thriller. Spade was an entirely new kind of hero, a tough guy who never yields for a moment to sentimentality, and Huston's low-key, shadowy lighting, and often startling camera angles, brilliantly created the movie's shady world. *The Maltese Falcon* is considered the first American film noir. It turned Bogart into a superstar and launched Huston's career as a major Hollywood director.

SULLIVAN'S TRAVELS
Preston Sturges, 1941

Sullivan's Travels is a witty send-up of pretentious filmmakers who make socially worthy drama. Young director John "Sully" Sullivan (Joel McCrea) is renowned for his frothy comedies, but goes on the road disguised as a tramp in order to gather material for a serious movie about the downtrodden. He meets the Girl (Veronica Lake), who hopes to be an actress, and soon realizes that making comedies that take people's minds off their worries is of more social use than a serious movie with a profound message.

MESHES OF THE AFTERNOON
Maya Deren and Alexander Hammid, 1943

Ukrainian-born choreographer Maya Deren was one of the most important experimental filmmakers of the post-World War II years, and *Meshes of the Afternoon*, made with her husband Alexander Hammid, is a landmark of the avant-garde. It lasts just 18 minutes, and, through unsettling camera angles, spirals through the dreams of a woman falling asleep at home, where ordinary objects—a knife, a key—become frightening and surreal in her subconscious. The revelation that movie could explore the workings of the mind in this way was hugely influential.

DOUBLE INDEMNITY
Billy Wilder, 1944

Billy Wilder's *Double Indemnity* uses the classic film noir setup, with a femme fatale, shabby motives, betrayal, and murder; however, the movie has romance at its heart. An ordinary insurance man is persuaded by a beautiful blonde (Barbara Stanwyck) to issue an insurance policy in her husband's name, and then to murder him in a staged accident, but the plan unravels horribly as each believes the other has betrayed them. The movie gains an edge by casting against type: Fred MacMurray, so often Mr. Nice Guy in Disney movies, plays the seedy insurance man; while Edward G. Robinson, so often the gangster, plays the decent investigator.
See also: *Sunset Boulevard* 114–15 ▪ *Some Like It Hot* 148–49

BRIEF ENCOUNTER
David Lean, 1945

British director David Lean's early masterpiece is a simple story, based on a Noel Coward play, and very different from the epics, such as *Lawrence of Arabia*, for which he later became better known. Housewife Laura (Celia Johnson) and Doctor Alec (Trevor Howard) meet at a train station café. Tempted into an adulterous affair, they pull back because both are, at heart, deeply decent people. The shadowy light of the station, and the music of Rachmaninoff's *Piano Concerto No. 2*, give emotional weight to Johnson's and Howard's understated performances.

MURDERERS AMONG US
Wolfgang Staudte, 1946

Murderers Among Us was one of the first German movies made after World War II, completed in the Soviet-occupied sector, and reflecting Germany's struggle to come to terms with its past. Shot in the ruins of Berlin, it tells the story of a military surgeon who returns home to find his home destroyed. He moves in with a young woman who survived the concentration camps. The surgeon plans to kill his captain, who murdered Polish civilians in the war, but the woman persuades him to let the man go to trial.

BUILD MY GALLOWS HIGH
Jacques Tourneur, 1947

Known in the US as *Out of the Past*, the movie *Build my Gallows High* captures the grand tragedy at the heart of film noir. A private eye (Robert Mitchum) tries to escape his seedy past and start a new life with a decent girl, but he is haunted by a beautiful femme fatale (Jane Greer), with whom he may or may not be in love, and who may or may not be in love with him. They are tied together by fate, and, as she goes on the run for murder, their mutual destruction becomes all too inevitable.

THE RED SHOES
Michael Powell and Emeric Pressburger, 1948

Powell and Pressburger's *The Red Shoes* is both a glorious and seductive tribute to the ballet and a horror movie full of menace, as ballerina Victoria (Moira Shearer), is driven to despair by the ruthless and obsessive demands of an impresario, Lermontov (Anton Walbrook). The movie contains a story within a story: the 20-minute ballet sequence telling Hans Christian Andersen's tale of "The Red Shoes," in which a ballerina is danced to death by a pair of magic shoes, echoes the movie's main story.
See also: *A Matter of Life and Death* 86–87

ALL ABOUT EVE
Joseph L. Mankiewicz, 1950

Dark and bitingly witty, Joseph L. Mankiewicz's *All About Eve* is one of the bleakest movies ever made about show business. At its heart is a riveting performance by Bette Davis as the aging star Margo Channing, who is targeted by ambitious actress Eve Harrington (Anne Baxter). With a sob story that has "everything but the bloodhounds snapping at her rear end," Eve worms her way into Margo's life and takes over her celebrity—but at a price, since she ends up in the power of manipulative theater critic Addison DeWitt. The movie also features a brief appearance by a young Marilyn Monroe.

LOS OLVIDADOS
Luis Buñuel, 1950

Also known as *The Young and the Damned*, *Los Olvidados* is Buñuel's retort to neorealist movies. Set in the slums of Mexico City, it is the story of two boys: El Jaibo, who escapes from prison; and Pedro, who is led astray by El Jaibo as he tracks down and kills the boy he thinks put him in jail. To this gritty scenario Buñuel adds his own brand of realism, including dreams, which for him were as much a part of life as pots and pans. He eschews a liberal social conscience for a confrontational approach that got the movie banned in Mexico for many years.
See also: *The Discreet Charm of the Bourgeoisie* 208–09

THE BIG HEAT
Fritz Lang, 1953

"Somebody's going to pay… because he forgot to kill me…" reads the tagline on the poster for Fritz Lang's taut film noir, scripted by crime reporter Sidney Boehm. Glenn Ford stars as an honest homicide detective who becomes caught up in a world of organized crime and police corruption. Gloria Grahame is the memorable femme fatale, a gangster's moll who turns against her boyfriend, brutally

played by a young Lee Marvin. Much of the violence occurs offscreen, but that reduces none of the movie's power—honesty may win out in the end, but only after exacting a terrible cost. The movie is the ultimate refinement of Lang's realistic, brutal style.
See also: *Metropolis* 32–33 ▪ *M* 46–47

LA STRADA
Federico Fellini, 1954

Fellini's *La Strada* (*The Road*) can be seen as his reaction against the neorealist movement of which he had been part. It is a determinedly unrealistic fable of three circus performers, for whom a theatrical façade hides their inner sadness. The strongman Zampanò buys the waif Gelsomina from her mother to be his comic foil, but he continually abuses her, until she eventually leaves him for high-wire artist Il Matto. In a fit of jealousy Zampanò kills Il Matto, and Gelsomina is desolate. The movie features Fellini's trademark visual themes, such as figures suspended between heaven and earth, and a desolate seashore.
See also: *La Dolce Vita* 160–65

SEVEN SAMURAI
Akira Kurosawa, 1954

Kurosawa's *Seven Samurai* was inspired by Hollywood Westerns, and it, in turn, inspired the Western *The Magnificent Seven*, but it is very much a Japanese movie, steeped in the traditions of the Samurai warrior class and notions of honor. The story is a simple one—seven warriors band together to protect a village against bandits—but Kurosawa's stunning

visual style and fast-paced editing, plus his ability to give scenes a huge emotional kick, turn it into an epic of true heroism. The movie is also a study in Japanese social mores, as two mutually distrustful social classes uneasily come together in pursuit of a common cause.
See also: *Rashomon* 108–13

RIFIFI
Jules Dassin, 1955

In French heist movie *Rififi*, the robbery of a jewelry store on Paris's Rue de Rivoli takes place in 20 minutes of almost total silence. The effect was so believable that some critics have called the movie a guide for criminals. Dassin hated the novel on which the movie was based (he changed the villains' ethnicity to make the story less racist), but this only made him work harder to give the movie both tension and heart, paying meticulous attention to detail in a way that was to be imitated later by movies such as Quentin Tarantino's *Reservoir Dogs*.

INVASION OF THE BODY SNATCHERS
Don Siegel, 1956

Invasion of the Body Snatchers is a science-fiction thriller that reflects the paranoia of the Cold War era. The idea is simple: a doctor is mystified when all his patients complain to him that their families have been replaced by impostors. He soon discovers that the town has been colonized by alien seedpods that can replicate humans in all but their emotions. The movie has been seen as a

political allegory, but it is unclear whether its message is attacking communism, or the oppression and paranoia created by McCarthyism.

TOUCH OF EVIL
Orson Welles, 1958

Crime thriller *Touch of Evil* was one of the last of the classic film noirs. It is extravagantly theatrical, with the gigantic presence— literally and figuratively—of Orson Welles, who wrote and directed the movie, and who also plays the bent and bloated cop Quinlan. Set on the Mexico–US border, the story focuses on a Mexican drug enforcement official (Charlton Heston), who realizes that Quinlan is corrupt. The movie is famous for its uninterrupted, three-minute-long crane tracking sequence, which moves slowly through four blocks of the troubled town.
See also: *Citizen Kane* 66–71

ASCENSEUR POUR L'ÉCHAFAUD
Louis Malle, 1958

Known as *Elevator to the Gallows* in the US and *Lift to the Scaffold* elsewhere, Louis Malle's *Ascenseur pour l'échafaud* is a dark thriller about a pair of lovers, Florence (Jeanne Moreau) and Julien (Maurice Ronet), who plot to murder Florence's husband. The plan goes horribly wrong when Julien is trapped in an elevator on his way from the crime scene. The claustrophobic shots of Paris at night give the movie a noirish feel, but there is a sense of realism that anticipates the French New Wave. The action is accompanied by an atmospheric jazz score from Miles Davis.

PEEPING TOM
Michael Powell, 1960

Peeping Tom received a negative response on its release, but it is now considered a masterpiece. A photographer (Karlheinz Böhm) introduces himself to women as a documentary filmmaker, then murders them while using a movie camera to record the terror of their dying moments. The movie opens itself up to various psychoanalytic interpretations as it homes in on the phallic role of the camera. It also throws a chilling spotlight on the way movies turn audiences into voyeurs.
See also: *A Matter of Life and Death* 86–87

PSYCHO
Alfred Hitchcock, 1960

Psycho had an extraordinary effect on contemporary audiences. The shower scene, in which a woman (Janet Leigh) is stabbed repeatedly, is now one of the most famous in cinema. The movie set new standards for horror movies with its psychological complexity and the way Hitchcock ratcheted up the tension to fever pitch—helped by Bernard Herrmann's extraordinary jagged string score—as disturbed motel owner Norman Bates (Anthony Perkins) dresses up as his mother and turns murderous.
See also: *Vertigo* 140–45

WEST SIDE STORY
Robert Wise and Jerome Robbins, 1961

West Side Story takes William Shakespeare's *Romeo and Juliet* and turns it into a dynamic musical played out between New York gangs, with the Sharks on one side and the Jets on the other. The movie is made exhilarating by Leonard Bernstein's sophisticated score, hugely memorable songs such as *Tonight* and *Somewhere*, with lyrics by Stephen Sondheim, and the spectacular dance sequences directed by Jerome Robbins. It won 10 Oscars, more than any other musical, including one for Rita Moreno, who made the song *America* her own, as Best Supporting Actress.

THE INNOCENTS
Jack Clayton, 1961

The Innocents is a chilling British supernatural thriller inspired by Henry James's 1898 novella *The Turn of the Screw*. Miss Giddens (Deborah Kerr) is employed as a governess to take care of a girl and a boy, and finds that they are haunted by the ghosts of their former governess and the alcoholic valet who seduced her. Director Jack Clayton brilliantly uses dissolves created by editor Jim Clark to suggest ghostly presences, and to bring tension and terror into everyday scenes such as lessons and bath time. The innocence of the children gradually transforms into something "secret, whispery, and indecent."

JULES ET JIM
François Truffaut, 1962

Truffaut's *Jules et Jim* was a classic of the French New Wave, shot in black and white, and packed with stylistic innovations such as freeze frames, wipes (frame transitions), and voice-over. The story is based on Henri-Pierre Roché's 1953 semiautobiographical novel, and focuses on the relationship between two friends—shy Austrian writer Jules and French bohemian Jim—and a free-spirited girl, Catherine (Jeanne Moreau), whom they both fall for. It celebrates friendship but ends in pain and betrayal.
See also: *The 400 Blows* 150–55

THE MANCHURIAN CANDIDATE
John Frankenheimer, 1962

Shot during the Cuban Missile Crisis, when paranoia about encroaching Soviet power was at its height, John Frankenheimer's Cold War conspiracy thriller captures the spirit of the times perfectly. It concerns an apparently heroic American officer, Shaw (Laurence Harvey), who was captured by the Soviets and brainwashed to commit murder when triggered to do so. Major Marco (Frank Sinatra) is the friend who discovers that the KGB "operators" controlling Shaw are actually his mother (Angela Lansbury) and stepfather. Dark, surprising, and inventively shot in a style that owes a debt to the French New Wave, it is a gripping, disturbing satire.

DRY SUMMER
Metin Erksan, 1963

Metin Erksan's powerful story of passion and greed upset critics in his home country when it was made, because of what they considered its negative portrayal of Turkish people, but it is now widely regarded as a masterpiece. The movie tells the story of a selfish tobacco farmer who builds a farm

to stop water from being lost to his neighbors' crops, and who is in love with the village girl whom his brother marries. Shot in shimmering black and white, the movie elevates melodrama into poetry.

JASON AND THE ARGONAUTS
Don Chaffey, 1963

Underpinned by Bernard Herrmann's stirring brass music, Don Chaffey's movie makes the most of Ray Harryhausen's stop-motion animation of clay models to bring to life the story of Jason, the hero of Greek mythology who led his crew, the Argonauts, on a quest for the legendary Golden Fleece. Harryhausen's animations have a distinctive style, and his army of skeletons rising from the ground is impressive even today. Seen on the big screen in full color and sound, *Jason and the Argonauts* remains a genuinely stirring epic.

ONIBABA
Kaneto Shindo, 1964

Kaneto Shindo's *Onibaba* works both as a horror movie and a period drama. It tells the story of a mother and daughter who set traps and murder samurai in order to survive during a time of civil war in 14th-century Japan. Shot in a decidedly chilling black and white, it is a parable of the suffering undergone by all the innocent bystanders throughout history. When the old woman kills one samurai, she pulls off his mask to find his face disfigured like a *hibakusha* (a victim of the nuclear bomb). When she wears the mask, her face becomes disfigured too.

I AM CUBA
Mikhail Kalatozov, 1964

Hidden away in Soviet archives for three decades, Kalatozov's *I Am Cuba* was restored following a campaign led by US director Martin Scorsese in the 1990s. A joint Soviet–Cuban production, it was not well received on release, and had been mostly forgotten. Yet the movie is an extraordinary document of its time, telling the story of oppressed peasants in 1950s Cuba, and their resistance, spurred on by the hope that Fidel Castro's revolution would bring a brighter future. The movie is now also celebrated for its extraordinary tracking shots in which the camera seems to float magically about— an effect achieved by strapping the camera to the cameraman's waist and moving him along a carefully linked set of pulleys.

CLOSELY OBSERVED TRAINS
Jirí Menzel, 1966

Set in Nazi-occupied Czechoslovakia, Jirí Menzel's *Closely Observed Trains* (known in the US as *Closely Watched Trains*) is a wry and touching look at the perils of sexual awakening. The grim realities of war are never far away as young station guard Miloš strives to lose his virginity, but Menzel's witty screenplay, inspired by Bohumil Hrabal's book, keeps the focus firmly on a universal human problem. Like other movies of the Czech New Wave, the movie serves as a reminder to Czechs of the brutalizing effects of the system under which they live, but the tone is sardonic and gentle rather than strident.

PERSONA
Ingmar Bergman, 1966

Persona, by Swedish director Ingmar Bergman, is an intense psychological drama that turns into a horror movie as the central relationship unravels. A young nurse (Bibi Andersson) is assigned to take care of a well-known actress (Liv Ullmann), who has mysteriously become mute. To fill the silence, the nurse confides in her about her life, including having an abortion as a young girl. But things turn nasty when the nurse discovers the actress has been psychoanalyzing her. The actress's silent rejection of the gender-restrictive roles of motherhood and nursing is, some critics believe, the focus of the movie, but it also explores the bleakness of illness and madness.
See also: *The Seventh Seal* 136–39

THE GRADUATE
Mike Nichols, 1967

At the time it was released, *The Graduate* seemed daring in its subject matter, dealing as it does with intergenerational sex. Young college graduate Benjamin Braddock (Dustin Hoffman) embarks upon a sexual relationship with Mrs. Robinson (Anne Bancroft) and then falls in love with her daughter Elaine Robinson (Katherine Ross), when he. The apparently conventional happy ending, in which Benjamin stops Elaine from marrying the wrong man and escapes with her on a bus, is not quite what it seems. The movie deliberately aimed to tap into youth culture with its iconic sound track (by Simon and Garfunkel), setting a trend for youth movies.

BELLE DE JOUR
Luis Buñuel, 1967

Spanish director Luis Buñuel's French movie *Belle de Jour* appears on the surface to be a conventional male sexual fantasy in movie form. A bored housewife, played by the ravishingly beautiful Catherine Deneuve, spends her afternoons as a prostitute in a local brothel, indulging all kinds of strange requests—a lady of the day (*de jour*), rather than of the night. In Buñuel's hands, the story becomes a poetic, psychological study in which the sex is never graphic and appears almost incidental. It blends reality and dreams in a hallucinatory and beguiling way that leads toward an ending in which, unexpectedly, the woman and her husband are happy at last. **See also:** *The Discreet Charm of the Bourgeoisie* 208–09

ROSEMARY'S BABY
Roman Polanski, 1968

Roman Polanski's horror movie about satanic possession was filmed with an understated realism, which has the effect of making it more frightening. Rosemary (Mia Farrow) and her husband Guy (John Cassavetes) are portrayed as a convincingly real couple with a typical set of marital issues, before their situation takes a sinister turn. Eschewing the normal conventions of suspense, Polanski gives plenty of hints about what is really happening next door. Ruth Gordon excels as the couple's strange neighbor, and won one of the few Oscars ever to go to a horror movie. **See also:** *Chinatown* 216–21

SALESMAN
Albert and David Maysles, 1968

This fly-on-the-wall documentary follows four traveling salesmen as they peddle illustrated Bibles around suburban New Jersey. The movie is an example of the "direct cinema" movement of documentary making, in which lightweight cameras were used to capture everyday life with a minimum of interference from the filmmakers. The four men appear remarkably unaffected by the presence of the cameras, but the precariousness and quiet desperation of their existence is plain to see. At a motivational meeting, the area manager chillingly points out that he has "eliminated a few men." The money is out there, he says, and if you can't get it, that's your fault. The movie was made in the late 1960s, but depicts an America that has changed little since the 1950s. A year later, the Maysles brothers would document a very different world with their movie *Gimme Shelter*, in which they followed the Rolling Stones on tour.

ONCE UPON A TIME IN THE WEST
Sergio Leone, 1968

This tense, slow-burning Western was a critical and box-office flop on its release but is now recognized as Leone's greatest movie. It is a simple tale of greed and revenge in a small town where the railroad is due to arrive. With Henry Fonda cast against type as a killer and Charles Bronson as the mysterious loner out to get him, the movie revels in the atmosphere and ritual of the build up to a shoot-out, rather than the shoot-out itself. The music by Ennio Morricone gives an epic quality to long, drawn-out scenes in which almost nothing happens.

KES
Ken Loach, 1969

Based on Barry Hines's 1968 novel *A Kestrel for a Knave*, *Kes* was the first fiction movie made by British director Ken Loach following a string of raw and powerful docudramas. It tells the story of emotionally neglected and bullied teenager Billy Casper (David Bradley), who finds inspiration in training a kestrel he takes from a nest on a farm. Through the bird, Billy learns to open his eyes to broader horizons. The lyrical realism of the movie and the beautiful shots of the bird in flight help make this a moving, uplifting movie despite its almost inevitable sad ending.

MIDNIGHT COWBOY
John Schlesinger, 1969

Reverberating to Harry Nilsson's jaunty song *Everybody's Talkin'*, *Midnight Cowboy* is a poignant movie that homes in on the loneliness of the seedy side of life in the city, yet delivers an ultimately upbeat message about the power of relationships. It follows young Texan Joe Buck (Jon Voight) as he arrives in New York determined to make a fortune as a gigolo. Joe's naivety ensures that his seedy encounters come to nothing, and he ends up bonding with consumptive con man Ratso (Dustin Hoffman). When it transpires that Ratso is dying, Joe gives up his ambitions and takes him on a trip to Florida.

A CLOCKWORK ORANGE
Stanley Kubrick, 1971

Adapted from Anthony Burgess's dystopian novella, *A Clockwork Orange* is an anarchic and inventive satire that aroused so much controversy over its violent content that Kubrick himself withdrew it from release in the UK for 30 years. In futuristic London, sociopathic delinquent Alex (Malcolm McDowell) and his gang of "droogs" go on a spree of "ultraviolence" that ends in rape and murder. Alex is later arrested, and the institutional violence to which he is in turn subjected robs him of his humanity.
See also: *Dr. Strangelove* 176–79 ▪ *2001: A Space Odyssey* 192–93

HAROLD AND MAUDE
Hal Ashby, 1971

Hal Ashby's dark comedy *Harold and Maude* breaks many taboos in its story of an unlikely relationship between a young man and a 79-year-old woman. They meet through their mutual interest in funerals, but their characters could not be more different. Harold (Bud Cort) is morbid and suicide obsessed, doing his best to thwart his mother's efforts to make him conform to the expectations of his privileged upbringing. Maude (Ruth Gordon) relishes every moment of life, with a complete disregard for rules and disdain for money. The movie's ending reveals a secret that explains Maude's attitude. In the background looms the threat of Vietnam for Harold, as his uncle tries to persuade him to enlist. It is a warm, irreverent movie with moments of comic genius.

LAND OF SILENCE AND DARKNESS
Werner Herzog, 1971

Werner Herzog's documentary follows a deaf-blind German woman who works on behalf of other deaf-blind people. The movie depicts the isolation of severely disabled people who are largely excluded from modern life. The woman, Fini, has lost her sight and hearing in her youth, but many of those she visits have been born deaf-blind, and struggle to connect with others in any way. Their obvious distress is harrowing, but Herzog also tries to convey the possibilities of a rich inner life for someone whose contact with the world is through taste, smell, and touch. Since the 1970s, Herzog has made a number of documentaries that attempt to capture a poetic truth about their subjects' everyday lives.
See also: *Aguirre, the Wrath of God* 206–07

WALKABOUT
Nicolas Roeg, 1971

Based on James Vance Marshall's novel, Nicolas Roeg's beautiful and haunting movie *Walkabout* is about a teenage schoolgirl (Jenny Agutter) and her young brother (Luc Roeg) stranded in the Australian outback after their father kills himself. They meet an Aboriginal boy (David Gulpilil) who helps them survive in the wild, though communication between them is difficult. Metaphors abound in Roeg's movie, and the outback has a hallucinogenic intensity, full of movement and color, suggesting a vibrancy and an

unpredictability in the desert that is absent from the ordered world of the city.
See also: *Don't Look Now* 210–13

THE HARDER THEY COME
Perry Henzell, 1972

Perry Henzell's *The Harder They Come* is the movie credited with popularizing reggae music beyond its Jamaican home, with a sound track by Desmond Dekker and The Maytals, and a title track by Jimmy Cliff, who also plays the movie's lead, Ivanhoe "Ivan" Martin. Country boy Ivan comes to Kingston, Jamaica, full of hope, but when every avenue leads to nothing, including the song he wrote and recorded, he turns to drug dealing, and becomes a trigger-happy gangster. Despite the movie's grim ending, it has an energy that matches its sound track.

A WOMAN UNDER THE INFLUENCE
John Cassavetes, 1974

A Woman Under the Influence was a family affair, with the director's wife Gena Rowlands taking the lead, and with both of the couple's mothers in the movie, too. Rowlands plays Mabel, who is so unstable in her desperation to please that her husband Nick (Peter Falk) commits her to an institution. However, Nick proves no better than Mabel at looking after their children. Upon her release Mabel seems unable to cope, but the children's profession of love for her seems to offer hope. Cassavetes' picture of the family is unflinching but ultimately liberating in its freedom from judgement.

SHOLAY
Ramesh Sippy, 1975

Often credited to director Ramesh Sippy's producer father G. P. Sippy, *Sholay* is a Hindi action-adventure movie, which transported the conventions of the Hollywood Western to India, to create the country's first blockbuster. Set in the rocky terrain of Karnataka in southern India, it tells the story of two small-time villains, Veeru and Jai, who become heroes when they are hired by a retired police officer to help capture the *dacoit* (bandit) Gabbar Singh, who is terrorizing their village. Some critics condemned the movie's glorification of violence, but it was a huge hit at the box office in India, and quotes from the movie ("What's going to happen to you now, Kaalia?") are embedded in Indian culture. It is the defining "masala" movie—a blend of action, drama, comedy, romance, and music.

XALA
Ousmane Sembene, 1975

Xala is a movie by Senegalese director Ousmane Sembene, adapted from his own novel. "Xala" (pronounced "hala") is the curse of sexual impotence that businessman El Hadji believes has befallen him after his third marriage. As he searches for a cure, El Hadji neglects his business. Finally, a beggar who has haunted his office for years reveals it was he who laid the curse on El Hadji, for ruining his own life years before. El Hadji will only be cured by standing naked while beggars spit on him. The movie is seen as a metaphor for the French-speaking Senegalese

elite following independence, who exploited the poor and became pawns in the colonial game.

ERASERHEAD
David Lynch, 1977

David Lynch's debut feature was an enigmatic, low-budget movie that became a cult hit. The story focuses on Henry Spencer (Jack Nance), a label printer with a weird shock of hair, whose girlfriend has a reptilian-looking premature baby. But the basic plot is just a hook for an increasing array of unsettling images and scenarios. The movie's title comes from a moment when part of Henry's head is removed and taken to a pencil factory to be made into erasers.
See also: *Blue Velvet* 256–57

DAWN OF THE DEAD
George A. Romero, 1978

Dawn of the Dead is the classic zombie horror movie, an unrestrained follow-up to Romero's 1968 feature *Night of the Living Dead*. After the US is devastated by an infection that reanimates the dead, four friends escape by helicopter and hole up in a shopping mall, where they have all their needs met but are besieged by the living dead. While the movie is generally regarded as a clever critique of American consumerism, it is also an unashamed gore fest.

DAYS OF HEAVEN
Terrence Malick, 1978

Days of Heaven is most memorable for its sumptuous Texan landscapes and its captivating score by Ennio

Morricone. The movie begins in 1916 and tells the story of Chicago steelworker Bill (Richard Gere) who, after a bust-up with his boss, flees to Texas with his girlfriend Abby (Brooke Adams) and teenage sister Linda (Linda Manz), who narrates the movie. They work long hours in the fields until, seeing a chance to escape poverty, Bill encourages Abby to marry the farmer, who has apparently just a year to live. However, the farmer lives on, and the story spirals into a tragedy of jealousy and biblical plagues.

APOCALYPSE NOW
Francis Ford Coppola, 1979

Inspired by Joseph Conrad's 1899 novella *Heart of Darkness*, Coppola's *Apocalypse Now* is set during the Vietnam War, as Captain Willard (Martin Sheen) is ordered to go deep into the jungle and kill Colonel Kurtz (Marlon Brando), a decorated officer who has gone insane and commands his troops as a demigod. The difficulties faced while filming in the Philippines are legendary, but the result was a movie of hallucinatory power, with a relentless sound track that swings from roaring helicopter blades to the pounding rock of The Doors.
See also: *The Godfather* 200–05

RAGING BULL
Martin Scorsese, 1980

Robert De Niro's Jake La Motta is a hungry and desperate boxer who, after finally winning a champion's belt, descends into a world of seedy bribes. He abuses his wife and all his friends, and ends up bloated and overweight. It's a measure of Scorsese's and De Niro's skill that

viewers retain their sympathy for this angry, frustrated man as he desperately tries to prove himself to the world.
See also: *Taxi Driver* 234–39

THE SHINING
Stanley Kubrick, 1980

Adapted from Stephen King's book of the same name, Kubrick's *The Shining* turned the author into a household name. Jack Nicholson plays the writer (and recovering alcoholic) Jack Torrance, who takes an off-season caretaker job at the Overlook Hotel in the Colorado Rockies, bringing his wife Wendy (Shelley Duvall) and young son, Danny, to stay with him in the vast, empty building. Over the weeks, Danny is haunted by increasingly horrifying visions as Jack slowly becomes homicidal, eventually chasing his family with a fire axe and the now-famous cry, "Heeere's Johnny!" Kubrick laced the movie with symbolism to produce a horror masterpiece, although King is said not to have liked it.
See also: *Dr. Strangelove* 176–79 ▪ *2001: A Space Odyssey* 192–93

E.T. THE EXTRA-TERRESTRIAL
Steven Spielberg, 1982

Few screen creatures have captured the hearts of the world as effectively as Spielberg's E.T., with its giant, baby eyes and the distinctive cute, rasping voice (spoken by Pat Welsh). Spielberg's direction and Melissa Mathison's script mix sentiment, sadness, and comedy in just the right proportions to keep the audience enthralled as E.T. befriends 10-year-old Elliott and then faces danger when

government agents move in. The movie is also notable for some outstanding performances by its child actors, including Henry Thomas as Elliott and Drew Barrymore as Gertie.
See also: *Jaws* 228–31

SCARFACE
Brian De Palma, 1983

Violent, graphic, and over the top, Brian De Palma's remake of the 1932 Howard Hawks movie pulls no punches as it charts the rise and fall of gangster Tony Montana, played with relish by Al Pacino. Montana spirals so far out of control that he kills his sister's husband on her wedding night. The movie divided critics. Some reveled in its detailed characterization; others found it unpleasant and clichéd.

BLOOD SIMPLE
Joel and Ethan Coen, 1984

The Coens began their directorial careers with this blood-soaked debut, a noirish thriller that features many of the themes they would revisit in later movies. A sleazy bar owner (Dan Hedaya) hires an even sleazier private detective (M. Emmet Walsh) to kill his wife (Frances McDormand). Through crossing, double-crossing, and plain incompetence, the hit goes bloodily wrong for everyone involved. Yet the Coens succeed in making the outcome absurd, funny, horrible, and inevitable. Critic Roger Ebert has remarked of the Coens' skill in plotting that "they build crazy walls with sensible bricks," and this was never more true than in *Blood Simple*.
See also: *Fargo* 282–83

PARIS, TEXAS
Wim Wenders, 1984

Paris, Texas opens with a man (Harry Dean Stanton) wandering lost in the Texan desert, and follows his slow and painful return to his old life, as his brother drives him across the country to Los Angeles to be reacquainted with his son and wife. Playwright Sam Shepard wrote the script, producing a sensitive and understated character study that explores the nature of family and fatherhood, as the man, who starts the movie mute, gradually regains his voice and identity. Shot by Wenders's regular collaborator Robby Müller, the movie features stunning, bleak shots of the desert and of the seedy neon world of the city.
See also: *Wings of Desire* 258–61

COME AND SEE
Elem Klimov, 1985

Soviet director Elem Klimov's *Come and See* is one of the few movies to show the devastation of war without a redeeming gleam of heroism. Drawing on Klimov's own boyhood trauma of fleeing the besieged city of Stalingrad during World War II, the movie follows the boy Florya, who joins the Belarusian partisans to fight the Nazis but is separated from his unit. An explosion shatters his eardrums, and from then on the movie moves through a series of ever more dire scenes, including one that shows his home village piled high with corpses. There is no redemption in the movie, or flinching, and yet Klimov finds a strange beauty in the terrible images he creates.

BRAZIL
Terry Gilliam, 1985

Terry Gilliam's *Brazil* (which takes its title from a 1939 song) is part satire, part fantasy. It is set in a surreal future where people are trapped in humdrum urban lives controlled by a Kafkaesque Ministry of Information. When an innocent man is wrongly arrested due to a bureaucratic error and dies in custody, records functionary Sam Lowry (Jonathan Pryce) tries to make it right, and in the process falls in love with the enigmatic Jill (Kim Greist) whom he fears may be a terrorist working against the ministry. The movie is probably the most complete representation of Gilliam's absurdist humor.

DOWN BY LAW
Jim Jarmusch, 1986

Shot on a low budget in black and white, *Down by Law* adopts a laconic take on life. At some moments bleak and others cheerful, it tells the story of three misfits—down-at-heel disc jockey Zack (Tom Waits), hustler pimp Jack (John Lurie), and lost Italian tourist Bob (Roberto Benigni)—who happen to end up sharing a prison cell and decide to make a break for it. As they go on the run through the Louisiana forests, the story seems part dream, part postapocalyptic nightmare.

JESUS OF MONTREAL
Denys Arcand, 1989

Jesus of Montreal tells the story of a company of actors led by Daniel (Lothaire Bluteau) who are hired by a priest to perform a passion play. To prepare a thought-provoking production, Daniel draws on academic research relating to the life of Christ, but his novel interpretation of the story upsets the Church authorities, and he finds himself undergoing an ordeal that parallels the Passion itself. The movie seems to challenge the established Church hierarchy, suggesting that it would fail to understand Christ if he returned.

HEARTS OF DARKNESS: A FILMMAKER'S APOCALYPSE
Fax Bahr, George Hickenlooper, and Eleanor Coppola, 1991

Filmed by the director's wife, Eleanor, this behind-the-scenes documentary follows the troubled making of Francis Ford Coppola's 1979 Vietnam War movie *Apocalypse Now*. The production was beset with difficulties that paralleled the movie's actual narrative, with drunk, high, or uncooperative stars, bad weather, and political problems on location in the Philippines. The movie includes interviews with the surviving protagonists, in which Coppola reflects on the experience: "We were in the jungle, there were too many of us, we had access to too much money, too much equipment, and little by little we went insane." **See also:** *The Godfather* 200–05

HARD BOILED
John Woo, 1992

Hard Boiled is a high-energy thriller about two unconventional Hong Kong cops, Tequila (Chow Yun-Fat) and Alan (Tony Leung), who team up to break a gunrunning ring. It is relentlessly pacy and uncompromising in its violence, with explosive action scenes and slow-motion gunfights that become almost balletic even as they horrify. The centerpiece of the movie is an action scene in which a handheld camera follows the two cops in a single shot, guns blazing, through a hospital unit and up in an elevator to another floor. Woo's action style has since been widely imitated.

RESERVOIR DOGS
Quentin Tarantino, 1992

Tarantino's debut feature focuses on the aftermath of a diamond heist gone wrong, as the gang gathers in a warehouse and tries to identify the traitor in its midst. The movie made Tarantino a star, and drew strong performances from its mostly male cast, including Michael Madsen and Tim Roth. Its ultraviolence is made theatrical by smart, rapid-fire dialogue laced with pop-culture references. Combined with sharp suits and a retro sound track, the movie introduced Tarantino as a new and stylish filmmaker. **See also:** *Pulp Fiction* 270–75

NAKED
Mike Leigh, 1993

Naked follows a young man from Manchester, Johnny (David Thewlis), who, with nowhere else to go, turns up at the London apartment of an old girlfriend (Lesley Sharp). Johnny wanders the streets, where he has chance encounters, including one with night security guard Brian (Peter Wight), who shows Johnny the workings of his mundane job.

"Don't waste your life," warns Brian, but this bleak movie ends as it began, with Johnny on the move, in the process of doing just that. Director Mike Leigh uses a long rehearsal process with his actors to develop characters and scripts for his movies, and in *Naked*, he provoked a stunning performance from Thewlis—egoistic, bitter, and nihilistic, yet funny and endearing at times.

SHORT CUTS
Robert Altman, 1993

Based on nine short stories by Raymond Carver, Robert Altman's *Short Cuts* follows the fortunes of 22 ordinary people in Los Angeles as their lives interweave over a few days. The people, played by an all-star cast that includes Jack Lemmon and Julianne Moore, have little in common, and do nothing especially dramatic, but beneath their lives is a sense of insecurity and unease about the future, symbolized by a plague of flies and earthquake warnings. Altman creates a sense of something heroic in their willingness to keep trying, hoping for something better.

HEAVENLY CREATURES
Peter Jackson, 1994

After an early career making low-budget splatter movies, Peter Jackson had a dramatic change of direction with this touching movie based on a true story about a murder in Christchurch, New Zealand. Two misfit teenagers, rich English girl Juliet (Kate Winslet) and shy New Zealander Pauline (Melanie Lynskey), develop an intense relationship and decide to kill Pauline's mother when she tries to keep them apart. As the girls blur the line between reality and the fantasy world they create with stories, pictures, and plastic figurines, so does Jackson, creating a movie that deals with a grim story in a surprisingly uplifting way.
See also: *The Lord of the Rings: The Fellowship of the Ring* 302–03

DRIFTING CLOUDS
Aki Kaurismäki, 1996

Drifting Clouds, by Finnish director Aki Kaurismäki, is a wry, tender look at the lives of an ordinary couple brought low by a recession. Ilona (Kati Outinen) works in a restaurant and her husband Lauri (Kari Väänänen) is a bus driver. The couple scrape by until both lose their jobs. Lauri loses his licence for medical reasons, and although Ilona finds a new restaurant job, she is cheated out of her wages. It ends ambiguously, but hopefully, with the couple opening a restaurant and seeing it fill with customers.

BREAKING THE WAVES
Lars von Trier, 1996

Set in a remote part of Scotland in the 1970s, *Breaking the Waves* is the strange story of Bess (Emily Watson). Deeply religious and naive, Bess begins to come out of her shell when she impulsively marries Swedish oil rig worker Jan (Stellan Skarsgård). Things change dramatically when Jan is paralyzed in a rig accident. He tells her that they can still have a sex life—by proxy—if she will sleep with other men and describe for him her acts. Bess debases herself sexually with other men, believing that by doing so, God will cure Jan. Scandalized, her local church casts her out, but when, at the end, she sacrifices her life, Jan is apparently cured.

TASTE OF CHERRY
Abbas Kiarostami, 1997

Taste of Cherry, by Iranian director Abbas Kiarostami, is a minimalist movie about a man who drives around Tehran, looking for someone who will bury him once he has killed himself. We never find out why he wants to die. As he drives he picks up various candidates. Kiarostami had no script, but improvised the dialogue almost as a series of interviews, either from the man's point of view or that of his passenger. The end, in which the man is seen waiting for death in his grave, is surprisingly uplifting.

WERCKMEISTER HARMONIES
Béla Tarr, 2000

The Hungarian movie *Werckmeister Harmonies* consists of just 39 long shots in black and white, each a complete scene in itself. The story is set in a bleak town in winter. A circus arrives, and a stuffed whale is its main attraction. The story is seen through the eyes of the wise fool János (Lars Randolph). János looks after György (Peter Fitz), who believes the world's problems began with the musical theories of 17th-century organist Andreas Werckmeister. It may be an allegory for Communist-era Hungary. Its target could also be capitalism or totalitarianism; either way, its view of humanity is pessimistic, showing acts of collective brutality committed for no clear reason.

AMORES PERROS
Alejandro González Iñárritu, 2000

Sometimes translated as *Love's a Bitch*, the Mexican movie *Amores Perros* paints a disturbing world, especially with its graphic scenes of dog fighting. The movie is set in Mexico City, and consists of three stories of loyalty and disloyalty, each involving a dog and briefly linked by a car accident. Octavio runs off with his brother's wife; Daniel leaves his wife for a model who then loses her leg; and the hitman El Chivo is trying to make contact with the daughter he abandoned at two years old.

IN THE MOOD FOR LOVE
Wong Kar-Wai, 2000

Chow (Tony Leung) and Su (Maggie Cheung) are neighbors in a Hong Kong apartment block in 1962. Each is convinced that their spouse is having an affair—perhaps with the other's spouse—and they meet to discuss it. They are aware that they may be in love with each other, but resist, unwilling to make the same mistake as their partners. The resignation to their fate is perfectly underpinned by the movie's luminous cinematography and the slow, mesmerising sound of a repeated Nat King Cole melody.

MULHOLLAND DR.
David Lynch, 2001

Originally conceived as a TV series, *Mulholland Dr.* leaves the viewer hanging, almost as if it were a trailer for episodes that will never happen. It is full of Lynch's characteristic enigmatic twists and visual inventiveness. On the face of it, the movie tells the story of aspiring actress Betty Elms (Naomi Watts) who arrives in Los Angeles and makes friends with amnesiac "Rita" (Laura Harring), but it follows many other little stories whose connection is cryptic. Lynch described the movie as "a love story in the city of dreams," and offered no more explanation than that.
See also: *Blue Velvet* 256–57

GOOD BYE, LENIN!
Wolfgang Becker, 2003

Wolfgang Becker's tender movie tells a story set in East Berlin just before and after the reunification of Germany. In 1989, Alex's mother suffers a nearly fatal heart attack when she witnesses him being arrested while involved in an antigovernment protest. She falls into a coma and doctors warn Alex that any sudden shock—such as the news that the Berlin Wall has just fallen—could kill her. And so, when she awakes, Alex goes through an elaborate and touching charade to keep her believing that life is carrying on as normal in the GDR.

TSOTSI
Gavin Hood, 2005

Adapted from an Athol Fugard novel, Gavin Hood's *Tsotsi* is the story of David, an inhabitant of a Johannesburg shantytown. As a boy, David finds himself homeless and has to grow up quickly to become Tsotsi, the brutal leader of a violent gang. He is stopped short when he finds a baby in the car of one of his victims. The helplessness of the baby challenges him as he finds himself obliged to care for it. The movie is driven by the vibrant Kwaito music of Zola, described by one critic as "slowed-down garage music," and a dynamic score by Mark Kilian and Paul Hepker.

CACHÉ
Michael Haneke, 2005

Michael Haneke's *Caché* (*Hidden*) is a French psychological thriller starring Daniel Auteuil and Juliette Binoche as a well-to-do couple who are sent a series of anonymous surveillance videos showing the exterior of their home. The videos take on a more disturbing significance when they are accompanied by crayon drawings that reveal an intimate knowledge of the man's early years, when his family was considering adopting an Algerian boy. The movie is partly about the repressed memory of *la nuit noire*, the night of October 17, 1961, in Paris, when French police massacred demonstrators against the Algerian War. Haneke skillfully handles the political message while keeping a taut, edge-of-the-seat menace that carries the movie along.
See also: *The White Ribbon* 323

TIMES AND WINDS
Reha Erdem, 2006

Reha Erdem's *Times and Winds* is a visual poem. It is an affecting look at the lives of three adolescent children in a mountain village in Turkey—two boys, Ömer and Yakup, and a girl Yildiz. Life in this bleak place is harsh, as the villagers try to scratch a living from the soil, but the challenges the three children face in growing up are harder still.

This is no coming-of-age movie, but a deeply felt and realistic portrait that captures the pain and beauty of young life.

TEN CANOES
Rolf de Heer and Peter Djigirr, 2006

Ten Canoes was the first Australian movie ever made completely in an Aboriginal language, and with an exclusively Aboriginal cast. But it would be a mistake to think it was notable for these things alone. In fact, it is a charming and hugely imaginative movie in which there is rich complexity behind apparent simplicity. Set in the remote Arnhem Land, at first the story seems like a simple fable of young love, but with flashbacks to ancient times it becomes a mesh of different perspectives. The most modern time period is shot in black and white, while the past is brought to life in color, a beautifully simple idea that illustrates how the past can be as vital as the present. The movie is narrated by David Gulpilil, who starred in Nicolas Roeg's *Walkabout*, and one of the cast is Gulpilil's son Jamie.

THERE WILL BE BLOOD
Paul Thomas Anderson, 2007

At the heart of Paul Thomas Anderson's *There Will Be Blood* is a remarkable performance by Daniel Day-Lewis as Daniel Plainview, the silver miner turned oilman in his ruthless pursuit of wealth. To persuade small landowners to allow him to drill on their land, Plainview presents himself as a prophet of profit. He becomes so obsessed with finding oil and destroying his competitors that he is eventually

driven insane. The movie seems to get to the nub of capitalism's true nature: that, ultimately, it is about domination not profit.

THE SECRET IN THEIR EYES
Juan José Campanella, 2009

Retired Buenos Aires federal agent Benjamín (Ricardo Darín) is writing a novel, but has writer's block. So he calls on former colleague Irene (Soledad Villamil) to go over the details of a case they worked on together 25 years earlier. As Benjamin revisits the case, he rekindles a buried passion for Irene, as well as revealing the obsessions of the other people involved in the case. Campanella splits the action between the 1990s and the 1970s, a time of brutal military dictatorship, in which political murders were sanctioned by the state. The result is a movie that works both as a tightly scripted thriller with a very clever twist, and as a frank examination of Argentina's troubled recent past.

THE KID WITH A BIKE
Jean-Pierre and Luc Dardenne, 2011

The Kid With a Bike (*Le gamin au vélo*) is the tender story of 12-year-old Cyril (Thomas Doret) finding comfort with a young woman called Samantha (Cécile de France) who gives him a bicycle after his father abandons him. Samantha is in some ways a fairy godmother, but the Dardenne brothers' directing keeps the movie realistic. Their work owes a clear debt to neorealist classics about childhood such as *Kes* and *The Bicycle Thief*. In a departure from their previous, intensely naturalistic work, the

brothers used incidental music for this movie, explaining that its fairy-tale structure required it.

HOLY MOTORS
Leos Carax, 2012

Holy Motors, a fantasy drama by French director Leos Carax, has been described as a parable of human relationships for the internet age. It is a hard movie to pin down, however, and is certainly surreal. It follows businessman Monsieur Oscar (Denis Lavant), who is taken around Paris in a white limousine, driven by Céline (Edith Scob), entering a bizarre sequence of worlds and roles: as assassin, raging father, bag lady, and many more. It defies narrative logic, and seems to combine the worlds of Lewis Carroll with those of David Lynch and Luis Buñuel.

THE GRAND BUDAPEST HOTEL
Wes Anderson, 2014

In *The Grand Budapest Hotel*, Wes Anderson maintains his reputation for walking the line between folly and genius. Set in a fictional central European state between the two world wars, the story recounts in flashback the comic adventures of Gustave H. (Ralph Fiennes), a legendary concierge, and his trusted bellboy Zero Moustafa (Tony Revolori and F. Murray Abraham). The plot is driven by Gustave H.'s attempts to get his hands on a priceless painting, with the rise of fascism providing the background tension. The film is a fast-moving farce, a love story, and a lament for a vanished aged of spa hotels and their eccentric guests.

INDEX

ACKNOWLEDGMENTS

Dorling Kindersley and Tall Tree would like to thank Helen Peters for the index, and Sheryl Sadana and Ira Pundeer for proofreading.

PICTURE CREDITS

The publisher would like to thank the following for their kind permission to reproduce their photographs:

(Key: a-above; b-below/bottom; c-center; f-far; l-left; r-right; t-top)

2 United Artists/**Kobal**/Witzel. 6 (br) Warner Brothers/**Kobal**/Jack Woods. 7 (tl) Film Andre Paulve/**Kobal**. 8 (tl) Paramount/**Kobal**. 9 (br) IFC Productions/Detour Filmproduction/**Kobal**. 12 (tl) Decla-Bioscop/**Kobal**. (tr) Deutsche Kinemathek; (tr) Nero/**Kobal**. 13 (tl) MGM/**Kobal**; (tc) Warner Brothers/**Kobal**; (tr) Paramount/**Kobal**. 14 (tl) 20th Century Fox/**Kobal**; (tc) Paramount/**Kobal**/Steve Schapiro; (tr) Universal/**Kobal**. 15 (tl) Bavaria/Radiant/**Kobal**; (tc) Globo Films/**Kobal**; (tr) Film4/Celador/Pathe/**Kobal**. 20 (tl) Melies/**Kobal**; (br) Melies/**Kobal**. 21 (tl) Melies/**Kobal**. 22 (tl) Wark Producing Company/**Kobal**; (bc) **Kobal**. 23 (tl) Wark Producing Company/**Kobal**; (br) Wark Producing Company/**Kobal**. 25 Decla-Bioscope/**Kobal**. 26 (tr) Decla-Bioscope/**Kobal**. 27 (b) Decla-Bioscope/**Kobal**. 28 (tl) Goskino/**Kobal**; (c) Goskino/**Kobal**. 29 (tr) Goskino/**Kobal**. (b) Paramount/**Kobal**/Otto Dyar. 30 (tl) Fox Films/**Kobal**; (bc) Paramount/**Kobal**. 31 (tc) Fox Films/**Kobal**; (br) Fox Films/**Kobal**. 32 (tl) Deutsche Kinemathek; (c) **Kobal**/Deutsche Kinemathek. 33 (tl) **Kobal**/Horst von Harbou-Deutsche Kinemathek; (br) **Kobal**/Horst von Harbou-Deutsche Kinemathek. 34 (tl) United Artists/**Kobal**; (cr) United Artists/**Kobal**. 35 (tl) Societe generale des films/**Kobal**; (bc) Societe generale des films/**Kobal**. 36 (tl) UFA/**Kobal**; (bc) UFA/**Kobal**. 37 (tl) Filmstudio Berlin/**Kobal**. 39 United Artists/**Kobal**. 40 (bl) United Artists/**Kobal**; (tr) United Artists/**Kobal**. 41 (br) United Artists/**Kobal**. 46 (tl) Nero/**Kobal**. 47 (tl) Nero/**Kobal**; (bl) Paramount/**Kobal**. 48 (tl) Paramount/**Kobal**; (cr) Paramount/**Kobal**. 49 (tr) RKO/**Kobal**; (br) RKO/**Kobal**. 50 (tl) Jacques-Louis Nounez/Gaumont/**Kobal**; (c) Everett/**REX** Shutterstock. 51 (tr) Jacques-Louis Nounez/Gaumont/**Kobal**. 52 (tl) Universal/**Kobal**; (br) Universal/**Kobal**. 53 (tl) © 1937 Disney/**Kobal**; (bc) © 1937 Disney/**Kobal**. 55 MGM/**Kobal**. 57 (b) MGM/**Kobal**/Eric Carpenter. 58 (t) Paramount/**Kobal**. 59 MGM/**Kobal**. 60 (tl) Nouvelle Edition Francaise/**Kobal**; (br) Nouvelle Edition Francaise/**Kobal**. 61 (tr) Nouvelle Edition Francaise/**Kobal**. 62 (tl) MGM/**Kobal**; (c) MGM/**Kobal**. 63 (tr) MGM/**Kobal**/Laszlo Willinger; (bc) MGM/**Kobal**. 64 (tl) Columbia/**Kobal**; (br) Columbia/**Kobal**. 65 (tc) United Artists/**Kobal**; (br) SNAP/**REX** Shutterstock. 67 RKO/**Kobal**. 68 (tl) RKO/**Kobal**/Donald Keyes. 69 (tc) RKO/**Kobal**. 70 (b) RKO/**Kobal**. 71 (br) RKO/**Kobal**. 72 (tc) Warner Brothers/**Kobal**. 73 (t) Warner Brothers/**Kobal**/Jack Woods. 74 (t) Warner Brothers/**Kobal**/Jack Woods. 75 (t) Warner Brothers/**Kobal**/Jack Woods; (tc) Columbia/**Kobal**/Bob Coburn. 76 (tl) United Artists/**Kobal**/Bob Coburn; (tc) United Artists/**Kobal**/Bob Coburn. 77 (bc) United Artists/**Kobal**/Bob Coburn; (tc) SNAP/**REX** Shutterstock. 78 (tl) ICI/**Kobal**. 79 (t) 20th Century Fox/**Kobal**; (bc) 20th Century Fox/**Kobal**. 81 (t) Pathe/**Kobal**; (br) Pathe/**Kobal**. 82 (tl) Pathe/**Kobal**. 83 (tr) **Kobal**; (bl)

Pathe/**Kobal**. 84 (tl) Films Andre Paulve/**Kobal**; (bc) Films Andre Paulve/**Kobal**. 85 (tr) Films Andre Paulve/**Kobal**; (bl) Films Andre Paulve/**Kobal**. 86 (tl) AF archive/**Alamy**; (b) AF archive/**Alamy**. 87 (t) ITV/**REX** Shutterstock; (tr) INTERFOTO/**Alamy** 89 RKO/**Kobal**. 90 (t) RKO/**Kobal**. 92 (b) RKO/**Kobal**. 93 (tc) RKO/**Kobal**; (tr) Columbia/**Kobal**. 95 (b) Produzione De Sica/**Kobal**. 96 (b) Produzione De Sica/**Kobal**. 97 (tc) Produzione De Sica/**Kobal**; (tr) **Kobal**/Bob Hawkins. 98 (tl) © 1949 Studio Canal Films Ltd../**Kobal**. 99 (tl) © 1949 Studio Canal Films Ltd../**Kobal**; (br) © 1949 Studio Canal Films Ltd./**Kobal**. 100 (b) © 1949 Studio Canal Films Ltd./**Kobal**. 101 (tr) © 1949 Studio Canal Films Ltd./**Kobal**. 102 (b) © 1949 Studio Canal Films Ltd./**Kobal**. 103 (tr) © 1949 Studio Canal Films Ltd./**Kobal**. 109 Daiei/**Kobal**. 110 (bl) **Kobal**. 111 (tl) Daiei/**Kobal**; (bc) Daiei/**Kobal**. 113 (tl) Daiei/**Kobal**. 114 (tl) Paramount/**Kobal**; (br) Paramount/**Kobal**. 115 (tl) Paramount/**Kobal**; (tr) Paramount/**Kobal**. 116 (tl) Warner Brothers/**Kobal**; (cr) Warner Brothers/**Kobal**. 117 (tr) Warner Brothers/**Kobal**. 119 (tl) United Artists/**Kobal**. 120 (b) United Artists/**Kobal**. 121 (tc) United Artists/**Kobal**; (tr) **Kobal**. 122 (bc) MGM/**Kobal**. 123 (tl) MGM/**Kobal**. 124 (tl) MGM/**Kobal**/Eric Carpenter; (bc) MGM/**Kobal**/Virgil Apger. 125 MGM/**Kobal**/Ed Hubbell. 126 (tl) Shochiku/**Kobal**; (c) Shochiku/**Kobal**. 127 (tl) Shochiku/**Kobal**. 128 (tl) Filmsonor/CICC/Vera-Fono Roma/**Kobal**; (b) Filmsonor/CICC/Vera-Fono Roma/**Kobal**. 129 (tl) Toho Film/**Kobal**; (bc) Toho Film/**Kobal**. 130 (tl) Universal/**Kobal**. 131 (tl) Warner Brothers/**Kobal**; (bc) Warner Brothers/**Kobal**. 132 (tl) Government of West Bengal/**Kobal**; (b) Government of West Bengal/**Kobal**. 133 (tl) Government of West Bengal/**Kobal**; (tr) Priya/**Kobal**. 134 (tl) United Artists/**Kobal**; (cr) United Artists/**Kobal**. 135 (tl) Warner Brothers/**Kobal**. 136 (cr) Sunset Boulevard/**Corbis**. 137 (br) Photos 12/**Alamy**. 138 (tl) Pictorial Press Ltd./**Alamy**. (b) AF archive/**Alamy**. 139 (t) Bettmann/**Corbis**. 141 Paramount/**Kobal**. 142 (bl) Paramount/**Kobal**. 143 (br) Paramount/**Kobal**. 144 (c) Paramount/**Kobal**. 145 (c) Paramount/**Kobal**. 146 (tl) Film Polski/**Kobal**; (c) Film Polski/**Kobal**. 147 (t) **Kobal**; (c) Film Polski/**Kobal**. 148 (t) United Artists/**Kobal**; (c) United Artists/**Kobal**. 149 (tl) United Artists/**Kobal**. 150 (tc) Columbia/**Kobal**. 151 Sedif/Les Films du Carosse/Janus/**Kobal**. 152 (bl) Anglo Enterprise/Vineyard/**Kobal**. 153 (tr) Sedif/Les Films du Carosse/Janus/**Kobal**. 154 Sedif/Les Films du Carosse/Janus/**Kobal**. 155 (bl) Sedif/Les Films du Carosse/Janus/**Kobal**. 161 Riama-Pathe/**Kobal**. 162 (tr) Riama-Pathe/**Kobal**; (bl) PEA/Artistes Associés/**Kobal**. 163 (br) Riama-Pathe/**Kobal**. 164 (cr) Leontura/**iStockphoto**. 165 (tr) Riama-Pathe/**Kobal**; (tr) Titanus/Vidas/SGC/**Kobal**. 166 (tc) SNAP/**REX** Shutterstock. 167 (tr) SNC/**Kobal**; (bl) SLON/**Kobal**. 168 (tl) Woodfall/British Lion/**Kobal**; (br) Woodfall/British Lion/**Kobal**. 169 (bl) Woodfall/British Lion/**Kobal**; (bc) Woodfall/British Lion/**Kobal**. 170 (tl) Terra/Tamara/Cormoran/**Kobal**/Georges Pierre; (bc) Spectafilm. 171 (tl) Terra/Tamara/Cormoran/**Kobal**/Georges Pierre; (br) Terra/Tamara/Cormoran/**Kobal**/Georges Pierre. 172 (t) Argos Films/**Kobal**. 173 (t) Parc Film/Madeleine Film/Beta Film/**Kobal**; (tr) Parc Film/Madeleine Film/Beta Film/**Kobal**. 174 (tl) Copacabana Films/**Kobal**; (c) Copacabana Films/**Kobal**. 175 (tl) Everett/**REX** Shutterstock; (b) Photos 12/**Alamy**. 177 (bl) Hawk Films Production/Columbia/**Kobal**. 178 (t) Hawk Films Production/Columbia/**Kobal**. 179 (bl) Hawk Films Production/Columbia/

Kobal; (tr) Warner Brothers/**Kobal**. 180 (tl) 20th Century Fox/**Kobal**; (bc) 20th Century Fox/**Kobal**. 181 (tr) 20th Century Fox/**Kobal**. 183 Casbah/Igor/**Kobal**. 184 (tr) Casbah/Igor/**Kobal**. 185 (br) Casbah/Igor/**Kobal**. 186 (b) Casbah/Igor/**Kobal**. 187 (bl) Casbah/Igor/**Kobal**. 188 (tl) Everett/**REX** Shutterstock. 189 (tl) Specta Films/Jolly Film/**Kobal**; (cr) Specta Films/Jolly Film/**Kobal**. 190 (tl) Warner Brothers/**Kobal**; (bc) Warner Brothers/**Kobal**. 191 (t) Warner Brothers/**Kobal**. 192 (tl) MGM/**Kobal**; (c) MGM/**Kobal**. 193 (tr) MGM/**Kobal**. 194 (tl) Warner 7 Arts/**Kobal**; (bc) Columbia/**Kobal**. 195 (tl) Warner 7 Arts/**Kobal**; (b) Warner 7 Arts/**Kobal**. 196 (tl) Columbia/**Kobal**; (cr) Columbia/**Kobal**. 197 (tl) Columbia/**Kobal**. 198 (tl) Films la Boetie/Euro International/**Kobal**; (c) Films la Boetie/Euro International/**Kobal**. 199 (tl) Classic Film/Cinevideo/Filmel; (br) Films la Boetie/Euro International/**Kobal**. 201 Paramount/**Kobal**/Steve Schapiro. 203 (tr) Paramount/**Kobal**; (bl) **Kobal**. 204 (bl) Paramount/**Kobal**. 205 (tr) Warner Brothers/**Kobal**; (bl) Paramount/**Kobal**/Steve Schapiro. 206 (tl) Photos 12/**Alamy**; (bc) **Kobal**/Maureen Gosling. 207 (t) Photos 12/**Alamy**. 208 (tl) Greenwich/**Kobal**; (bc) **Kobal**. 209 (tl) Greenwich/**Kobal**; (br) Greenwich/**Kobal**. 210 (b) © 1973 Studio Canal Films Ltd../**Kobal**. 211 (tr) © 1973 Studio Canal Films Ltd../**Kobal**. 212 (b) Moviestore/**REX** Shutterstock. 213 (tr) © 1973 Studio Canal Films Ltd../**Kobal**. (br) EMI/**Kobal**/David James. 214 (tl) Elias Querejeta Productions/**Kobal**; (br) Elias Querejeta Productions/**Kobal**. 215 (tl) Elias Querejeta Productions/**Kobal**. (tr) **Kobal**. 217 Paramount/**Kobal**. 218 (bl) Paramount/**Kobal**. 219 (tl) Paramount/**Kobal**. 220 (c) Paramount/**Kobal**. 221 (tr) **Kobal**. (bl) Paramount/**Kobal**. 222 (tl) Tango Film/**Kobal**; (c) Tango Film/**Kobal**. 223 (tr) Tango Film/**Kobal**; (bl) AF archive/**Alamy**. 228 (br) Universal/**Kobal**. 229 (tr) Universal/**Kobal**. 230 (tr) Universal/**Kobal**; (bl) Universal/**Kobal**. 231 Universal/**Kobal**. 232 (tr) Picnic/BEF/Australian Film Commission/**Kobal**. 233 (tl) Picnic/BEF/Australian Film Commission/**Kobal**; (tr) MGM/UA/**Kobal**. 235 Columbia/**Kobal**/Steve Schapiro. 237 (t) Columbia/**Kobal**/Steve Schapiro; (bl) Columbia/**Kobal**/Steve Schapiro. 238 (t) Columbia/**Kobal**/Steve Schapiro. 239 (tr) Paramount/**Kobal**. 240 (tl) United Artists/**Kobal**/Brian Hamill; (c) United Artists/**Kobal**/Brian Hamill. 241 (t) United Artists/**Kobal**/Brian Hamill. 242 (t) Courtesy of **Lucasfilm** Ltd. LLC, *Star Wars: Episode IV – A New Hope* ™ & © Lucasfilm Ltd. LLC; (bc) Courtesy of **Lucasfilm** Ltd. LLC, *Star Wars: Episode IV – A New Hope* ™ & © Lucasfilm Ltd. LLC. 243 (tl) 20th Century Fox/**Kobal**; (c) 20th Century Fox/**Kobal**. 244 (c) Mosfilm/**Kobal**. 245 (cr) Mosfilm/**Kobal**; (bl) Mosfilm/**Kobal**. 246 (tl) Mosfilm/**Kobal**. 247 (b) Mosfilm/**Kobal**. 248 (tl) Bavaria Film/Radiant Film/**Kobal**; (c) Bavaria Film/Radiant Film/**Kobal**. 249 (tr) Bavaria Film/Radiant Film/**Kobal**; (bl) Kurt Vinion/EdStock/**istockphoto**. 251 Warner Brothers/**Kobal**. 253 (tl) Warner Brothers/**Kobal**; (tr) Warner Brothers/**Kobal**. 254 (tl) Warner Brothers/**Kobal**. 255 Warner Brothers/**Kobal**. 256 (tl) De Laurentiis/**Kobal**; (c) De Laurentiis/**Kobal**. 257 (tl) Universal/**Kobal**; (bc) De Laurentiis/**Kobal**. 258 (br) Road Movies/Argos Films/WDR/**Kobal**. 259 (tr) Road Movies/Argos Films/WDR/**Kobal**. 260 (tl) SNAP/**REX** Shutterstock. 261 (tc) Road Movies/Argos Films/WDR/**Kobal**. 262 (tl) El Deseo/Lurenfilm/**Kobal**/Stephane Fefer. 262 (tl) El Deseo/Lurenfilm/**Kobal**. 263 (br) Snap Stills/**REX** Shutterstock; (bc) Everett/**REX** Shutterstock. 264 (tc) Universal/**Kobal**. 265 (tl) Era International/**Kobal**; (bc) Era International/

Kobal. 271 Miramax/Buena Vista/**Kobal**/Linda R. Chen. 272 (c) Miramax/Buena Vista/**Kobal**/Linda R. Chen. 273 Miramax/Buena Vista/**Kobal**/Linda R. Chen. 274 (tc) Miramax/Buena Vista/**Kobal**/Linda R. Chen. 275 (tr) Miramax/Buena Vista/**Kobal**/Linda R. Chen. 276 (tl) CAB/FR3/Canal +/**Kobal**; (br) CAB/FR3/Canal +/**Kobal**. 277 (tl) CAB/FR3/Canal +/**Kobal**; (tr) **Kobal**/Rommeld Pieukowski. 278 (tl) ITV/**REX** Shutterstock; (c) SNAP/**REX** Shutterstock. 279 (tc) **Kobal**; (b) SNAP/**REX** Shutterstock. 280 (tl) Pixar/Walt Disney Pictures/**Kobal** © Disney-Pixar; (bc) Pixar/Walt Disney Pictures/**Kobal** © Disney-Pixar; Slinky © Dog is a registered trademark of POOF–Slinky, Inc.; Mr. Potato Head © is a registered trademark of Hasbro, Inc. Used with permission © Hasbro. All rights reserved. 281 (tl) Les Productions Lazennec/Canal+/La Sept Cinema/Kasso Inc./**Kobal**. 282 (tl) Working Title/Polygram/**Kobal**; (c) Working Title/Polygram/**Kobal**. 283 (t) Imagine/Alphaville Films/**Kobal**; (b) Working Title/Polygram/**Kobal**. 284 (tl) Ego Films Arts/**Kobal**; (bc) Ego Films Arts/**Kobal**. 285 (tl) Videofilmes/Mact Productions/**Kobal**. 286 (tl) Nimbus Film/**Kobal**; (bc) Pascal Le Segretain/EdStock/**istockphoto**. 287 (tl) Nimbus Film/**Kobal**; (br) Nimbus Film/**Kobal**. 288 (tl) Toho Company/Omega Project/**Kobal**; (bc) Toho Company/Omega Project/**Kobal**. 289 (tl) Toho Company/Omega Project/**Kobal**. (br) Dreamworks/**Kobal**/Gemma La Mana. 291 Columbia/**Kobal**/Chan Kam Chuen. 292 (tl) Columbia/**Kobal**/Chan Kam Chuen. 293 (cr) Columbia/**Kobal**/Chan Kam Chuen. 294 (t) Columbia/**Kobal**/Chan Kam Chuen. 295 (tc) Columbia/**Kobal**; (tr) Focus Features/**Kobal**. 296 (tl) Studio Ghibli/**Kobal**; (br) Studio Ghibli/**Kobal**. 297 (tl) Studio Ghibli/**Kobal**; (br) Studio Ghibli/**Kobal**. 298 (tl) UGC/Studio Canal +/**Kobal**; (c) UGC/Studio Canal +/**Kobal**; (br) Claudie Ossard/Constellation/**Kobal**. 299 (t) © Miramax/Everett/**REX**. 300 (tl) Aamir Khan Productions/**Kobal**. 301 (br) Aamir Khan Productions/**Kobal**. 302 (tl) New Line Cinema/Wingnut/Pierre Vinet; (bc) New Line Cinema/Wingnut. 303 (tl) New Line Cinema/Wingnut/Pierre Vinet; (tr) New Line Cinema/Wingnut/Pierre Vinet. 305 Globo Films/**Kobal**. 306 (c) Globo Films/**Kobal**; (bl) Rhombus Media/**Kobal**. 307 (c) Globo Films/**Kobal**. 309 (b) Globo Films/**Kobal**. 310 (tl) Egg Films/Show East/**Kobal**; (br) Egg Films/Show East/**Kobal**. 311 (bc) Pascal Le Segretain/EdStock/**istockphoto**; (t) Egg Films/Show East/**Kobal**. 312 (tl) Wiedermann & Berg. 313 (tl) Wiedermann & Berg/**Kobal**; (br) Wiedermann & Berg/**Kobal**. 315 Warner Brothers/**Kobal**. 316 (cl) Warner Brothers/**Kobal**; (bl) Warner Brothers/**Kobal**. 317 (b) Warner Brothers/**Kobal**. 318 (tl) Film4/Celador/Pathe/**Kobal**. 319 (tl) Film4/Celador/Pathe/**Kobal**; (tr) Film4/Celador/Pathe/**Kobal**. 320 (tl) First Light Production/Summit/**Kobal**; (b) First Light Production/Summit/**Kobal**. 321 (tl) First Light Production/Summit/**Kobal**; (tr) First Light Production/Summit/**Kobal**. 322 Snap Stills/**REX** Shutterstock. 323 (tl) Wega Film/Lucky Red/**Kobal**; (bc) Wega Film/Lucky Red/**Kobal**. 324 (tl) Imaj/**Kobal**; (c) Imaj/**Kobal**. 325 (t) Bredok Film/Zeynofilm/**Kobal**; (b) Snap Stills/**REX** Shutterstock. 326 (tl) Warner Brothers/**Kobal**; (b) Warner Brothers/**Kobal**. 327 (t) IFC Productions/Detour Filmproduction/**Kobal**; (cr) IFC Productions/Detour Filmproduction/**Kobal**. 330 (tl) Sashkinw/**istockphoto**.

All other images © Dorling Kindersley. For more information see: **www.dkimages.com**